DATE DUE

JAN 0 4 2008			

Demco, Inc. 38-293

ENTERED JAN 3 1 2005

JAPANESE AMERICAN MIDWIVES

THE ASIAN AMERICAN EXPERIENCE

Series Editor
Roger Daniels, University of Cincinnati

*A list of books in the series
appears at the end of this book.*

JAPANESE AMERICAN
MIDWIVES

Culture, Community, and Health Politics,

1880–1950

SUSAN L. SMITH

University of Illinois Press

Urbana and Chicago

Library of Congress Cataloging-in-Publication Data

Smith, Susan Lynn, 1960–
Japanese American midwives : culture, community, and health
politics, 1880–1950 / Susan L. Smith.
p. cm. — (The Asian American experience)
Includes bibliographical references and index.
ISBN-13: 978-0-252-03005-5 (cloth : alk. paper)
ISBN-10: 0-252-03005-2 (cloth : alk. paper)
ISBN-13: 978-0-252-07247-5 (paper : alk. paper)
ISBN-10: 0-252-07247-2 (paper : alk. paper)
1. Midwifery—United States—History. 2. Midwifery—Japan—
History. 3. Midwives—United States—History. 4. Midwives—
Japan—History. 5. Japanese American women—History.
6. Japanese—United States—History. 7. Japan—Emigration and
immigration—History. [DNLM: 1. Midwifery—history—United
States. 2. Asian Americans—history—United States. 3. Health
Policy—history—United States. 4. Race Relations—history—
United States. WQ 11 AA1 S659j 2005] I. Title. II. Series.
RG950.S655 2005
362.198'2'0089956073—dc22 2005007104

CONTENTS

ACKNOWLEDGMENTS

This book is dedicated to Donald Macnab and Susan Hamilton, who made it possible, in their own special ways, for me to complete it. They not only offered wonderful suggestions for how to improve this work, they also provided solid moral support. Sue, my book's midwife, helped me to persevere through some of the hardest labor I have known outside of giving birth. Donald, along with our children Erin, Andreas, and Caitlin, has survived this challenging experience with me. It was he who insisted that I quit talking about finishing the book and just do it. And so, at last, I did.

This book is also written in memory of my parents, Lori and Bob Smith, who always demonstrated their love and faith in me. I also thank my aunts Norma and Carole Smith, and brothers Larry and Jerry Smith, and my friends Karen SheltonBaker, Marie Hughes, and Dennis and Patricia Edney for all their support.

Many colleagues have given of their time and shared their wisdom with me since I began this project in 1995. They have read and reread drafts of conference papers, chapters, and sometimes the entire book manuscript. Very special thanks to Roger Daniels, Molly Ladd-Taylor, Judith Walzer Leavitt, Laura McEnaney, Leslie Reagan, and Leslie Schwalm for their long support and careful reading of my work at various stages. The scholarship and teaching of Judy Leavitt in the history of women and health first drew me into the field and so inspired me that I have never left. Roger Daniels, who has encouraged so many scholars in Asian American history, generously gave of his time and vast knowledge. Tremendous thanks also to the former and current members of my writing group at the University of Alberta: Annalise Acorn, Glenn Berger, Lesley Cormack, Judy Garber, Lois Harder, Susan Hamilton, and Teresa Zackodnik. I also thank my friends and colleagues in the Department of History and Classics for facilitating

my research in different ways, including Linda Bridges, Lesley Cormack, Pat Prestwich, David Marples, and Robert Smith. I also acknowledge the important support and insights from Laurie Adkin, Charlotte Borst, Hal Cook, Marguerite Dupree, Gina Feldberg, Eve Fine, Louis Fiset, Gwenn Jensen, Vanessa Northington Gamble, Karen Hughes, Maneesha Lal, Hilary Marland, Kate McPherson, Herb Northcott, Ronald Numbers, Gary Okihiro, Sumiko Otsubo, Pat Prestwich, Johanna Schoen, Yuki Terazawa, and Sinh Vinh. Finally, it was Gerda Lerner and Linda Gordon who first sharpened my historical thinking two decades ago, and Nancy Worcester and Mariamne Whatley who taught me about health politics.

I also wish to acknowledge the helpful feedback from audiences at conferences for the American Association for the History of Medicine, the Canadian Society for the History of Medicine, the Berkshire Women's History conference, the Organization of American Historians, the Western History Association, and audiences at Willamette University, the University of Wisconsin at Madison, the University of Illinois, the University of Iowa, the University of Colorado, the University of Lethbridge, Simon Fraser University, York University, and the University of Glasgow.

I have been blessed with excellent research assistants over the years. My thanks to Linda Affolder, David Dolff, Robynne Healey, Kandace Keithley, Amrita Chakrabarti Myers, Dawn Nickel, Anatol Scott, Norma Smith, and Denise Thompson. Febe Pamonag deserves special mention, for she provided not only valuable research assistance, but also essential translation assistance and feedback on the entire manuscript based on her knowledge of Japanese women's history.

I also thank the many archivists and librarians who make it possible for scholars to do their work. Special thanks to Aloha South at the National Archives in Washington, D.C., for her wise suggestions and extraordinary assistance. I also thank Margaret Adams and Tab Lewis at the National Archives; Jeannette Buckingham and Chuck Humphrey at the University of Alberta; David Hastings at the Washington State Archives; Ruth Vincent (formerly) at the Wing Luke Asian Museum; Jo Anne Myers-Ciecko at the Seattle School of Midwifery; Chieko Tachihata and Sherman Seki (and Michaelyn P. Chou who retired in 1995) at Special Collections in the Hamilton Library at the University of Hawaii–Manoa; Charlene Dahlquist at Lyman House in Hilo, Barnes Riznik at Grove Farm in Kauai; and Dr. Troy Kaji in Burbank, California, who shared his research and suggestions. Thanks also to Roger Shimomura and Katharine Kohler for allowing me to use the priceless records under their care.

Finally, this research was funded by the Hannah Institute for the History of Medicine, Associated Medical Services, in Toronto. At a time of scarce financial resources for scholars in the humanities and social sciences, this organization provided vital financial assistance to historians. I am also grateful for a McCalla Professorship from the Faculty of Arts at the University of Alberta, which provided me with the time I needed to complete this project. Portions of chapter 4 appeared earlier in "Alice Young Kohler," *American Nursing: A Biographical Dictionary,* vol. 3, edited by Vern L. Bullough and Lilli Sentz (New York: Springer Co., 2000), 167–69. Used with permission by Springer Publishing Company, Inc., New York 10012. Portions of chapter 5 appeared earlier in Smith, Susan L., "Women Health Workers and the Color Line in the Japanese American 'Relocation Centers' of World War II," *Bulletin of the History of Medicine, 73*: 4 (Winter 1999): 585–601. Copyright Johns Hopkins University Press. Reprinted with permission of Johns Hopkins University Press.

JAPANESE AMERICAN MIDWIVES

INTRODUCTION: JAPANESE AMERICAN
WOMEN, RACIAL POLITICS, AND THE
MEANINGS OF MIDWIFERY

Japanese American midwives were women who established their expertise as childbirth attendants in Japan but spent most of their working lives in the United States. Midwives, almost all of whom were women, and doctors, most of whom were men, were the predominant formal health-care providers among Japanese immigrants. This project explores the experiences of Japanese immigrant midwives and the shifting meanings of midwifery from the late nineteenth century to the mid-twentieth century.

This study examines the lives of women such as Toku Shimomura,[1] who kept a diary for over fifty years. Toku's diary is one of the few surviving first-hand accounts of either Japanese immigrant women or American midwives. It is an important source for understanding the history of midwifery from the midwife perspective. The diary reveals that Toku practiced midwifery as part of a community of midwives. For instance, on 17 January 1914, twenty-five-year-old Toku attended the New Year's gathering of midwives at Koto Takeda's house. It was the first *sanba kai*, or midwife association, meeting of the year. Toku, who immigrated to the United States only two years earlier, was part of a small group of Japanese midwives or *sanba* (pronounced "samba") living in Seattle, Washington. Toku regularly attended midwife meetings from the 1910s, when she arrived in Seattle, through the 1930s. The *sanba* met together monthly, and sometimes more frequently, to socialize, discuss their work delivering babies, and keep informed about events in Japan.[2]

Toku's diary provides us with an unusual glimpse of how she, like thousands of Issei,[3] meaning the Japanese immigrants or first generation, continued to identify with Japan even as she built a new life in the United States. It illustrates most Issei women's ongoing emotional connections to the people

of Japan. For example, at the January 1914 midwife meeting, the women decided to send a $10 donation to aid the residents of Kagoshima, in southern Japan. Kagoshima had just been hit hard by over 200 earthquakes and what proved to be the largest volcanic eruption in Japan in the twentieth century, requiring residents to evacuate the city.[4] In April of that same year Toku sadly noted in her diary that the emperor's mother had died. A month later she was excited when two Japanese ships, *Asama Maru* and *Azuma Maru*, entered the port of Seattle. Like some Japanese midwives, Toku had worked as a nurse on a hospital ship during the Russo-Japanese War in 1905–1906 and the *Azuma Maru* had guarded her ship.[5]

The history of the American *sanba* demonstrates that midwifery was both a cultural practice and a health-care occupation. For Issei women, midwifery bridged the past in Japan and the present in the United States. Midwifery was a central part of Japanese women's health culture in the United States, just as it had been in Japan. Japanese midwifery was not static and timeless, however, but instead part of a dynamic process of change. At the beginning of the twentieth century in Japan, the Japanese midwife was part of the modern health movement that hoped to save women and babies by eradicating unsafe childbirth practices. These modern, licensed health-care workers were the midwives who immigrated to the United States.

Japanese immigrant midwives actively participated in the creation of Japanese American community and culture. The *sanba* who immigrated to the United States acted as both preservers of culture and agents of cultural change. They not only provided Issei women with Japanese birthing customs, they also broke traditions and initiated new ones. For example, immigrant women continued to use the *hara obi,* or pregnancy sash. In addition, new patterns emerged in some midwives' families in that wives became a key source of family income, while husbands took on nontraditional roles and performed some of the household labor.

A midwife is neither a nurse nor a doctor, although she may draw on some of their skills, but someone who attends women in childbirth. She is involved in the care of women in pregnancy, labor, and delivery and often prenatal and postnatal care for the woman and infant care for the newborn. I use the Japanese term *sanba* to evoke meanings not entirely captured by the English word *midwife. Sanba* was the standard legal and popular term for midwives in Japan from the 1880s to the 1940s.[6] It is a term that implies a specific gender, cultural, and professional identity—a woman, a Japanese person, and a modern midwife.

This study frames the story of Japanese American midwifery in relation to the history of health politics, as well as in relation to health care. It addresses the question: What was the impact of American health politics on Japanese immigrant midwives? In the case of Japanese Americans, the practice of delivering babies was enmeshed in national and international politics, gender, and race relations. Birth was, and still is, not only a biological event, but also a political one. In the early twentieth century, a time of often-tense U.S.-Japan relations and an anti-Japanese movement, the American *sanba* nonetheless managed to preserve midwifery, a Japanese cultural practice. Despite the difficulties faced by many Japanese immigrants on the American West Coast and the islands of Hawai'i,[7] then an American territory, the *sanba* attended tens of thousands of deliveries. They imported and safeguarded Japanese birthing practices for the Issei, who had most of their babies between 1910 and 1940. In the process, the *sanba* delivered many, perhaps most, of the American-born or second generation, the Nisei. Japanese immigrant midwives drew on modern Japanese approaches to deliver Americans.[8]

This study blends a midwife-centered approach with an analysis of the impact of the state on midwifery. It demonstrates how public health policies, racial politics, foreign affairs, and war affected Japanese American midwifery. Like the work of historian Laura McEnaney on gender and civil defense, this study examines "both state and society—at the recorded, official politics of state and the less visible politics of everyday life and culture."[9] By "the state" I mean federal, state, and territorial governments, legislative and judicial bodies, and the military. State responses to midwifery varied depending on time and place, peacetime and wartime. In the United States, unlike in European nations and Japan, no centralized health-care system developed and all midwife regulation took place at the local and state government level. In this study, most of the government officials I refer to are health officials. As we will see, because of the gendered nature of public health work, midwife negotiations with health officials entailed interactions with other women more than men, and nurses more than doctors.

Although midwives were the primary birth attendants throughout North America, Europe, and Japan for centuries, they came under increasing scrutiny across the industrialized world at the beginning of the twentieth century. Government officials, physicians, nurses, public health advocates, birthing women (by which I mean the women who gave birth), and midwives themselves generated and participated in national debates about the appropriate status of midwifery and the role of midwives. The resulting legal require-

ments and government regulations were far from uniform, however. Even as the debates and controversies about the place of midwifery transcended national boundaries, transformations of midwifery hinged on specific national contexts.[10]

The American experience with midwifery was in sharp contrast to developments in Europe and Japan, where midwifery became a clearly defined and respected occupation for women. In 1900, for instance, more than 1,000 women convened in Berlin for the first international gathering of midwives. German midwives joined those from Denmark, Holland, Romania, Russia, Switzerland, Sweden, Austria, and Hungary in an effort to improve the status and increase the public recognition of midwifery. By 1919 European midwives created the International Midwives Union, known today as the International Confederation of Midwives. They launched this organization because midwives sought to be recognized as a distinct professional group.[11]

The issue of professionalization and midwifery has remained a complex one for historians. Historian Charlotte Borst, for example, argues in her pathbreaking book, *Catching Babies: The Professionalization of Childbirth, 1870–1920,* that even as school-trained midwives began to replace the untrained or apprentice-trained midwives in the early twentieth century, American midwifery "did not professionalize." Borst asserts that midwives still lacked control over education and developments in the field of midwifery and were marginal to the process of legally defining it.[12] Focusing on Wisconsin, she finds that even urban midwives with a large number of paying clients "viewed their practice in entrepreneurial, rather than professional, terms."[13] Her study builds on and challenges earlier work that focused on the American debates about midwifery among doctors. Borst explains that previous scholarship focused on midwifery in relation to a crisis within medicine. She asserts, however, that midwives were not merely passive victims of medical concerns. Instead, the history of American midwifery was shaped by a crisis of professionalization within midwifery and midwives' failure to organize as a profession.[14]

Although the history of Japanese American midwives shares aspects of the pattern charted by Borst, there are also differences. Even though the field of midwifery was subordinate to medicine in both Japan and the United States, Japanese American midwives and their communities treated midwifery as a health profession. Trained and licensed in Japan, the American *sanba* saw themselves as both entrepreneurs and professionals, and they organized their own midwifery associations in urban areas.

This study also addresses the question: What does Japanese American midwifery reveal about the history of American midwifery? In part, it shows that although midwives were marginalized in the American health-care system, they were not marginal figures, especially within their communities.[15] Still, historians do not always make clear this important distinction between social status and cultural authority. For instance, Irvine Loudon states that unlike other European immigrants with a profession or trade, immigrant midwives did not thrive but were professionally isolated and despised by Americans. Loudon insists that they did not succeed because Americans had "no tradition of female midwifery." Uncritically echoing the findings of an early twentieth-century study by an American nurse, he explains that immigrant midwives had forgotten their skills. "What they lacked," he writes, "was support, supervision, and above all a sense of self-respect and pride in their occupation."[16] Although such characterizations of midwifery tell us about the attitudes of some American health professionals, they do not explain how midwifery was understood by midwives and within midwives' communities. My study demonstrates that Japanese immigrant midwives took great pride in their work and people held them in high regard. Midwifery was a respected and respectable health-care occupation in Japanese American communities just as it had been in Japan.[17]

The study of the American *sanba* also shows that Japanese Americans were not a monolithic group. Japanese American midwives' class status, social mobility, and work lives varied according to where they settled and according to whether they lived in urban or rural locations.[18] Like many of the licensed midwives in Japan, urban Japanese immigrant midwives often achieved middle-class status, created midwife associations, and readily fulfilled local licensing requirements. In contrast, the *sanba* who lived in rural areas often faced greater poverty and isolation from each other. They had fewer opportunities to build social networks or a paying client base.

The history of Japanese American midwives illuminates some of the ways that issues of race and region worked together to shape the history of women and health. "Race" is a complex concept in American history. Racial meanings are historically constructed and racism takes different forms.[19] The history of Japanese American midwives demonstrates that racial politics was not parallel for America's midwives. For instance, western responses to Japanese American midwives differed from southern reactions to African American midwives. Furthermore, government responses to Japanese American midwives in Hawai'i differed from government responses to Japanese American midwives on the mainland. Midwife regulations in Hawai'i

were closer to those in the American South than to those in the American West.

The issue of how to characterize the Asian American experience has been addressed by numerous scholars. Roger Daniels, for example, emphasizes that Asian immigrants shared in the American immigrant experience and should not be left out of that history. Daniels asserts that they had parallel experiences to European immigrants, even though there was no monolithic Asian immigrant experience. Ronald Takaki, in turn, insists that despite diverse roots, Asian immigrants had a similar experience in the United States and one that differed significantly from that of European immigrants.[20] My approach draws on both strands and analyzes Japanese midwives as immigrants who were treated as a racial minority within the United States. It emphasizes the impact of racial politics on Japanese Americans and offers occasional comparisons to the history of African Americans.[21]

I invoke the term "Japanese American" advisedly, with a new consciousness about its inadequacy as a way to describe women of the immigrant generation. When I began this book I thought of the women simply as Japanese American midwives, as though their lives and work were solely rooted in the American context. In the course of writing about Issei women I came to see how simplistic my vision had been. I began to see women of the immigrant generation not only as "Americans," but also as Japanese women living in the United States. Terminology remains a dilemma in describing such transnationals. In casually calling not only American-born people of Japanese descent but also members of the immigrant generation Japanese Americans, I mask the fact that the Issei had been denied the right to become naturalized American citizens until after World War II. In only referring to them as Japanese women, however, I hide the fact that most of them had spent their entire adult lives living in American territory, either on the mainland or in Hawai'i. Consequently, throughout this book I use several terms interchangeably to describe these immigrant midwives from Japan, including Issei, Japanese immigrants, Japanese Americans, Japanese women, and *sanba*. These terms help to capture and reflect the full range of their identities.

Although midwifery played a central role in the creation of Japanese American communities, the history of the American *sanba* has remained unknown because of their gender, ethnicity, health-care occupation, and location. For instance, despite the pioneering work of a few scholars, Japanese American women remain underexamined in accounts of Japanese American history, U.S. women's history, and the history of medicine and health.[22] Scholars have not investigated Japanese American midwifery because it

centered on women's lives in a marginalized ethnic community. Because of the nature of their expertise, midwives mattered more to women than to men, who have remained the focus of most Japanese American history. In addition, because of the history of childbirth in the twentieth-century United States, midwives mattered more to racial minority women and immigrants than to American-born white women, who have remained the focus of much of the history of women and health. Midwifery was also more significant to Japanese immigrants than to other Asian immigrants in the early twentieth century because a higher percentage of them were women. Finally, we know so little about Japanese American midwifery because it is part of the history of the American West and Hawai'i, places still too little examined in the history of American health.[23]

Midwifery is a wonderful way into the study of Japanese American women's history. As Bertha Parker, a traditional African American midwife in Mississippi, observed in 1996, midwives are "in vogue again, not for delivery of babies but for their stories."[24] In documenting these stories, anthropologists, sociologists, midwives, nurses, novelists, and historians participate in the cultural recuperation of midwifery and the communities they served. This study joins that project while also answering historian Elizabeth Jameson's call for scholarship that builds toward a "multicultural history of women in the western United States" and historian Judith Walzer Leavitt's encouragement of more work on Asian Americans and health care. In addition, historian Sucheng Chan urges scholars to examine "the work performed by women of color in the American West, as well as of the impact of such labor on women's social status, economic worth, self-esteem, life satisfaction, family dynamics, political power, and role in the mediation, transformation, and transmission of culture."[25]

In order to address these various themes, this project draws on a wide range of sources, including material from national and local government records. I conducted extensive research in collections at the National Archives in Washington, D.C., especially in the records of the U.S. Children's Bureau, the U.S. Public Health Service, and the War Relocation Authority (WRA); the WRA was the organization that supervised the incarceration of Japanese Americans during World War II. I also examined government records at state archives in Washington, Oregon, California, and Hawai'i and the holdings of specialized museum archives. I draw extensively on government records because relying solely on personal sources and interviews is inadequate and insufficient for the historian's task. Archival sources, however, are not necessarily ready-made for easy use. The historian must often both excavate and interpret the data.

I also turned to personal records to learn more about the meanings of midwifery in the public and private lives of the American *sanba*. In the process of researching and writing this book I have thought a lot about how we write history. Sprinkled throughout this text the reader will find observations about how different types of sources lead to very different understandings of the past and, in this case, reveal different meanings of midwifery. For example, government records are extremely useful sources for understanding the formal health-care system, but they are limited in what they can reveal about informal caregiving, and midwifery straddles both types of health care. Furthermore, although government records can explain the meanings of midwifery for health authorities, they reveal little of the meanings for communities, birthing women, and midwives themselves. Therefore, I examined personal records of midwives, including the diary of Toku Shimomura, as well as other midwives' delivery record books, midwifery bags and tools, photographs, a videotaped interview, and oral histories of midwives and nurses. Finally, I conducted nearly twenty-five interviews with the adult children, the clients, and a nursing supervisor of midwives.[26] There is a paucity of sources written by the American *sanba*, and therefore their stories are mostly filtered through the words of others. Such words, in turn, have been influenced not only by the passage of time, but also by the desire to honor the Issei. Nonetheless, I have tried hard to include a midwife point of view in this story.

Without family knowledge and local community support for the preservation of Japanese American history, I would have found little personal information, even about the prominent urban, middle-class midwives. It was the midwives' family, friends, and clients, and members of Japanese American communities who made this information available. For example, Chiyohi Creef, a retired journalist and post–World War II Japanese war bride, helped set up and translate two of my interviews with Issei women in Washington State. Ed Seguro provided me with material from the Wing Luke Asian Museum in Seattle, where he served as a volunteer and helped put together an exhibition on Japanese American history. Because of Seguro's contacts, I spoke to Toku Shimomura's relatives, who put me in touch with the esteemed artist and professor of art Roger Shimomura, who had his grandmother's diaries.[27] In California, Mary Hida, my childhood neighbor, introduced me to members of the East San Gabriel Valley Japanese Community Center, located in West Covina. Through her I met midwife Kimi Yamaguchi's daughter Alyce. I also met Bacon Sakatani, who has invested many years in organizing reunions and researching the history of the Heart Mountain Relocation Center.

In the case of Hawai'i, I had access to more details about Misao Tanji's life than to those of any other midwife because of the efforts of family, friends, and community to preserve her history. In addition to interviews and photographs, I saw her midwife bag and instruments, which she donated for an exhibition at Hawaii's Plantation Village on Oahu.[28] Finally, I drew on the personal papers of midwife supervisor Alice Young Kohler. Thanks to the foresight of Alice and her daughter Katharine, Alice's archive survives.[29] These records make visible aspects of women's health work that would otherwise have remained unknown. Their very existence reveals the role of individuals and family in safeguarding history.[30]

In sum, what I have learned about Japanese immigrant midwives was to a large extent due to the efforts of individuals and members of Japanese American communities who sought to record their history. Because the material specifically on Japanese immigrant midwives that I read in federal and state government records was so meager, I was delighted by the rich community resources. They helped me to understand the central role that the *sanba* played in maintaining Japanese customs in a new land and in reproducing the Japanese immigrant community itself. Although it can be easier to focus on archival research in government records, scholars interested in documenting the history of ethnic groups, women's lives, and health workers benefit tremendously from drawing on community resources, diaries, and oral histories.[31]

No doubt the issue of how we do history occupied so much of my attention because of the difficulties I faced in working with the available sources. For example, like some scholars of Japanese American history, I do not read Japanese and therefore I was dependent on translators for access to the Japanese-language diary of midwife Toku Shimomura. I could never just see for myself what Toku said, not to mention the complicating factors of how and why she said it. Furthermore, by the time I began research on this project in the 1990s, there were very few Issei still alive, and so most of my interviews were with the American-born Nisei. Still, despite the frustrations I had and the limitations of these sources, my work would have been greatly impoverished without them. I hope readers will find this book interesting, not only for what they learn about Japanese American women's history and the history of midwifery, but also for thinking about how we use sources from the past and the present to do history.

As part of my effort to personalize this history, I have struggled to flesh out individuals, even if only briefly. Toku's diary has been especially important because it helps us come to know her with some depth. Sadly, there are few, if any, well-known Japanese American women in American history.

It is in this spirit that I refer to most of the midwives in this study by their given names, like "Toku," instead of solely with honorific titles and family names, like "Mrs. Shimomura." I wish no disrespect, but in today's world titles can be distancing elements. This is especially an issue for the history of ordinary people, whose stories too often become a history of the anonymous. It is in learning about specific individuals that we become engaged and start to care about what happened to people in the past. Biographical and autobiographical information helps to humanize history and to know the subjects of social history as individuals who otherwise come across as the undifferentiated masses. Such personal details can "convey some sense of the consciousness—the thoughts, feelings, attitudes, and perceptions—of men and women of color."[32]

Even as I try to highlight the lives of specific individuals, this study also contributes to efforts to internationalize American history. It provides a transnational perspective on the history of women's health work by tracing Japanese midwifery across the Pacific, beginning in Japan and then following the midwives to the American West Coast and to Hawai'i. Like much of today's scholarship on globalization, it seeks to understand linkages that transcend nation-states. Still, as a historical approach reminds us, it is the specifics of time and place that determine experiences and meanings. Although this book is primarily a work of American history, it also speaks to and draws on the history of Japan and U.S.-Japan relations. Thus, my research joins the work of numerous scholars, including those in immigration history, women's history, and Japanese American history, who try to move "beyond national boundaries."[33]

This study is also attentive to the ways that narrative structure affects how we interpret the past and that "where one chooses to begin and end a story profoundly alters its shape and meaning."[34] The history I tell emerges in Japan in the 1880s and concludes with the impact of war with Japan at mid-twentieth century. I begin in the 1880s because that decade witnessed the start of the transition from the *toriagebaba,* or traditional midwife, to the *sanba,* or modern midwife. Modernity was linked to the influence of western science and the rise of the industrial nation-state in Japan. The 1880s were also a time when Japan reversed its previous policy and made emigration possible and desirable. As a result, Japanese immigrants went to Hawai'i as contract laborers for sugar plantations and began to create Japanese communities on the American West Coast.[35] These immigrants were part of the larger movement of Japanese people from the late nineteenth century to World War II. Some 700,000 Japanese went abroad during these years, not only to the Hawaiian Islands and North America, but also

to South America, the Caribbean, Southeast Asia, and Oceania, and more than 200,000 participated in Japan's colonization of parts of Asia.[36]

Chapter 1, then, examines the emergence of the *sanba* in Japan in the Meiji Period (1868–1912),[37] when doctors and government officials created new limitations on the previously unregulated practice of midwifery. In this background chapter I am indebted to scholars of Japanese women's history and the history of Japanese midwifery. Unfortunately, although English-language works on Japanese women are frequently translated into Japanese, the reverse has rarely been the case and therefore much Japanese women's history scholarship has been unavailable in English. Through the assistance of translators and recent English-language publications, however, I have drawn on some of this important work to better understand how and why Japanese women helped to create the *sanba*.[38]

Chapters 2, 3, and 4 investigate the history of Japanese midwives who immigrated to the American mainland and Hawai'i, where they contributed to the creation of the Issei way of birth, which included midwife-attended home births. Chapter 2 examines how race relations and midwife regulations affected Japanese immigrants in the American West. It demonstrates that despite tense race relations and the predominance of Japanese midwives on the West Coast, state health officials responded with indifference to the emergence of the American "midwife problem." They viewed midwifery as relatively insignificant and did not expend much effort to regulate midwives. They did not see midwifery as part of the American way of birth, even though a variety of American residents continued to value midwives as birth attendants. Chapter 3 provides an in-depth look at midwifery practice by examining the history of one community. In documenting the stories of the Seattle *sanba,* it demonstrates that even when western government interest in midwifery was low, interest in the Japanese immigrant community remained high. Chapter 4 shifts the story to Hawai'i, which had a higher percentage of Japanese immigrant women than did the mainland.[39] It examines the government regulation of midwifery on the islands, demonstrating how Japanese immigrant midwives negotiated to meet their needs even as midwife supervisor Alice Young tried to impose the new regulations of the Territorial Board of Health.

Finally, chapter 5 explores the impact of World War II on the history of Japanese American midwifery. It investigates how Japanese American midwives provided health care during mass incarceration on the mainland and the imposition of martial law in Hawai'i. It demonstrates how the war contributed to the decline of midwife-attended births. At the same time, social and political forces, both internal and external to their communities,

were at work. Despite the health care and cultural value of midwifery across Japanese American communities, it did not survive beyond the immigrant generation. Still, midwives continued to contribute to the history of childbirth as they supported the emergence of the Nisei way of birth.

The history of Japanese American midwives demonstrates that American midwifery had dimensions not fully captured by previous studies. In telling the story of how Japanese immigrant midwives encountered and contested American health politics, I offer a new approach to the history of racial politics and American health care. In previous research on African American midwives, I argued that midwives were not only birth attendants but also vital to public health work in the twentieth-century, racially segregated South.[40] Now, in studying the history of Japanese American midwives in the first half of the twentieth century, I demonstrate that they were not only important health-care providers but also key cultural workers in Hawai'i and the American West.

CREATION OF THE *SANBA*
IN MEIJI JAPAN

At the beginning of the twentieth century, many women in Japan gave birth without assistance, although a few women had access to the aid of traditional midwives. Gradually Japanese cultural practices changed and more women turned to the services of the modern midwife, or *sanba,* especially for difficult births. In 1907, for instance, thirteen-year-old Shin Tanaka[1] watched as a *sanba* saved her mother's life in their village in Kanagawa prefecture (or province) in central Japan. The midwife's help made a deep impression on Shin. Shin's mother had called on a midwife after two long days of labor with her fifth birth. Although the baby was stillborn, her mother lived through the ordeal, unlike four other unattended women in the neighborhood who died in childbirth. Shin never forgot that midwife and the important role she played in aiding her mother. After working as a teacher and a nurse for several years, she decided to become a midwife. She trained at the Sakai School of Midwifery and later opened her own midwifery school, the Tanaka Maternity Hospital and Midwifery School.[2]

The history of Japanese American midwives begins in Japan with the creation of the *sanba,* or modern, licensed midwife.[3] The *sanba* was a product of national and international politics, including Japan's quest for empire. The figure of the *sanba* drew on two of Japan's routes to modernity and international power: more education for women and knowledge of western science. Midwifery reform took place during the Meiji Period (1868–1912), when the Japanese government standardized midwifery through educational and licensing requirements. Nonetheless, women as well as men, midwives as well as state officials and doctors, constructed the *sanba* of modern Japan.

Japanese women who trained as midwives used Japan's quest for empire and modernity to pursue their own personal and professional interests. Many young, urban women benefited from the increased opportunities to

earn a living. Between 1880 and 1920, the *sanba,* or state-certified midwife, began to replace the *toriagebaba,* or traditional midwife, who lacked formal education and licensing. Government regulation had both positive and negative consequences for midwives. Even as midwife licensing placed limitations on who could practice midwifery and what services midwives could provide, it institutionalized the field of midwifery in modern Japan to the benefit of a new generation of women workers and birthing women.

The Quest for Empire

The history of midwifery in Japan was shaped by the nation's imperial quest. Interest in public health and healthy babies was bound up with Japanese nationalism and resistance to foreign domination. In this sense, the modernization of midwifery in Japan was part of a pattern, long noted by scholars, in which Japan sought to become a modern, imperial nation by using the tools of the West to compete with and protect itself from western imperialism. Modernity meant such developments as industrialization, the emergence of the nation-state, and an enlarged middle class.[4] As a small island nation, Japan maintained its autonomy by arming itself in new ways and absorbing useful practices from others. In order to avoid the subjugation China had faced at the hands of western nations, Japan embraced, rather than rejected, the ways of outsiders. Unlike China, who in the nineteenth century had resisted western ideas and practices, Japan borrowed from them. Japan was able to achieve its goals because it was a small nation with a strong, centralized system that controlled various aspects of society, including education and the police. As it had done earlier in its history, Japan survived and flourished by changing, although the extent and nature of the change was complicated. The goal was to escape western control, modernize in western ways, and still remain thoroughly Japanese.[5]

In the last third of the nineteenth century, Japan created a nation and an empire. Japan had been closed to outsiders from the West, except for a few Dutch, since the mid-seventeenth century of the Tokugawa Period (1603–1867). Then, in 1853, U.S. President Millard Fillmore sent the American commodore Matthew C. Perry to Japan. Perry arrived with four warships in Edo (later Tokyo) Bay and used cannon power to force Japan to sign a treaty of trade with the United States. In 1868 Japan entered a new era with the overthrow of the Tokugawa government and restoration of political power to the emperor, who took the reign name Meiji, meaning "Era of Enlightened Rule." At a time when the United States and European powers were carving up the world, Japan fought to maintain sovereignty.

Japan transformed itself from an agricultural society into a military power and an industrialized nation, a strategy summed up by the Japanese slogan *fukoku kyōhei,* or "rich country, strong army."[6]

Japan, alone among Asian nations in the late nineteenth and early twentieth centuries, resisted western colonization by becoming a colonizer. Japan's imperial quest was influenced by its desire for national security and a defense perimeter, and also access to natural resources. Through a series of military victories, Japan demonstrated its new strength: in 1895 Japan defeated China and in 1905 it defeated Russia. After Japan's war with China, it acquired new territories, including the island of Formosa (or Taiwan, as China called it). Japan's successful war with Russia resolved their rivalry over Korea and Manchuria.[7] The Russo-Japanese war of 1904–1905 marked a turning point in Japan's sense of itself and the West's sense of Japan's power. Japan now demanded and received an end to the unequal commercial treaties that western nations had imposed on it in the late nineteenth century, treaties that symbolized Japan's status as an inferior nation. Japan's victory over tsarist Russia on both land and sea was also a turning point in Asian nationalism and inspired many leaders of independence movements in Asia. It showed that Asians could challenge and defeat Europeans in warfare, suggesting the possibility that they could overthrow western imperialism. Finally, in 1910, Japan conquered Korea and, at the end of World War I, Japan, who sided with the Allies, took over many of Germany's possessions in China and the Pacific islands.[8]

Nevertheless, even as Japan joined the imperial powers, racial politics clouded Japan's relationship with western governments. North Americans and Europeans continued to treat the Japanese as inferior, deficient people. In response to western prejudice, Japanese leaders asserted the equality of the Japanese people by insisting that Japan had become as civilized, orderly, and modern as the West. Indeed, the Japanese considered themselves to be superior to other Asians and at least equal to westerners.[9] The difficulty, in the words of a Japanese militarist in the 1890s, was that Japan had to convince the West that "civilization is not a monopoly of the white man."[10]

Education for Modern Womanhood

Meiji reformers advocated the development of midwifery schools and other avenues for women's education as one way to address western prejudice against Japan. They argued that an educated womanhood would be evidence of Japan's enlightened, progressive character. As Christian educator Iwamoto Zenji wrote in 1885, "In present-day Japan, the condition of women is such

that Japan cannot be considered a civilised or cultured country."[11] Japanese leaders concluded that improvements in women's status would make Japan more respectable by western standards. Throughout the nineteenth century, western nations, and the feminist movements within them, used the status of women in society as a barometer of civilization. Despite the ongoing struggles for women's rights within western nations, western leaders considered their own nations superior in their treatment of women. Influenced by such attitudes and the work of Christian missionaries, male and female Japanese reformers concluded that the creation of modern womanhood required more education for women.[12]

Education and literacy for girls was a basic requirement for the modernization of midwifery. The Education Ordinance of 1872 made compulsory several years of primary school education for girls and boys. Although only 25 percent of all students were girls in the 1870s and 1880s, there was a growing interest in their education. Between 1873 and 1910, the percentage of girls attending elementary school jumped from 15 to 97 percent. In 1899 the government passed an ordinance encouraging higher education for girls. Girls' high schools were designed to train students to become, in the words of the national policy of *ryōsai kenbo,* good wives and wise mothers. This motto summed up the emancipatory and conservative elements in Japan's approach to women's education.[13]

Christian missionaries provided some of the educational offerings for Japanese women in the late nineteenth century. They encouraged literacy for women as well as men in order for them to read the Bible. Japan was receptive to the arrival of foreign educators, even though Christian-based, because it was committed to the transmission of knowledge from the West to Japan. Japan not only welcomed foreigners to its shores, it also sent observers and students to Europe and North America.[14] In 1873 the Edict of Toleration promoted religious toleration and the legitimization of Christian missionary work in Japan. It was one example of Japan's willingness to use the tools of western imperialism to serve its own interests. Furthermore, many Meiji leaders were well-educated Japanese Christians, even though most Japanese were Buddhists or followers of Shinto. Although tolerance for Christianity and Christian proselytizing dropped noticeably by the 1890s, it had already begun to have an impact on Japan, especially on the education of women.[15]

Western Science and Medical Reform

The Japanese government endorsed not only education for women, but also adoption of western science as part of its quest for international power.

In Japan, the scientific revolution began with the field of medicine. West-
ern medicine, which was introduced to Japan in the Edo Period, gained
prominence in the country by the 1890s. Standardization of medicine did
not eliminate all previous medical practices such as *kanpō*, or traditional
Japanese medicine. *Kanpō* derived from Chinese and Korean medicine and
included such practices as acupuncture, herbal treatments, and moxibus-
tion (burning small cones of artemisia plant or dried mugwort leaves on
the skin). Nonetheless, the government endorsed western medicine because
it satisfied the modernizing imperative.[16]

Japanese medicine had long drawn on doctrines and practices from
elsewhere. Chinese medicine was the most influential until the eighteenth
century, at which point Dutch medicine started to have an impact. In the
nineteenth and early twentieth centuries, Japan turned increasingly to other
European and North American medical practices. Most notably, in 1871,
Japan launched a mission led by Tomomi Iwakura, a leader and court
aristocrat, to revise the unequal aspects of the foreign treaties and study
European and American social systems and political institutions. After more
than a year of investigations, the "Iwakura Mission" returned without the
desired changes to the treaties but with great enthusiasm for certain western
institutions, especially Germany's.[17]

German medicine had a major influence on Japanese medicine in the
1870s and 1880s. In Germany, medicine was treated as an experimental
science, and the study of bacteriology and access to well-equipped labo-
ratories were key components of medical education. Medical studies also
required a university education. Although the Japanese, like the Americans,
borrowed selectively from the German model of medical education, the Ger-
man approach inspired significant reforms in both Japanese and American
medical education. German medical books were translated into Japanese
and Japanese medical students went to Germany. As with other types of
educational reform, Japanese leaders encouraged foreigners to provide train-
ing in western medicine and surgery in Japan. For example, Dutch and Ger-
man physicians working in Nagasaki directly influenced the development
of obstetrics.[18]

In 1870 the University of Tokyo hired German doctors to set up a Ger-
man model of medical training, an approach to medical education that
was institutionalized as the approved Japanese method by the early 1880s.
Among the German doctors present was the surgeon Wilhelm Schultze,
trained by Joseph Lister in Scotland, who introduced Lister's antiseptic
techniques to Japan. Lister and the antiseptic revolution of the 1880s were
important in improving obstetric practice, especially in lying-in or maternity

hospitals. Attention to antisepsis made birth safer and reduced the high rates of maternal mortality from childbed fever in hospitals. Nonetheless, at the beginning of the twentieth century in Japan, as throughout Europe and the United States, most births continued to take place at home, where childbed fever rates were lower.[19]

The introduction of western science and the standardization of medicine proceeded incrementally as physicians became part of the new middle class in Japan. In 1883, for example, the Medical Licensing Act created a physician registry system. It required all physicians to pass an examination but did not stipulate the type of medical education required, permitting doctors to learn through apprenticeship, independent study, or training in medical school. The Japan Medical Association, established in the 1890s, tried to further standardize medicine. A 1906 law ended the flexibility in medical training so that by 1916 all physicians had to graduate from a government-approved medical school in order to take the licensing examination. As a result, western medical practitioners gained ascendancy over traditional practitioners.[20]

Although few Japanese women became doctors in the early twentieth century, some of those who did had first received a midwifery license. Midwifery was an acceptable route into medicine for women. In 1884 women were allowed for the first time to take the Tokyo medical examination, which only Ginko Ogino passed, becoming the first Japanese woman licensed to practice medicine. Although Japan's medical system was based on Germany's, Germany did not permit women to take the medical examination until 1899, the last major European country to do so. Tokyo Women's Medical College, established in 1900 by the woman doctor Yayoi Yoshioka, was the first medical school for women. By the 1920s, the number of women entering medicine was increasing, although there were still few women physicians, probably fewer than a thousand.[21]

Medical Control and Midwifery Schools

The modernization of midwifery was a gendered process that combined Japanese interests in educating women and in incorporating western medicine. Local and national government officials and doctors pushed for medical control of midwifery education and state regulation of midwifery practice through licensing laws. The Japanese government acted on physicians' criticisms and expanded medical authority over midwifery rather than allow midwifery to develop as a fully autonomous field. The interests of organized medicine and the state combined in constructing modern midwifery as an

important health-care field, but one subsumed under medicine. Men were
expected to control the work of women. As in Europe and North America,
state tolerance for women's independence in Japan had its limits.[22]

A small number of doctors influenced developments in midwifery. Since at
least the eighteenth century, some physicians in Japan had condemned mid-
wifery. Midwives first came under fire with the rise of obstetrics, especially
through the Kagawa school. Gen'etsu Kagawa established the school in the
mid-eighteenth century in the city of Kyoto. The first midwifery textbook
in Japan, published in 1830, was written by Jūsei Hirano of the Kagawa
School. The school's practitioners in the late eighteenth and early nineteenth
centuries criticized midwives for intervening in complicated births, which
obstetricians believed should be turned over to them. Throughout the nine-
teenth century, various physicians identified midwives as old women who
lacked cleanliness and supported superstitious childbirth practices. They
frequently represented midwives as ignorant and dirty, the antithesis of the
health-care professional.[23]

In Japan, as throughout the West, the government promoted midwifery
reform as part of its pronatalist push. The Meiji government was interested
in midwifery reform not only to protect the health of the population by
spreading hygienic practices, but also to control women's reproduction and
increase the population. As early as 1868, a government order prohibited
midwives from performing abortions or assisting with infanticide. Midwife
regulation was linked to state interest in the production of healthy babies
who would grow up to be soldiers and workers, a need that was defined as
paramount to Japan's efforts to become a military and industrial power.[24]

In this context, members of the medical profession, especially obstetri-
cians, and midwives struggled to establish professional boundaries. It was
hardly a level playing field, since from the beginning state regulations treated
midwifery in an ambiguous fashion. State actions contributed to conflicts
between midwifery and medicine when they permitted the medical profes-
sion to direct not only midwifery education, but also the licensing of mid-
wives. Indeed, midwife regulations initially addressed midwifery as merely
an aspect of medicine. Still, midwives themselves remained independent
practitioners.

As with medicine, midwifery reform in Japan proceeded gradually through
the development of midwifery schools and licensing laws modeled on Ger-
many's. Government regulation not only limited midwifery practice, it also
protected midwives from competitors. For instance, by the mid-nineteenth
century, German midwives secured a place as licensed birth attendants and
used the law to challenge those who usurped their role. By the end of the

century, German midwives developed a national midwife organization and by 1898 Germany had 37,000 licensed midwives. At the time, German midwifery schools, many of which were attached to lying-in or maternity hospitals, offered from five months to two years of instruction to female applicants with at least an elementary school education.[25]

Japan followed the German approach and opened the first schools of midwifery in the 1870s with the support of local governments. In that decade, midwifery training programs were established in prefectural hospitals in Kyoto, Osaka, Niigata, and Tokyo. Soon physicians, especially obstetricians, established private midwifery schools in several cities and by the 1910s midwifery schools were almost entirely run by doctors. In 1880 Ikujirō Sakurai, a social reformer, established the Kōkyō School, later known as the Tokyo Midwifery School. Japanese doctors who had studied medicine and midwifery in Germany, such as Dr. Gentatsu Hamada and Dr. Masakiyo Ogata, also established midwifery schools. In 1890 Dr. Hamada opened at the Tokyo Imperial University one of the best-known midwifery programs. Masakiyo Ogata, an obstetrician and gynecologist who trained in Germany from 1889 to 1892, established an influential midwifery school and hospital of gynecology and obstetrics in Osaka in 1892. The Fukuoka Midwifery School in Kyushu opened in 1901. By the early twentieth century, there were more than 120 midwifery schools, most of them private schools and, as in Germany, many attached to maternity hospitals.[26]

The Japanese government was attracted to the German approach to midwifery and medicine in part because of the German system of health administration through police authorities. Japanese leaders saw advantages in the use of the police to record the details of the population and monitor public health. The medical police, operating under the Japanese Sanitary Bureau beginning in the 1870s, were in control of health issues, including reproduction and midwifery. The *sanba,* for instance, were supposed to inform the police of each birth they attended.[27]

Training in western medical science at midwifery schools produced a professional identity for midwives, yet it subordinated midwifery to medicine. It marked midwifery as a scientific health-care field, but it restricted midwives to normal births. In her study of modern Japanese midwifery, historian Julie Rousseau argues that even as the *sanba* remained central to the history of childbirth, modern midwives obtained their authority only through medicine.[28] Nevertheless, midwives gained cultural authority from within their communities.

Throughout the Meiji Period and into the Taishō Period (1912–1926), doctors taught midwifery students their vision of the responsibilities and

limitations of midwifery. They sought to improve midwifery through disseminating knowledge of hygiene, sanitation, and bacteriology. The medical science framework emphasized the dangers of childbirth and the search for the abnormal. Schools offered enough education in medical science so that midwives could identify problems when they developed and then bring in a physician to take over the delivery. The result was that midwifery education trained young women to work as the attendants for normal childbirth only.[29] Still, it was the midwives who determined what was "abnormal."

Unlike medicine, nursing performed a minor role in the modernization of midwifery in Japan, although it later had an impact on midwifery in the post–World War II era. Nursing was less well organized in Japan than in western nations like Britain and the United States. In nineteenth-century Britain, for example, Florence Nightingale, a founder of modern nursing, argued that midwifery should be incorporated into nursing. Nightingale was critical of medical claims over the field of midwifery. She urged the adoption of a formal two-year midwifery training program, like that offered in Paris. Nightingale considered midwives to be valuable birth attendants who simply required appropriate training.[30]

Nursing emerged as a modern health-care field in Japan in the 1880s, influenced by American and British approaches. An American missionary named Linda Richards played a particularly important role. In 1873 Richards became the first woman to graduate from a nurses' training school in the United States and in 1877 she went to England to study the nurses' training system created by Nightingale. She attempted to implement Nightingale's approach by establishing and reorganizing nursing programs throughout the eastern United States. Then, in 1885, she met an American missionary who worked in Japan and was fundraising in New England. She had wanted to become a missionary even as a child and became captivated by the idea of working in an "exotic" eastern nation. In addition, as an advocate for women's rights, she was eager to elevate the supposedly oppressed Japanese women through education. Like other western feminists, Richards viewed "Oriental" women as victims of their culture who needed to be saved. Thus, she volunteered to go to Japan for five years to spread Christianity and establish a nurses' training program. In 1886 Richards opened the Dōshisha Training School for Nurses, located in Kyoto, one of the first nursing schools in Japan. Although the Dōshisha nursing school closed in 1896, after graduating seventy-five nurses in ten years, more nursing schools followed.[31] A nurse training program also began in 1886 at the Tokyo Voluntary Public Hospital Nursing Education Center, established by Dr. Kanehiro Takagi. Nonetheless, the development of nursing in Japan lagged

behind that of midwifery. It was not until 1915, well after the introduction of midwife legislation, that the government first passed national nursing legislation to regulate the field. Although nursing and midwifery remained distinct health-care fields, some Japanese women obtained both midwifery and nursing licenses.[32]

Women were especially drawn to nursing in wartime. Many Japanese nurses were part of the Red Cross, which began formal instruction of nurses in Japan in 1890. Nurses had an important role in military hospitals attending to wounded soldiers in Japan's imperial wars against China and, especially, Russia. For example, the Japanese Red Cross provided more than 2,000 nurses for the Russo-Japanese War of 1904–1905. Medical and nursing leaders in the United States were very impressed by the efficiency of Japanese military field hospitals, doctors, and nurses.[33] The success of the Red Cross nursing service in Japan served as a model for the expansion of Red Cross nursing in the United States. Even as the West influenced women's education and health-care developments in Japan, the reverse was also true.

Despite developments in nursing, medicine had a greater influence on the transformations in midwifery. Sometimes physicians even appealed directly to birthing women to advocate the benefits of the new midwife and her scientific training, pointing out that modern births were modern because they were germ-free. They promoted the western notion that women of civilized nations required trained assistance during childbirth. For instance, a speech by Ikujirō Sakurai that was reprinted in *Women's Hygiene Magazine* in 1889 illustrated the view that the modern midwife was "a sign of progress, a marker of civilization, no longer the dirty old woman thought to inhabit the past."[34]

Midwife Legislation and Licensing

Modernization of midwifery took place through legislation as well as midwife education. The first official mention of the term *sanba* occurred in an 1868 government edict stating that midwives were not to sell medicine or perform abortions. Although the term *sanba* originated in China and first appeared in Japanese writings in the early nineteenth century, the government's use of *sanba* in 1868 contributed to its status as the new term for midwife. Included within Japan's first legislation to regulate medicine, an ordinance of 1874 and a revised one in 1875, were sections on midwifery. These ordinances set specific standards for who could practice midwifery. For example, a midwife was to be over forty years old, have knowledge about birthing

women and infants, and a certificate from an obstetrician that the midwife had attended successfully ten normal and two difficult births. The ordinances did not call for a specific length of training, only an indication from a doctor that the midwife had the appropriate skills. They recommended physician supervision of midwives and forbade midwives from prescribing medicine or using medical instruments. Unlike later midwife laws, there was no mention that a midwife had to be a woman. Officials at the provincial level implemented Japan's national midwife policy, and so the degree of enforcement varied widely across the country. Government policy had its greatest impact in the cities, such as Tokyo, Osaka, and Kyoto, where government control was strongest and populations were concentrated.[35]

The new midwifery law of 1899 had a profound influence on the development of midwifery in the first half of the twentieth century. This ordinance placed midwifery solidly under the control of doctors and the state. The law differed from that of the 1870s because it established new national qualifications that required all midwives to obtain a license by passing a written examination. It also created a midwifery registry, parallel to the physician registry, which enabled the government to better monitor the field of midwifery.[36]

The new midwife examination requirement had several consequences. It reinforced medical control over midwifery because physicians and bureaucrats set the examinations and therefore determined what knowledge was appropriate for midwives. It made literacy a prerequisite for midwifery and therefore privileged skills like reading and writing, even though hands-on clinical training was still deemed important. The law also lowered the minimum age, stipulating that midwives need only be over twenty years old. The government codified its preference for younger, educated women in the field. The law also stipulated that midwives could not perform surgical procedures, use technology, or administer drugs, although they could give enemas and cut the umbilical cord. Finally, the 1899 law restricted midwifery to women. In the Edo Period (1603–1868) and the early decades of the Meiji Period, male midwives occasionally attended births. The law not only made explicit the prevailing gendered nature of midwifery, but the few men who engaged in midwifery were now legally denied that option unless they were licensed as doctors.[37]

Despite the significance of the 1899 law as a blueprint for midwifery in the nation, there was still a great deal of flexibility. In the area of training, for example, a candidate for the midwife examination could have a range of backgrounds, including graduation from a midwifery school, apprenticeship, or prior years of midwifery practice. By the Taishō Period, however,

a two-year training program became a requirement, at which point the basic educational level of midwives was very high compared to the general population. A law in 1910, with a subsection added in 1912, stated that graduates of accredited midwifery schools were not required to take the examination, and after 1917 this exception included midwives licensed in a foreign country.[38]

As midwifery education and licensing expanded, the number of "new" midwives, or *sanba,* began to exceed the number of "old" midwives, or *toriagebaba.* The new midwives were those who passed the midwife examination as part of the licensing process or trained in midwifery schools or who did both. The old midwives were those who had practiced before the new licensing law and were "grandmothered" in and given a license to practice without taking an examination. Of course, the number of practicing midwives always exceeded the number of licensed midwives because many women did not bother to comply with the new regulations, but the number of new midwives still increased rapidly. Around 1900 the government licensed 24 new midwives and 8,500 old ones, and by 1912 the total had increased to 10,800 new midwives and 16,300 old. Thus, in 1912 there were nearly 28,000 licensed midwives in Japan. By 1925 there were 48,000 licensed midwives, the vast majority of whom were the new midwives. The number of licensed midwives continued to increase until 1941, when it peaked at nearly 63,000.[39]

Clearly, the Meiji government and its successors viewed midwives as assets to the nation. Lack of midwife regulation at a time when medicine was standardizing would have signaled the absence of state recognition and validation for midwifery. For example, one interpretation of the Midwives Act of 1902 in England was that it secured an official place for trained and licensed midwives. National midwife legislation had been blocked for years in Britain by the powerful medical profession prior to the passage of this act. As an imperial nation, Japan also regulated midwifery in its colonies, including Taiwan in 1907 and Korea in 1914.[40]

Midwife Associations and Journals

Midwife associations and journals, as well as schools and legislation, contributed to the modernization of midwifery. Created by both doctors and midwives, they helped build a sense of community and professional identity among midwives. Midwife Sachi Torii, for example, turned to journals and association meetings to keep up to date in her work. Born in 1895, Sachi worked as a midwife for more than 50 years and delivered 3,000 babies.

A graduate of the Kyoto Maternity Hospital and School for Midwives, Sachi learned the latest health-care information by reading her monthly midwifery journals. She also attended the local midwife association meeting in her farming village as part of her continuing education. The meetings were held at the local Buddhist temple and attended by several midwives, and sometimes by a physician.[41]

Although Japan had a national midwife association, most midwives were active at the local level where associations were first created. Among the earliest associations founded were those in urban centers, including the Kyoto Midwives' Association in 1875, the Osaka Midwives' Association in 1888, and the Niigata Midwives' Association in 1901. Ai Tsuge, a midwifery graduate in 1891, founded the Tokyo Midwives' Association in 1907. Doctors also had a role in the midwife associations. For example, by the early 1920s, the head of each city and county medical association in Fukui prefecture created and chaired a local midwife association.[42] The formation of the *Nihon Sanba Kai,* or Japanese Midwives Association, in 1927 established a national professional organization. It promoted occupational rights, regulated ethics, and supported research and continuing education, although few midwives seemed interested in joining it at first.[43]

Midwifery journals were another way that midwives and doctors served as advocates for the reform of midwifery. The first midwifery journal in Japan, *Josan no shiori,* or *Guidebook for Midwives,* was established in the 1890s by the Midwives' Study Society. Society members wrote articles for the monthly journal. The German-trained obstetrician and gynecologist Masakiyo Ogata and his follower Tatsugorō Takahashi created the society. The number of midwife journals and publications produced by and for midwives increased in the early twentieth century, especially in the 1920s and 1930s. At a time when women were active consumers of popular health-care literature, midwives had access to a dozen midwifery journals, newsletters, and association magazines and more than seventy midwifery textbooks. Doctors wrote many of the articles in order to disseminate the latest scientific findings to readers, most of whom practiced midwifery in urban centers.[44]

Midwifery Practice: The *Toriagebaba* and the *Sanba*

Midwives also transformed their field through their everyday cultural practices. The *sanba* used their approach to childbirth to distinguish not only midwifery from medicine, but also modern from traditional midwifery. The *sanba* pointed to their training in scientific medicine to emphasize

their break with the past and distinguish their knowledge and skills from those of the traditional midwife, or *toriagebaba*. At times their attempts to validate themselves as the appropriate birth attendants took place through denigration of the traditional midwife.

For the *sanba*, her book learning placed her in a privileged position relative to those who learned solely through experience and apprenticeship. Midwife Nami Murakami reported that as she began her practice she did not always feel that she was respected in the community, and so she would inform people about the expert knowledge she had gained through her formal studies.[45] Still, the *sanba* were not always well prepared by their theoretical training for births in the community. Kazu Tanaka of Kyoto, who graduated from midwifery school in 1923, recalled: "I was 20 years old and watched a birth for the first time. I was bewildered and fainted. I hadn't expected the baby to come out there, although I had left my village and been a *sanba*-student for one or two years."[46]

Midwife respectability and modernization came at the price of reinterpreting midwifery's own history. During the transition era of the early twentieth century, the wisdom and experience of traditional midwives were discredited.[47] The traditional midwife was denounced as an old-fashioned figure of bygone days and as an aged woman. Western nations constructed this same dichotomy between what were considered to be the trained modern midwife and the ignorant traditional midwife.

The *sanba* frequently faced opposition from the local traditional midwives as they moved into new communities. Akino Uenaka, who delivered thousands of babies in her career, explained that she decided to practice midwifery in the mountain village where she grew up because she believed that midwifery was no longer appropriate work for old women with rough and unsanitary ways. Born in 1899, Akino graduated from nursing and midwifery schools. In 1918 she returned to her village in Fukui prefecture to attend her younger sister in childbirth and was appalled at the standards of midwifery care. She went to the mayor of the village and asked that she be designated the official village midwife. As a result, she received many clients who were apparently pleased with her approach, which led to much resentment from the traditional midwives.[48]

From the perspective of at least some birthing women, the *sanba* differed from the *toriagebaba* in her effort to bring new, foreign childbirth practices into the Japanese way of birth. For this reason, some women referred to the *sanba* as the "western midwife." By 1920 the *sanba* began to outnumber the traditional midwives, who remained a feature longest in rural areas. Some birthing women remained loyal to the traditional midwife. They preferred

a familiar caregiver who provided a sense of security. They felt that the new western midwife came across as strict and distant. The traditional ways may have lasted longest in mountain and fishing villages, but *sanba* success with difficult deliveries eventually helped convince even rural birthing women to accept them.[49]

Popular health books for women advised them to seek out the *sanba*, who they were to recognize by their attire and scientific birthing practices. The *sanba* was supposed to be identifiable by her western clothes, instead of traditional Japanese clothing, and use of sterilized gauze, sheets, and bandages instead of old rags. She was also known to use a scrub brush to ensure she had clean, disinfected hands instead of working with unwashed hands. In addition, she had the reputation for requiring birthing women to deliver in the supine position on their backs, instead of the traditional Japanese practice of giving birth in a squatting position. Finally, the modern midwife was known to visit the birthing woman until the umbilical cord healed on the newborn and to encourage the mother to rest for thirty days or at least a week.[50]

Some modern midwives benefited from good working relationships with local doctors who provided backup care, but often their own experience and scientific training in childbirth was superior to that of the doctors. For example, Hatsui Yamaguchi served as a midwife in a fishing village in Fukui prefecture. Although she had a comfortable relationship with the local doctor, he was of no help as backup. He told her that if she could not handle a problem, he was unlikely to be able to either.[51] Akino Uenaka had problems with village doctors because they did not know as much about obstetrics as she did. One time a birthing woman died when the doctor refused to act on the midwife's insistence that he operate.[52] In the case of midwife Yoshi Aoki, who worked in a mountain village, she found that even when a doctor was willing to assist her, the family refused to accept him until she offered to pay for the doctor's house call.[53]

Unlike the *toriagebaba*, many of the *sanba* approached delivering babies as a commercial enterprise, as well as an expression of personal relationships, womanly duty, or special talent. The *sanba* usually requested, even though she did not always get, cash payment for her services. Traditionally, birth attendants were paid with a small token of appreciation, such as with rice or courtesy money wrapped in paper. Sometimes the *sanba*, like the traditional midwife, received nothing at all. Still, the *sanba* hoped to receive remuneration like any other skilled worker or professional. When clients did pay, especially in urban areas, some of the *sanba* became quite prosperous and a few could even hire assistants to aid them in deliveries.

That said, the cost of a midwife placed hard burdens on poor families, and therefore many midwives accepted whatever they could pay.[54]

Some birthing women without financial resources gained access to modern midwives through the creation of the official public midwife, or *kōsetsu sanba,* in towns and villages across Japan. For example, beginning in the late 1910s and early 1920s, each town and village across Fukui prefecture hired a public midwife and by 1929 there were over sixty public midwives in the province. Public midwives received fairly good wages. Some companies also hired their own midwives for their employees. Tami Yamada, for instance, was paid by the Oriental Spinning Company in Fukui prefecture to deliver the babies of its employees.[55]

Initially, midwifery had difficulty attracting young women because childbirth had long been associated with the concept of impurity. Many Japanese considered delivering babies to be lowly and unclean work because of its contact with blood, excrement, urine, placentas, umbilical cords, and dead fetuses. The parents of Yoshi Aoki, for example, did not want her to become a midwife because midwives sometimes wrapped the placenta for burning, which was too much like the low-status work of those who cremated the dead. Nonetheless, Yoshi attended a midwifery school in Osaka and later returned to her hometown of Katsuyama City in the mountains to practice midwifery.[56] When Mii Takeshima of Mozen-machi chose to become a midwife in the 1920s, she too faced disapproval from her father and grandmother because they viewed midwifery as unclean work, appropriate only for social outcasts.[57]

Gradually, the older taboos abated and little new social resistance emerged. Midwifery became an acceptable avenue for young women because it did not threaten gender conventions, even as it expanded women's employment options. Midwifery was compatible with marriage, despite the fact that it allowed a woman to survive financially without it.[58] Still, rural women did not have the same opportunities for midwife training as urban women. Most midwifery schools were located in urban centers, even though most Japanese women lived in rural areas. As late as 1898, 80 percent of the Japanese population lived in towns and villages with fewer than 10,000 people. Midwifery offered new opportunities for economic self-sufficiency for young women of the middle class, especially in large, urban centers like Tokyo and Osaka, and for those rural women who managed to migrate to the cities.[59]

Although women became midwives for a variety of reasons, many young literate women entered this female occupation for the financial benefits to their families and independence for themselves. Some women became mid-

wives because of the death of a husband or father. In other cases, a woman followed a family member or in-law who engaged in midwifery or medicine. Still others were attracted to an occupation that promised self-sufficiency and relatively high social status, akin to that of schoolteachers. The *sanba* also enjoyed an unusual degree of mobility for women of the time. For example, because of their line of work, they were often the first women to ride a bicycle in their communities. Furthermore, according to historian Brigitte Steger, "Whereas most of the women of her age never left their home villages, the *sanba* studied in the city where she met women from other prefectures and learned about the modern way of thinking and living."[60]

Personal gain was not the only reason women became midwives. Modern midwives, like traditional midwives, wanted to help other women. Kotami Miyake, who was born in Osaka in 1879, explained that she became a midwife to help women who did not have much money. She graduated from the Ogata midwifery school in 1893, among the first midwives trained at this influential school. She claimed to have delivered 10,000 babies over the next sixty-five years. As a teenager, Nami Murakami watched the constant flow of soldiers through her community during Japan's war with Russia. She decided that she, too, would serve her country, and so she enrolled in a nursing program at a private hospital. The war ended, however, before she finished her studies. Later, after she married and had three children, the difficulties in her own pregnancies convinced her that she could best serve others by helping women through childbirth. She graduated from a midwifery school and established a successful midwifery practice.[61]

The *sanba* were convinced that they could reduce maternal and infant mortality by eradicating unsafe childbirth practices. Midwife Yoshi Aoki found that many times birthing women did not call on her until there were problems, especially with delivery of the placenta, or afterbirth. She recalled some of the terrible practices that she witnessed, including her horror at seeing a man stomp on a woman's stomach in order to eject the placenta. In another case she found a birthing woman who wrapped the umbilical cord around her big toe in an effort to tug the placenta out.[62] Other midwives complained that it was hard to get birthing women to embrace the modern ways of birth. Many women continued to view childbirth as an unclean event well into the twentieth century and therefore relegated it to the crudest, darkest part of the house. Some believed that darkness protected the birthing woman's eyes. Others may have chosen a darkened location because they believed that the arrival of a soul required a place more like the world of the gods. This powerful, spiritual dimension to the work of midwives is illustrated in the idea that the midwife controlled which infants lived and

which died. Midwives were also disturbed by the preference of some birthing women for delivery on a bed of straw, ashes, and rags because of the mess and "pollution."[63] Midwife Akino Uenaka explained that many women wanted to deliver on ashes spread on straw mats because they believed it promoted healing. In her view it was not hygienic, so she would at least lay a sheet down on top. Midwife Tami Yamada would cover the straw and ashes with a newspaper mat she made out of fifteen sheets of newsprint with cotton placed on top for the woman to lie on.[64]

Midwife education, familiarity with scientific medicine, and a business approach contributed to new cultural practices in the realm of childbirth and a professional identity for the *sanba*. As the history of midwifery demonstrates, the process of industrialization created not only new relationships between workers and employers, but also new relationships between health-care providers and clients.[65] Government regulation of midwifery, prompted in large measure by the quest for empire and the promotion of western medicine, modernized midwifery to the benefit of some, but not all, midwives in Japan. Older, rural birth attendants bore the costs of midwifery reform, while younger, especially urban, women gained the rewards in the transition from a traditional society to the new capitalist order. The *sanba* gained recognition from birthing women and local authorities by distinguishing her ways from that of the *toriagebaba*. In this sense, the modern midwife's authority came not just from medicine, but also from birthing women who accepted these distinctions.

The creation of the *sanba* by government officials, doctors, midwives, and birthing women signaled the preservation of midwifery's distinct role in childbirth, even as it altered midwifery practice. The history of midwifery in modern Japan indicates where and how the Japanese immigrant midwife acquired her skills, sense of competency, and professionalism. It reveals how central midwifery was to Japanese birthing culture and why Japanese immigrants wanted to preserve midwifery in the United States.

RACE RELATIONS, MIDWIFE REGULATIONS, AND THE *SANBA* IN THE AMERICAN WEST

Hundreds of Japanese midwives, or *sanba*, immigrated to the United States in the early twentieth century at a time when the nation grappled with concerns about both the "Japanese problem" and the "midwife problem." As immigrants from Japan, the *sanba* were proud subjects of the emperor, leader of a rising imperial power. Nevertheless, they had to contend with antagonism from a growing anti-Japanese movement in the American West. As modern midwives, they were part of an established health-care occupation for women in Japan. In moving to the United States, in contrast, they attended birthing women in a nation engaged in questioning the value of midwifery. What does the history of the American *sanba* reveal about the impact of race and region on government reactions to midwifery in the United States? How did West Coast officials respond to the arrival of Japanese immigrants and the practice of midwifery? This chapter examines the racial politics and health policy environment encountered by the American *sanba*.

An American *Sanba* in Rural California

In 1906 Kimi Otaka, a Japanese midwife, married a man who soon after left to seek his fortune in America. Kimi's husband, Yasutaro Yamaguchi, promised to send for her as soon as he had made enough money. Ten years later, Kimi Yamaguchi arrived with her daughter in San Francisco, the port of entry for thousands of immigrants from Asia, where she reunited with her husband. She felt great trepidation about moving to California because she had to leave so much behind. Kimi, like so many midwives, had enjoyed the freedom of riding her bicycle around the Japanese countryside, visiting clients. After her husband left Japan, she had moved to the city, where she

found a nice apartment and built up a successful midwifery practice. Now, her worst fears about reuniting with her husband were realized when she reached her new home in Sanger, a small agricultural town in the San Joaquin valley, halfway between San Francisco and Los Angeles. Yasutaro took her to live in a rural location, like so many of the Japanese immigrant women who came to the West Coast states of California, Oregon, and Washington. As soon as Kimi stepped inside the house she sat down on her suitcase and sobbed. She was miserable. The man she had married in Japan had become no more than a poor farmer in California. Her new home was just a shack, with a dirt floor. She found the living conditions and the drop in her economic status shocking. Like many of the Japanese immigrant generation, known among Japanese Americans as the Issei, Kimi could not believe that this was the America she had always heard about.[1]

Born about 1880 in Saga in southern Japan, Kimi grew up in a family of girls in a beautiful Buddhist temple where her father, Doukan Otaka, was a landowner and Buddhist priest. Like an increasing number of women in the Meiji Period (1868–1912), she and her sisters went to school. Kimi later attended midwife training school in her prefecture (or province) and one of her sisters opened her own sewing school. Despite the expectation that Japanese women should get married, Kimi had no desire to marry and no need to—she was able to support herself as a midwife. She was quite satisfied with her life. Her father was disturbed, however, that she had not married. By the time Kimi was twenty-six years old and her two younger sisters had married, her father could stand the embarrassment no longer and forced her to marry. Her new husband, Yasutaro Yamaguchi, sold herbal medicine.[2]

In 1916, ten years after her husband Yasutaro had left for America, he still had not sent for her. It is not known what type of contact Yasutaro maintained with Kimi. He may have sent a few letters now and then, and perhaps a bit of money, or there may have been simply ten years of silence. It was not uncommon for Japanese couples to be separated while the husband established himself in the United States before bringing over his family or returning to Japan permanently. In the late 1880s, young Japanese men began to create Japanese communities in the American West Coast. In the case of Yasutaro, it is not clear what he did with his money, but it is likely that he just never made much. When he first arrived in San Francisco it was not long after the devastating earthquake of 1906.[3]

Like other Japanese men, Yasutaro had a difficult time finding employment and so he traveled constantly, performing farm labor and other types of low-paid work. Japanese immigrant men, even those with an education,

faced constraints within the American labor force because of language barriers and racism. They often resorted to doing domestic service work and gardening, and performing work in the agriculture, lumber, fishing, canning, mining, and railroad industries. A few established successful small businesses.[4] As for Yasutaro, at one point he ended up working as a dishwasher in Mexico before he moved back to California. Whether as a result of economic failure or a lack of interest, he never did send for his wife and new child.

While Kimi's husband encountered economic constraints as a Japanese man in the United States, Kimi faced familial constraints as a woman in Japan. Months after her husband's departure, Kimi gave birth to a daughter, Kinuye, and had to adjust to her new life as a working mother. Eventually the two of them moved to the city where Kimi could expand the number of clients and Kinuye was able to attend a good school. Kimi was content there and had no desire to leave Japan. Kimi's father could not, however, stand the embarrassment and constant questions from others about why his son-in-law did not send for his daughter. His reputation, as well as his daughter's, was on the line. He once more intervened in her life. At a time when many Japanese women immigrated to the United States, Kimi's father sent her to her husband. He invoked his parental authority, even over a married daughter, and sent her off. Even though she was economically independent, she remained a social liability to him as a daughter with a child of her own but no husband at her side. Her respectability was not secured, at least in his eyes, and so he paid for his daughter and granddaughter to move to California.[5]

Like other immigrants, the Japanese came to the United States for a wide variety of reasons. Some, like Yasutaro, left Japan out of a personal desire for travel, adventure, and economic success, while others, like Kimi, were compelled or urged to go by parents, spouses, and teachers. The Japanese government encouraged emigration, as well as territorial expansion, as a solution to Japan's problems. In 1885 Japan reversed its previous antiemigration policy and encouraged it as a way to address the worsening economic situation, especially in the countryside where taxes were burdensome during Japan's rapid industrialization.[6] The government also urged emigration to alleviate the perceived population problem. Population density was a growing concern in Japan; some argued that the small island nation had become overpopulated. By the early 1920s, about 60 million people lived in Japan on a land mass roughly the size of California, which at the time had a population of only about 3.5 million. Gordon Nakayama, for instance, left Japan in 1919 for Canada, where his aunt and uncle lived, because "my father

[a farmer] used to say, 'Japan is a small country and there are too many people.'"[7] Iyo Tsutsui, an Issei woman in California, likewise remembered her teacher told the class there were too many people in Japan and urged them to go abroad.[8]

For Kimi, life in California meant engaging in exhausting physical farm labor, a far cry from what she had been accustomed to as a midwife in Japan. In California, her family, like so many other Japanese American families, engaged in agricultural production. Indeed, until World War II, the most common types of work by Issei women outside their homes were in agriculture and domestic service.[9] At one point Kimi's husband Yasutaro worked as a foreman on an avocado ranch in Sanger. Later, the family moved to Fresno, where they raised grapes, boysenberries, and strawberries and engaged in truck farming, which meant selling produce at the side of the road from the back of a truck. Like thousands of Japanese immigrant women in California, Oregon, Washington, Montana, Idaho, Utah, and Colorado, Kimi performed all types of farm labor, in addition to household labor. She also gave birth to five more children, including Alyce, whose Japanese name was Misao, born in 1922. Childbearing occupied much of Kimi's life. Her first child, Kinuye, was born about 1906 and her last child was born in 1925 when Kimi was about forty-five years old. She faced more hardships when she lost two of her daughters, Pauline, who died of polio at about five years old and Kinuye, who died of tuberculosis as a young adult.[10] We do not know whether Kimi informed her parents in Japan about her troubles, but surely the life she had in California was not what her father had imagined for her.

Moving to the United States offered Kimi freedom from filial obligations but produced new marital ones, as well as a drop in her economic standing. Issei women escaped some of the social restrictions and family obligations imposed on women in Japan. Kimi, for instance, had no mother-in-law to interfere with her affairs, although she still had to follow her husband's wishes to a great extent. By the same token, the very absence of family members meant that many women were lonely and those in unhappy marriages had few avenues for escape. For example, in later years several Issei women interviewed by Linda Tamura remarked upon how lonely and isolated they felt living in Hood River Valley in rural Oregon. Michiko Tanaka, an Issei woman who lived in rural California, described her sense of isolation in an interview with her daughter, the anthropologist Akemi Kikumura: "I was lonely—not a single relative. It might have been different had I been with someone I liked, but Papa never treated me gently. We never had a conversation. We just worked and had babies."[11] According

to their adult daughters, Issei women often lacked emotional fulfillment in these Japanese-style marriages based on duty rather than romantic love. Some Issei women believed they lacked love, companionship, and respect from their husbands.[12]

Japanese women like Kimi who grew up in the Meiji Period were expected to be obedient to parents and husbands, although the extent to which they were forced to do so varied. Both men and women were supposed to be disciplined, industrious, thrifty, selfless, and obedient to their superiors. Kimi's daughter Alyce recalled in an interview that Kimi, like other Japanese immigrant women, did not discuss her marital unhappiness but was resigned to her fate. Still, Kimi did communicate her frustrations to her daughter. Alyce learned that it was only out of love for her children that Kimi stayed with her husband, who was often unkind to her and nearly worked her to death.[13] Alyce reported that her mother worked hard and, like other farm women, had little time for leisure or the arts. In Japan, Kimi had loved to sing, dance, and play Japanese instruments like the *koto* (a large, wooden, stringed instrument placed on the floor) and the *samisen* (a three-stringed, rectangular banjo). Kimi's musical training was typical for accomplished, cultured Japanese women.[14]

Many Japanese immigrant women had reasonably comfortable lives in Japan and were disappointed to find themselves working as farm laborers in the United States. Michiko Tanaka, for example, was born in 1905 to a family of some wealth. The family ran a confectionery and wholesale sugar business and was able to provide her with an education at a Buddhist school, where she learned English. As a young woman Michiko Tanaka had desperately wanted to go to America and urged her husband to move with her. "I was on the adventurous side," she explained. "I wasn't afraid of anything. I wanted to see foreign countries."[15] To pay for the trip, she and her husband sold Michiko's kimonos and borrowed $150 from her parents and $350 from his parents. Michiko left Hiroshima in 1923 as a young bride, expecting America to offer wealth, beauty, and cleanliness. Like Kimi, Michiko admitted, "Life in America was so different from what I had imagined."[16] In California she ended up spending years cooking in migrant labor camps and working as a field hand picking fruits and vegetables from Marysville, north of Sacramento, to Watsonville, south of San Jose. Michiko grew skilled at pruning grape vines. Throughout the 1920s and 1930s she cut and packed asparagus and picked pears, peaches, apples, and strawberries. Her family was so poor during the Great Depression of the 1930s that others urged them to sign up for government welfare benefits, but Michiko's husband refused. Despite the fact that they had eight children to clothe and feed, he

believed welfare was *haji,* or shameful.[17] Japanese immigrants survived in their new nation, but only some thrived financially. Kimi and Michiko, like many Issei, did not visit Japan in later years because they were ashamed to face family and friends in light of their lack of financial success. Michiko explained, "I never forgot that I did not repay the money we borrowed. From embarrassment I never went back."[18]

Many of the Japanese laborers hoped to one day purchase land. Land was power in the American West, and that important commodity was to be denied to Japanese immigrants. California led the way with the 1913 Alien Land Act, reinforced in 1920, followed by Arizona in 1917, Idaho, Montana, and Washington in 1921, and Oregon in 1923.[19] The Issei challenged, unsuccessfully, the restrictions on their right to own land through a series of legal cases. In the late nineteenth century, California, as well as several western states, also passed another type of legislation designed to limit property ownership. Antimiscegenation laws, which prohibited interracial marriages between people of color and whites, were racial restrictions that not only controlled reproduction but also the transmission of property.[20]

Even though life in rural California turned Kimi into a farmworker, Kimi continued to practice midwifery. Kimi, like most of the immigrant generation, is no longer alive, and so we have to rely on the memories of her Nisei (American-born) daughter to understand something of her life. According to Alyce, her mother was glad to have the opportunity to provide childbirth assistance to neighbors and other people she knew. As a *sanba,* it is not surprising that Kimi was eager to ply her trade and ensure the safety of birthing women living nearby. Kimi, like many Issei midwives, continued to use her midwifery skills, despite the dramatic lifestyle change she experienced in her move to the United States.

Japanese Immigration, Race Relations, and International Politics

The stories of individual midwives like Kimi are best understood within the larger history of Japanese immigration, U.S.-Japan relations, and West Coast race relations. At the beginning of the twentieth century, when the United States and Japan were emerging imperial powers, U.S. officials took a cautious approach toward Japan and its subjects living in the United States. Unlike many immigrants, "the Japanese had behind them a government that inspired and demanded growing respect." Foreign policy objectives and the promotion of trade led U.S. presidents, especially Theodore Roosevelt and Woodrow Wilson, to try to curtail some of the effects of the emerging anti-

Japanese movement in the West so as not to offend Japan. International relations mattered because Japan was central to the American search for trade in the Pacific.[21] Indeed, American imperial interests in Asia at times cushioned the impact of anti-immigrant sentiment.

Most Japanese immigrants arrived on the Pacific Coast between 1890 and 1924. From the perspective of many western inhabitants, there was a flood of Japanese immigrants. The Japanese came after passage of the U.S. Chinese Exclusion Act in 1882, which barred Chinese laborers and opened the way for other sources of cheap immigrant labor.[22] The Gentlemen's Agreement of 1907–1908 led to an increase in the number of female immigrants among the Japanese. The Japanese arrived steadily until passage of the National Origins Act of 1924, which ended further Japanese immigration. By 1895 there were about 6,000 Japanese immigrants in the United States, most of whom lived along the West Coast. After the forced annexation of Hawai'i in 1898 and creation of a territorial government in 1900, many Japanese moved from the islands to the mainland. With immigrants arriving from both Hawai'i and Japan, the Japanese immigrant population increased to about 25,000 in 1900.[23] In the few years from 1895 to 1900, the number of Japanese immigrants who lived in the American West quadrupled. The numbers only continued to rise over the next two decades as the Issei established communities up and down the West Coast from Vancouver to San Diego. By 1920 there were over 100,000 Japanese immigrants and their children living on the U.S. mainland, including 72,000 in California, 17,000 in Washington, and 4,000 in Oregon.[24]

When compared to the millions of European immigrants during these same years, the number of Japanese immigrants was small, even though the anxiety their presence provoked among some westerners was not. For example, in 1920 at their peak population in California, Japanese Americans constituted only about 2 percent of the total population. Furthermore, unlike European immigrants who filled the major cities of the North and Midwest, at no point did Japanese immigrants constitute a majority of the population in West Coast cities. Instead, the Japanese population was spread out, almost evenly split between rural and urban areas in the West.[25]

Some westerners saw Japanese immigrants as an economic and imperial threat. Despite the small number of immigrants from Japan, they became targets in the rhetoric about rights for workers and farmers in the American West.[26] Still, unlike many others, they were not usually seen as a health threat. In contrast, Chinese immigrants, like the Irish, Eastern European Jews, and Italians, were stigmatized as constituting a specific public health threat as a dirty, diseased "race." Although Japanese immigrants also en-

countered health inspections upon arrival in the United States, with particular attention to the presence of trachoma eye infection or hookworm disease, they were not characterized as a medical menace in the same way as the Chinese.[27] The higher educational level and economic status of many Japanese immigrants and the rising international role of Japan lessened the focus of public anxiety on health issues. Instead, more Americans feared that the arrival of Japanese immigrants signaled Japanese imperial efforts.[28] As leaders of the American Legion cautioned: "These people have come here, not as future American citizens . . ., but as colonists of Japan, establishing centers of Japanese population and influence which are . . . outposts of Japanese Empire on American soil."[29] Nonetheless, what these critics missed was that Japan's quest for empire focused on Asia, not North America.[30]

Understood in this context, the work of birthing babies was the work of empire building. Issei reproduction was politicized as an imperial threat. The Issei were suspect because they applied for Japanese citizenship for their American-born children and they established local Japanese language schools where they sent their children after attending public schools. It appeared to a growing number of Americans on the mainland and in Hawai'i that Japanese immigrants were not to be trusted to produce loyal American citizens.[31]

Issues of loyalty, national identity, and citizenship remained hotly contested for Japanese immigrants who, like the Chinese and some other Asian immigrants, were denied the right to become naturalized American citizens on racial grounds. The U.S. Nationality Act of 1790 permitted naturalization of "free, white persons" only. The Nationality Act of 1870, coming in the wake of the 14th Amendment that provided birthright citizenship to "all persons born in the United States," added "aliens of African nativity and persons of African descent" to the list of those eligible for naturalization. There were some Japanese immigrants, as well as Asian Indians, who challenged the naturalized citizenship restrictions. About 420 Issei were naturalized by lower federal court rulings as a result of the ambiguity of the racial category "white" before 1922. Then in 1922 the U.S. Supreme Court ended such ambiguity in *Ozawa v. United States,* which established that the Japanese were not white. Thus, even when Japanese immigrants were residents in the United States their entire adult lives, they were not entitled to American citizenship. Instead, the Issei were treated as permanent aliens until 1952, when passage of the McCarran-Walter Act at the end of the postwar American occupation of Japan removed racial restrictions on immigration and naturalization. As a result, Japanese immigrants were finally permitted to become naturalized U.S. citizens.[32]

Given West Coast concerns, westerners sometimes acted in ways that interfered with good international relations between the United States and Japan, to the immense frustration of federal officials. For example, anti-Asian riots erupted periodically among West Coast residents, especially in California. One notable instance of West Coast racism revolved around a school segregation controversy in San Francisco, the port city for most Asian immigrants. As Kimi Yamaguchi's husband found out upon his arrival in San Francisco, a powerful earthquake had hit the city in 1906. In addition to the thousands of deaths caused by the earthquake and resulting fires, many buildings were destroyed, including schools. On the grounds that there were limited facilities now available, the San Francisco Board of Education ordered that "all Chinese, Japanese, and Korean children go (sometimes at a great distance) to a segregated Oriental Public School." As historian Walter LaFeber observes, "The timing was not thoughtful: Japan's Red Cross had just sent a quarter-million dollars to help California's earthquake victims."[33]

Japanese leaders and some American businessmen were not pleased with the school board's attempt to segregate Asian Americans. In Japan, leaders reacted with heightened rhetoric and anger at the racial segregation imposed on the Japanese in California.[34] The people of Japan read California's action as an insult on several levels. First, the Japanese were appalled that their children were lumped together with other "inferior" Asians. Second, they were offended that the Japanese should be treated with the same oppressive policy of racial segregation that was currently enforced against African Americans in the South and to a degree against African Americans and Mexican Americans in the West.

American officials responded to the crisis with the Gentlemen's Agreement of 1907–1908, a compromise between the Japanese government's desire to protect its subjects and the American government's desire to appease anti-Japanese westerners.[35] In exchange for an end to the school segregation of the Japanese children by the westerners, President Theodore Roosevelt promised to restrict the immigration of Japanese laborers to the United States, not only from Japan, but also from Hawaii, Mexico, and Canada. Nonetheless, property owners and the wives and children of those Japanese immigrants who were already in the United States could immigrate.[36]

The Gentlemen's Agreement directly contributed to family unification and an increase in the number of Japanese women arriving in the United States, producing a large female immigration from Japan. Like the Chinese before them, the Japanese learned how to utilize anti-immigration policy loopholes. "Paper sons" from China and "picture brides" from Japan were

both methods of circumventing immigration restrictions. "Paper sons" emerged after the 1906 San Francisco earthquake and fire destroyed many government records. Some Chinese immigrants took the opportunity to falsely claim American-born status and therefore were entitled to bring to the United States any children born abroad. In the case of the Japanese, the Gentlemen's Agreement allowed Issei men to bring over their wives. As a result, about 40 percent of the decade's Japanese immigrants were women. Japanese immigrants not only summoned existing wives from Japan, they also found new ones through an exchange of photographs. An influx of "picture brides" began to arrive. They were the wives from newly arranged marriages between Japanese men living in the United States and women in Japan. Thousands of Japanese women arrived as picture brides, probably about half of all Japanese immigrant women.[37]

The arrival of Japanese women in significant numbers increased western fears. Thousands of Japanese women arrived from 1905 to 1924, the years of greatest female immigration. In 1900 there were about 1,000 Japanese women and 24,000 men, and by 1920 there were about 38,000 women and 73,000 men on the mainland. The sex ratio began to even out and with it the possibilities for increased reproduction and the need for midwives. Their arrival contributed to a population increase among the Japanese living in the United States, both in terms of the number of immigrants and through the birth of children, which seemed to signal the Japanese intention to settle permanently.[38]

The decades in which significant numbers of Japanese women arrived coincided with increased restrictions on Japanese immigration and strains in U.S.-Japan relations. After 1882 the government began to tighten its immigration policies, impose literacy tests, and establish numerical quotas.[39] In 1920 the United States no longer accepted picture brides as a result of allegations that the women were exploited as prostitutes.[40] Still, these anti-immigrant measures were timid compared to the National Origins Act of 1924, an anti-immigration law that severely restricted European immigrants, especially those from southern and eastern Europe, and excluded all immigrants who were ineligible for citizenship under U.S. Naturalization Law—in other words Asians, who were categorized as not white.[41]

The 1924 immigration act had specific consequences for the development of Japanese American communities and for the history of midwifery. To Japan and the Issei, the 1924 law was in practice, although not in name, a Japanese exclusion act. With no new immigrants arriving from Japan, the act created a clear break between the generations, sharply distinguishing between the

Issei and the Nisei.[42] The Japanese, as well as some Americans, were offended by immigration restrictions that targeted Japan. "Japan's deepest sensibilities—the desire to be 'equal' in the family of nations—were injured by this action," notes historian William J. Miller.[43] The United States had sent a clear message to Japan that Japanese immigrants were not welcome.

Racial Politics and the "Midwife Problem"

Kimi Yamaguchi and hundreds of other midwives came to the West Coast not only at a time of growing tensions in U.S.-Japan relations and American race relations, but also at the very moment that a national debate on midwifery emerged. The midwife debate led to a series of new midwife regulations, including state licensing laws and nurse-led training programs for midwives. In the early twentieth century American midwives were not a monolithic group. Yet after 1900, as an increasing number of American-born, white women turned to physicians to deliver their babies, midwifery came to symbolize the foreign or "backward" practices of America's marginalized—the poor, immigrants, Mormons, African Americans, Mexican Americans, and Native Americans. In the American national context, a midwife was seen as a premodern, traditional childbirth attendant. How did Japan's modern midwife fit into the American framework?

Midwifery survived for decades in numerous communities from Alabama to California. As a growing body of literature demonstrates, the first forty years of the century witnessed thriving midwifery practices throughout North America, albeit in pockets. European immigrants seemed to dominate midwifery in the North and Midwest, African Americans in the South, Mexican Americans in the Southwest, and Japanese immigrants on the Pacific Coast and in Hawai'i.[44]

Midwifery had a place in modern America, albeit a marginalized one. Historians have long noted that across the nation midwives delivered half of all babies as late as 1910 and still attended at least 15 percent of all births in 1930. In the early 1920s, the federal government reported that there were over 43,000 midwives in the United States.[45] By 1938, after at least two decades of restrictions on midwifery, the U.S. Children's Bureau still found 35,000 midwives in thirty-four states. In 1939 the bureau estimated that midwives attended 9 percent of all births, including 3 percent of the white births, 50 percent of black births, and 9 percent of all other "races." About 80 percent of the midwives practicing in the United States during the 1930s were African Americans and the number of southern black midwives did

not drop significantly until after 1950.[46] Among the remaining 20 percent were midwives in the American West, many of whom continued as birth attendants until World War II.

In the first half of the twentieth century, American midwifery did not disappear—it was racialized. As white, American-born women increasingly turned away from performing or selecting midwife deliveries, the changing racial demographics of midwifery made it vulnerable to criticism. A national debate on midwifery developed in the 1910s and 1920s in large part because midwifery was increasingly the purview of immigrants and racial minorities, including the *sanba* who were seen as both. We have had only a partial vision of the history of American midwifery because of insufficient attention to the history of racial and ethnic minorities. As numerous community and state studies have demonstrated, twentieth-century midwifery was central to a wide range of immigrant, ethnic, religious, and rural communities.[47] The *sanba* were part of American midwifery's multicultural history.

The history of midwifery in the United States represents a pattern that deviates from that of most other industrialized nations. For example, the United States did not try to modernize midwifery in the same way or to the same degree as did Japan, Great Britain, Germany, or the Netherlands. Government actions in many European nations and Japan led to the maintenance of midwifery as an independent, even professional, health-care field through midwife education and licensing. In the process, midwife regulations typically excluded some women and all men from the occupation, producing a clash between traditional and modern midwives.[48] In contrast, national and many local government officials in the United States treated midwifery as a public health problem.

Midwife regulations illustrate how local conditions and global processes affect the way nations monitor reproductive life. In the first decades of the twentieth century, issues of military mobilization, nationalism, and human compassion inspired the United States, as well as Japan, European nations, Britain, and Canada to address high infant and maternal mortality rates. Such rates were used as political measures of national well-being. Compared to other industrialized countries, American infant and maternal mortality rates were unacceptably high. They were an embarrassment to a nation seeking to enhance its power and prestige internationally.[49] Public policy therefore emphasized improvement in maternal and infant health, a trend that only accelerated with World War I and the need for healthier citizens and soldiers. Officials in the United States, like those in other western nations, were dismayed when a high percentage of young men were rejected

for military service on account of preventable illnesses and disabilities. Public health authorities therefore turned their attention to the health of the newborn and birthing women.

The history of government responses to midwifery in the United States and Japan differed significantly. American regulations developed at the state level in the 1910s and 1920s, whereas Japan had national midwife legislation by 1899, as we saw in chapter 1. In Japan health policy was centralized, but in the United States it was decentralized, with the result that there was a great deal of regional and state variation. Finally, in Japan the regulation of midwifery was linked to its modernization through promotion of women's education and scientific medicine, including in midwifery schools. In the United States there were a few midwifery schools in American cities by the late nineteenth century, but they were not designed to create a new profession for women. Instead, midwife reform in the United States was most closely tied to the public health movement and linked to the promotion of maternal and child health.[50]

In the United States there was no national attempt by midwives, physicians, or nurses to secure midwifery as an independent occupation for women. The fields of medicine and nursing were dominated by white, middle-class Americans who established national organizations to be advocates for their occupations. Although there were African American health professionals, racism forced them to create their own separate national organizations. Midwifery, in contrast, lacked a powerful national group able to lobby for its interests. Furthermore, it faced opposition from some health professionals. Obstetricians, in particular, objected to midwife licensing and the creation of midwifery schools. Competition also emerged among some public health nurses, who viewed midwives as impediments to establishing nurses' authority among the general public.[51]

At the same time that Japan looked to Germany as a model of how to reform midwifery, the United States looked to Great Britain. All the same, Americans did not fully follow Britain's lead. In Britain, female reformers campaigned to modernize midwifery and eliminate the traditional, working-class midwife, or so-called "handywoman," in order to reduce mortality rates and provide middle-class women with a new profession. The traditional midwife's practice focused on delivering babies but also included care for the sick and laying out the dead. The British Midwives Act of 1902 created the Central Midwives Board and preserved midwifery as a healthcare field within the modern health system by privileging trained midwives over traditional midwives. In Britain by the 1920s, midwifery was seen as

a branch of nursing.[52] In the case of the United States, some nurses trained to become nurse-midwives, but those who did remained few in number.

American middle-class female reformers were more interested in medicalizing childbirth than in professionalizing midwifery. Midwifery lacked the credibility and respectability of fields like nursing and medicine, which were seen as avenues for social mobility. The reformers' aims were to increase the safety of midwife deliveries and expand medical services. In 1912 they succeeded in creating the U.S. Children's Bureau, housed within the Department of Labor, to address a range of health and welfare issues, including infant and maternal health. The emphasis on expanding medical over midwifery care is not surprising since many of the women reformers at the Children's Bureau and state child hygiene bureaus were female physicians.[53]

Americans debated the "midwife problem" in a health-care context that strongly supported regular or orthodox medicine. The debate began in the 1890s and gained prominence in the 1910s and 1920s. Public health officials, public health nurses, and those sensitive to the needs of America's diverse ethnic groups, and even some opponents of midwifery, understood that midwives remained vital health-care providers in many communities. Even supportive health officials who did not call for the immediate elimination of midwifery, however, agreed on the goal of its eventual demise. In a nation with a medical profession able to claim scientific authority and cultural power, there was growing agreement that the solution to the "midwife problem" was to replace midwives with doctors, especially obstetricians. Modern America privileged doctors, assisted by nurses, as the appropriate health-care experts in childbirth.[54]

Midwife regulations were a local, state-controlled affair, and so the timing and degree of implementation varied by region and by state. Some states provided midwives with basic health education programs and issued midwife permits, while others refused to recognize midwifery at all in the hopes it would simply disappear. Still others on the West Coast provided no training or supervision of midwives, but licensed them much as they did doctors.[55] The closest the United States came to national midwife legislation was passage of the Maternity and Infancy Act of 1921, known as the Sheppard-Towner Act. The act was America's first national welfare program of the twentieth century, the result of women's national lobbying efforts. Among the provisions of the act were federal matching grants to states for the registration and training of midwives. Administered by the U.S. Children's Bureau during the 1920s, the act focused on health education because of the view that ignorance contributed to infant mortality.[56]

State government responses to the "midwife problem" in the United

States first focused on the midwife traditions of European immigrants in the cities of the North and the Midwest, where officials tried to control midwifery with varying degrees of success. Many European immigrant midwives had trained in midwifery schools, which emerged in the eighteenth and nineteenth centuries, and considered themselves to be quite competent. Furthermore, many pregnant women, especially those from southern and eastern Europe, chose to retain their use of midwives. Italian, Russian, and Jewish immigrants, for example, came from cultures in which the midwife was a valued artisan.[57] Nevertheless, according to Lillian Wald, one of New York's leaders in social welfare and public health, the American response to immigrant midwifery followed from the fact that Americans did not respect immigrant culture. "Perhaps nothing indicates more impressively our contempt for alien customs than the general attitude taken toward the midwife," she observed in 1915.[58] Despite the general attitude, the health care provided by midwives was often very good. Studies conducted in the 1910s and 1920s in the Northeast showed that immigrant midwife deliveries were as safe as or safer than physician deliveries. They suggested that maternal mortality rates were lowest where the percentage of midwife-attended births was highest. Some U.S. public health officials made the same argument about the benefits of midwifery practice internationally.[59]

In the 1920s, government interest in the midwife shifted to rural America, especially to the African American midwife of the rural South. Indeed, by the interwar years, the black midwife had come to epitomize the perceived midwife problem.[60] The shift in focus was due to immigration restrictions enacted in 1924 and American-born urban women's increasing preference for childbirth attendance by physicians. Children's Bureau interest in midwifery regulation was highest in the South and in New Mexico because birth registration records showed that those states had the highest percentage of midwife births and the highest infant mortality rates. Interest in the South was also strongly motivated by a growing national concern over how black health affected the southern economy. Until World War II, most African Americans lived in the rural South where white southern society placed a low value on black life. "Hospitals could, and routinely did, refuse medical care to black patients even in emergency situations," explains historian Vanessa Northington Gamble.[61] Over time, unhealthy living conditions contributed to black migration out of the South and the loss of cheap agricultural labor. Furthermore, federal officials feared that black morbidity and mortality were holding back the development of the South and the South was holding back the nation.

Although midwife regulation varied across the South, by the mid-1920s

almost all southern states had midwife training programs in place. The programs required public health nurses in the South, most of whom were white, to carry out the difficult process of locating midwives, most of whom were black. Nonetheless, the nurses registered midwives by the thousands, including at least 3,000 in Alabama, 4,000 in Mississippi, 6,000 in Virginia, 9,000 in Georgia and in North Carolina, and 10,000 in Florida.[62] Since these figures include only those midwives identified by the state, the actual number of southern midwives was even higher.

State intervention was designed to ensure that there would be fewer but better midwives, but it was not the same type of effort seen in Japan and Europe. Unlike the government-backed transition from the *toriagebaba* to the *sanba* in Japan, American health officials were not invested in producing school-educated midwives, but in placing further restrictions on all midwife practice. For example, many physicians, nurses, and public health officials believed black midwives were ignorant, unsafe birth attendants who promoted dangerous, "primitive" customs. In 1925 Children's Bureau officials explained that unlike the foreign midwives, the black midwives were untaught and unclean.[63] Health officials believed that midwife training in the South could provide valuable information about sanitary techniques that could contribute to improvements in black health. There was little recognition of midwife skills and knowledge gained from experience and what some African Americans called "motherwit."[64] Rather, regulations in the South were inspired by the perspective that midwifery was a "necessary evil" because there was a shortage of physicians willing to serve poor, rural African Americans. As a result, in the 1930s and 1940s Children's Bureau officials urged young literate women to become midwives, but there were few or no modern midwifery schools for them to attend unless they trained first as a nurse. Still, African American women, American Indian women, and Mexican American women of "good type" were encouraged to become midwives to replace the so-called uneducated "granny" midwives in their communities.[65]

Although southern infant and maternal mortality rates were among the highest in the nation, such rates tell us more about the presence of poverty than about the quality of midwifery care. As one Georgia public health nurse admitted in the 1940s, "You know, under the circumstances in which they often work I could not do as well as they do."[66] With few exceptions, the care that black midwives provided was simply not available elsewhere. Indeed, as health care providers to poor women, black midwives were a godsend, not a liability. Their economic conditions, their engagement in folk medicine and black cultural practices, and their reliance on experience

and God made them vulnerable to state intervention, however. Echoing the words of Toni Morrison, their knowledge "was discredited, because it was held by discredited people."[67]

The *Sanba* and Midwife Regulation in the American West

Unlike southern midwives, midwives in the American West faced relatively little government intervention. In the 1910s a number of western states passed legislation that required midwives to register with the state, but it is not clear how much influence it had, especially in rural areas. Midwife laws went into effect in Wyoming in 1910; Idaho, Utah, and Nevada in 1911; Oregon in 1915; and California, Washington, and Colorado in 1917.[68] Further research is needed to explain how and why western midwife laws were passed. It appears that club women, some of whom were physicians, led the efforts to push for midwife legislation.[69] Even though California and some other states required midwives to pass a licensing examination, rural midwives like Kimi Yamaguchi usually never took the examination. Further, because Kimi delivered babies among the rural poor, no one checked to ensure that she did.[70] Although public health nurses in some eastern and midwestern cities and parts of the rural South were involved in supervising midwives, few public health nurses in the West were. It is certain that no public health nurse offered Kimi midwife training classes or examined her home for cleanliness, as public health nurses did in the South. Such inaction on the part of western health officials begs for an explanation because it suggests that midwifery was not seen as a public health problem in that region.

Although western states did not completely ignore midwifery, they exhibited little interest in the topic. In the 1920s, when the U.S. Children's Bureau surveyed midwife regulations of the various states, federal officials learned that there was little attention to midwifery in the West. A health official in Idaho, for example, explained that the state had so few midwives that "we do not consider it much of a problem here." Montana had no midwife legislation, even though state officials knew there were at least 150 practicing midwives. According to one Montana official, there was no need for midwife legislation because doctors attended 96 percent of all births. In New Mexico, where most midwives were Mexican Americans, midwife training programs and supervision began in the 1920s, but the state did not restrict who practiced as a midwife until the 1930s.[71]

Furthermore, despite the growth of federal authority and state power in the West, there was uneven enforcement of the few midwife regulations that

did exist.[72] For example, officials in Wyoming and Utah indicated in correspondence with U.S. Children's Bureau officials that midwives practiced in their states but none had registered and state officials did not bother to track them down. In Colorado, where Japanese and Mexican midwives delivered many babies, health officials admitted "there has been such laxity in the past." By 1925 more than one hundred white, African American, Mexican American, Native American, and Japanese American midwives had registered in Arizona, although Arizona had no state legislation that set the necessary qualifications. The reason, according to one health official, was that "the medical profession does not wish to recognize them by registration but desires to eliminate them," although the official admitted that it was impossible at the time.[73]

Ultimately, most western health officials treated midwifery as an insignificant health issue. They often did not know how many midwives practiced in their states or seem particularly concerned about their presence. Only in New Mexico and the cities of Los Angeles and San Francisco were there concerted efforts to supervise and train or eliminate midwives.[74] In California and Washington, where most of the *sanba* lived, officials registered those midwives deemed to have adequate knowledge and hoped that those without a license would stop practicing.

If we look closely at the actions of California, however, the picture is not so simple. By licensing midwives in much the same way that it licensed physicians, the state reinforced a professional identity for midwives. At the same time, even as the state treated midwifery as a legitimate health-care field, it subordinated midwifery to medicine. California's midwife licensing law of 1917 placed midwifery directly under medical control by amending the health professions licensing act to include a new section on midwifery. The law gave authority to the State Board of Medical Examiners to register midwives, along with doctors, but no other health practitioners. A midwife was required to pass an examination that covered such topics as anatomy, physiology, obstetrics, hygiene, and sanitation. She then had to pay $2.00 annually to renew her license. She was required to have attended at least one year of high school and one year of midwifery school. She was not permitted to use any drugs or instruments. As in the 1899 midwife ordinance in Japan, California law had a "grandmother" clause to permit currently active midwives to become licensed without an examination if they had been practicing for at least one year and had attended at least twenty-five cases of labor and delivery before the new regulations went into effect. In addition, all midwives were required to file testimonials of "good moral character" from a doctor or a member of the clergy.[75]

Repeatedly, state regulations judged midwives on moral standards and not just appropriate childbirth skills. Among the behaviors deemed immoral and unprofessional by the state was providing an abortion. As historian Leslie Reagan argues, the identification of midwives with abortion paved the way for state control of urban midwives, including European immigrant midwives in Chicago. California records suggest that abortion did not figure prominently in the justifications for midwife regulation in that state. Nonetheless, California did crack down on anyone performing abortions in 1919, as well as on Chinese herb doctors, who not only provided an alternative medical approach but may have provided abortifacients. There was also an abortion ring scandal in the 1930s. Other behavior prohibited in California among health professionals was habitual intemperance and excessive use of cocaine, opium, morphine, codeine, or heroin. Midwives in particular were warned that they must call in a physician when childbirth complications arose and they must not put their hands into the vagina to remove the placenta.[76]

California, like other states, enacted midwife licensing to better enforce the registration of births. In 1918, only one year after establishing midwife licensing, California asked the U.S. Census Bureau to admit it to the national birth registration area, which was a term created in 1915 to identify states that complied with federal requirements to register births. California health officials wanted to standardize the regulation of midwifery, which had previously been a municipal affair, in order to comply with the birth registration requirements and potentially obtain federal funding.[77]

California's midwife regulations mirrored, at least in part, the licensing procedures for doctors. From 1875 on, state governments began to create medical examining boards that issued medical licenses to those doctors who successfully passed a test or graduated from a qualified medical school. One could no longer just call oneself a doctor based on self-training or apprenticeship. California began licensing physicians in 1876 and by the 1890s most states required a medical license to practice medicine. By 1900 medicine was a fully regulated profession in the United States.[78]

The parallels with medical licensing suggest that the licensing of midwives showed a willingness on California's part to cast a certain degree of legitimacy on the work. State officials assumed that the registration process would weed out the unskilled practitioners, but it meant that those midwives who passed the examination could continue as independent practitioners with the state's approval. After the new law was passed, the state board sent the new midwife rules to every county and city health officer in the state.

California's midwife regulations were modeled on the requirements estab-

lished previously by the city of Los Angeles, where midwifery had caught the attention of local health officials. According to historian Jennifer Koslow, the city first began to register midwives in 1910, and by 1915 the Los Angeles Department of Health established a Division of Obstetrics to provide a home birth service for poor women in order to eliminate business for local midwives. Under the city's program, medical students performed the deliveries, assisted by nurses. Still, in 1917 there were at least eighteen Japanese midwives with significant practices in the city. Although midwifery continued, health officials claimed success in reducing the number of unlicensed midwives in Los Angeles. The long-serving secretary of the State Board of Medical Examiners, Dr. Charles B. Pinkham, met with Dr. L. M. Powers, the health officer of Los Angeles, and Dr. Lyle McNeile, head of the city's Division of Obstetrics, to develop procedures for midwife registration statewide.[79]

The state licensing process produced difficulties for immigrants who lacked adequate English language skills to take the state board examinations for medicine and midwifery. The issue of conducting examinations in a foreign language proved to be a problem for California officials. The board had discretion to permit a translator, and it did so on various occasions for Spanish, French, and, especially, Japanese.[80] Japanese doctors, for example, had the option of taking the medical examination with translator assistance from 1917 through 1920, possibly because of the shortage of doctors in California as a result of World War I. In 1917 the Japanese Medical Society of Southern California requested that the board provide medical examinations in Japanese, which was granted. The board also adopted the society's recommendation that each applicant pay for his or her own translator, a layman to be selected by the Japanese consul in Los Angeles or San Francisco. The number of licensed Japanese immigrant doctors in Los Angeles increased from four in 1908 to thirteen in 1917 to twenty-seven in 1927.[81]

Nonetheless, the opportunity to use a translator was short-lived. In 1918 there was a scandal involving cheating among Japanese applicants taking the examination for a medical license. After the arrest of the translator, a Japanese informant in Los Angeles was shot at twice and two of the applicants named in the controversy died, apparently from committing suicide. The case went to federal court in San Francisco, where in 1919 the translator and the applicants were found not guilty. In 1920 the board asked the new Japanese translator whether authorities in Japan permitted applicants for medical licenses to take their examination in English and was told that the Japanese medical practice law of 1906 permitted graduates of American

medical schools to do so. Nonetheless, because of the scandal, the board decided in 1920 to eliminate the option of providing state medical examinations in a foreign language.[82]

Many of the *sanba* in California used the foreign language option in order to comply with the licensing requirement. From 1917 to 1923 midwives could take the examination in a foreign language. It was a very small window of opportunity, but one that dozens of Japanese midwives utilized. Despite the California board's decision to end the option for medical examinations in 1920, in 1921 the board decided to continue to allow midwives to write their examinations in a foreign language, but for the exorbitant fee of $50. As the head of the board explained, the state was willing to bend because it wanted "better control over the practice of midwifery" and given that the "foreign population demand" midwives, "we are safe in assuming that 50% of those now practicing midwifery in California are unable to take the examination in the English language." After 1923 midwives also no longer had this option and, with the addition of immigration restrictions, far fewer new midwives registered.[83]

At least 75 percent of the nearly 200 midwives licensed by the state board were Japanese midwives. The *sanba* were the midwives most likely to comply with state licensing rules because they were best prepared to meet the bureaucratic requirements. Many *sanba* had trained in midwifery schools in Japan and had the health-care knowledge tested by the state. The Board of Medical Examiners awarded about a hundred midwife certificates from 1917 to 1921 and about ninety more until 1945, after which no one applied for a license. Koslow found, in her study of Los Angeles, that the Japanese dominated midwifery there by the 1920s, constituting about 70 percent of the midwives from Los Angeles listed in the state directory.[84]

Many Japanese midwives passed the examination and then continued to conduct themselves as independent practitioners. For example, Haruyo Nishioka, a midwife in Stockton, California, practiced midwifery for more than forty years. Haruyo, who graduated from a midwife school in Japan, was among the first to pass the new state licensing examination in 1917. She thereafter paid her $2.00 annual renewal fee and carried her business card, indicating that she was a licensed midwife. In the mid-1920s she was one of seven licensed midwives in Stockton, all of whom were Japanese immigrant women with certificates from the State Board of Medical Examiners.[85] Kamechiyo Takahashi, another northern California midwife, trained for two years in Japan. In 1917, the year she arrived in San Mateo County, she passed the California licensing examination with the aid of a translator. She practiced midwifery from 1917 to 1930 throughout San Mateo and

Santa Clara counties, attending Issei women who preferred her to the local white doctors.[86]

Other midwives in California practiced without a state license, although sometimes that was because they had licenses from their city or county officials. Because California is a large state, midwife certification remained decentralized and many midwives escaped notice. In addition, permission to practice midwifery was granted not only by the State Board of Medical Examiners, but also sometimes by county and city health officers, and even by county registrars of vital statistics. The board found that some city and county health officers made inaccurate assessments of midwife activities in their regions. For example, Dr. Paul E. Dolan, a county health officer, responded emphatically to a query from state health officials: "I have no record of any midwives in Alameda County. I have never been requested by any midwife to carry on their practice. We have no midwives in Livermore. If I hear of any midwives practicing in Alameda county, I will inform you." Despite his protests, the state board's records showed that eleven midwives practiced in Alameda County. At other times it was the state board that was in the dark. In San Francisco, for example, state board records indicated there were eleven licensed midwives, but city and county health officials knew of more than one hundred midwives practicing in the area. The names of midwives included not only Japanese women, but also some Italian and Chinese women.[87]

Enforcement of California's midwife licensing law was difficult and immigrants were not always well informed. State officials were frustrated by the fact that some midwives never obtained a state license and instead merely paid their annual occupation tax, assuming that payment of the tax legally entitled them to practice midwifery. In a very few cases the state actively intervened to stop midwives from practicing without a license. For example, the San Joaquin County Health Officer, Dr. John Sippy, reported that he had several midwives who were illegally delivering a large number of babies but were not fit to practice. The state sent special agent H. G. Henderson to investigate ten midwives, one of whom was Japanese, in the Stockton and Lodi area. At the urging of Dr. Sippy, the state decided to prosecute two of the "more flagrant violators" for ignoring the law, and the rest of the women agreed to stop their work until the State Board of Medical Examiners certified them.[88] As Dr. Pinkham of the board conceded, however, it was hard to enforce the law. "Evidence to support alleged violation of the law is difficult to obtain," he explained, "as most of the midwives are operating among foreigners who either will not give the desired information or their inability to speak English makes testimony unavailable."[89]

Despite the licensing requirement in California, state health officials had

no clear idea how many midwives were practicing and little indication that midwives followed state licensing procedures. When pressed on the issue of midwifery by Children's Bureau officials in 1923, California health officials conducted a survey of midwifery in the state. A nurse was appointed as temporary midwife inspector for all fifty-eight counties in the state. She interviewed some 500 midwives, about 100 of whom were licensed after passing the state's written examination. Most of the licensed midwives, 75 to 80 percent, were Japanese women. Italian immigrant women made up the next-largest group of licensed midwives, a topic worthy of further research. Nine years later, the state reported it had increased its registration to nearly 300 midwives. This figure may include those licensed by officials in San Francisco, because the State Board of Medical Examiners listed only 200 licensed midwives.[90] There were also many Mexican American women who practiced midwifery in the counties of southern California, but they were rarely represented among the licensed midwives.[91]

In 1924 the journal of the California Medical Association, *California and Western Medicine,* complained briefly about midwifery. An editorial in January stated that midwives were unnecessary and should be eliminated. Another editorial appeared in August, opposing state licensing of midwives because it endorsed unskilled, ignorant attendants. The second editorial argued that childbirth was dangerous to the mother and child and that it was not the natural, normal process depicted by some. It shared the view of at least some physicians that medicine should save women and infants from the risks of childbirth. It was critical of the approach by the Children's Bureau, which the essay said criticized physician birthing care and foolishly sought to educate midwives. Midwives, the editorial suggested, only worked by instincts, superstition, and experience. The piece concluded by noting that 10 percent of all births in California were attended by midwives and the state should move to eliminate all licensed midwives and prosecute unlicensed ones.[92] In a third article in October, the journal addressed the question of how many midwives practiced in the state. It pointed to the confusion over the actual number of midwives practicing in San Francisco, mentioned earlier, as an illustration of the fact that the state had a bigger problem than it realized: "If the facts noted above obtain elsewhere in the state—as they probably do—the number of midwives practicing legally and illegally in California is in the thousands rather than hundreds as has been claimed."[93] According to the medical journal's estimates, the state had many more health-care practitioners than it licensed, for a total of some 8,000 physicians, 6,000 chiropractors, 3,000 Christian Science healers, 2,000 osteopaths, 2,000 naturopaths, and 2,500 midwives.[94]

Despite the concerns expressed in the medical journal, California health officials justified their relative lack of attention to midwives on the grounds that they were simply not a problem. In 1923 Dr. Pinkham of the State Board of Medical Examiners responded to a query from the National Midwives Association indicating that the board was "greatly interested in the midwifery problem." Most California health officials, however, did not share this view.[95] For example, Dr. Ellen S. Stadtmuller, head of the Bureau of Child Hygiene, wrote to Children's Bureau officials in the 1920s: "As we do not feel our midwife situation is creating a real problem in California so we have not stressed an attempt to educate them."[96] The California Bureau of Child Hygiene was established in 1919 with Dr. Ethel Watters, a graduate of Stanford University and Johns Hopkins Medical School, as its first head. Stadtmuller served as chief of the bureau from 1923 to her untimely death in 1941. In the 1920s, Stadtmuller explained to federal officials that no midwife training programs were available because the state simply did not have the staff to work with midwives scattered across the state's large and geographically diverse territory with seasonal restrictions on travel. Some areas were mountainous with narrow roads and could not be crossed in winter. Other areas were vast deserts that could not be crossed in summer.[97]

Stadtmuller also explained to federal Children's Bureau officials that some midwives ran maternity homes and the state could reach those midwives through inspection of those facilities. For instance, Kamechiyo Takahashi, a midwife in San Mateo County, opened one in her home in the 1920s because it was easier to deliver babies at her place than to travel all over. She charged about $20 for the delivery and $1 per day for room and board. A Japanese midwife in Sacramento turned her home into a birthing center in the 1930s so that Issei women who lived out in the country and could not speak English could have a place to give birth with a midwife. Rural women could stay over, sometimes a week after having their babies. A Nisei physician in Los Angeles remembered such a maternity home in her city run out of a midwife's house.[98]

In 1925 the California Bureau of Child Hygiene began to license maternity hospitals and maternity homes, many of which were run by Japanese midwives and Japanese doctors. The state used Sheppard-Towner funds not only to subsidize nurses' salaries in counties with high infant mortality rates, but also to employ two maternity home inspectors. Some of the maternity homes were small and took only two or three patients at a time. Stadtmuller informed Grace Abbott of the Children's Bureau in 1926, "At present we have two workers making a complete survey of the maternity homes in the State." In the mid-1920s the inspectors examined 230 maternity hospitals

and 100 maternity homes, and by 1930 some 370 maternity hospitals and 250 maternity homes. Like at least twelve other states, California tried to license the good ones and weed out many of the unsanitary, one-bed maternity homes.[99] Some officials in midwestern antiabortion campaigns claimed that midwives' maternity homes were simply covers for providing abortions. There were also homes for unwed mothers created to promote adoption instead of abortion. It is not clear whether private maternity homes run by the Issei provided abortion or adoption services, but they certainly were another location for childbirth. Maternity homes and hospitals run by midwives or nurses in the early twentieth century deserve further investigation, for they were more common in the American, and Canadian, West than existing scholarship would suggest.[100]

In 1924 California health officials compared birth and death certificates to investigate whether midwives were contributing to maternal or infant death rates. Stadtmuller concluded that "we feel we cannot blame the midwives, even though uninstructed, for our maternal or infant deaths" and therefore educational work with midwives will not be a priority.[101] Such a position by a public health official was extraordinary in the 1920s, at the height of national concern over the "midwife problem." What she does not say is whether she thought midwife births were safer because so many were performed by women who had attended midwifery schools, including those in Japan.

In the 1920s, when doctors attended most western, urban births, the availability and quality of physician care was a greater public health concern than midwifery. In Oregon, as in other western states, the scarcity of doctors in rural areas led health officials to leave midwives alone. Ironically, at the same time that a shortage of rural doctors was used by southern health officials to justify state intervention in midwifery, Oregon officials used it to account for state inaction. Oregon made a largely meaningless effort to regulate midwives when it passed midwife registration legislation in 1915.[102] In 1923 an Oregon health official reported to the Children's Bureau that the state had sixteen registered midwives, but then she admitted that "registration is rather a flimsy thing." Indeed, the state never did a survey of the total. As Dr. Estella Warner, head of the Oregon Bureau of Child Hygiene since 1922, explained: "The problem of midwifery in our state is really so negligible in comparison with the problem of insisting upon good obstetrics among our professional people, that I think we all feel it does not require immediate attention on our part."[103]

Washington health officials echoed this familiar western refrain: midwifery is not a problem. In 1917 Washington enacted legislation requiring

all midwives to obtain a license by passing an examination administered by the State Board of Medical Examiners. In order to take the examination they had to present a certificate indicating that they had graduated from a school of midwifery with at least a fourteen-month training program. As in California, they could take the examination with the aid of a translator if necessary. Between 1917 and 1925, Washington registered about sixty midwives, two-thirds of whom were Japanese immigrants. Physicians attended 95 percent of all births in the state, yet midwives attended more than 65 percent of all Japanese births and 20 percent of Chinese births. Thus, although doctors attended most white women, midwives attended most Japanese immigrant women.[104]

Why did West Coast states consider licensing legislation a sufficient response to the activities of midwives? Why were midwives treated as a problem in the South but not in the West? With 6,000 midwives registered in the southern state of Georgia and a mere 60 midwives registered in the western state of Washington, perhaps demographics alone explains why the West Coast had no "midwife problem"—it had so few midwives! Still, if it is difficult to know from government records how many midwives practiced in the South, it is even harder in the West because of lax enforcement of registration laws. Estimates from U.S. Children's Bureau surveys during the 1910s and 1920s indicated that when compared with the North and the South, the West had the lowest percentage of births attended by midwives, ranging from 5 to 25 percent.[105]

There are several reasons for western officials' approach to midwifery. One factor is that midwives were not a threat to the medical profession there and western doctors did not organize against them. According to government statistics from the federal Children's Bureau in the 1920s, physicians already attended most births in the West: about 95 percent in California, Oregon, and Washington. By 1920 at least 50 percent of the population in West Coast states lived in urban areas of more than 2,500 residents, where physicians were more readily available. Such figures contrasted with those in the South, which had a rural majority. Physician deliveries in the same decade accounted for only about 70 percent of all births in Alabama and 50 percent in Mississippi.[106] By the 1930s the Pacific Coast region had one of the highest rates of hospitalized births in the nation.[107] Since the West had enough doctors in urban areas and there was little pressure from organized medicine for the government to circumscribe the work of midwives, health officials did little beyond licensing. Furthermore, western mortality rates were low compared to the rest of the nation, and therefore midwives were not singled out for blame.

In addition, midwife registration did not mean the same thing in each case. In many southern states, midwives were permitted to practice as long as they registered with the state and followed state rules. In contrast, California and Washington were far more demanding and required midwives to be graduates of a midwifery school and pass an examination. Consequently, the midwives who came forward to register were mostly school-trained midwives, especially those from Japan. As we saw in chapter 1, many of the *sanba* were formally educated in the scientific, hygienic approach to midwifery. Federal and state officials saw the *sanba* in the West as skilled practitioners, even though they were still "only" midwives. Indeed, Dr. Frances C. Rothert, an official at the U.S. Children's Bureau, stated in 1929 that the licensed midwives of California, most of whom were Japanese, were among the best midwives in the country.[108] The correspondence of California health officials suggests that they recognized the abilities of Japanese midwives, and that even those midwives who were not well trained were still doing well enough.

Nevertheless, health officials' portrayal of the *sanba* as a kind of "model midwife" was itself full of contradictions. Historically, Asian Americans have been characterized as a "model minority" for racially divisive purposes. For example, praise for Asian American workers in the United States and Hawai'i was a way to criticize and discipline African American laborers, Irish immigrants, and native Hawaiians. Distinctions were also made when health officials in California engaged in backhanded compliments of Japanese immigrants. For instance, in 1925 Dr. Gladys Shahovitch, the Los Angeles County health officer, praised the Japanese in the county for being more cooperative with health officials than the Mexicans. She believed, however, that they acted that way because "they belong to an imperialistic government and are accustomed to obey[ing] orders so they always do whatever they are told to do." She continued, "From a health point of view . . . the Japanese are no problem at all, as the Mexicans are. But the Mexicans are no menace to the country and I believe the Japanese would take part of California if they could."[109] So, too, a few late twentieth-century social commentators contrasted the success of the Asian American work ethic with the failure of African Americans due to their supposed dependency on the welfare state. The model minority label both denigrated other racialized minority groups and overstated Asian American success.[110] In that sense, West Coast officials' relatively positive reception of Japanese immigrant midwives did not signal the absence of racial prejudice.

West Coast officials' satisfaction with limiting their response to merely licensing midwives was a result of both respect for the *sanba*'s training and

skills and neglect of the health needs of their clients. Health officials were not concerned about the quality of midwifery care because doctors delivered the babies who mattered most—white babies. Western satisfaction with, or indifference to, midwifery was a sign of admiration and racism.

Although government records provide evidence of state responses to midwifery, they tell us little about the meanings of midwifery for midwives and birthing women, a topic explored in the next chapter. For many pregnant women in California, a midwife was a welcome presence, even if she did not speak their language. Midwife Haruyo Nishioka of Stockton, California, practiced midwifery from 1914 to at least 1955 and possibly until 1960. Over the years she delivered about 1,500 babies, including about 80 non-Japanese babies.[111] Kimi Yamaguchi, whose story opened this chapter, attended not only the births of Japanese women but also of Mexican women. Agricultural labor and racial prejudice frequently brought Mexicans and Japanese together. For instance, Japanese and Mexican farmworkers sought an alliance during the successful strike in 1903 in Oxnard, California. At other times, such as the El Monte Berry Strike in 1933, Mexican farmworkers went on strike against Japanese growers. Bacon Sakatani, who grew up in the 1930s in a family of farmworkers in El Monte, California, went to a segregated school for Japanese and Mexican kids. So, too, Mexican and Japanese women built connections through childbirth. Many of the Mexican families in Kimi's community used her midwifery services. One family in particular called on her to deliver all seven of their children. Even though Kimi spoke only a little English and a little Spanish, it was enough to communicate with birthing women. The women she assisted never paid her much, if anything at all, but they thanked her with gifts like homemade tortillas and beans.[112]

As the Nisei children of the *sanba* emphasized—midwifery mattered not only to birthing women but also to their midwife mothers. Kimi's daughter Alyce explained that despite Kimi's drop in economic status and unhappy marriage in America, midwifery remained central to Kimi's identity. She was able to preserve a part of the fulfilling life she had led in Japan through continuing to practice midwifery. Even as a full-time farmworker, Kimi found time to deliver babies, although she no longer earned a living doing so. In an often discouraging environment, Kimi used midwifery to keep alive a part of her past and validate herself. She hung onto something that mattered to her—a form of labor that took place outside her husband's control and her family responsibilities. Ironically, Kimi was not able to get a midwife to assist her during the births of her own children, but she knew what to do. Like so many rural Issei women who did not have access to a

midwife or a doctor, she had her husband's assistance with the births.[113] As Kimi's daughter Alyce recalled, Kimi remained proud of her midwifery skills and the fact that she had never lost a baby, either someone else's or her own. Practicing midwifery helped Kimi and other American *sanba* make life meaningful.[114]

In the American West, as in Japan, there were significant differences in the midwifery practices of the *sanba* who lived among impoverished farmworkers in rural areas and those who lived in urban centers. Like Kimi, most rural midwives delivered babies on an informal, part-time basis for friends and neighbors for little or no remuneration. In contrast, midwives who lived in urban centers, such as Seattle, set up full-time, formal midwifery practices, which were sometimes quite lucrative. As we will see, urban areas provided the greatest economic opportunities for the American *sanba*.

SEATTLE *SANBA* AND THE CREATION
OF ISSEI COMMUNITY

At 10:00 A.M. on a rainy January day in 1927, Toku Shimomura drove the family Ford to the house of Mrs. Okiyama, who safely gave birth to a baby boy five hours later.[1] It was a typical, uneventful birth for Toku, a *sanba* who delivered about twenty babies that year in her hometown of Seattle, Washington. The birth of a baby, however, accounted for only a fraction of Toku's time. She also spent many hours every day making house calls, during which she would check on clients and perform various aspects of prenatal and postnatal care. Most of her days were filled with home visits and caregiving, activities that were less quantifiable, but nonetheless meaningful, aspects of her work as a health-care provider to birthing women and their babies. Meanwhile, like other working mothers, this thirty-nine-year-old midwife also did the laundry, cleaned the house, and cooked the meals for her family, which included three young children: son Michio (age three), daughter Fumiko (age eight), and son Kazuo (age thirteen).[2] In between attending to clients and her household, she ran errands, went shopping, and even took the car to the garage for repairs. Somehow, she also maintained an active social life: She spent time with friends, enjoyed dancing with her husband, went to Bible classes, sang in the choir, and attended service at the Japanese Methodist Church. In 1927, as in most years, family, friends, and church occupied much of her time. The life of midwife Shimomura was like a tapestry in which the birth of a baby was but a single, if bold and continuous, thread.

The history of midwives like Toku Shimomura presents a vision of Japanese American womanhood that challenges the stereotypical image of the unchanging, servile, reserved, and deferential figure. Although women were expected to exhibit such traits, they did not necessarily do so.[3] For example,

Toku was strong-willed and fiercely independent. Midwifery, as well as immigration, seemed to attract Japanese women who were self-sufficient, ambitious, and entrepreneurial. These qualities certainly characterized Toku, who was an imposing woman in many ways. Not only was she tall for a Japanese woman, but she had a grand tone and style with which she ran her family. According to her grandson Roger Shimomura, she was best described by the Japanese word *chanto*, meaning proper, righteous, and respectable. She did everything that was expected of a woman of her status.[4]

The Washington State approach to midwife regulation, as discussed in the previous chapter, enabled midwives like Toku to conduct midwifery with relatively little interference. Still, health officials' response tells us little about midwifery's significance within immigrant communities. What were the meanings of midwifery in the lives of the *sanba*, their family members, and clients? What was the impact of gender relations, racial politics, and class dynamics on their health-care work? How did midwifery shape Japanese immigrant communities? Government records are not forthcoming about these unofficial meanings of health-care work, and so we must supplement them with oral histories, interviews, and diaries.

The history of the Seattle *sanba* illuminates the meanings of midwifery to Japanese immigrant communities in general and to Japanese immigrant or Issei women in particular. It demonstrates that midwives, moving in and out of their homes and those of their clients, contributed to the creation of Issei women's culture and community.[5] Young immigrant women, most of whom had left both mothers and mothers-in-law behind in Japan, were especially eager for the emotional and social support provided by midwives during pregnancy and childbirth. Each midwife developed an individual reputation in the community. At the same time, the midwives shared an approach to childbirth that maintained modern Japanese cultural practices, while developing new business opportunities for themselves. The *sanba*, along with family members and clients, broke Japanese traditions as well as safeguarded them. Their history extends the arguments of scholars who have shown that there is much more to the story of American midwifery than merely its demise.[6] The *sanba*, like midwives throughout the United States, were not simply denounced and eliminated—they continued to care for mothers and babies well into the twentieth century. Nonetheless, even though individual midwives remained meaningful to members of the next generation, the American-born Nisei, midwifery was a health care and cultural practice engaged in by only one generation, the Issei.

A Community of Midwives

Although midwives were independent practitioners, the Seattle *sanba* worked within a community of midwives. We can catch a glimpse of this community in a photograph, taken in 1918, which shows thirteen members of the [Japanese] Seattle Midwives Association along with some of their children.[7] In urban areas like Seattle, Los Angeles, and Honolulu, Japanese immigrant midwives formed midwife associations to provide personal and professional support. The Seattle Midwives Association existed since at least 1913.[8] Similarly, Japanese immigrant doctors created their own medical associations in Los Angeles and Honolulu, although I found no evidence of one in Seattle. In the 1920s, Japanese doctors in southern California and Mexico could even subscribe to the *Japanese-American Medical Journal*, published quarterly by Dr. Takashi Furuzawa and edited by Dr. Isami Sekiyama for the Los Angeles Japanese Medical Association.[9] Professional associations provided opportunities to meet together to share knowledge and to ensure conformity in a field. In the case of the *sanba*, their training in Japan produced a standardized approach to childbirth, while their associations in the United States created a support network for practitioners.

Many of the Japanese immigrant midwives had been licensed in Japan, but some states required a new license to practice in the United States. When western states passed midwife registration laws, as Washington did in 1917, Japanese women were among the first to apply for a license. In Washington, midwives had to present evidence that they had graduated from a midwife school and pass an examination on such subjects as anatomy, hygiene, and pregnancy.[10] Toku Shimomura took the examination with the aid of a translator in a high school auditorium along with "twelve other Japanese, seven German and three Italian applicants." According to Toku, "Later I heard the examiner was amazed at the outstanding knowledge Japanese midwives showed, and it made me feel good."[11] The Seattle *sanba* did not hesitate to meet the new state requirements, but not all midwives complied. In 1925, for example, the state convicted Mary Collins of practicing midwifery in Seattle without a license, fining her a hefty $150.[12]

Across the state, Japanese immigrant midwives equaled in number, and often outnumbered, Japanese immigrant doctors. In 1920 Seattle (in King County) had about 20 licensed Japanese midwives and about 16 licensed Japanese physicians. Washington State began to license doctors in 1890. By the mid-1920s the state had licensed at least 30 Japanese doctors out of a total of 1,700 physicians and surgeons, and at least 40 Japanese midwives out of a total of 60 midwives. There were likely even more Japanese

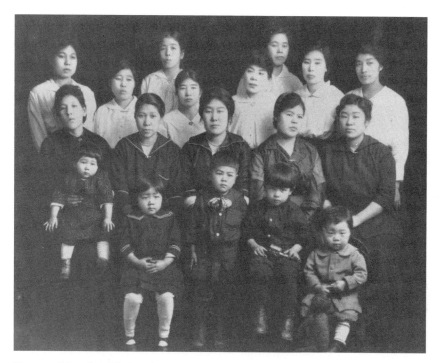

[Japanese] Seattle Midwives Association, 1918. The children are (left to right) Miss Kawai, Tomo Yasutake, Ed Shimomura, Lincoln Beppu, and Gus Nikaitani. The midwives wearing dark colors are (left to right) Mrs. Kawai, Mrs. Tsuchiya, Toku Shimomura, Sawa Beppu, and Mrs. Yoda. The midwives in white are (left to right) Mrs. Koyama, Tome Yasutake, Koto Takeda (far back), Michi Nakayama, Tsuya Hirano, Mrs. Nikaitani (far back), Mrs. Sekijima (?), and Mrs. Hiro Sato. Courtesy of Dell Uchida, who donated the photograph to the Wing Luke Asian Museum, Seattle.

midwives practicing in the state. For instance, King County alone had 36 licensed Japanese immigrant midwives by the 1920s, and with Japanese midwives practicing in Tacoma and rural areas there were easily more than 40 Japanese midwives statewide.[13]

The photograph of the Seattle *sanba,* taken not long after the women received their Washington midwifery licenses, may have marked the celebration of this achievement in their adopted country. It also may have been taken to capture an image of the group before one of their members left a month later.[14] Whatever the occasion, it nicely captures some of the multiple meanings of midwifery in their lives: an indication of the importance of family life, an identification with Seattle as their new home, and a sense of being a part of a community of health-care practitioners. The existence of the association demonstrates that at least some midwives in the United

States did not work in isolation in the early twentieth century but had a sense of themselves as part of an occupational group. The presence of children reminds us that midwifery was not their sole preoccupation.[15] These Issei women were working mothers who valued the professional and personal support that they provided to other women, including each other.

Strangers in Japan, the *sanba* became friends and colleagues in Seattle. Most of them lived in Japanese immigrant neighborhoods and went to the same Christian churches or Buddhist temples. Typically, Japanese immigrants had left most or all of their family members behind and therefore spent time socializing with other immigrants from the same area in Japan. In the absence of extended families, the Issei expressed their traditional sense of obligation to the *ie* (or household) toward other immigrants from the same village or prefecture (province).[16]

The Seattle *sanba* had much in common with each other and other Issei women, who as a group seemed to be better educated and more "modern" and who married at a later age than most women in Japan. Like many Issei women, their educational background may have been a factor in their decision to emigrate. They also may have had parents who urged them to go because of greater opportunities to marry or earn money. Furthermore, they may have been drawn to the United States after exposure to western ideas, progressive notions about women's rights, English language training at Buddhist and Christian schools, or Christianity. Interviews with Japanese immigrants conducted in the 1920s showed that many of them had had contact with Christian missionaries while in Japan, sometimes because they or their parents wanted them to learn English. Although Japanese Protestants made up less than 1 percent of the population of Japan in the early twentieth century, Christian missionaries became an avenue to knowledge about the United States and contributed to the decision of some Japanese to emigrate. American missionary activity facilitated new opportunities for some Japanese women, even as it contributed to American colonialism abroad.[17]

The Seattle *sanba* generally came from the Japanese middle class, which included independent farmers, artisans, and merchants.[18] Women who trained at midwifery schools generally had some financial resources, even if their resources were limited. They were not among the poorest of Japan because an education cost money, but they were also not from the elite because few from the elite classes would have taken on employment. Although midwives often had similar backgrounds in Japan, where they settled introduced differences among their lives in the United States. The lives of the Seattle *sanba* differed from that of a farmworker midwife like Kimi Yamaguchi in

64

California as a result of having immigrated to an American city or married a man who had settled in one.

Seattle was a major port for emigrants from Japan beginning in the 1890s, and by the early twentieth century a close-knit Japanese immigrant community emerged with strong social networks. By 1920 there were about 17,000 Japanese immigrants and their children in Washington, about 8,000 of whom lived in Seattle, a city of about 300,000 people. Even as the Japanese immigrant population grew, it remained an active, cohesive community. Seattle, and nearby Tacoma, boasted Japanese newspapers, several Japanese Christian churches and Buddhist temples, Japanese language schools, and social organizations. There were many immigrant businesses, including hotels, shops, grocery stores, and restaurants. Entrepreneurship was a major characteristic of the Seattle Japanese.[19]

The economic and social relations of the city provided an important backdrop for the midwifery practices of the Seattle *sanba*. Seattle, the largest city in the state, proved to be an ideal place for Japanese immigrant midwives. In 1921, for example, there were more than 1,200 births to Japanese immigrants in the state and midwives delivered more than 800 of those babies, most of whom were born in Seattle or in rural King County. Doctors delivered about 330 of the babies, and fathers, other relatives, or the birthing woman delivered the rest.[20]

Despite the vibrant economic opportunities Seattle provided to Japanese immigrants within their ethnic community, racism also existed in the city. A Japanese immigrant woman recalled her surprise at encountering prejudice on the streetcar her first day in the city. "There was an empty seat and I sat down," explained Toyo Shinowara, "and a white woman who sat next to me immediately got up and walked to the end of the car and stood there. I thought maybe I was not supposed to sit there so I got up too hoping the woman would come back and take her seat but she didn't." Shinowara shrugged off the incident and remarked in a 1924 interview, "I have never had that happen since and I think she was just rude and thought herself superior."[21] Throughout the 1920s, Japanese immigrants on the West Coast encountered a range of discrimination, such as in hotels and restaurants. In addition, the Issei were not permitted to build Japanese churches in white neighborhoods, to play on public tennis courts, or to rent bathing suits to swim at public beaches. Barbers refused to cut their hair and store signs read "no Japs." Some were turned away when they tried to rent rooms from the Young Men's Christian Association (YMCA). Other Japanese families who moved into "nice" neighborhoods in Seattle had stones thrown at their homes.[22]

Despite the racism in Seattle, Japanese immigrant midwives developed busy midwifery practices, bringing the Japanese approach to childbirth to their new Issei communities. Educated in Japan, the *sanba* knew the basics of scientific medicine, including how to maintain a hygienic environment, and they had learned that it was important for the birthing woman to lie down on a bed for delivery. Instructors had also taught them the limitations of their work and that they should call in a physician when labor and delivery did not proceed normally, a policy that meshed well with the new Washington State requirements. In addition, midwives maintained specifically Japanese customs when they provided a *hara obi,* or pregnancy sash, to a pregnant woman, urged a woman to endure the pain of childbirth silently, and encouraged a woman take the traditional resting period after birth. For most Japanese immigrant women, the Issei way of birth meant delivery by a midwife who preserved modern Japanese birthing practices within the American context.

In order to understand what is unique about Japanese immigrant midwives, it is helpful to compare them to European immigrant midwives. For example, midwifery was an acceptable occupation for women in Russian, German, and Italian immigrant communities in the United States, just as in Japanese immigrant communities. In Wisconsin, where most of the immigrant midwives were German, many urban midwives delivered babies as an income-producing activity. Just like the Seattle *sanba,* the urban German midwives did not just act neighborly. Further, both German immigrants and Japanese immigrants readily applied for midwifery licenses when required by new state laws. There were also important differences between the Wisconsin German midwives and the Washington Japanese midwives. Although many of the German immigrant midwives had children, they did not have active midwifery practices until after their children were of school age. In contrast, Japanese immigrant midwives delivered babies before they had any children and continued to do so even after their children were born.[23]

Japanese midwives were not the only midwives in Seattle and the state of Washington. Entries in city directories and state licensing records show that there were trained midwives from several European nations: England, Germany, Russia, Italy, Iceland, and Norway. Some of the midwives were educated in the United States, perhaps American-born, and attended midwifery programs in Philadelphia and Chicago.[24]

Unfortunately, direct information about midwifery from midwives is difficult to locate. Apart from Toku Shimomura's diary, most of what I learned about the Seattle *sanba* comes from the observations and memories of their relatives, especially daughters and daughters-in-law. It is a history recorded

and preserved in the memories of the next generation of Japanese American women. This history was then shared selectively with me, an outsider, as a way to honor the Issei midwives, which led them to emphasize positive characterizations. Furthermore, even as the Nisei preserved memories of the history of midwifery, they did not retain midwifery as a cultural practice and health-care role for themselves. Consequently, there are gender and generational dimensions to this source material. It is worth keeping in mind that children have their own perspectives on their parents' lives and that the American-born generation has its own views of the Issei generation.[25]

What follows, then, are glimpses of the family lives and midwifery practices of five of the *sanba* who posed for the photograph of the Seattle Midwives Association. As these biographies demonstrate, there was no single midwife experience, even among Japanese American midwives in one city. The midwives were individuals with specific family formations and household arrangements that shaped their work lives and vice versa. Given women's primary responsibility for raising children and doing housework, the more household assistance midwives had, the more opportunities they had to build their midwifery practices. As we will see, the distinctions among the five Seattle *sanba* are most apparent in their family lives.

Examining midwife biographies reveals how midwife work structured family life and domestic relations shaped midwife practices. Work, family, and community identities and activities linked and shaped each other. Midwifery was an occupation that offered Japanese immigrant women unusual autonomy, economic rewards, freedom of movement, and regular contact with other women, both midwives and clients. In a context in which women's domestic responsibilities remained unquestioned, regardless of their other activities, midwifery was a source of independence and status compatible with marriage and children. Indeed, these stories show the extent to which midwives received valuable support from their children and husbands. Still, it was not an effortless process. It was the midwives who had to juggle so much in order to fulfill their own desires for family, work, and community. Midwives negotiated the demands on them as workers, wives, mothers, and community members. Some of these life stories illustrate the conflicts that emerged and the disappointments experienced by midwives, their families, and their clients.[26]

Midwives were the primary childbirth attendants for Issei women and vital to a community in the midst of a baby boom. I begin with the life stories of Toku Shimomura and Sawa Beppu, two outgoing, ambitious women who developed busy midwifery practices that lasted well into the 1930s. Next I explore the stories of Koto Takeda and Michi Nakayama,

two sisters who led very different lives. Finally, I examine the experiences of Tome Yasutake, a midwife who practiced both in Seattle and in lumber camps in rural Washington. All five midwives were Meiji women, born in Japan in the late 1870s and the 1880s. While still young, unmarried women, they trained as midwives at midwifery schools after passage of the 1899 midwife ordinance in Japan. They arrived in Seattle between 1905 and 1912, and most either arrived with husbands or joined husbands from arranged marriages as "picture brides."[27]

Toku Shimomura

There is more evidence about Toku Shimomura's life and work than about that of any other American *sanba,* or about those of most American midwives. The reason is that Toku kept a diary for fifty-six years and her family had the foresight to save it. Day after day Toku wrote in a conventional printed diary or *nikki,* a habit of a growing number of middle-class urban women in Japan in the early twentieth century.[28] Toku, however, wrote her diary in the United States—it is an American diary written in Japanese. She began it aboard the ship *Awa Maru* on which she traveled to America in 1912, at a time when thousands of Japanese women immigrated to Hawai'i and the North American mainland. Toku's diary is extremely important because there is so little primary source material available to the historian to tell the story of the *sanba* from their perspective.

I first learned of the diary of Toku Shimomura from staff members at the Wing Luke Asian museum in Seattle. They showed me references to it in the massive compilation on Japanese American history by the Japanese journalist Kazuo Ito.[29] Although Ito's thousand-page book covered the struggles of Japanese immigrants throughout North America, much of the work focused on Seattle, where a Japanese American association sponsored his research during the 1960s. The museum staff members also put me in touch with one of Toku's relatives who told me where the diaries were located—in Kansas.

My thinking about the significance of this diary has been influenced by the historical detective work of Laurel Thatcher Ulrich, the eminent scholar of early American women's history. In 1990 Ulrich published the diary of another midwife, an eighteenth-century Maine woman named Martha Ballard. Entitled *A Midwife's Tale,* this Pulitzer Prize–winning book offered a rich interpretation of early America from a source that historians had previously dismissed as "trivial and unimportant."[30] Although Toku and

Martha were separated in time by more than one hundred years and resided in opposite corners of the United States, Ulrich's painstaking research and astute analysis of midwife Ballard's life serves as a useful model for interpreting the diary and life of midwife Shimomura.

The existence of Toku's diary is extraordinary. She wrote almost daily in her diary until she died in 1968. Her eldest son Kazuo, also known as Eddie, inherited her diary after his parents died. He kept the set of bound volumes in a bookcase and kept threatening to throw them out, but his eldest child Roger repeatedly told him not to because they were important. The diaries were special to Roger, who became an artist and professor of art at the University of Kansas. For the last fourteen years of Toku's life Roger had given his grandmother a diary each Christmas. The existence of Toku's diary is even more amazing when we consider that some of the personal records of the immigrant generation were lost or destroyed by families during World War II because the U.S. government considered all Japanese language works to be suspect material.[31]

Having located the volumes of Toku's diary, I soon found that they were difficult to work with for several reasons. First, like many North American scholars, I do not read Japanese and had to rely on translators. Second, Toku's Japanese characters are often indecipherable, especially when she wrote quickly and her character formation became difficult to discern, and therefore even those who are fluent in Japanese face a painstaking task in reading the diaries. Indeed, my own translators repeatedly expressed their frustrations to me as they struggled to understand Toku's script. Finally, the rewards of reading the diary are not readily apparent. The entries for some years are merely a series of curt statements. Toku's grandson Roger encountered this issue when he looked up the date he was born. He had high hopes of reading her emotional response to the birth of her first grandchild. He had remembered being told that she even had come out of retirement to deliver him. Instead, to his disappointment he found that her terse entry merely indicated that he had been born. Although not steeped in emotion, her diary entry was still warm. She wrote that she watched over the labor process and then brought in midwife Senda about one hour before "my favorite baby boy was born."[32] It is possible that Toku did not bother with careful penmanship or elaborations in her diary because she wrote only for herself. In contrast to the early Japanese diary tradition, which assumed an audience, usually of family members, Toku apparently had no intention of having others read her diary. She also showed little concern about protecting the privacy of her writings. She made no provision to have the

diary destroyed upon her death, or to pass it on to her children, or to have it published. She simply left the volumes of her diary in the care of her husband.[33]

As an organized and efficient person, Toku kept a diary as part of ordering her life. There is often little in it about her interior life, especially before World War II. In general, she rarely used her diary as "an expression of the self" or to process her feelings. This relative absence of emotional display was typical of the diary writings of Japanese women of the nineteenth and early twentieth centuries, even if it is surprising and disappointing to the modern reader.[34] Instead, Toku wrote mostly of the weather and her various activities, including housekeeping, social engagements, her health, and the health of family members, friends, and clients. She wrote down the names of people she saw and unusual or interesting events in her day. At times the diary seems merely a place she kept track of her incredibly busy social life. One of Ulrich's key observations about Martha Ballard's diary was that its value lay in its everyday nature. Its dailiness, she argued, the very quality that led other scholars to dismiss it as trivial, provided the dedicated historian with a clearer view of the past.[35] So, too, Toku's diary is a record of the daily life of an American *sanba* and the entries are her personal and professional archive. The entries, however brief, illuminate the contours of her life.

The diary reveals little about Toku Shimomura's life before she came to Seattle. She was born Toku Machida on 12 June 1888, in Saitama Prefecture in central Japan near Tokyo. She was the eldest daughter of a "forester." She trained as a nurse and midwife at the Japanese Red Cross Hospital and Nursing School in Tokyo, graduating in 1905 at the age of seventeen. In the midst of the Russo-Japanese War, she worked as a Red Cross nurse and helped treat the wounded on a hospital ship of the Japanese Imperial Navy. After the war she worked in a hospital as a nurse and/or midwife at the Ishikawa Silk Mill in the city of Kamagoe.[36]

Toku's life comes into clearer focus in 1912, a pivotal year for both Toku and the Japanese nation. Japanese nationalist and imperialist activity created the context in which individuals made emigration decisions. It was the year she began her diary as she sailed to Seattle and the year the emperor died, ending the Meiji Period. For Toku, a new life was just beginning.

At twenty-three years old, Toku felt young and a bit afraid when she left Japan with sixty other picture brides and her future brother-in-law, the hospital superintendent from the silk mill where she had worked. The picture bride practice was in many ways merely an extension of the tradition of arranged marriages in Japan. Before departing for Seattle, where Toku

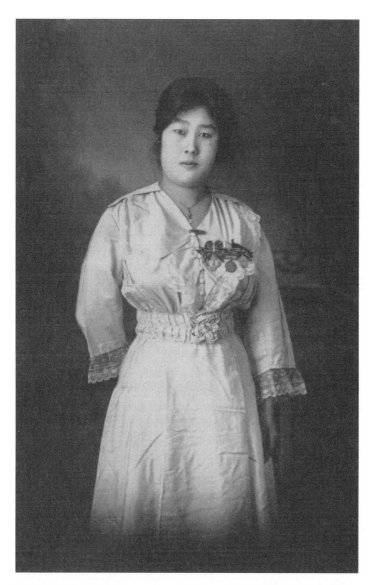

Midwife Toku Shimomura, 1912. She is wearing the medals awarded to Red Cross nurses by the emperor for service during the Russo-Japanese War of 1904–5. Courtesy of Roger Shimomura.

would meet her new husband Yoshitomi Shimomura, she visited his parents. They treated her very kindly and, as she recalled in her diary, "My heart leaped as I stood in front of the picture of my future husband."[37] Before her departure she also stopped to check on one of her pregnant clients, indicating that she had already begun practicing midwifery in Japan, possibly at the silk mill. She noted in her diary that she was very sad to leave her family and friends, and that she expected to stay in the United States for about ten years. Some thirty people came to the train station to bid her farewell. As a member of several women's organizations, she had developed a large circle of friends, many of whom she continued to correspond with over the years. Leaving was very hard, and she wrote, "I have cried so much lately I should soon run out of tears."[38]

Toku was a woman with access to at least some economic resources. Her account of her voyage indicates that she traveled with a degree of luxury compared to most immigrants. She sailed in second class, one of only fifteen passengers to do so on her ship, unlike most immigrants, who traveled in third-class steerage. Still, she faced the difficulties of ocean travel and, like others, Toku sometimes felt seasick. Another Japanese woman, Michiko Tanaka, sailed for two weeks before she arrived in San Francisco and remembered "I was sick on the ship all the way to America."[39] Toku's ship left 28 February 1912, and on 15 March it arrived in Victoria, Canada, and then docked in Seattle the next day.

Toku's diary indicates that she was excited about her adventure and spent time imagining life as a married woman. At a time when she had the leisure to record her emotions, she wrote about her high expectations for her new husband and her new life in America, and she tried to prepare herself for becoming a wife. At one point while sailing across the Pacific Ocean, Toku and another young woman sang songs. In her diary she wrote, "It was funny but I unconsciously closed my mouth after singing these childish songs, suddenly realizing that I will be a wife in a few days."[40] Toku had a photograph of her new husband Yoshitomi with her. She wrote in her diary, "Excessive loneliness caused me to yearn for him so I spent time looking at the photograph. Since last year I have been dreaming of meeting him in Seattle. I indulged myself in a deep need for him."[41]

Despite these fantasies about her new husband, it was her children's belief later in life that Toku was very surprised, even dissatisfied, when she first met him. Her diary reveals nothing about her immediate impressions of him, but her silence speaks volumes about her disappointment. After writing of her hopes on board the ship, she wrote nothing about him after they finally met. Instead, she described Seattle and American women: "The beautiful city streets

Yoshitomi Shimomura, 1912. Courtesy of Roger Shimomura.

and the impressive department store made a [positive] first impression on me. The women's activeness and their saucy conduct showed me the American style." She saw American women as independent and self-confident.[42]

Dissatisfaction with new husbands was not uncommon among picture brides. Some Japanese men in the United States misrepresented their attrac-

tiveness, even sending along a photograph taken much earlier or one of a handsomer or younger friend. Others exaggerated their economic success. It was not unusual for young Japanese immigrant women to be shocked at how poor or how old, sometimes ten to fifteen years older than expected, their new husbands turned out to be once they joined them.[43]

In Toku's case, as possibly for many of the *sanba* who moved to America, she felt she had married "down" and that she was more educated and cultured than her husband. According to her grandson Roger, she was probably right. There is evidence that the average educational level of Issei women was equal to or sometimes higher than that of Issei men. Many Japanese immigrant women studied at American mission schools in Japan. Other women may have agreed to immigrate because they were older, less attractive, or divorced. Such women were more readily available as picture brides, even if it meant marrying below their class, because they were seen as less marriageable in Japan.[44]

Toku probably married Yoshitomi not only at the encouragement of the hospital superintendent, who wanted to see his brother-in-law make a good match, but also on the basis of information that he had graduated from business school and shared her Christian faith.[45] Toku became a Christian in Japan and she was one of the early members of the Seattle Japanese Methodist Church, established in 1904. Methodist churches actively recruited Japanese immigrants throughout the West Coast, and like other Christian missions, provided people with care when they were sick and information about employment and lodging. Toku remained very active in the church throughout her life.[46] Eventually Toku came to see what a jewel her husband Yoshitomi was, despite his lack of impressive employment. He was very loyal to her, respected her wishes, and defended her to others. They made a good team. In 1913, when she became ill after the birth of their first child, Toku gratefully noted in her diary that she now realized how much her husband loved her.[47]

Yoshitomi suffered downward economic mobility, a common phenomenon for many immigrants, whereas the *sanba* had a ready clientele in Seattle and little competition from outsiders. Yoshitomi's general demeanor and his work life doing odd jobs and working as a cook were not particularly impressive when contrasted with the rising expectations of an educated woman like Toku. He studied business in Japan and graduated from the Nagoya Commercial Academy in 1906, at which point he set off for the United States. Like many Asian immigrants, he headed for San Francisco, or so the family story goes, but 1906 was the year of the great earthquake

that devastated the city. The ship's captain got word of it just before arrival, and so he turned the ship northward to Seattle. Yoshitomi had imagined he would quickly find work in business in the United States, but he found it was not easy to do. So he wandered around and spent two years in Canada, mostly in Vancouver, British Columbia, where he joined the Japanese Methodist Church. Japanese immigrants frequently moved up and down the North American West Coast from British Columbia to southern California. In 1908 he moved permanently to Seattle and four years later his brother helped him arrange a marriage in Japan.

Yoshitomi earned money doing a variety of jobs, including work as a cook. For twenty-five years he was a cook at the Elks Club in Seattle. In most things, Yoshitomi was a frugal man, but he did love to play the stock market. It was a personal passion and one of which Toku did not completely approve. The stock market was a bit of a mystery to her, but she did understand that there was a financial risk involved. In fact, her worst fears were realized when he lost a great deal of money during the stock market crash of 1929. The result was that from that point on she controlled all the money in the family, paid the bills, and gave Yoshitomi his spending money. Finally, in 1935 he and Toku opened a grocery store in the university district, one of nearly 150 groceries owned by Issei at the time. It was a business venture in which they were both actively involved.[48]

According to grandson Roger, Yoshitomi was not resentful or threatened by Toku's busy social life or success in midwifery. In fact, Roger had the impression from his grandfather that he was in awe of her work as a midwife. Although, like most Issei men, Yoshitomi did not do housework himself, he accepted the idea that Toku needed some domestic help. In 1923 they hired a housekeeper because so much of her time was spent looking after their young children and attending deliveries.[49]

Toku Shimomura was one of the busiest Japanese midwives in Seattle and able to earn a steady income. "I delivered nearly a thousand babies in twenty-seven years," she wrote.[50] Toku received her midwife license in Washington in 1917 at the age of twenty-nine. She wrote in later years that midwife licensing facilitated the midwives' efforts to set a standard fee. Before 1917 she stated that they charged about $15 per birth, but after receiving the new state license they charged about $35. Toku's diary indicates that at least a few times she was paid more than $15 in the early years, as she carefully noted the $20 or $25 she received for a delivery. For example, in 1913 at least twice women paid her $25 on the last day of her postnatal care visits to their homes. In later years she also sometimes received less

than $35. Payment to midwives covered many hours of health-care service, including prenatal and postnatal care visits and staying overnight during a delivery.[51]

A midwife earned a good income compared to many wage earners, but still less than a doctor. In the early twentieth century, a migrant farmworker might make about $1 per day, a waiter $3 per day, and during World War I a Seattle shipyard worker earned just over $4 per day. One Issei man recalled the wages in Seattle in 1910 as about $20 per week for a cook or a porter at a liquor store. If one totaled the number of hours a midwife spent per case, the hourly wage was certainly equivalent to these working-class wages. Doctors earned more income and typically charged more than midwives to deliver a baby, often nearly twice the rate. In the 1910s in Massachusetts, for example, a midwife's fee was about $5 and a doctor's fee about $10. One Issei woman on Vashon Island in the Seattle area remembered that in about 1915 she paid $20 to $50 for a midwife and more for a doctor. In 1921 doctors in nearby Vancouver charged $35 for a delivery when everything went well, but $45 to $50 if there were complications, such as bleeding or the need for forceps delivery. Furthermore, doctors also earned income from attending to the sick and injured. Toku herself believed that doctors charged too much. In 1922, for example, Toku was outraged that a doctor wanted $5 for one house call to visit her sick child, although the fee was certainly in line with those recommended by medical societies at the time.[52] Like doctors, a midwife's income fluctuated with her client load. When clients were few, she made little. Although Toku delivered fifty births per year in the early 1920s, at the height of the Issei baby boom in Seattle, some years she attended very few births. In 1918, for instance, when family concerns took up more time, she only attended nine births and in 1932, fourteen births.[53]

Toku was one of the better-known Seattle midwives, not only because of the number of births she attended, but also because she was such an ambitious woman. In several interviews I conducted, Seattle Nisei spoke fondly of Mrs. Shimomura, often with a bit of awe. "She's the one that we all remember," stated Billee Kimura. "She has that ability and the guts to do things that a lot of the Japanese wouldn't do." Billee's husband Sam added, "She was quite a woman, you know."[54] Nonetheless, not all Nisei viewed Toku Shimomura's ambitions positively, perhaps out of jealousy at her success or because their views clashed over how professionalized midwifery was supposed to be. For example, Toshi Yamamoto, the daughter of midwife Tome Yasutake, charged that Toku's actions sometimes bordered on the ruthless or greedy. Toshi remarked that Mrs. Shimomura was choosy

about her clients and only wanted those who could pay well. She had a set fee and if you could not afford her you had to go to someone else. Toshi objected that Toku was not among the original Japanese midwives in Seattle, but still wanted the best clients.[55] In Toshi's view, perhaps inspired by what she had heard growing up, Toku was very money-oriented and did not abide by the informal system of seniority among midwives, in which the first arrivals had their choice of clients.

Toku's diaries do suggest that she paid a lot of attention to money and kept close track of it. For example, in 1913 she noted that she had bought herself a new diary for 25 cents and that she gave Mrs. Okazaki, a woman whose baby she had just delivered, material to make baby clothes, which cost her $1.25. She also kept track of the money she spent on gifts, especially for people who were returning to Japan or for Christmas.[56] One could, however, also read these entries as nothing more than careful recordkeeping and generosity. Still, given the paucity of sources about midwife relations, these comments by the Nisei raise questions about the presence of conflict and tension, and not just cooperation, even among midwives of the same ethnic background.

The Seattle *sanba* had generally positive experiences with clients, but occasionally there were conflicts. Some birthing women followed the Japanese tradition of honoring the midwife with an invitation to attend a special ceremony for the baby, such as the anniversary of the hundredth day after birth or the baby's naming ceremony. For example, in 1913 Mrs. Maekawa invited Toku to the naming celebration for her baby.[57] Nonetheless, tensions emerged when clients tried to get more service than the midwife usually provided and resisted midwife efforts to set limits and impose professional boundaries. For instance, one client asked Toku's backup physician to tell Toku that she needed to continue her postnatal visits for this client beyond her usual two weeks. The client drew on the doctor's authority to advance her own interests in negotiating with the midwife for an additional week of care. Toku confessed in her diary: "Such rude behavior. How maddening. Somehow I suppressed my anger and I have decided to make the visits for one more week to her."[58]

In what proved to be a wonderful coincidence, one of the few Issei women I was able to interview, whose numbers are declining due to their increasing age, turned out to be a former client of Toku's. Toku Shimomura delivered all four of Toku Toshiko's children between 1924 and 1930. In fact, Mrs. Shimomura was a friend of the family and her daughter Fumi was the flower girl at Mrs. Toshiko's wedding. I asked Mrs. Toshiko, who arrived in Seattle in 1918, why she had chosen midwife deliveries. She responded that for a

Japanese woman there was nothing peculiar or unusual about the desire to have a midwife because at the time that was simply the Japanese way. She viewed the choice of the midwife as *atarimae*, meaning what is common, proper, usual, and natural. In her view, she and other Issei women had a midwife out of habit—it was just what one did. Midwives were the logical, reasonable choice and she selected Mrs. Shimomura because she knew her.[59]

There were a few Japanese doctors available in Seattle, although Mrs. Toshiko indicated that she would not have wanted one. Dr. K. Murakami, a graduate of Okayama Medical School in Japan, was one of more than a dozen Japanese immigrant doctors working in Seattle around 1920. He had a general practice and started delivering babies in 1918.[60] Mrs. Toshiko also noted that she would not have wanted a white doctor either, because they did not always treat the Japanese respectfully. They did deliver some babies, however, for the Issei in rural areas. For instance, Dr. Howard L. Dumble delivered many babies for Japanese immigrants in the Hood River Valley in Oregon. In California, a white doctor attended Misayo Tsuneta. Her daughter Mary was born in Baldwin Park in 1919, delivered by Dr. Reed of Covina. He took care of many of the farmworkers and farmers in the East San Gabriel Valley. He did not charge much, because as migrant farmworkers the Tsunetas only earned about a dollar a day.[61] Michiko Tanaka explained that "Tamura-san, the woman whose husband sold bean curd, was my midwife. In the country, doctors were not available, and when they were, either they would not treat us [Japanese] or their services were too expensive. So as a rule, the midwives substituted for doctors in delivery of the baby or the woman did it herself."[62]

Issei birthing women wanted reassurance and familiar cultural practices during what could be a scary experience. Masoko Osada, an Issei woman who lived in nearby Tacoma, had both midwife and physician deliveries, but she preferred the midwife. She felt she had more frequent and personalized contact with her than with the doctor during her pregnancies. The midwife would usually visit her every few weeks, whereas the doctor would come only once a month. Also, after the birth the midwife came to her house every day for two weeks. Plus, she noted, midwives cost less than doctors.[63] Issues of female modesty also shaped Issei women's choice of birth attendant. Most Issei women selected their own midwives, although there was at least one case in Seattle in which the husband selected the midwife without consulting the wife, a practice that may have been more common in Japan.

Mrs. Toshiko found midwife Shimomura to be a comforting, competent

birth attendant. Midwife Shimomura came to Mrs. Toshiko's house once a month while she was pregnant to check on her and sometimes provided a massage. Midwife Shimomura wore a white apron, kimono style, during deliveries, which took place with Mrs. Toshiko lying on her bed. She did not remember receiving any herbs or drugs to reduce pain or speed up delivery. She also mentioned that women typically delivered their babies early in the morning, and so the midwife stayed through the night. She insisted that most women in Seattle had their babies at high tide, in line with the Japanese view that birthing was connected to the tide. Finally, she explained that after childbirth midwife Shimomura cleaned her and then came every day for two weeks to check on the baby and bathe it. Her description of events corresponds to those described in Toku's diaries.[64]

Toku Toshiko also pointed to some of the specifically Japanese traditions she engaged in because of the presence of midwives like Toku Shimomura. In particular, she remembered that she used the *hara obi,* a pregnancy sash or maternity belt.[65] Her *hara obi* was a strip of cotton material, usually an off-white natural color, about six feet long and seven inches wide. In Japan it was also sometimes red and white or pure white. The midwife, friends, family members, or the woman herself wrapped the cloth three times around the abdomen. Several entries in Toku's diaries mentioned that she did this for pregnant women.[66] Unlike the regular *obi* that was worn on top of the Japanese woman's kimono, the pregnancy *obi* was worn firm and tight against the skin under one's clothing. A woman started to wear one beginning in the fifth month of pregnancy at the point of "quickening," when she first felt fetal movement. Binding with this cloth served a variety of purposes, according to Japanese customs: a way to provide or call on an invisible spiritual power, to restrain the fetus from moving around too much, and to keep it in position with its head down. Japanese women also used the *hara obi* to keep the baby from growing too big, which might lead to a difficult delivery. This idea is illustrated in the Japanese expression that one should "birth small, grow big." Women also found that the *hara obi* made pregnancy more comfortable by providing back support and warmth. Masoko Osada, an Issei woman of Tacoma, said that it felt good to have a corset supporting you. American catalogues at the time sold similar devices, sometimes called "pregnancy corsets," to provide abdominal and back support to pregnant women. Some women in the United States and Canada wore a version of the pregnancy *obi,* even if they called it a corset or binder.[67]

Toku, like other Seattle *sanba,* operated within two cultures: one Japanese and one American. Racial politics hindered an easy blending of the

two in her life. For example, her diary indicates that she kept track of current events in both places. She noted when the Japanese emperor had a birthday or was sick and when a woman was elected mayor of Seattle for the first time.[68] Even though she made her home in the United States, as an immigrant from Japan she was not allowed the privileges of other Americans. When American women won the right to vote in 1920, she was not among the enfranchised. When Washington State accepted Sheppard-Towner funds in the 1920s to do health education work with doctors and mothers, health officials failed to translate breastfeeding literature into the Japanese language or encourage the *sanba* to bring their clients to well-baby clinics. Instead, the Japanese midwives volunteered to assist with health programs sponsored by the Japanese immigrant community. For the Issei, like other racialized minority groups, the denial of government health programs meant that self-help was central to meeting their community's needs. The message was clear: the Issei could live and work in the United States, but they were not entitled to services.

Toku's diary suggests how independent the practice of midwifery was. For example, nurses who provided home care looked after a doctor's patient, whereas Toku and other midwives cared for their own patients. As long as birth took place at home, the midwives and their clients retained authority over the childbirth process. As Judith Walzer Leavitt demonstrates in her groundbreaking book on the history of childbirth, women's control over birth was shared with doctors, not given over to them.[69] Although Leavitt's primary focus was on birthing women, Toku's diary suggests that a similar process operated for midwives. They remained in charge of birth in the home, even though the licensing process specified that the midwife must call in a physician for all abnormal births.[70] As the interpreters of state rules within the birthing room, midwives determined when childbirth was no longer progressing normally and therefore they decided when to call in a backup physician.

Toku and other Seattle *sanba* apparently had good relations with local physicians, who were willing to assist them if problems developed. Several Issei doctors and white doctors provided backup care for the midwives. Toku seemed to have had an arrangement with a few doctors and relied on them over the years. She called in a doctor on those few occasions when there was a problem with excessive bleeding in a birthing woman or a tear in the perineum that needed to be sewn up. Only rarely did she call on a doctor to perform a forceps delivery at a difficult birth, such as in 1913 when her own physician, Dr. Y. Uyematsu, used forceps to aid the delivery of one of her clients.[71] Toku had a few cases of stillborn babies, but they were rare, too.

For example, in 1925 Toku attended a difficult delivery and had to call in a doctor. The baby was stillborn as a result of pressure from the umbilical cord around its neck. For most of her patients, however, Toku determined that no physician's services were warranted, even during especially busy times in the early 1920s when she was attending eight or nine births per month, and sometimes two births on the same day. Throughout Toku's twenty-eight years of practice, the vast majority of her deliveries went well, requiring no medical assistance, and her diary entry simply read that that Mrs. so-and-so delivered a boy or girl "safely."[72]

Over the years, through friendships and the midwife association, the *sanba* in Seattle created a support network for each other. They stood together in good times and bad. For instance, in 1922 Toku attended the funeral of a stillborn baby with several other midwives. Another time she asked midwife Koto Takeda to deliver a client when her child was sick.[73]

Midwifery remained an important component of Toku's identity throughout her early years in the United States and even when the number of deliveries she attended declined. For instance, in 1913 Toku kept up with the latest information in her health-care field through reading a midwife journal from Japan, *Sanba Gaku Shi.*[74] She also regularly attended meetings of the Seattle midwives' association, which met monthly throughout the 1910s and 1920s. Unfortunately, Toku's diary tells us little about what went on in the midwife meetings. Sometimes she indicated how many people attended, as few as five or as many as ten, or at whose house they met. The midwives continued to meet well into the 1930s, a decade when Toku and most Issei midwives began to stop delivering babies regularly. The midwives seemed to meet more frequently as their practices declined, often two or three times per month. They may have had more time to meet even though they had fewer cases to discuss. At least once the *sanba* connected across state lines. In 1939 Toku wrote that eight of the Seattle midwives met together with Oregon midwives for a combined midwives' meeting. Perhaps the Japanese immigrant midwives hoped to create a regional or national midwife association similar to those in Japan. Finally, Toku and Sawa Beppu continued to be listed as midwives in the Seattle city directory until 1935 and in the *Japanese American Directory* as late as 1941.[75] Toku's diary suggests that the midwives even met after World War II ended and many Japanese Americans had returned home from their incarceration in government camps. A midwife meeting at this late date suggests the importance of continuing friendships among these Issei women. Furthermore, it reveals the ongoing significance of their professional identity as midwives. Even when they no longer delivered babies, midwifery remained meaningful in their lives.

Sawa Beppu

Toku Shimomura's good friend, Sawa Beppu, was an equally imposing figure in Seattle's community of midwives. She, too, was not only tall for a Japanese woman but also known for her boldness and sense of authority.[76] Sawa came from Tokyo, where she was born in about 1886 into a family of military officers. She attended school in the city, including the prestigious Keio University, and graduated in 1901 from the midwifery school at the Tokyo Imperial University, which was established in 1890. She sailed to Seattle with her new husband, Hisuji Beppu, in 1905, after the conclusion of the Russo-Japanese War. The Beppus settled in a big house in the Japanese section of Seattle, often called Japantown or Jap town in the early years.[77]

The Beppus, like many of the Issei, wanted their children to take pride in being both Japanese and American. Although Hisuji and Sawa gave their daughter a Japanese name, Hiro, they called their sons Grant, Lincoln, Monroe, and Taft—all named for American presidents. The oldest child, Taft, was born in 1908, the same year that William Howard Taft was elected president. Hisuji was so proud to live in the United States and so eager to impress others in his adopted country that he named his son after the new president and the practice continued with the birth of the later sons. This practice was noted and admired by other Seattle Nisei. Unlike most Nisei, the sons were not given Japanese names in addition. Notably, Hisuji did not name his daughter after a significant American woman. The Beppus also ensured that their children learned the Japanese language and customs. They sent them to the local Japanese language school, nicknamed "Tip." Like many Nisei, the Beppu children attended the Japanese school after completing their day at the American public school.[78]

In the Beppu family it was not the husband but the wife who provided the steady income. Like Yoshitomi Shimomura, Hisuji Beppu had many kinds of jobs over the years. He gave private music lessons and taught classical Japanese music for the opera and at one point worked in a department store. Still, his income was secondary in the family. A similar pattern occurred among European immigrants in Milwaukee, where midwifery at times provided more regular income than some men's occupations did. Sawa's financial contributions may help explain why Hisuji, like Yoshitomi, was supportive of his wife's work and did not seem threatened by it. He knew she was a midwife when he married her. Given that some Japanese husbands were much older than their wives, including Hisuji, they tended to slow down physically much sooner than their wives. In Sawa's case, her husband had a stroke and was no longer working by the 1930s.[79]

Even as we note that midwife Sawa Beppu supported the family financially, however, family members made it possible for her to maintain an active midwifery practice. Her husband, along with the children, did most of the household chores, including cooking, ironing, and laundry. His domestic contributions were unusual for an Issei man. As one Issei woman in Washington explained, "My husband was a Meiji man; he didn't even glance at the house work or child care."[80] Hisuji's assistance illustrates one of the ways that families compensated for Japanese immigrant men's limited employment opportunities. In addition, his household work was a consequence of the restrictions on Sawa's time because of her line of work.[81]

Indeed, household help was so important to maintaining Sawa's midwifery practice that when her son Lincoln wanted to get married in 1937, Sawa told him that he could not marry unless he continued to live at home so that his wife could help Sawa by taking care of the housework. Such a request was consistent with the Japanese filial traditions, in which a woman was expected to leave her family behind and live with her husband's family, especially if her husband was the eldest son. One of the bride's new duties was to assist her mother-in-law, who ran the household.[82] In this case, Lincoln was the oldest son who was still living in the United States, because Taft had gone to Japan, and so Sawa's request put an American twist on a Japanese tradition. Lincoln's wife Teru, who like many Issei and Nisei women had worked in domestic service previously, ended up taking care of the entire Beppu family's household needs, just like many daughters-in-law in Japan. Teru would have preferred the privacy of having their own place, but she agreed to the live with the Beppus so that she could marry their son.[83]

Midwifery was not only a form of economic support but also a source of pride in the Beppu family. Sawa and her family were pleased that she was Seattle's first licensed midwife. It was a point of honor. They were under this impression because after she passed the state's midwife examination she received midwife license number 1. Although state records show that the license number was merely an artifact of the alphabetical listing of those who passed that exam, Sawa, like Toku Shimomura, was in the first group of midwives to be licensed to practice midwifery in Seattle. To her family, she was a pioneer.[84]

Like so many Japanese women who trained in midwifery, Sawa became a midwife because it was a good occupation for a woman. She never spoke of midwifery as a calling and she never indicated that her mother was a midwife or had pushed her to become one. Nonetheless, she loved her work and was devoted to it. She practiced midwifery for forty years beginning in 1901 and delivered at least a thousand babies. In one newspaper account

her sons suggested she had delivered more than 4,000 babies. Sawa certainly had a very busy practice, with clients all over King County, including Bellevue and Bothell as well as Seattle.[85]

Like Kimi Yamaguchi in California, who had Mexican clients as well as Japanese, Sawa Beppu had a multicultural midwifery practice. Even though she spoke only Japanese and a little English, she delivered not only Japanese babies but also some white, African American, Chinese, and Filipino babies. Although the Issei, including midwives, usually socialized only within their own ethnic community, they did interact with members of other ethnic groups in their business transactions.[86] The history of the *sanba* suggests that the various communities were not as segregated as we might have thought. Childbirth was one avenue through which some women connected with each other across racial and ethnic lines.

Sawa built a thriving midwifery practice throughout the Seattle area not only through her personal skill but also her access to a telephone and car. Her neighbor and physician later in life, Dr. Ben Uyeno, remembered that "she went all over the city of Seattle delivering babies." Like the early twentieth-century physician, midwives benefited from the availability of new technology. Such access not only signaled Sawa's economic and social status, it also aided her ability to reach clients and expand her income. In the early days Sawa used to go out in a horse and buggy to attend deliveries. By the 1920s, however, she had a car and could travel farther and more easily. Her household also had one of the few telephones in the neighborhood. When she would get a phone call, which could be at any hour of the day or night from women in labor, she would hop in her car and head out to the delivery.[87]

The ability to drive and access to a car were signs of independence and autonomy, traits not usually associated with Japanese women. According to family and friends, Sawa Beppu and Toku Shimomura were among the first women to drive cars in Seattle, especially among the Seattle Japanese. Just as midwives in Japan were among the first women to ride bicycles, many of the Seattle *sanba* wanted access to the latest forms of transportation in order to reach clients. Many Issei lived in the countryside working on farms, which required one to drive great distances, especially in the days before Seattle's bridges were built.[88] In an American context, a car made one "modern." Henry Ford's Model T, the automobile for the masses, had been available since 1908 and by 1926 cost just under $300. As in the rest of the nation, it was in the 1920s that residents in Seattle started purchasing cars in greater numbers. The number of cars nationwide in that decade jumped from 6 million at the start of the decade to more than 20 million by

Midwife Sawa Beppu, her car, and her children in Seattle. Courtesy of Teru Beppu.

1929, at which point half of American families owned a car. In the case of Seattle, by 1928 there were about 130,000 automobiles, about one car for every three people. By that time, women in Seattle and other urban centers more readily took to the automobile, constituting 15 to 20 percent of all drivers.[89]

Still, prejudice against women behind the wheel lingered and driving a car was a bold move for women, especially Issei women, who faced restrictive Japanese gender conventions. When traveling at night on the poor roads, Sawa would often follow the telephone poles to find her way. Sometimes she took one of the boys with her, even when they were young. In the middle of the night she would wake one of them, wrap him in a blanket, and put him in the seat beside her. It is possible that this was her way of keeping an eye on her children. As they grew older, she also may have found them to be a source of company and protection. It would have been unusual for a woman to be out alone at night. Sawa used to take her son Grant with her on deliveries, and as he got older he translated English for her. Like European immigrant midwives elsewhere, she eventually let her son drive her to deliveries at night.[90]

Sawa's midwifery practice was much like Toku's, busiest during the 1910s and 1920s. In these years, she did about eight to ten deliveries per month.

85

Each time she brought along her midwife bag, which contained such items as a stethoscope, Lysol for disinfecting, and the special smock or apron she wore over her clothes. Before a delivery she wrapped her head to keep her hair back. Also, like Toku, she kept a book that she used for filling out the birth certificates, giving one to the parents and sending one to the Washington State government to satisfy its requirement for birth registration. After delivering a baby she would continue to check on the baby for the next two weeks, returning to bathe it and provide postnatal care. Over the years she, too, worked with backup physicians, including Dr. Carroll, a white doctor, and Dr. Paul S. Shigaya, an Issei family doctor who attended medical school at the University of Oregon and practiced medicine until the mid-1950s.[91] This backup care proved to be helpful when Sawa delivered her son Grant's first baby and the boy's arm came out first, causing problems. When this happened she immediately called in Dr. Shigaya. The available evidence suggests that Sawa found cooperation from local doctors, who accepted midwives as the primary birth attendants for Japanese immigrants.

Like other *sanba,* Sawa delivered babies at the birthing woman's home. At least once, however, she turned her home into a birthing center, like those established in California. One day a woman who lived out in a rural area where she and her husband raised flowers asked Sawa if she could have her baby at Sawa's house. The woman, who already had other children, wanted to be able to get some rest after giving birth to her sixth child. Sawa consulted with her daughter-in-law Teru, who would be the most affected by the additional work. Sawa offered to give Teru any extra money she earned, and so Teru consented to the arrangement. The woman was told she could come to the house, and she stayed for the birth of her child and for two weeks of rest afterward.[92]

Sawa, like other Issei women, believed in the Japanese cultural tradition that women should endure the pain of childbirth in silence. Japanese immigrant women felt that they responded to the pain of labor and delivery in a more honorable fashion than American women, who would cry out. When Issei women gave birth, they were expected to persevere and bear up under the pain, known as *jintsu,* or "battle-pain." As Michiko Tanaka, a California Issei woman who had eight children by the age of thirty-one, proudly explained, "I never let out a scream even once with all the children I had."[93] Sawa referred to Japanese women's silence in childbirth as *gaman suru,* meaning they had the strength to endure, control themselves, and tolerate the pain. She did not believe in indulging herself either during pregnancy. Even near the end of her pregnancy with Grant, her youngest child, she was still delivering babies. She delivered a baby on 25 November

1916 but could not complete the full two weeks of follow-up care because she herself gave birth on 5 December.[94]

As the children of the Issei became adults, some of them tried to live up to the cultural imperative to show restraint. When Teru Beppu felt labor pains with her first baby, she did not know what to do, but she was so determined to remain strong and bear the pain that she kept right on fixing dinner even as labor advanced. When Sawa returned home later that day, she was shocked to find Teru standing there cooking when Sawa could tell by the impact of the contractions that Teru was nearly ready to deliver. Sawa immediately told her to lie down on the bed because the baby was almost ready to come out. Sawa placed pillows behind Teru and then tied a sheet or cord around the head of the bed so that when the contractions came Teru could hang on to it and pull while bearing down.[95]

Although midwives' primary concern was childbirth, at least one client asked Sawa for information about birth control. Teru recalled that one day Sawa returned home and laughed while retelling a poignant incident in which a woman with many children had complained to Sawa that she needed a new form of birth control. Sawa suggested condoms to the woman, but the woman complained that they did not always work. Sawa soon learned why after passing by the woman's house and seeing a row of condoms hung up on a clothesline. The frugal woman had washed the condoms to reuse them.[96]

In contrast, Toku Toshiko, the Issei client of midwife Shimomura, stated that Issei women did not want birth control, but were proud to have big families. She pointed out that at the time she had her babies Japan wanted more children, not less, suggesting that Japan's pronatalist policy may have influenced even those Japanese living abroad.[97] Still, as the story of Sawa's client suggests, we should not be too quick to accept the notion that Japanese immigrant women did not want birth control information. After all, there were various methods of birth control available in Japan, including rubber condoms, which were manufactured there by 1909. Furthermore, Margaret Sanger visited Japan only one year after founding the American Birth Control League. Her invitation to come to Japan in 1922 helped to expand public awareness of birth control and launch the Japanese birth control movement.[98] As Mrs. Toshiko mentioned later in our interview, she might have wanted birth control information but she was too embarrassed to ask for it. An Issei woman from Vashon Island remembered that peddlers sold contraceptives.[99] At least some Issei women turned to midwives for birth control information because they saw the *sanba* as important resources for reproductive issues.

Koto Takeda and Michi Nakayama

A supportive husband was an important factor in the development of a midwife's successful practice in Seattle. Likewise, a husband's objections to a wife's career could limit or even eliminate her practice. Sisters Koto Takeda and Michi Nakayama were midwives whose lives followed similar paths until marriage, at which point their lives diverged and Michi stopped working as a midwife.

Born Koto and Michi Hayashi, the sisters grew up in Japan in a merchant's family of six girls and one boy. Although the family was not wealthy, all the children received good educations. Like Toku Shimomura, Koto trained as a nurse and assisted the wounded during the Russo-Japanese War by working at a hospital in Manchuria. She then attended the Yamaguchi Provincial Midwifery School and graduated in 1906. In 1909 Koto's sister Michi graduated from the same school. At graduation, they were both in their late twenties.[100] According to Dell Uchida, her mother Michi Nakayama and aunt Koto Takeda probably chose midwifery as an alternative preferable to waiting to get married. Midwifery was a good job for women and the family needed the money. By 1917 Koto was married, either moving to Seattle with a new husband or joining one as a picture bride. Michi soon followed her sister to Seattle, where she worked in nursing and midwifery. In 1917 Koto and Michi, like Toku and Sawa, passed Washington's midwife licensing examination. Dr. Jiro Sato, a graduate of Okayama Medical College, served as their local physician reference, vouching for their skills on their applications.[101]

During Michi's early years in Seattle, she worked at the Japanese Hospital, one of several Japanese hospitals in the North American West and Hawai'i. There were also Chinese hospitals on the West Coast, including one that opened in San Francisco in 1925 and one in Vancouver, Canada.[102] Issei doctors ran some of the Japanese hospitals, most of which were small proprietary hospitals, while a few hospitals were larger community institutions. In contrast to midwives, who worked almost exclusively in private homes, doctors increasingly required hospitals to practice medicine and perform surgeries. There were several Japanese hospitals in Hawai'i, including a large one in Honolulu and smaller ones on the island of Hawai'i. There were also smaller Japanese hospitals scattered across the Rocky Mountain West, including Idaho and Montana, and in several California cities, including San Francisco, Stockton, Fresno, San Jose, and Sacramento.[103] Los Angeles had two Japanese hospitals, the Southern California Japanese

Hospital on Turner Street and one on Fickett Street. An Issei nurse, Mary Akita, had turned her home into a maternity hospital in the 1910s and in 1918, in response to the influenza epidemic, it was expanded under Dr. Jyuhei Tanaka into the Southern California Japanese Hospital. In order to establish the hospital on Fickett Street, Issei doctors led by Dr. Kikuo Tashiro had to challenge the California laws that prohibited them from owning land. The Issei doctors battled in court over the right to incorporate and lease land, which had been refused by the California secretary of state. The case, *Tashiro v. Jordan,* went to the California Supreme Court in 1927 and the U.S. Supreme Court in 1928. The Los Angeles doctors won their case, not because the alien land law was ruled to be unjust, but on the grounds of established commercial and trade rights for the Japanese in the United States under a 1911 treaty with Japan. After the legal victory, the Japanese American community raised more than $100,000 to build a new modern hospital, which opened in 1929. It served mostly Japanese Americans but also a few Caucasians and Mexican Americans. In 1935 the two Japanese hospitals in Los Angeles merged into one.[104]

Like African American doctors, who in the era of racial segregation were frequently denied access to white-controlled hospitals and medical schools, and therefore practiced in segregated and black-controlled hospitals, Japanese immigrant doctors faced restrictions on their medical training and practice in the United States. For example, Masajiro Miyazaki moved from Japan to Vancouver in 1913 and graduated from the University of British Columbia in 1925, but when he tried to enter medical school in the United States, "many obstacles lay in my path because of my race. One of the schools would not accept me because non-whites couldn't serve as interns in the hospitals. One medical school in Michigan was willing to accept me but the American immigration Board wanted me to put up a large cash bond which I didn't have." Finally, he ended up graduating from a medical school in Missouri. He later went to Los Angeles, where he received "further training and worked at the Mexican Hospital" before returning to Vancouver.[105] Issei doctors brought their patients to Japanese hospitals, but Nisei doctors sometimes did not need to by the time they began practicing medicine. Nisei doctors graduated from American medical schools, but sometimes they had difficulty gaining admission to medical schools on the West Coast. Racism also affected medical careers after graduation. Although some Nisei doctors gained admitting privileges at white hospitals in the 1930s, many still faced discrimination and were not accepted for internships or residency training. White hospitals also did not accept Issei nurses, but by 1940 they did accept

Japanese American patients. Toku Shimomura, for example, visited Mr. Tanagi at the Columbus Hospital and Mr. Hirosato at the General Hospital in Seattle in 1941.[106]

Michi Nakayama worked at the Japanese hospital in Seattle, located at Twelfth Avenue and King Street. A community institution, it was called Reliance Hospital when it opened in 1913 and later called *Nippon Byoin* (Japanese Hospital) in 1920. Japanese midwives like Michi worked as nurses in the hospital, although it is not clear whether they also delivered babies there. At one point the hospital employed seven Japanese doctors and ten Japanese midwives. Toku described going to the hospital in 1913. Apparently one of her clients, Mrs. Ogishima, had surgery. Toku mentioned disapprovingly that she found the hospital to be very unsanitary and disorganized.[107] Conditions likely improved over time and in 1914 Toku wrote in her diary that she was going to start working there the following month, although she eventually decided not to leave her midwifery business to work at the hospital. The Japanese Hospital remained an important community resource throughout the 1920s. Sam Kimura, a Seattle Nisei, remembered that Dr. Jiro Sato took his tonsils out at the hospital. Dr. Sato was supposedly the best doctor around.[108]

Michi Nakayama's work in the hospital and as a midwife ended shortly after her marriage. Sometime between 1917 and 1921 Michi married Zenshiro "Frank" Nakayama and in 1921, at the age of forty, Michi gave birth to her first child, daughter Dell. A son was born two years later. She then raised her children, looked after the house, and worked as a seamstress doing alterations in her husband's shop, a dye works and cleaners.[109]

According to Michi's daughter Dell, Michi and Koto were very different women. Michi was a quiet, demure woman who left health-care work because of her husband, whereas Koto was an assertive, domineering woman who developed a lucrative midwifery practice with the aid of her husband. Unlike Michi, who quit her job to care for her family and assist her husband's business, Koto continued to work as a midwife until the 1930s, for as long as she could get clients.[110]

Koto Takeda was a busy midwife who made good money delivering babies. Her niece Dell remembered that Koto performed deliveries all over the Seattle area, including out in Bellevue, a great distance to travel in the days before there was a bridge. Koto, like Toku and Sawa, drove around in her car, a Model T Ford. She purchased it with her own money. Dell remembered that Koto had many expensive items, including a telephone, lovely clothes, and jewelry. Sam Kimura, whose family rented part of Koto's

house, attributed Koto's success in midwifery to the fact that "she was one of the better-liked ones."[111]

Koto managed her workload by sending her children to Japan to be raised by her family as soon as they were old enough. Like other Issei midwives, she minimized her child-care duties and expenses this way. Furthermore, she provided her children with a Japanese upbringing and language skills, which would be useful if the family returned to Japan permanently. Later she brought back one son and one daughter to Seattle. Children born to Japanese immigrants in the United States who were partially or entirely educated in Japan were known as "Kibei" to distinguish them from the Nisei who grew up in the United States. Sam Kimura had fond memories of living in the downstairs of Koto's large house where his family rented in the 1920s. He also remembered going mushroom picking every Sunday in the fall with Koto, her sister Michi, and their husbands. Mushroom gathering in the foothills of the Cascade and Olympic mountains was a popular activity with the Seattle Japanese.[112]

Despite Koto's financial success, she faced a tragic loss when her husband, an alcoholic scholar, died in the mid-1920s. Like Sawa Beppu's husband Hisuji, Koto's husband looked after the household while she was busy with her midwifery practice. Then one day he apparently forgot to turn the iron off after ironing the clothes. In those days, with no automatic shut off, the iron just got hotter and hotter. It got so hot that the house caught on fire. He burned to death in that terrible incident. Dell, who was only a young child at the time, still remembers the event vividly. She recalled that her aunt Koto was so upset at what had happened that she was afraid to go into the house alone and so brought Dell with her. Seventy years later Dell still recalled the depth of her aunt's fear and the smell of that burned house.[113]

Koto faced another difficult loss in 1929 when her sister Michi returned to Japan, where she moved in with their wealthy eldest sister. According to Michi's daughter Dell, Michi was homesick and not well, and so she left. Needless to say, Michi's absence was very hard on her children. Dell was only eight years old at the time and her brother was just six. Sadly, they never heard from her again and they never found out if there were other reasons for her departure. What compelled a woman to leave her children? Was she forced to go by her husband or her parents? Even though Koto was also separated from her children, at least she kept in touch with them. Dell believes that Michi may have had tuberculosis, as Dell did in later years, a shameful disease among the Japanese in Japan and in the United States. Japanese people avoided marriage to members of families in which there

was tuberculosis for fear it would be transmitted to future generations. In the United States, tuberculosis was also a disease that carried a social stigma in the early twentieth century because of its association with poverty, immigrants, African Americans, and Native Americans. At the time, doctors urged institutionalization as part of the treatment.[114]

If Michi was sick, did she leave because she was afraid that she would make her children ill or affect their marriage prospects? Did she leave because she feared that she was dying? We will never know the answers to these questions. In Dell's telling of the story, her mother Michi fits the image of the stereotypical Japanese woman who meekly followed her husband's wishes, and therefore it is possible that she left because her husband sent her back to Japan. Yet, hard as it is to imagine, she may have chosen to go. Leaving her children in Seattle was undoubtedly very painful, but it may have been an act of love. She may have left her children in order to protect them. Ultimately, no one ever talked to Dell about her mother and she just assumed that she had died. She found out years later, however, that her mother had lived for more than a decade in Japan and did not die until sometime between 1942 and 1946.[115]

Meanwhile, Michi's husband Zenshiro raised the children alone. There was so much conflict between Zenshiro and Michi's sister Koto that Koto proved to be no help to the family. They did not get along because at a time when Japanese women were expected to be modest and submissive, Koto was anything but. "That really irritated my father something terrible," explained Dell. The two argued a lot, and Dell remembered one time when her dad was furious because Koto had invited Dell and her brother over to her house when two of Koto's children were visiting. While they were there, Koto had a photograph taken. Zenshiro was angry because he knew Koto would send that photo back to her parents, implying that she was looking after his children. Dell listened to all these conflicts as a child. Still, Dell had fond memories of being raised by her father. Her dad, a well-educated man, loved his children very much and did his best to raise them. According to Dell, he did not want to lose them too.[116]

As a widow in the 1920s, Koto expanded her midwifery practice by creating a birthing center in her home. After her previous home burned down, she built a large house on land where the Keiro nursing home for Japanese Americans is now located.[117] She turned part of her home into a place where women could stay to have their babies. Although Sawa Beppu's story suggests that, on occasion, the American *sanba* delivered babies in their own homes, Koto did more than that. She ran a lying-in home or private maternity home, like those run by Japanese midwives and doctors in California.

The notion of giving birth in a place outside one's own home and getting rest for a specified period of time was a longstanding practice among Japanese women. In Meiji Japan, and even later in some villages and rural areas, women sometimes gave birth in a "birth hut" (*san-goya* or *ubuya*). A birth hut served many purposes. It was used to seclude the birthing woman from others in order to keep the mess of childbirth out of the family's dwelling. It also served to isolate the family from "birth-related blood," which was seen as unclean and taboo. Finally, it benefited the birthing woman, for it provided her with privacy and an escape from the demands of the household, not only for labor and delivery, but also for two to four weeks of rest afterward. The idea of rest for days or weeks after giving birth was one promoted by many cultures.[118]

Issei women, both midwives and birthing women, tried to preserve those Japanese customs that they felt benefited them. At least some Japanese immigrant women tried to continue aspects of this tradition of separation to claim a similar respite from the demands of daily life during and after childbirth, even if they rested only a few days. Toku Toshiko, midwife Shimomura's client, remembered that it was a Japanese custom that the birthing woman was not supposed to get up for two weeks after delivery, but instead lie quietly and rest. Her family even hired a Japanese girl in the neighborhood to do her housework and wash diapers for one month. As she explained, in those days washing was hard work because it was all done by hand, even dirty diapers. Masoko Osada, an Issei woman in Tacoma, also mentioned the tradition of resting twenty-one days after birth. Nevertheless, since she had nine children, her ability to rest diminished with the arrival of each new baby. With her first baby she was able to rest for one month, then with the next one she rested for only three weeks, and with the next baby only two weeks, and finally only one week with the later births. Not all Japanese immigrant women had even this much rest. It was difficult for women to stop working, especially in farming communities where they were an essential part of the family labor force. Still, Michiko Tanaka, who spent much of her life performing agricultural labor, indicated that she had a break with at least one of her births. "After giving birth I didn't work for a month," she said, because "in Japan that's the way it was."[119]

As for Koto Takeda, even as she built a lucrative midwifery practice, she continued to go back and forth to Japan. She had money for travel and she missed her family, especially her sister Michi. Although Koto and Michi longed to be in Japan, their time living in the United States had an effect on them. For instance, Dell has a treasured photo of her mother and her aunt in Japan, dressed in American-style clothing with hats, while others around

them were dressed in the Japanese style. Eventually, in the late 1930s, Koto also returned to Japan, where she lived in the house of her in-laws. The Issei baby boom was over, her husband was gone, and so she returned home for good.[120]

Tome Yasutake

In contrast to the often sad family lives of the sisters Koto Takeda and Michi Nakayama, midwife Tome Yasutake had a happy home life. Nonetheless, Tome was familiar with domestic problems, for she dedicated herself to assisting Issei women who were in unhappy marriages. According to family members, Tome was generally well liked and easy to get along with. "I thought she was wonderful," explained her daughter-in-law Alice Yasutake. Tome was a modest person and never flaunted her skills and accomplishments. She was born in 1885 into the landowning Watanabe family in Kumamoto, Japan. She was the youngest of five children. Her mother died when she was about ten years old, and her father married a woman Tome did not like. Tome may have become a midwife because she was motivated to find an occupation that allowed her to get away from her stepmother. Tome's daughter, Toshi Yamamoto, considered her mother to be an unusually independent woman. In 1908 Tome graduated from the Kumamoto Nurse and Midwife Training School, over the objections of one of her brothers who did not think it appropriate for a woman to train for a career.[121]

Tome, like Toku Shimomura and Koto Takeda, worked as a Red Cross nurse in the Russo-Japanese War. Wartime nursing service was especially meaningful to Tome because, like Toku, she received a medal from the Japanese emperor. The war was a pivotal event in the lives of many women, just as it was for men.[122]

In 1909, only a few years after the war, Tome married Mokuji Yasutake, who had been living in Seattle for several years. Although Tome traveled alone to join her husband in America, she was not a picture bride, because she already knew him. Tome came to the United States because of pressure from her family to fulfill the arranged marriage, but also because she wanted the adventure. Toshi, one of Tome's daughters, believed that serving in Japan's war against Russia expanded her mother's horizons. After meeting people from Russia and Siberia, Tome wanted to see more of the world. She did not want to be tied down by the restrictions on women in Japan. In Washington, Tome and Mokuji had six children, plus one stillbirth, between about 1913 and the early 1930s. There were five daughters, including Toshi, and one son named Takeshi or George. (The Yasutakes, like many Issei,

gave their children both American and Japanese names.) Like the sons in the Beppu family, who were each named after a U.S. president, the Yasutakes' son George was named after President George Washington.[123]

Tome remained extremely proud of her wartime medal, awarded to nurses for their service. As her children learned, it was one of her most cherished possessions. Tome's daughter Toshi remembered that when she and her sister Tomo were children, they used to put that medal on and Tome would tell them they should not go outside with it because that would be *pin shō koshōku*, or boasting and bragging.[124] Boasting behavior was not valued or encouraged in Japan or among Japanese immigrants. That is why family members still recall the day when Tome's son George wore the medal around his neck to school. His sisters were mad at him for doing such a shocking thing. Yet, to everyone's surprise, Tome did not get angry but was touched by her son's pleasure in her wartime honor, perhaps because it was more acceptable for a son to boast than for a daughter.[125]

Tome's husband Mokuji was a proud, hardworking man. Like some Issei men, he found employment with lumber companies and sawmills. Eventually he became a lumber foreman. Mokuji had come to the United States with hopes of getting an education. He, like many young Japanese men, came over as a "school boy" or "house boy," a practice that involved living with an American family and performing domestic service work while attending school. In addition to room and board, the young man received about one or two dollars per week. According to the story passed down in the family, Mokuji quit his job after he was asked to wash the mistress's underwear. In Japan, much like the United States, most men did not do menial household labor like washing, and certainly not women's intimate apparel. To Mokuji, the job had become simply too humiliating, especially for the son of land-owners. Afterward, he went to work at a bar at night and attended English classes in the daytime. He was proud of learning to read and speak English. Toshi remembered that her sister Tomo once gave him a subscription to *Reader's Digest* in Japanese, and he was very insulted and insisted she get a refund. He read a number of English-language publications, including the *Christian Science Monitor*, the *Oregonian*, and the *Seattle Times*. He never read any William Randolph Hearst newspapers because of Hearst's anti–Japanese immigrant stance. Though Mokuji could not vote because the Issei were denied the right to naturalized citizenship, he kept up with American politics and remained a staunch Republican his entire life.[126]

Mokuji, who apparently had strong feelings about many things, did not object to Tome's work as a midwife, as long as she was willing to move where his job was. He was frustrated, however, by Tome's activity as an

informal social worker. According to daughter Toshi, Tome liked to help people. Indeed, Toshi explained, "she loved people." She liked to talk a lot, whereas her husband was not a person who talked just to enjoy conversation. "He never talked too much, but when he did, boy, it was to the point," observed Toshi.[127]

As a midwife who came in contact with many Issei women, Tome was especially concerned about the difficulties faced by picture brides, some of whom were as young as fifteen years old. Mokuji was not supportive of Tome's rescue work. He would tell her not to push people to share their problems, arguing that it was none of her business. Toshi remembered that her mother would retort that it *was* her business as long as she was on this earth. Tome's efforts were in line with the work of white Protestant missionary women in the American West, who sought to aid other women and in the process turn their moral influence into what historian Peggy Pascoe termed "female moral authority." So, too, Tome's rescue work had wider social significance and illustrates how Issei women helped each other. They were the rescuers as well as the rescued. As Tome learned more about the private details of women's family lives, she used her leadership role as a midwife to advise and protect Issei women.[128]

Tome enjoyed acting as a kind of social worker. Sometimes Tome and her daughters made rice balls and went down to the immigration station to give them to the newcomers. Toshi explained that it was difficult for those Japanese who were temporarily detained for health reasons at the immigration center. It was especially hard on those few who had been denied entry and were being held until they could be sent back to Japan. Toshi felt that their visits helped and the Japanese people at least received something familiar to eat.[129]

Tome dedicated much of her time to aiding Issei women who found their arranged marriages intolerable. Like other immigrant women who lived in a land where they did not speak the language and they were without family or friends, Japanese women had a great need for support when their marriages did not work out. Toshi explained that many of the young women feared they could not go home to Japan but would have to stay with their new husbands even if they did not like them. Some families had borrowed money to send their daughters to America and the women were ashamed to return home. Nonetheless, some women decided to leave their husbands anyway. A few times women even gave birth at Tome's house because they had already left their husbands. Some of the women were pregnant by men other than their husbands. Occasionally women decided they would return to Japan and Tome helped them out, even giving them money she

had earned from midwifery work. At least once, according to Toshi, her mother went into a saloon and dragged two picture brides out. The young women did not have any money and Tome worried about them getting into prostitution.[130]

In her own private way, Tome contributed to the efforts of female reformers in the late nineteenth and early twentieth centuries who established, according to Pascoe, "a network of rescue homes in western cities." The goal of these homes was to help women escape family problems and male abuse. Several of the homes were geared toward Asian immigrant women. For example, San Francisco had a Methodist Mission Home and a Presbyterian Mission Home to rescue Chinese women, including prostitutes.[131] Japanese immigrant women could escape domestic violence or poverty at the Victoria Oriental Home, run by the Women's Missionary Society of the Methodist Church in British Columbia, Canada. Honolulu was the location of the Susannah Wesley Home, operated by the Methodist Church Women's Association and the Board of Missions, which served as a refuge for Korean and Japanese women fleeing prostitution or their husbands. So, too, Seattle had its own rescue home, the Fujin Home for Women, established by the Japanese Baptist Church in 1903 through the leadership of a local Japanese minister's wife, Yoshiko Okazaki. Funded by the American Baptist Women's Society of New York City until 1953, the home provided temporary lodging to Japanese immigrant women and their children. Some of the women were picture brides who left their husbands, some were women seeking shelter when they had a fight with husbands, and some were widows.[132] Despite her husband's objections, Tome ran her own private "rescue home" for Issei women.

Tome's efforts to provide support to women in need illustrates the difficulties entailed in a system of arranged marriages when a community lacked any place to escape, such as to one's family of origin or other relatives. A considerable number of desperate women deserted their husbands, sometimes for other men. This practice, known as *kakeochi*, became common enough that it led to the publication of desertion notices and desertion stories in Japanese immigrant newspapers. Such publicity was used to try to shame or ostracize "unruly" immigrant women and warn others to conform. Nonetheless, it had little effect on women who felt their marriages were unbearable.[133]

One benefit of Tome's work with needy picture brides was that some of the young women helped Tome and her older daughters look after the household and the younger children, especially when she was away attending a delivery. Tome's husband Mokuji did not clean or cook and Tome

was not much of a cook either. Instead, some of the Japanese women who sought Tome's assistance lived at the house and helped cook. Toshi recalled that living with picture brides was frustrating because just as she became attached to one, she would return to Japan. Then, when there were no picture brides to help look after the children, Tome might also rely on the Italian neighbors to help out. They spoke Italian to Tome and she spoke Japanese back, but they still managed to communicate.[134]

One consequence of Tome's efforts to assist immigrant women escape unhappy marriages was the feminist sensibility she brought to the education of her daughters Toshi and Tomo. Her daughter Toshi recalled that she taught them the value of economic independence, a longstanding theme in the history of feminist thought and a contribution to what historian Gerda Lerner called "the creation of feminist consciousness."[135] Toshi remembered that her mother drew on the example of the picture brides' difficulties to warn her daughters about the dangers of financial dependence on men. For example, she told Tomo and Toshi that when they married they should be sure to have their own bank accounts, separate from their husbands' accounts. Tomo would always question their mother and Toshi, who was two years younger, would listen to the answers. Tomo responded, "But, mother, you're not supposed to hide anything from your husband," and Tome replied that economic dependence was not good for women. She told them that many of the picture brides were so dependent on their new husbands that even if they wanted to send a gift to their family back in Japan, they had to ask them for money. Her message was that women needed control of their own money, something a career in midwifery had provided her.[136]

Tome, who was among the earliest midwife arrivals in Seattle, practiced midwifery for more than thirty years, not only to earn money but also to help other women. Like Toku Shimomura, Tome would leave an envelope on her last postnatal visit for the woman to pay what she could. The *sanba* referred to payment as a token of appreciation or courtesy money. Tome was sometimes paid in kind, however, rather than with cash. Toshi remembered hearing stories about her mother and Sawa Beppu having more clients who still owed them money than all the other midwives put together. Toshi recalled that her mother and Mrs. Beppu had many of the poorer clients and also some non-Japanese clients, including Italians. Toshi remembered that sometimes people stopped by the house to pay her mother the money they still owed her, but she would tell them that it was not necessary. If they insisted she would donate the money to those in need. One time Toshi wanted to use the money to buy Buster Brown shoes, but Tome told her to forget they even had that money. Proud of her mother's generous spirit,

Toshi nonetheless still recalled decades later the longing she felt for the nice things she had to pass up.[137]

One of the most chaotic times Tome faced as a midwife was in attempting to deliver babies during the influenza epidemic of 1918–1919, at the end of World War I. Toku's diary made several references to the influenza epidemic in Seattle and the fact that she too became ill. Toshi also remembered Tome discussing the devastating loss of life during the epidemic.[138] In a very short period, more people died during this pandemic than died during the entire war—20 to 40 million worldwide. In the United States, influenza killed half a million people. Western states were not as hard hit as eastern states, but the epidemic did have an impact on the West Coast, especially in San Francisco. In Seattle, Tome would go out to deliver babies and then get calls to come identify people at the morgue who fell dead on the street or on a streetcar. Toku mentioned in her diary that 500 people in Seattle had influenza by November 1918. According to Teru Beppu, at least a few Japanese immigrants and their children were admitted to a white hospital during the epidemic. Tome's children asked her why she never got sick during the epidemic and she said it was because she was very careful. She was especially concerned not to spread the flu to birthing women.[139]

For Tome's daughter Toshi, midwifery practice often meant the frustration of having an absent mother. Toshi recalled that her mother was constantly busy delivering babies, especially when she and her sister were young in the 1920s. Her mother stayed at birthing women's houses for hours, sometimes days. Tome would leave messages that she needed to come home to get clean clothes and then return to the client. Toshi remembered that her mom had a black bag and that it smelled like Lysol.

Tome not only practiced midwifery in Seattle, but also in rural Washington after the family moved to Thomas, a rural community where many Japanese immigrants engaged in truck farming and selling produce off the side of the road. She did not have a car in Seattle or Thomas, but instead she used a horse and buggy, or she would walk or ride the streetcars to her clients. In the lumber camps of rural Washington she just walked. Sometimes she would go early to the woman's home in order to be there in time to deliver the baby. When they lived in Thomas, Tome had her son George walk with her with a lantern part way down the railroad tracks when she had to deliver a baby at night. Like Sawa Beppu, Tome used her son for company and protection, at least for the sake of appearances.[140]

Toshi also remembered that she and her sister helped their mother with at least one important task related to midwifery work. Midwives, like doctors, were required by state law to register all births, and Japanese immigrant

midwives frequently filed birth registration papers with both the Japanese and American governments. In Tome's case, her husband would fill out the American birth certificates because he had studied English. Although Tome was insecure about her English skills, she would watch him to make sure he did not make any mistakes. As Toshi and her sister Tomo got older, they helped their mother by taking the birth certificates to city hall. It was part of their chores. Toshi remembered that she and her sister would get the birth certificates stamped with a big gold seal. At the same time, their dad would take another copy to the Japanese consulate in Seattle to record the birth in Japan. Before 1924 the Nisei automatically received Japanese citizenship because they were born to Japanese citizens, but after that date the midwife, doctor, or parents had to register the birth with a Japanese consulate by the time the baby was fourteen days old. Some Issei parents made sure that their children were registered with both the United States and Japanese governments and therefore had dual citizenship in case they moved back to Japan.[141]

By the 1930s, Tome and other Issei midwives delivered fewer babies. For Tome, she had given birth to additional children and she wanted to spend more time caring for them. Furthermore, with the restrictions on Japanese immigration introduced in 1924, the Japanese birth rate went down across the West Coast. For example, the Japanese birth rate in San Francisco more than doubled between 1910 and 1920 but by 1930 it was below the 1910 rate.[142] As a result, Tome did not have as many women requesting her services. Furthermore, Tome delivered fewer babies because the family moved around to the various lumber mills, including Longview, where there were not many Japanese. In at least one lumber camp Tome worked in a company hospital or health center, although it is not clear whether she worked as a nurse or as a midwife.[143]

The vast majority of midwife-attended births took place among the Issei, and by the 1930s the American-born Nisei started to have their children. The Nisei were more willing to have physician birth attendants, an issue explored in chapter 5. Nisei birthing women were also more willing to go to white doctors. By the 1930s, some white doctors were taking Japanese American patients, perhaps out of economic necessity during the Great Depression and because they were more comfortable with the English-speaking Nisei. Thus, within only one generation, the Japanese immigrant midwives witnessed a dramatic transition in childbirth patterns. Japanese American communities moved from the midwife-attended births of the immigrants to the physician-attended, hospitalized births of the next generation. Indeed, the Japanese immigrant midwives were the first and last American *sanba*.

Creation of Community among Issei Women

As the histories of these Seattle *sanba* illustrate, childbirth contributed to a web of social relations among Issei women, including midwives. The interviews and Toku's diary speak of friendships and connections among many women. There was even some contact with women outside the Japanese immigrant community. Some Issei women knew some English and a few like Toku Shimomura put a great deal of effort into learning it. Several of the people I interviewed indicated that Seattle's Japanese community was very close and that everyone knew and helped each other. Toku Shimomura's grandson Roger recalled that she used to tell him all the time, "Roger, whatever you do, good or bad, will reflect upon the entire Japanese community." Although he came to reject the notion that he had to be responsible to an entire community, like other Issei, she never did. That sense of community is what motivated and sustained the Issei.[144]

Midwifery contributed to the creation of community among Issei women by providing aid to women in one of life's most meaningful events, the birth of a baby. With their skills and sense of competency honed in Japan, the *sanba* reassured birthing women, including a few non-Japanese, that they were skilled childbirth attendants. For their part, Japanese immigrant women wanted midwife deliveries because they were comfortable with the caregiving that midwives provided and they valued the fact that they shared Japanese customs and language with the *sanba*.

The *sanba* helped to construct the Issei way of birth through transmitting and adapting Japanese cultural practices in a new locale. They did not provide a static version of Japanese culture to the Japanese living in a new land. Indeed, many aspects of daily life were changing in early twentieth century Japan, even in the realm of childbirth. Instead, the American context shaped the cultural practices of Japanese immigrants, including that of the *sanba* and their clients.[145] Despite arriving at a time of increased scrutiny of midwifery in many parts of the United States and increased hostility toward the Japanese in the American West, the *sanba* faced little resistance from western health officials and much support from Japanese immigrant women. They succeeded in preserving midwifery in Seattle and much of the West Coast even as they participated in cultural change.

Practicing midwifery made life meaningful for Issei midwives. Although there is scant direct evidence of what West Coast midwives thought aside from the musings of Toku in her diary, the interviews with family and friends suggest that the *sanba* were eager to preserve a part of the life they had led in Japan.

Midwives contributed to the creation of community among Issei women through attending births and much more. Midwives like Toku Shimomura, Sawa Beppu, Koto Takeda, Michi Nakayama, and Tome Yasutake spent day after day making home visits to reassure women and perform caregiving activities associated with prenatal and postnatal care. Such activities, then as now, are too often undervalued. As public health and childbirth advocates have shown repeatedly, in the long run good bedside relationships, continuity of care, and effective, respectful support for women before and after birth improve the outcome for both babies and mothers.

We should not underestimate the value and meaning of the full range of caregiving and community service provided by midwives, who were specialists in normal childbirth. Some entrepreneurial midwives, like Toku Shimomura, worked hard to set professional boundaries and enforce limits on their work. They were in private practice much like doctors and earned a living through midwifery. Like the *sanba* in Japan who tried to distance themselves from the *toriagebaba,* the Seattle *sanba* tried to make clear the distinctions between their activities and the birthing work engaged in by helpful neighbor women. Others, like Tome Yasutake, expanded their activities to engage in social welfare work, caring for women well beyond the birth of a baby. Tome, for example, broke Japanese traditions when she facilitated the demise of arranged marriages and forged a new kind of household when she opened her home to picture brides who wanted to escape. Finally, the registration of births, which all midwives and physicians were required to do, had special meaning to the Japanese immigrant community. Denied American citizenship, the Issei were determined to ensure the citizenship rights of their children, in Japan as well as the United States. Some of the Nisei did not even know they had Japanese citizenship until World War II, at which point they renounced it.[146]

In addition, as the history of the American *sanba* demonstrates, gender relations shaped midwifery and vice versa. For example, midwifery provided important financial resources for Issei women. Although many Issei women worked not only inside but also outside the home, midwives were unusual in that they engaged in a skilled occupation or profession. At the time, most Issei women worked in domestic service, small family businesses, agricultural work, or labor camps.[147] As Tome Yasutake taught her daughters, women's access to their own money increased women's control over their lives, even within marriage. Nonetheless, we should be cautious about drawing conclusions about conjugal power relations based solely on women's income-producing activities. Issei women's paid labor was not necessarily a "major factor in the balance of power between Issei spouses."

All the same, midwifery was not like domestic service work. At least some midwives' husbands were willing to alter the typical gendered division of labor in Issei marriages and perform household tasks in order to facilitate their wives' midwifery practices, suggesting the potential for more egalitarian relationships.[148]

Racial politics and class dynamics also played important roles in the history of the Seattle *sanba*. As in African American communities, it was the limitation on Japanese immigrant men's employment opportunities that made the financial contributions of wives more necessary and acceptable. In addition, some white doctors' treatment of Japanese clients heightened the value of the *sanba* to Issei women. Finally, the combination of housing segregation and the Issei preference for living in ethnic communities led to the formation of "Japantowns," the distinct Japanese communities that were the primary location of the *sanba*'s clients.[149]

In examining the personal stories of the Seattle *sanba*, we must be wary of overgeneralizing from the lives of only a few individuals. Too often the economic success of a few influenced the image of Japanese Americans in the United States. After all, Japanese midwives who ended up as farmworkers or mill hands usually failed to register with West Coast states. Rural midwives like Kimi Yamaguchi in California simply fell out of the historical record. Indeed, the Washington State licensing records identified all licensed midwives as residents of one of three cities: Seattle, Tacoma, or Spokane. Therefore, the *sanba* examined here are representative of the urban, not necessarily rural, Japanese immigrant midwife. Although a midwife like Koto Takeda may have owned a big house and Sawa Beppu and Toku Shimomura drove around in their cars, other midwives had far fewer financial resources as tenant farmers and residents of lumber camps. As we will see, differences between urban and rural midwives also appeared among the *sanba* in Hawai'i.

MIDWIFE SUPERVISION
IN HAWAI'I

In 1937 the Territorial Board of Health in Hawai'i selected public health nurse Alice Young to become its first supervisor of midwives. Alice, a Chinese American born in Honolulu, was in charge of the licensed midwives, most of whom were Japanese immigrants. Although Alice spoke English, Cantonese, and the Hawaiian Creole English or pidgin language of many islanders, she did not speak Japanese.[1] She was therefore dependent on the help of Japanese translators, especially her friend and colleague, the Japanese American nurse Luella Ekern.[2] Alice's appointment was influenced, at least in part, by island racial politics. According to Esther Stubblefield, a white public health nurse who worked for the board of health in the 1930s, Alice was a beautiful, easygoing person. "She was a smart person, as most Chinese are," explained Esther, revealing how ideas about race and nationality inhabit even compliments.[3]

Alice Young (1911–92), Hawai'i's first nurse-midwife,[4] played a pivotal role at the center of complex negotiations between midwives and the Territorial Board of Health over new restrictions on midwifery. Luckily, Alice left us a key to unlock this story when she preserved a set of the monthly narrative reports she submitted to the director of the Bureau of Maternal and Infant Hygiene. She safeguarded them at home, possibly to prevent their destruction by the board of health. The reports reveal a great deal about the history of women's health work in Hawai'i, including the relationship between public health nurses and midwives. They present some of the frustrations of nurses engaged in improving maternal and child health in Hawai'i. Midwives were spread over isolated settlements and plantations on several islands and at least some resented nurses' intrusions into their work. The reports also provide some insight into the anxieties of midwives in rural and urban practices as they resisted and accommodated themselves to the new

regulations. Finally, Alice's reports illustrate her central role in government efforts to impose new public health standards on midwife care.

As we have seen, midwife regulation was part of the expansion of public health programs to women and children in the early twentieth century. In 1925 Congress extended federal Sheppard-Towner funds, administered by the U.S. Children's Bureau, to Hawai'i and the following year the board of health created the Bureau of Maternal and Infant Hygiene. Like its counterparts in mainland states, the bureau in Hawai'i was charged with reducing maternal and infant mortality rates. In Hawai'i's case the responsibility extended only to the four major islands of Oahu, Maui, Kauai, and the island of Hawai'i.[5]

In the 1930s, when midwife licensing began in Hawai'i, most of the midwives who applied for a license lived in urban areas, even though most of the population lived in rural areas. Government records indicate that licensed midwives delivered about 40 percent of all babies born in Honolulu, the urban center of Hawai'i, and 25 percent of the 10,000 babies born annually throughout the islands. Many of the midwife deliveries were for Japanese immigrant women who gave birth to some 4,000 babies annually in the 1930s.[6]

The history of midwife regulation in Hawai'i demonstrates that there was no single American government response to the *sanba* or Japanese immigrant midwife. Relations between Japanese immigrant women and the government were not monolithic. Midwife regulation in Hawai'i differed from the West Coast approach. The Hawai'i *sanba* encountered a far more interventionist program of midwife registration, education, and direct supervision. Since the *sanba* in Hawai'i and on the Pacific Coast had the same training in Japan and encountered anti-Japanese sentiment in both locales, the different degrees of government action illustrate the influence of the plantation economy on midwife policies.

Relations between licensed midwives, most of whom were Japanese immigrants, and the midwife supervisor, who was Chinese American, illustrate "women in cross-cultural relationships" and "interactions among different peoples of color."[7] The points of contact reveal a little-examined aspect of the history of racial politics and health care, in contrast to the more frequently told story of interactions between people of color and whites. Whites were known in the Hawaiian context as *haoles*. *Haole* is a Hawaiian word that formerly meant "foreigner" and referred to any outsider. Within the plantation system it came to have racial and class meanings, signaling a non-Hawaiian and nonlaborer. Today it refers to a white person.[8] Alice Young, an American citizen born in Honolulu of Asian and Hawaiian de-

scent, was not a *haole,* yet she represented the interests of the Territorial Board of Health in her interactions with midwives.

Alice's narrative reports to the board of health reveal her navigation of island health-care politics and racial politics, both of which were influenced by the plantation system. Alice rarely spoke of midwives as a homogeneous group. As she indicated to her supervisor, midwives needed to be treated as individuals. At the same time, she readily categorized midwife skills by nationality. Alice reproduced the nation-based racial hierarchy of the islands in her rankings of midwives' skills, with indigenous Hawaiians and Filipinos at the bottom and people of Chinese and Japanese descent above them. Although most of the licensed midwives were Japanese, as late as 1939 there were also "one Chinese, one Hawaiian, and a few Portuguese and Filipinos."[9]

Although Alice did not treat all midwives the same, she believed that all required supervision because of their status in Hawai'i as immigrants and nonprofessional health workers. For instance, Filipino midwives, many of whom lived on plantations, sometimes appeared in her writings as the ignorant and the uneducated. They were the unlicensed midwives she sternly warned to stop accepting patients. Her interactions with them were minimal, other than to communicate the territorial government's insistence that they were breaking the rules by practicing without a license. In contrast, Japanese immigrant midwives emerged in Alice's reports as skilled, educated women. Generally, Japanese immigrant women in fact had a higher level of education than other immigrant women in Hawai'i.[10] In addition, as we have seen, many of the midwives had attended midwifery and nursing school. Nonetheless, health officials saw them as outsiders who had to be taught the superior American approach to health care. Alice acknowledged their qualifications, but she made it clear that they required her supervision. Although she thought the *sanba* were better than other island midwives, they were still just midwives and not health professionals like doctors and nurses. Furthermore, she saw them as foreigners with at least some unacceptable childbirth customs, such as the use of massage. Finally, Alice remained wary of Japanese midwives because of their occasional challenges to her authority. She argued in her reports that she and the other public health nurses had to keep close watch on all midwives, licensed and unlicensed.

The history of midwife regulation in Hawai'i demonstrates that midwifery was a site of constant negotiation among women, whether between midwives and nurses or among midwives themselves. In Hawai'i, these power struggles took place among ethnically diverse women within a colonized land where the three most powerful players—the territorial government, the planter elite, and the military—represented competing *haole* interests.

Asian Immigration, the Plantation System, and Imperial Politics

Hawai'i provides an important, although often overlooked, setting for studies of American history. A few scholars of Japanese American history have emphasized what we can learn from the differences between Hawai'i and the mainland. Japanese American residents also have identified important differences between those people of Japanese descent who resided in Hawai'i and those on the mainland.[11] For example, Hawai'i's history offers an important reminder of the inaccuracy of uniformly applying a term like *minority* to ethnic groups. Such a label does not hold true across time and place. In the case of Hawai'i, Japanese Americans were part of the growing predominance of Asians on the islands throughout most of the twentieth century.

The history of the Japanese in Hawai'i was different from that on the mainland because of the impact of the plantation system and its tremendous need for labor. First, in terms of sheer numbers, by 1940 more than 150,000 Japanese Americans lived on Hawai'i's relatively small land mass compared to about 120,000 spread across the American West Coast. Second, in contrast to the situation in the American West, where Japanese immigrants and their children constituted less than 2 percent of the population in the early twentieth century, in Hawai'i they were the largest ethnic group and constituted about 40 percent.[12] Third, a more even sex ratio developed earlier among the Hawai'i Japanese than among Japanese immigrants on the mainland. The first Japanese immigrants to Hawai'i, known as the *Gannenmono,* faced poor living and working conditions when they came in the 1860s, although perhaps no worse than what they had left behind in Japan. Nonetheless, their experiences as contract laborers led the Japanese government to be more cautious and offer some protection to the next round of immigrants in the 1880s.[13] One method of improving conditions was to send more women. The Japanese government insisted that Japanese women be included among the laborers to the islands in order to discourage gambling, prostitution, and drunkenness. In 1910, for example, when only about 15 percent of the Japanese in California were women, in Hawai'i the 25,000 Japanese women accounted for about 30 percent of the Japanese immigrant population on the islands. Although plantation workers and Japanese immigrants were mostly men, most of the women working on Hawaiian plantations in the early twentieth century were Japanese. In fact, Japanese women constituted about 80 percent of the women on Oahu plantations by 1920. The percentage of Japanese women who worked for wages in Hawai'i was higher than among other ethnic groups.[14]

Hawai'i, at the crossroads of North America, Asia, and Polynesia, has been described as one of the world's most successful multiethnic societies. Yet far from being a multicultural paradise, Hawai'i's social structure was "built upon a clearly demarcated racial hierarchy."[15] From the late nineteenth century until World War II, a white minority ran the islands in a neocolonial fashion, relying on cheap labor. The American presence had been notable since the early nineteenth century when frequented and then settled by sailors, missionaries, merchants, and planters. More like the Deep South than the Pacific Coast in its economic and class structure, Hawai'i had a plantation economy built on cash crops, such as pineapple, coffee, rice, and, most important, sugar. Hawaiians made up most of the plantation workforce until the 1870s. Labor remained scarce because of the decrease in the Hawaiian population as a result of diseases from contact with Europeans and Americans, as well as the emigration of many Hawaiians to California. Although planters recruited laborers from Portugal, Puerto Rico, and Germany, and even several hundred African Americans, they turned to Asia for most of their labor supply.[16]

Planters sought a diversity of immigrants. For much of the twentieth century the majority of Hawai'i's people were people of Asian descent, roughly 70 percent. Over 300,000 Asians, including first the Chinese, then Japanese, Koreans, and Filipinos, entered the islands between 1850 and 1920. Planters turned to different ethnic groups in response to changes in immigration policies. They also brought in laborers from various nations in the hopes that language and cultural differences would make it more difficult for them to communicate with each other and unite against the planters. They even segregated the workers in separate sections of the plantation camps, although workers also lived among their own nationalities by choice. Planter efforts to check the possibilities of labor organizing was not always effective. By 1900 the Japanese were the largest ethnic group on the islands at about 60,000, outnumbering both the Chinese and the Hawaiians. At that time they also made up the majority of workers on the sugar plantations. Unlike Japanese agricultural workers on the Pacific Coast who moved around to pick the crops, the plantation workers in Hawai'i tended to stay in one place and form close communities, with Japanese Buddhist temples, Christian churches, and Japanese language schools. The creation of Japanese immigrant communities had direct consequences for labor organizing.[17]

Planters valued the work of Japanese immigrants yet remained suspicious of them as potential labor agitators, and with good reason. The Japanese led the major strikes of the early twentieth century in Hawai'i and they did so

sometimes in unity with other workers, especially Filipinos. In 1909 some 7,000 Japanese workers went on strike at plantations throughout Oahu. In 1920 more than 8,000 Japanese and Filipino workers, along with 300 Spaniards and Puerto Ricans, went on strike. To counter accusations of radicalism and anti-Americanism, some 3,000 Japanese and Filipino strikers marched in the streets of Honolulu with slogans on signs such as "We Are Not Reds, God Forbid, But Are Brown Workers Who Produce White Sugar."[18] Strikes had a particularly prominent role in Hawai'i.

It is difficult to document the extent to which imperial politics, as well as labor concerns, directly shaped health politics in Hawai'i. By the turn of the twentieth century, the United States and Japan were emerging imperial powers eager to create overseas empires, and both nations affected the history of Hawai'i. It is nevertheless worth distinguishing between those Japanese immigrants who settled in a location that came under Japan's control, such as Manchuria or Korea, and those who settled in Hawai'i, which was under American control.[19]

Hawai'i, an American territory from 1898 until statehood in 1959, was central to the creation of the American empire in the Pacific. Located more than 2,000 miles from California, Hawai'i nevertheless figured prominently in the nation's westward expansion. In 1893 American residents with the aid of the American military overthrew the monarchy of the Kingdom of Hawai'i and created the Republic of Hawai'i, which was later annexed in 1898. Americans today commonly think of the Hawaiian islands "less as part of the American West than as part of the American vacation." Historian John Whitehead argues, however, that "Hawai'i may well be considered America's first and last Far West."[20] Like the continental American West, a legacy of conquest characterized the history of Hawai'i.[21]

Hawai'i was also important to Japan, becoming the initial destination of large-scale emigration from the nation. The first group of Japanese migrants to travel east across the Pacific went to the then-independent Kingdom of Hawai'i in the 1860s. By the 1880s, thousands of immigrants left Japan for Hawai'i to escape some of the political and economic consequences of Japan's effort to build a military-industrial society. Even as Japan joined the world's imperial powers, however, racial politics clouded Japan's relationship with western governments, which continued to treat the Japanese as inferior people. After the United States forcefully annexed Hawai'i, Japan's ambassador Komura Jutaro tried to protect the rights of Japanese immigrants in Hawai'i and California, but with little success.[22]

What kind of social history evidence can we locate that reveals imperial politics not only in terms of states, but also in human terms as a clash of

cultures?[23] How do we get from the local stories of birth attendants to larger political struggles? The connection between midwifery and imperialism is, of course, babies. Japanese immigrant midwives facilitated the reproduction of American citizens and workers at a time when relations between Japan and the United States were in constant flux. The U.S. government was wary of the Japanese, and eventually Japanese immigrant reproduction came to be seen as potentially antagonistic to American control of the Hawaiian Islands.

Fears about the Japanese presence in Hawai'i escalated with the immigration of Japanese women. As on the mainland, the number of female immigrants increased after the Gentlemen's Agreement of 1907–1908. This agreement was a compromise worked out between the United States and Japan to appease anti-Japanese critics. Japanese women's arrival in Hawai'i—more than 14,000 came from 1907 to 1923—contributed to a dramatic population increase and signaled the Japanese intention to settle permanently. At this time there was concern that the Japanese would "overwhelm the Territory numerically, politically, and commercially," and they were alleged to have a higher birth rate than any other ethnic group on the islands.[24] It is true that Hawai'i's Japanese population more than doubled, from about 60,000 in 1900 to more than 150,000 by the outbreak of World War II. Furthermore, although under American law Japanese immigrants were denied the right to become naturalized U.S. citizens, critics argued that the immigrants' children represented a threat to the elite of Hawai'i and American national security. After 1900 children born in Hawaii were entitled to American citizenship. Therefore, the children of Japanese immigrants were entitled to the right to vote and could one day control Hawaiian politics and undermine planter power. Thus, for at least some elites, Japanese immigrants and their children were seen as part of the "yellow peril" that threatened to conquer and colonize the Pacific, a task the United States reserved for itself.[25]

Alice Young and Nurse-Midwifery

Records available in government archives, including those of the U.S. Children's Bureau and the Territorial Board of Health, provide us with the barest details of Alice Young's work as midwife supervisor.[26] They present the often-repeated American narrative that celebrates the decline of infant mortality through the decline of midwifery and the rise of physician-attended hospital births. Hence, the records indicate the board of health's pride that even though only 10 percent of all births in Hawai'i took place in hospitals

with physicians in 1931, by 1951 98 percent did.[27] There is, of course, more to this story, as we learn in Alice's own records.

Alice, born Alice Hing Tong Young, grew up in the 1910s and 1920s in Honolulu's Chinatown, where Chinese politics formed an important backdrop in her family life. Alice's father, Wah Kam Young, was a Chinese immigrant who came to Hawai'i at the age of seventeen. He worked as a fish merchant in Honolulu. He and other Chinese immigrants in Hawai'i, like Dr. Khai Fai Li, became involved in the reform movements in China. He traveled to China frequently to see his family, for his business as a fish merchant, and as a supporter of the Chinese nationalist leader Sun Yat-sen, who was educated in Hawai'i. Alice's father became sick and died in 1923 during a visit to China to see his parents, who were ill. Alice was still a young girl and her mother, Bow Ngan Sum, was left to raise nine children without a husband. Alice's mother, who was adopted by a Chinese family, was accepted as Chinese within Chinatown, despite the fact that she was born to a Chinese father and Hawaiian mother and had a darker complexion than most Chinese.[28] Chinese immigrant men on the mainland and Hawai'i formed relationships and sometimes married Native American women, Mexican American women, African American women, native Hawaiian women, and, rarely, white women.[29] Even though some Chinese immigrants looked down upon marriage with other ethnic groups, there were still inter-racial relationships, as there were also in Alice's family.

Alice was a bit of a rebel and, although her mother provided Alice with strong emotional support, she could not always assist her ambitious daughter financially. For example, nursing was not Alice's first career choice. After graduating from high school in 1929, she wanted to become a doctor. Her mother was a widow with nine children, however, and there was no money to spare for tuition. Thus, she became a nurse because nurses could still get an education without having to pay tuition fees by working in the hospital. At the age of eighteen she went to California, where she attended St. Luke's Hospital School of Nursing in San Francisco, along with Harriet Kuwamoto and Luella Tanner, who later married and became Luella Ekern. After graduating with basic nurse training in 1932, Alice wanted to study public health at the University of California at Berkeley, but again her mother could not afford it. Therefore, she returned to Hawai'i, where she, Luella, and Harriet earned a public health nursing certificate from the rigorous program at the University of Hawaii in 1933.[30]

Alice used her career in public health to help people across the islands. From 1933 to 1943, Alice was engaged with many of the key issues in the

field at midcentury. Alice, like several other public health nurses in Hawai'i, began working with the Palama Settlement, a social welfare program formed in 1905 in one of the poorer areas of Honolulu. The settlement provided health and welfare services to the poor, including treatment for tuberculosis and well-baby clinics. Meanwhile, the board of health increased its public health nursing staff from sixteen nurses in 1925 to fifty-five nurses in 1938.[31] In 1935, during this expansion, the board of health hired Alice as a public health nurse for the island of Molokai, where people with Hansen's disease (or leprosy) were sent to live in isolation in the name of public protection. Molokai was known for its so-called leper colony, where over the course of 125 years more than 7,000 people were confined. Alice worked on the island for two years with the general public, most of whom were native Hawaiians, but not directly with Hansen's disease patients as her friend Luella did.[32]

Alice worked for the board of health at a time when white Americans ran the board and Asian American nurses were not promoted to senior positions.[33] Many of the public health nurses employed by the board of health were Japanese American women, including the American-born or Nisei nurses Clara Sakamoto and Harriet Kuwamoto, and Luella Ekern, who was an immigrant from Japan and had a Japanese mother and white American father. In addition, a well-trained Nisei doctor, Dr. Kusunoki, served as the county health officer on Maui. According to a U.S. Public Health Service official in early 1941, the planters did not give Dr. Kusunoki their cooperation. The same official also observed that except for the department heads, most of the nurses, doctors, and laboratory workers of the Territorial Board of Health were of Hawaiian, Chinese, and Japanese descent.[34]

In 1937 the board of health hired Alice for her new position and sent her to train as a nurse-midwife. The federal government funded her education through grant money allocated in the 1935 Social Security Act. She went to New York City, where she attended a nurse-midwifery program recommended by the U.S. Children's Bureau. The Maternity Center Association and the Department of Nursing Education in Teacher's College at Columbia University offered courses and midwifery field service at the Lobenstine Clinic in Harlem. Many of Alice's teachers were British nurse-midwives, some of whom were associated with the Frontier Nursing Service in Kentucky. Her clients were mostly African Americans and Puerto Ricans living in Harlem.[35]

Nurse-midwifery emerged as a field in the United States in the 1920s, an outgrowth of the debates about midwifery. Nurse-midwives were school-trained nurses, often specialists in public health, who then went on to take advanced training in midwifery. The United States had both traditional

midwives and nurse-midwives, whereas nations like Britain and Japan tried to eliminate traditional midwives entirely and only retain school-trained birth attendants, who were simply called "midwives." Eventually several schools of nurse-midwifery opened in the United States. The Maternity Center Association, formed in 1918, opened the Lobenstine Midwifery Clinic in New York in 1931 to provide a nurse-midwifery program specifically to train public health nurses like Alice in the supervision of midwives. Alice was one of 125 graduates from the school in the 1930s and 1940s.[36] There were six other nurse-midwifery schools in the United States. By the early 1940s, there were 175 nurse-midwives and 250 by 1947, many of whom were employed as midwife supervisors by local governments.[37] Unfortunately for the graduates, the field of nurse-midwifery remained hampered in its development because it provoked opposition from both nurses and physicians over issues of competition and professional boundaries.[38]

Alice graduated as a nurse-midwife in 1938 and, upon her return to Hawai'i, she was appointed the territory's supervisor of midwives. She continued her work even after she married in 1942, although she resigned a year later when she became pregnant.[39]

Japanese Doctors and Plantation Health Care

Gender conventions and a health-care hierarchy shaped the ways in which professions were monitored by governments, as a comparison of Japanese midwives and Japanese doctors in Hawai'i reveals. The government in Hawai'i regulated medicine, a field dominated by men, earlier and far more strictly than midwifery, a field dominated by women, because it considered medicine to be of far greater authority, prestige, and importance.[40] Yet, government responses tell us little about the meanings of Japanese medicine and midwifery for clients. Both doctors and midwives were valued health-care providers for male and female plantation workers and people living in the surrounding areas.

The first Japanese immigrant physicians arrived in Hawai'i at the invitation of the leaders of the Kingdom of Hawai'i and the insistence of Japan. After the experience of the earlier *Gannenmono*, Japan sought to safeguard its immigrants who began to come as contract laborers for the sugar plantations in 1885. Under contract labor arrangements, the Hawaiian government ensured that Japanese physicians were brought along to minister to the immigrants' health needs. With aspirations to become a world power, Japan was eager to protect its immigrants because of the consequences for its diplomatic position and international reputation.[41]

Meanwhile, the government in Hawai'i wanted Japanese doctors in order to process and safeguard an important source of labor for the islands. The Hawaiian Bureau of Immigration needed Japanese doctors to assist as *translators* in the inspection of arrivals. Hawaiian authorities also wanted them to ensure worker productivity. Government authorities in Hawai'i recognized Japanese immigrant physicians as skilled health-care practitioners. Many had trained in western medicine in Japan, Germany, or the United States. In the 1880s and 1890s the Hawaiian government hired twenty Japanese doctors to work on plantations. Most of them went on to have successful private medical practices after leaving the Bureau of Immigration. In the first years of Japanese immigration, the Kingdom of Hawai'i permitted all doctors to practice medicine on the islands as long as they had a medical license or had graduated from a medical school somewhere.[42]

On the plantations, labor needs provided the context in which planters supplied free, but minimal, medical care as part of the labor contracts. Motivated by economic self-interest and the desire to retain workers, plantation owners from the late nineteenth century to World War II believed that a healthy workforce was good for business. By the beginning of the twentieth century nearly one-third of the island population was cared for by plantation physicians and plantation nurses, most of whom were *haole*. Many of the plantation doctors also worked part-time as government physicians paid by the board of health to care for indigents. For example, in 1926, the American Factors company offered its sugar plantation workers free medical care and hospitalization if they earned one hundred dollars per month or less.[43] "Healthy men are more contented and do better work," explained Donald S. Bowman, director of the industrial service bureau of the Hawaiian Sugar Planters' Association [HSPA]. In 1936, according to Bowman, "The 37 plantation members of the HSPA employ 29 fulltime doctors and 62 trained nurses; [and they] operate 18 fully equipped hospitals and seven smaller receiving hospitals."[44] In 1938, a public health nurse and regional consultant for the U.S. Public Health Service found that twenty-seven out of the thirty-three physicians employed by the board of health to provide care to the indigent nonplantation workers were also plantation doctors hired to care for the plantation workers. Still, each plantation had only one doctor for a population that could reach as many as 8,000 to 10,000 people.[45] In early 1941 an official with the Public Health Service was very impressed with the health-care provisions on the island of Hawai'i: "Medical service to the indigent and low wage groups is available to a far greater proportion of the people of low economic status than in the States of the Rocky Mountain and Pacific Coast areas."[46]

Hospitals were an increasingly important component of the plantation health-care system. Plantation physicians frequently provided care in plantation hospitals, which varied widely in quality. Some hospitals were established as early as the 1880s, although others were created to demonstrate "plantation paternalism" after the major sugar workers' strikes in the early twentieth century. In 1925 one official at the board of health described most of the hospitals as excellent and up to date. In the 1930s every plantation had access to a hospital, either on location or nearby, although the board of health found some that did not meet appropriate standards.[47]

Japanese immigrant workers on Hawaiian plantations drew on a dual health-care system of white and Japanese doctors to meet their health needs.[48] Immigrant workers welcomed the health care provided by Japanese physicians, whose services supplemented or substituted for that provided by white plantation doctors. For example, Dr. Harvey Saburo Hayashi, who attended medical school in both Japan and California, became a valued physician and community leader for plantation workers on the Kona coast of Hawai'i. Dr. Ichitaro Katsuki, who graduated from the University of California School of Medicine in 1896, first came to Hawai'i in 1900 to investigate the bubonic plague outbreak for the San Francisco Department of Health. He ended up staying and provided health care to plantation laborers who "complained that the plantation doctors were too busy to give each patient much attention and that they were sent to work when they were still sick."[49] Language barriers between white doctors and Asian plantation laborers often created problems. As employees of the planters, plantation physicians were supposed to maintain a healthy workforce and determine the laborers' fitness for fieldwork. It was no easy task. They were to identify those workers who feigned illness, yet still assist anyone who was truly too sick to work. Misunderstandings could and did result in faulty diagnoses of illness, sometimes with serious consequences. Japanese plantation workers therefore used both plantation doctors and private Japanese doctors. Furthermore, the demand for Japanese doctors was even higher once people left the plantations and no longer had free plantation health care.[50]

Like other religious and ethnic groups in the United States, Japanese immigrants established their own hospitals. As we saw in the previous chapter, throughout the early twentieth century, Japanese hospitals on U.S. soil provided a place for immigrant doctors to treat their patients with Western-influenced Japanese medicine.[51] Japanese hospitals in Hawai'i, like those on the mainland, were staffed by people of Japanese descent. Issei or Japanese immigrant physicians in Hawai'i, as on the mainland, found access to white hospitals closed to them, including plantation hospitals and the well-known

Queen's Hospital in Honolulu. Even when an Issei patient was accepted at a local hospital, the Issei physician had to turn the case over to a white physician who had admitting privileges. Japanese immigrant doctors, like African American doctors, created their own hospitals in order to create a place for themselves in the medical world.[52]

Ethnic and religious hospitals tried to meet cultural, as well as health-care, needs. Japanese immigrant doctors, like Dr. Zenko Matayoshi, established hospitals because they wanted to work in their own language and provide care following familiar customs. Like European and Chinese immigrants, and African Americans, Japanese immigrants created hospitals as important community institutions.[53] Dr. Matayoshi's hospital opened on the island of Hawai'i in 1922 and operated for thirty-nine years. It was the largest Japanese hospital in Hilo and the last to close. Most, although not all, of the patients at Japanese hospitals were people of Japanese descent. Unlike in the plantation hospitals, patients could count on the staff to speak Japanese and provide Japanese meals, including miso soup. As in Japan, the hospitals relied on family members to meet the personal needs of patients. They supplied a bed for a family member to help provide care and comfort, especially at night. Furthermore, patients were attracted to the Japanese hospitals because they were cheaper. For example, in the early twentieth century a stay at the Japanese hospital in Hilo cost half the price of the Hilo Memorial Hospital. Yet some plantation workers could not afford to pay any hospital fees. Issei physicians, like Dr. Matayoshi, also delivered babies in the hospital as well as in the home. Maternity patients had to bring their own diapers and launder them, however.[54]

Most of the Japanese hospitals were located on Oahu and the island of Hawai'i. More than twenty Issei doctors operated private Japanese hospitals on the island of Hawai'i from the 1910s to 1960. Ownership of the hospitals frequently changed hands, but at least eleven hospitals remained in operation for decades.[55] In 1900 in Honolulu, the Japanese Benevolent Society founded the largest Japanese hospital. In 1890 women of the Honolulu Japanese Christian Church had established the society in order to assist the indigent and the sick. Honolulu was also home to a Chinese hospital founded in 1895.[56]

The Japanese hospital in Honolulu opened in the wake of the devastating Chinatown fire. The fire was a "sanitary fire" started by the board of health in its attempts to fight an outbreak of bubonic plague in December 1899. Dr. Khai Fai Li, who worked at the Chinese hospital, reported to the board that he had a patient, a young Chinese bookkeeper, with the plague. He had seen such cases before as an intern in Hong Kong. Despite the board's reluctance

to accept his diagnosis, officials eventually acted to stop the spread of the disease after five more deaths.[57] Unfortunately, the board's use of quarantine, fumigation with sulfur fumes, and chemical spraying with bichloride solution failed to stop the plague. As a consequence, the board decided to burn the homes of the sick. The fire got out of control and, tragically, it burned most of the buildings in the Chinese immigrant community. In addition, more than 3,000 Japanese immigrants were left homeless, along with some Hawaiians. In response, the Japanese Benevolent Society created the Japanese Charity Hospital, later called the Japanese Hospital.[58] It opened under the medical direction of Dr. Iga Mōri, a graduate of medical schools in Japan and California and a longtime health-care provider to Japanese immigrants.[59]

As more Japanese doctors arrived in Hawai'i and American claims to the islands solidified in the 1890s, medical licensing became stricter under the board of health. King Kamehameha III, ruler of the Kingdom of Hawai'i, established the board of health in 1850, before any state on the mainland. By the 1860s, Hawai'i had its first law to license doctors. In 1897 there were 76 licensed physicians, several of whom were Japanese, and over 100 licensed physicians by 1900.[60] After 1895 the board of health required that licensing examinations be taken in English or Hawaiian, putting Japanese doctors at a distinct disadvantage. In response, the Japanese government stepped in and successfully lobbied for the acceptance of translators during examinations. This compromise agreement held until World War I, at which point the Board of Medical Examiners altered the rules and the examination had to be taken in English. As in California, without the Japanese language option, immigrant doctors were once more hampered in their ability to obtain a license to practice medicine.[61] Despite the difficulties government regulations posed for Issei doctors, they managed to establish a significant presence in Hawai'i. Some had sufficient knowledge of English to pass the medical examination and others had applied during the decade when the aid of translators was permitted. Still others, from both the Issei and Nisei generation, graduated from American medical schools.[62]

Hawai'i *Sanba:* On and Off the Plantations

The experiences of Japanese immigrant midwives differed from those of Japanese immigrant doctors as a result of initial government indifference to Japanese women's health needs, as well as gender inequality within the immigrant community and among health-care professions. Neither the Japanese nor the Hawaiian government made an effort to bring over midwives to care for female plantation workers. Midwives lacked prestige because

most worked in homes rather than in hospitals, which were increasingly seen as professional settings and centers of modern science. Although doctors shifted from attending patients in the home to caring for them in offices and hospitals, midwifery remained home-based. A few midwives worked in private Japanese hospitals in Hawai'i, including Honolulu, but mostly as nurses. Also, a few Japanese midwives worked in plantation hospitals, where they sometimes delivered babies. Finally, the government focused on doctors rather than midwives because of the nature of their expertise, which mattered more to women than to men.[63]

Despite midwifery's lower status in the health-care hierarchy in both Japan and Hawai'i, it retained its cultural significance for the *sanba*, their families, and clients. Cultural traditions, sexual propriety, and economic considerations led most Japanese immigrant women to chose midwife deliveries over attendance by Japanese or white doctors. As Issei midwife Misao Tanji of rural Oahu explained, before World War II "most women preferred to be under the care of a midwife, unless there was some complication with the mother's or fetus' condition." Besides, according to Misao, "Birth is a natural process; as long as there is no complication, natural birth is the best way. To resort to medication or forceps was not considered desirable. Natural birth is best."[64]

Misao Tanji (1901–1990) arrived in Hawai'i after marrying Takeo Tanji, a Christian Japanese immigrant who had returned to Japan in search of a wife for himself and, at Reverend U. Fujishiro's request, a midwife for his community. Misao was born in Japan and graduated from a nursing and midwifery school in Tokyo in 1921. She passed the midwifery requirements at the national and prefectural level in Japan and apprenticed for one year with an experienced midwife. She studied midwifery because she thought she was not attractive enough to marry and needed a way to support herself. She was therefore pleased to find a man looking for a midwife to marry and agreed to the arranged marriage. "I was happy because I didn't think any man would have a homely girl like me for a wife," she explained in an interview with her daughter-in-law later in life. She and Takeo married in Japan in 1923 and in 1924 they went to Oahu. "I had high expectations and hopes for the future," recalled Misao. She had heard that Hawai'i was warm and beautiful and she was not disappointed upon her arrival. "The trip from the immigration station to Wahiawa was so beautiful. The vegetation was lush; the mountains were bright and green. Even now I have that picture etched in my mind."[65]

Misao did not reside on a plantation, even though many of her clients did. When Misao came to Hawai'i, her husband Takeo no longer lived and

Midwife Misao Tanji with her bag, 1920s or 1930s. Courtesy of Hawaii's Plantation Village, Waipahu, Hawai'i.

worked on Ewa plantation, one of the largest plantations on Oahu. Takeo was among the 12,000 people evicted by planters from plantation housing in retaliation for the 1920 strike on Oahu sugar plantations. Whereas Japanese immigrants and their children had constituted nearly 70 percent of the plantation workforce in 1900, by 1930 they constituted about 20 percent. Whether by choice or force, the Japanese were leaving the plantations.[66] In short, when Misao arrived in Hawai'i, she and Takeo lived for several months in Wahiawa with Takeo's brother. There Misao assisted her sister-in-law Matsu, who was also a midwife. Eventually, Reverend Fujishiro of the Japanese Methodist Church helped them find their own place in Waipahu, where she was baptized at the local Japanese Methodist Church in 1926.[67]

As with some of the Seattle *sanba,* Misao was a successful entrepreneur. Her courage and hard work and Takeo's domestic labor contributed to her thriving midwifery practice. Misao and Takeo raised a family of two sons and one daughter while living in the back of Takeo's photography studio in Waipahu. He looked after the household, doing the cooking, cleaning, and tending to the children when she was with her clients. She disliked cooking and believed she was not good at it. He was able to care for the home because they lived where he worked. Misao's practice also benefited from the fact that, because of her husband's business, she had access to a telephone. In 1927 she qualified for her driver's license so that she could drive to clients instead of taking the Model T taxi driven by Mr. Noguchi. She needed to be able to reach clients living in some of the most isolated camps on Oahu. Like some of the Seattle *sanba,* Misao sometimes took a child with her when she went out on a case. Her son Tom remembered that he used to travel with her in the car and he would have to sit in it and wait for her, sometimes for hours. Like many Japanese midwives, she also advertised her services. She listed her name under the midwife section of the city directory each year beginning in 1925, and she had a midwife sign outside the photography studio with her name on it and the word *sanba.*[68]

Misao delivered babies not only as a way to make a living, but also to help women, many of whom could not afford her services. Her clients usually called on her when they were about five months pregnant, at the point they first felt fetal movement. She provided prenatal care, delivery, and postnatal care for about $10 to $15 in the early years and $35 to $50 after World War II. She tried to obtain payment before delivery because some of her clients moved away after giving birth. Sometimes she was simply paid with fruits or vegetables raised in home gardens or even nothing at all because the plantation families had so little. Nonetheless, she practiced

midwifery for more than thirty years and delivered so many babies that she lost count.[69]

Even though Misao did not live on a plantation, most of her clients did. Misao was one of five Japanese midwives practicing in Waipahu, including Mrs. Setsu Ishikawa, Mrs. Koike, and Mrs. Okawa. As one of the last midwives to arrive from Japan before the 1924 U.S. immigration restrictions went into effect in Hawai'i, Misao ended up with Chinese, Filipino, Korean, and Hawaiian clients, but few Japanese. Although Misao spoke only Japanese, she communicated with clients in the pidgin English used throughout the islands and through gestures. As she explained, "You don't need language."[70] Many of her clients were the wives of plantation workers and plantation workers themselves. She had few Japanese women because the Japanese were usually loyal to their midwives and kept the same one for all the births in the family. "The Japanese, by disposition, once they are under the care of one midwife, are unwilling to change to another. I suppose it is a form of *reigi* (courtesy) to a person who took care of you." Misao did not mind, however, explaining that her "relationship with these people was easier than with the Japanese, because with the latter there was constantly a feeling of mutual reticence. [In contrast,] [t]he other people were very candid."[71] Her comments suggest that even though she may have been disappointed not to have more Japanese clients, the result was an unexpected degree of freedom. With non-Japanese clients she did not have to worry about Japanese expectations for ritualized, appropriate behavior and mutual obligation.

The plantation economy produced a multiethnic population and many opportunities for people to assist each other across ethnic lines, during childbirth included. Although midwives usually attended women of the same ethnic background, several plantation midwives gained a reputation for their midwifery skills among women outside their own ethnic group. Like Misao Tanji, Uto Nakamatsu from Okinawa delivered babies for women of several ethnic groups on a plantation near Hilo. Mrs. Inaba, also on the island of Hawai'i, recalled that she delivered mostly Japanese babies, but also Portuguese, Chinese, and Hawaiian.[72] An oral history project conducted by the Ethnic Studies Program of the University of Hawaii at Manoa demonstrated that Japanese immigrant midwives delivered non-Japanese as well as Japanese babies in the early twentieth century. Among the Issei women's clients were Portuguese, Chinese, Filipino, and Korean families. Furthermore, a Puerto Rican midwife delivered Portuguese babies and a Portuguese midwife delivered Hawaiian babies and Japanese babies, at least until a Japanese midwife moved into the area. Interviewees described the

Japanese midwives as especially smart and as good as doctors. They noted that Japanese midwives kept very good records of births, which were useful for obtaining birth certificates when needed in later years.[73]

Plantation midwives, including *sanba,* were often unlicensed midwives who shared the lower economic status of their clients. They charged little or nothing to deliver, so in order to earn income many of them also performed agricultural labor, worked as domestic servants, sold flowers, or worked as a masseuse or in a family-run general merchandise store. Tsuru Yamauchi, an immigrant from Okinawa, remembered that the midwife for her first baby was also a plantation worker. She lived on the same plantation, but in another camp. According to Yamauchi, who lived on a Waipahu plantation on Oahu, "In those days a midwife just helped a baby be delivered, come out, you know. She took care of the umbilical cord and cleaned the rest. She bathed the baby and things like that. She would come back the next day to bathe the baby again. But it was far away, so as soon as the umbilical cord fell off, she stopped coming."[74] Yet a midwife's social status was not tied to her economic status. Communities cherished their midwives. For instance, when midwife Uto Nakamatsu died, the adult children of the women she had attended in childbirth came to her funeral from all over the islands.[75]

Regulation of Midwifery

In Hawai'i, as in Japan and on the American mainland, government interest in the registration of births contributed to the regulation of midwifery. Unlike Japan, however, which launched the registration of midwives in 1899, and unlike many U.S. states, which registered midwives in the 1910s and 1920s, the Territorial Board of Health in Hawai'i did not begin to register midwives until 1931. Even then, and again unlike California and Washington, the board merely required registration of midwives, in particular those advertising their services and accepting a fee, without insisting that they pass an examination.[76] The board had tried to pass midwife legislation in 1924, but the bill failed in the legislature because critics charged that it was too restrictive and would have eliminated most midwives. With the shortage of physicians for poor women, the law would have left most women without a skilled birth attendant during childbirth. Then, in 1925, Dr. Vivia Appleton, a self-described "physician and pediatrist of international experience," indicated to the U.S. Children's Bureau that Hawai'i needed to get a better birth registration law. She was director of the Bureau of Maternal and Infant Hygiene and believed that only doctors and midwives should attend and report births, instead of the usual "informants," consisting of husbands,

other family members, friends, and neighbors. Some, but not all, of these "informant" deliveries were by unlicensed midwives.[77] For example, in 1930, one-third of the 4,300 births in Honolulu were delivered by midwives, one-third by physicians, and one-third by "informants."[78]

The Territorial Board of Health used a two-pronged approach to midwifery reform in the 1930s. First, it sought to end the practice of midwifery on the plantations and in the sugar mill and pineapple cannery areas. Instead, it encouraged women to give birth in plantation hospitals attended by doctors, even though women preferred to give birth at home and go to the hospital only for complications. The plantations presented a particular problem to Alice and the board because most births there were informant deliveries. Alice's monthly narrative reports to the director of the Bureau of Maternal and Infant Hygiene reveal some of her frustrations with plantation managers and doctors who allowed unlicensed birth attendants to continue to practice.[79]

Second, in 1937 the board established several new policies to limit midwifery, including a one dollar renewal fee for licensed midwives, an age limit of sixty, and the requirement that all midwives applying for the first time had to have graduated from an approved midwifery school. A health official contacted the U.S. Children's Bureau to gather the names of acceptable midwifery schools in the United States, England, Germany, Sweden, Norway, and Japan (the only Asian nation included). The list of countries suggests that midwives from elsewhere would automatically be seen as untrained. In addition, the health officer of each of the four main islands published an annual list in the newspaper of the certified midwives on the island, apparently so patients would know which midwives the board of health had approved to practice. Finally, midwives had to submit a case report on every delivery to the Bureau of Maternal and Infant Hygiene so that the board would know the midwife's caseload.[80]

From 1938 to 1943 Alice Young was in charge of implementing the midwife regulations. Public health officials in Hawai'i believed that physicians should replace midwives, but until they did, midwives should be adequately licensed, educated, and supervised. The midwife policy of 1931 stipulated that a midwife was to attend only normal births and call in a doctor for premature or abnormal births; must be at least twenty-one years old; must not use any medical instruments or drugs, except disinfectants; must be of good moral character; must be a graduate from a midwifery school or have a physician certify that she had performed successfully at least twenty births; must keep a record of each birth and report it to the registrar; must keep herself, her clothing, and her equipment clean; and must make daily postnatal visits to each patient for one week. There was no requirement that

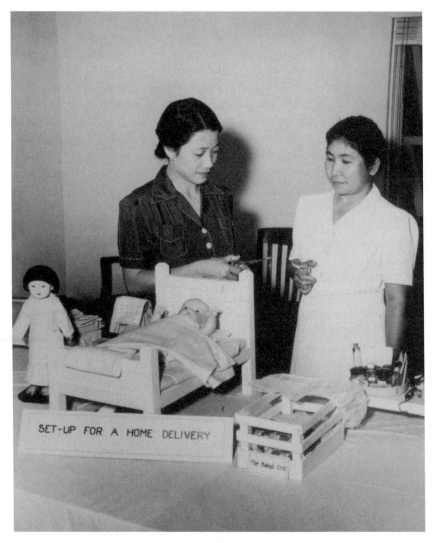

SET-UP FOR A HOME DELIVERY

The Baby's Crib

Alice Young (left), midwife supervisor for the Territory of Hawai'i, demonstrating proper techniques to a nurse in the late 1930s. Courtesy of Katharine Kohler.

a midwife had to be a woman, and at least one Issei man, Kiyugo Yanase, became a licensed midwife. Filipino men also did some deliveries and a few may have been licensed midwives.[81]

Alice worked with midwives on the islands of Oahu, Maui, Kauai, and the island of Hawai'i, urging them to comply with the new rules or give up delivering babies. Alice promoted the registration of eligible midwives, or-

ganized educational programs that included monthly classes for trained and untrained midwives, developed a midwife manual, inspected the content of midwife bags, and periodically observed midwife deliveries. She also organized annual midwife institutes on Oahu and the island of Hawai'i, in which Issei and Nisei physicians, including Dr. Richard Sakimoto, were invited to provide Japanese immigrant midwives with some of the latest medical knowledge.[82]

Alice spent much of her time supervising the midwives of Oahu, most of whom were Japanese, because the board of health was located there and because midwives in Honolulu constituted the largest number of licensed midwives in Hawai'i. She also inspected and licensed two maternity homes

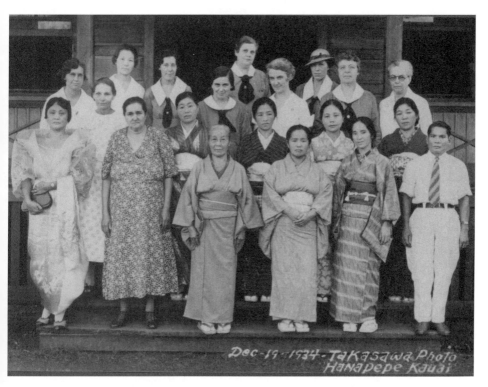

Nurses from the Territorial Board of Health and plantation nurses conduct a class for the instruction of midwives in Kauai, 1934. The midwives in the front row are Guadalupe Bisande, Andrea Santos, Maki Makimura Konishi, Tsumoru Iwamoto, and Cisco. The midwives in the second row are Nuncia Morris Bonilla, Mume Soo, (unidentified), Mrs. Matsumoto, Mrs. Onitsuka. The nurses in the back row are (unidentified), Doris Nishioka Hiramoto, Adeline Mooklar Deveraux, (unidentified), Edith Moore (far back), Claire Carra, Ethel M. Greathouse, Mabel Coleman, and Mabel I. Wilcox. Courtesy of Katharine Kohler.

Midwives Institute at the YWCA in Honolulu, July 1939. Courtesy of Katharine Kohler.

run by Japanese midwives, the Ogawa and Utsumi lying-in homes in Honolulu. Alice visited the licensed midwives on other islands about once a year when she traveled to what she called the "outside islands," where local public health nurses did most of the supervising of midwives.[83] In 1935, not long before Alice began her work as supervisor, the board licensed 163 midwives, 68 of whom lived in Honolulu and 22 in rural Oahu, 47 on the island of Hawaii, 14 on Kauai, 9 on Maui, and 3 on Molokai.[84]

Midwife regulation in Hawai'i was part of a wider effort to promote maternal and infant health, an endeavor complicated by the wide variety of ethnic groups and the number who did not know English. In the 1920s, the Bureau of Maternal and Infant Hygiene compiled health statistics and divided the population into numerous ethnic and national groups, including Chinese, Filipino, Japanese, Korean, German, Russian, Spanish, Hawaiian, Portuguese, Puerto Rican, Caucasian, and the "mixed race" categories of Asiatic Hawaiian and Caucasian Hawaiian.[85] According to Dr. Appleton, head of the division, it was especially difficult to do health promotion because "we have a large oriental population to deal with. We have had

to overcome their shyness."[86] Furthermore, the board could not send out literature to mothers because "it would not be practical with so many Orientals" who did not read English. In the 1920s, however, it did publish at least two articles in Japanese, including one on infant diets, in a Japanese newspaper and twenty-four articles on child hygiene in the Hawaiian language in a Hawaiian newspaper.[87]

Government statistics suggest that certain groups had more health problems than others. In the 1920s, Hawaiians had the highest maternal mortality rates, and Filipinos and Hawaiians had the highest infant mortality rates, while the Japanese, Chinese, and Caucasians had the lowest mortality rates.[88] Health officials placed much of the blame for high mortality rates on informant deliveries on plantations and in rural areas.

Alice found that unlicensed midwives attended some of the informant births. They ignored the new government licensing rules because they lacked the educational requirements, refused to pay or could not afford to pay the one dollar annual renewal fee, or did not read and write English. When they continued to deliver babies, they had the husband or someone else sign the birth certificate, resulting in an informant delivery in the records.[89]

The very process of midwife regulation excluded certain groups from the beginning. For example, many native Hawaiian healers and midwives, the *kahuna* and *pale keiki*, did not register with the board of health, a topic that warrants further exploration. Men, as well as women, and fathers, as well as husbands, played an important role in childbirth and healing among the indigenous Hawaiians.[90]

Although Japanese immigrant midwives were not the sole childbirth attendants in Hawai'i, they constituted the majority of licensed midwives because they met the bureaucratic requirements. Many of them were already licensed childbirth attendants in Japan. About 80 of the 93 midwives who registered in 1939 in Hawai'i were Japanese. More than half the licensed midwives had formal midwifery schooling, ranging from six months to six years, in addition to the nursing training that many had.[91] The *sanba*, as we have seen, came from a nation where midwifery had been modernized. In the 1930s the number of licensed midwives was between 100 and 200 and there were 270 licensed physicians; Issei midwives constituted a higher percentage of the licensed midwives than Issei physicians did of the licensed physicians. For instance, in 1937, 29 of the 33 midwives in the city and territorial directory for Oahu were Japanese, but only 46 of the 162 physicians were.[92] In many ways, the Hawai'i *sanba* were at the center of midwife regulation.

Negotiating Midwifery Policy and Practice

As with other aspects of social policy, midwives and nurses negotiated midwifery policy and practice in Hawai'i, although nurses had more power as government employees. Alice, who was trained in nursing schools to draw on the best of western scientific practice, experienced both frustration with and sympathy for midwives in her efforts. She did not believe that all midwives were incompetent. Indeed, in working closely with midwives she found that the care they provided was better than she had expected.[93] She did, however, have occasion to intervene at times when she found deviations from board of health recommendations. Midwives, for their part, found some benefits in government regulation. They utilized the resources provided by the board and made visits to Alice's office to discuss difficult cases or pick up health literature for their clients. They also had their own concerns. Some were distrustful of the nurses and unfriendly toward them. They were unhappy with the imposition of government rules on their previously unregulated practices. The more professional midwives, many of whom resided in Honolulu, were particularly annoyed when government policies failed to distinguish between them and uneducated midwives.[94]

Margaret Makekau, a Chinese American public health nurse in Honolulu, recalled supervising midwives and one time finding Dr. Tai Heong Kong on a case when she went to a Chinese home. Dr. Kong had registered as a midwife, for she was a qualified midwife as well as a physician. She was the wife of Dr. Khai Fai Li, and both were trained by German professors at the Canton Medical College. Dr. Kong, sometimes called Mrs. Li, and her husband began practicing in Honolulu in 1896, especially among poor Hawaiians and the Portuguese. Dr. Kong, who had thirteen children, specialized in delivering babies and, although accounts vary, it seems that she delivered more than 2,000.[95] According to a report on the reminiscences of early public health nurses, including Margaret's recollections, when Margaret came to the door the doctor "looked at Margaret and said, 'Oh, Ah Hin (her Chinese name), how good to see you. See, (she tells the expectant mother) see this girl, I delivered her.'" So Margaret thought, "'I'm supposed to supervise this midwife, the midwife who delivered me? Impossible!'"[96] Indeed, Alice Young turned over any investigation of the cases of Mrs. Li to the board of health because she was told a nurse should not investigate a doctor.[97]

Nurse relations with midwives depended to a large degree on the individual public health nurse involved. Alice acknowledged in an interview later in life that "some nurses got along nicely with midwives, got their

cooperation, and some didn't."[98] It was clearly challenging work. In 1938 an advisory nurse in the Bureau of Maternal and Infant Hygiene observed how difficult it was for nurses to carry out their health work with midwives, especially in the rural districts: "A month spent on [the island of] Hawaii impresses one with the difficult health problems to be solved on this island. The isolation which means much more travel time on the part of nurses with accompanying fatigue and the poverty which exists in some of the areas add to the difficulty in finding solutions to some of the problems. Only experienced, well-trained, conscientious public health nurses should be employed in these far-removed districts, since it is impossible to have close supervision and nurses must work to a very great extent entirely alone."[99] It was not just the nurse's sense of isolation that made her task difficult. Public health nurse Esther Stubblefield recalled that nurses in the 1930s and 1940s were taught to show people that there was one correct way to do things and other approaches would not be tolerated. "We told people what to do, or what was good for them, you know from our point of view." She continued, "I think that the longer you're out, and the more experiences that you have, the less sure you may be that your ideas were all that great to begin with, and you only hoped that God looked after things and you didn't traumatize too many people."[100]

Public health nursing involved providing health education to individuals, and one of the ways that Alice tried to ensure the safety of maternity patients was to meet with each midwife. She observed midwives performing a delivery and, sometimes, providing prenatal or postnatal care. She always sought the permission of the midwife and the patient ahead of time. When a patient objected, as one did in 1938, she agreed not to go along to attend the birth. After the birth, Alice made an appointment with the midwife to go over the case at Alice's office at the board of health in Honolulu. She would identify any techniques or procedures that needed to be improved and offer praise for what went well. In the process of close supervision she found that the Japanese midwives were very well trained. As she recalled in an interview later, they were "very precise, they learn very well, and they would follow instructions very well."[101] At the same time, she also realized that her prearranged observation of a birth meant that she did not get a complete picture of a midwife's usual approach. Some birthing women told Alice that the quality of care was different at the time she observed. A few Japanese midwives objected to Alice observing them during deliveries, finding the supervision unnecessary and insulting. They thought only the untrained midwives should be monitored. Some midwives refused to have Alice supervise a birth, invoking the wishes of their patients, when it was

they who objected. Frustrated, Alice noted in her monthly report that she had been lenient with the midwives by allowing them to opt out of her observations if patients objected and that some had taken advantage of it.[102]

Conflicts emerged between Alice and some of the midwives, especially Japanese immigrants. For example, sometimes midwives prescribed infant formulas consisting of cow's milk, sugar, and water to supplement breastfeeding, even though Alice wanted patients only to breastfeed or be referred to doctors when there were problems. Alice also urged midwives to have mothers put their babies on a three- or four-hour feeding schedule, even if they had to wake them up. This preference was common among American health professionals at the time, but it was not shared by all midwives and mothers. Nurses and midwives sometimes also disagreed over how long midwives should provide postpartum care, and the midwives' position depended on the ease with which they could return to clients. According to some Japanese midwives, it was too far to go to some of their rural patients and so they shortened the number of days they provided postpartum care, despite nurses' insistence on a ten-day period of daily visits.[103] Alice was also concerned about the use of pituitrin, a drug available without a prescription. Several Japanese midwives administered it to speed up labor and were told they had to stop. Finally, Alice frequently mentioned thermometer use in her reports. She was frustrated that midwives seemed unwilling or unable to take their patient's temperature, which could warn of serious health problems. She wanted them to check the woman's temperature during labor and delivery and at prenatal and postnatal visits. Even when they did so, many failed to keep the thermometer sterile. In a demonstration of proper thermometer use, "One midwife wiped the thermometer on her kimono sleeves before returning it to the case; another used a dirty handkerchief to clean her thermometer," observed a discouraged Alice.[104]

Many of the tensions that developed between Alice and the midwives were over hygiene requirements inspired by the germ theory of disease. Proper sanitation and cleanliness became major themes at the beginning of the twentieth century as public and private health crusades affected the practices of everyday life, including approaches to childbirth.[105] Alice was not necessarily any better educated than the best of the school-trained Japanese midwives, but she was trained more recently and in American techniques. Alice tried to ensure that midwives understood and utilized proper procedures to create a sterile environment. She conveyed the latest health-care knowledge in prenatal care, labor and delivery, postpartum care, and newborn care in order to reduce the risk of infection, injury, or death to mother and infant.[106] She taught midwives to keep their midwife bags and

equipment clean and urged them to wear clean, white uniforms to deliveries. She emphasized the importance of washing one's hands and cleaning the birthing woman's genitals before delivery. Much of Alice's instruction was based on the latest American views on the benefits of shaving the woman's pubic hair and giving an enema before birth occurred.[107]

Misao Tanji tried to follow the hygienic instructions that she had been taught in Japan and in Hawai'i by Alice. For example, when she performed a delivery she wore a sterilized gown and rubber gloves. In her midwife bag she carried a stethoscope to monitor the mother's and infant's heart rate. She also carried green soap to disinfect her hands and Lysol to disinfect the birthing woman. She dressed the woman in a sterilized hospital gown and tied linen wrappings around her legs up to the groin before the delivery. She used olive oil to swab the infant's umbilicus. In addition, she applied silver nitrate eye drops to the newborn's eyes to prevent blindness in case the baby passed through the birth canal of a woman with gonorrhea.[108] She also used a solution of boric acid as a mild antiseptic to wash the infant's eyelids, and possibly also as care for the woman's nipples. She carried glycerin to make an enema solution for the woman before birth and Ergotrate to stop excessive bleeding in the woman after the birth. In addition, according to Misao, the birthing woman's "friends and neighbors came to boil water and help

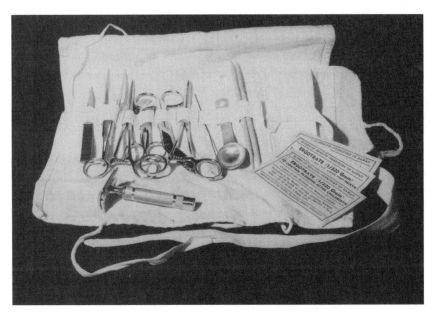

Misao Tanji's midwife instruments and supplies. Courtesy of Hawaii's Plantation Village, Waipahu, Hawai'i.

in various ways." She made house calls after the birth every day for a few weeks until the umbilical cord was healed. Like other midwives, however, she made the postpartum visits only every other day for those women who lived in the most isolated camps on the plantations.[109]

In order to meet some of the board's requirements, Misao required the assistance of others. For example, she had to submit a birth certificate after each birth. Beginning in 1937 all licensed midwives were required to submit a case report (form number 12) in English. Midwives complained about the work involved and the requirement was discontinued in 1939. Nonetheless, her eldest son Tom remembered helping her fill them out. As a result of the requirement, she decided she had to take classes to learn English. Like many Japanese midwives, Misao kept careful records of all her deliveries, but in Japanese. In case of complications, she also arranged for medical backup. Misao used a white doctor at the nearby Waipahu plantation hospital as backup, no doubt because that was where her clients lived. Other Issei midwives used Japanese doctors as backup, as did Koto Tanaka, who was aided by Dr. Yamashiro during a case of premature twins.[110]

Misao was more likely to adhere to the board of health recommendations when they corresponded with her own views of appropriate midwifery practice. For example, despite Alice's training sessions with midwives, Misao did not shave the birthing woman's pubic hair before delivery, a practice about which there is still little agreement today. Although Alice taught the midwives how to shave with a razor and scissors, she reported that many midwives found their patients reluctant to have the procedure and the midwives, too, were not convinced of its necessity. Misao also used massage in her practice, for example, to correct a breech birth by turning the baby to present head first in the birth canal. Alice commented in her reports that the Japanese midwives continued to use massage, a practice they had learned in Japan, despite her serious concerns about its value and safety. Public health nurse Luella Ekern followed some of the Japanese childbirth customs herself, such as the use of a *hara obi*, or pregnancy sash. She objected to others, however, such as drying and saving the umbilical cord for medicinal purposes or to be buried with the person later when he or she died.[111]

Alice's reports reveal instances in which midwives failed to follow the health rules or refused to register but continued to practice. Public health officials could do little to discipline midwives, except revoke their license. Alice gave a warning only to those midwives who engaged in what she considered to be unsanitary behavior, such as removing their rubber gloves before delivery was complete or attending a birth in bare feet wearing only a slip. In 1939 she visited the home of an unregistered midwife and insisted

she remove her midwife sign. Alice also kept close watch on some licensed midwives, including the Filipino immigrant midwife Guadalupe Bisande of Kauai. Alice found that most of Mrs. Bisande's patients were from the local plantation and cannery and told her to refer them to the plantation doctor instead. Alice urged her to stop practicing because she had a poor conception of aseptic technique and contaminated everything during a demonstration delivery. In 1940 Alice was appalled when she investigated an unlicensed midwife on a plantation in Oahu who had been practicing for the past twelve years and found evidence of unsafe folk medicine. She inspected the woman's midwife bag and found it contained several filthy cold cream jars and rusty tin cans filled with herbs, powders, and dried shrimps and squid. It also contained two cockroaches and cockroach eggs. The patient was to use them by standing over hot coals in which the eggs or dried seafood had been put in order to ensure a rapid delivery. The eggs were also used in brewing a drink for the patient. Leaders of the board of health reserved the most extreme disciplinary measures for midwives whose actions they saw as particularly egregious. For instance, only after eight years of repeated infractions of midwife standards did the board revoke the license of midwife Matsuru Omine. From 1937 to 1945 she failed to do the following: take the temperature of mothers and newborns, show good judgment when she gave a bath to an infant with an infected umbilical cord, report new cases or complications in cases to the public health nurse, or notify a physician when there was a premature birth.[112]

Midwife participation in informal adoption and abortion emerged as particular concerns of the board. In 1938 Sui Ishida had her license suspended for one month for misrepresenting the birth mother in order to facilitate an informal adoption. Adoption did not become a legal issue until the twentieth century, but when it did the politics surrounding it could be quite heated. Adoptions were common among Asian immigrants and Hawaiians, but only gradually did government regulations intervene in community practices. In this case, the midwife assisted the adoptive parents so that they could avoid the expense of a legal adoption. A year later, Alice was involved in a case in which the board of health revoked the license of a midwife for performing an abortion. Hisayo Fujii agreed to abort a Portuguese woman who later developed an infection and ended up at Queen's Hospital. The case was then referred to the public prosecutor, who had to drop it because of insufficient evidence. The client, Mrs. Eleanor Chambree, refused to give the police any information about services provided by Hisayo Fujii. Although the identification of midwives with abortion on the mainland paved the way for the regulation of at least some European immigrant midwives, it

seemed to play little role in Hawai'i or on the West Coast.[113] There is also some oral history evidence that Japanese midwives may have helped families in desperate financial situations to commit infanticide, especially at the birth of a daughter or deformed baby. The midwife supposedly covered the newborn's nose and mouth, sometimes with rice paper, and she would then report the baby as stillborn.[114]

Overall, Alice was less involved in punitive actions against midwives than in acting as a liaison between them and the board of health. Part of her job was to ease tensions when midwives objected to ever-increasing restrictions on their work. She was sympathetic to the midwives and aware of the need to convince them that the board was there to help not hinder them. For instance, she used her official connection with the board as leverage with doctors who objected to midwives.

Alice's reports analyzed the frustrations of Hawai'i's midwives, especially the Japanese, by contrasting them with African American midwives. As she explained to the director of the Bureau of Maternal and Infant Hygiene in 1939, the real issue underlying midwife discontent was that many of the midwives in Hawai'i were superior to black midwives and thus did not take to supervision easily. Indeed, they resisted it. She argued that "in Hawaii, we have an entirely different type of midwife to supervise; they are not like the Southern midwives who take to supervision so easily. It is to be admitted that they are a far superior group." No doubt she drew her conclusions from what she learned in her classes and from her training in midwifery at the Lobenstine Clinic in Harlem, the home of a sizable, and often poor and migrant, black population in New York City. Alice's point was that American midwife policy, as formulated in relation to black midwives, did not work in Hawai'i because the nurses did not encounter the same problems.[115]

Although Alice provided an admirable defense of why health policy needed to be attentive to ethnic and regional differences, she nonetheless reproduced a widespread image of African Americans as ignorant, deferential to white authority, and inferior to Asians. In contrast, she implied that the board's difficulties with midwives were linked to the fact that so many were intelligent, skilled Japanese midwives who simply resented the board's control. Throughout her reports she made occasional references to the fact that untrained midwives were more amenable to supervision, whereas school-trained midwives, like many of the Japanese, were offended by it.[116] In line with island racial politics, in which many of the Japanese had left the plantations and moved up in social status, Alice argued that Japanese immigrants were a superior group.

One way the urban *sanba* distinguished themselves from other midwives was through their midwife association. Japanese midwife associations, like other Japanese immigrant organizations, were important political and social groups. Midwives created midwife associations in Honolulu and Hilo, like those in Seattle and Los Angeles, to promote continuing education of licensed midwives, advance the profession, and provide support to each other. The midwife association was similar to the local medical association. As the number of Japanese immigrant doctors had increased, they had organized their own association in 1896, the Honolulu Japanese Medical Society.[117] In Honolulu, the Japanese Midwife Association was a very active organization that held monthly meetings and an annual meeting at the board of health to renew licenses. It was established at least by 1925, at which time there were fifty to sixty members.[118]

Although rural Oahu midwives like Misao Tanji joined the Japanese Midwife Association, it was predominantly for an elite group of Honolulu midwives. According to Alice, there were tensions among the Japanese midwives, especially between those who graduated from midwifery schools and those who did not. She found that the rural Oahu midwives got along well with each other, but the Honolulu midwives had a competitive attitude. Differences among the midwives, especially in social and educational status, contributed to tensions. In fact, Japanese midwives in rural Oahu felt so excluded at one point that they considered forming an organization of their own.[119]

The interactions between the Japanese Midwives Association in Honolulu and Alice reveal how some of the urban *sanba* defended their interests. Members of the midwives' association not only met together for dinners and social engagements, they also used the organization as a political platform from which to challenge government health policies when they interfered with their customs and professional prerogatives. Like the Russian, Polish, German, and Italian immigrant midwives of Chicago, who in 1910 organized to fight the way the government treated them, the *sanba* in Honolulu criticized policies and presented a set of demands.[120] In November 1938 officers of the midwives' association met at the board of health with Alice; the head of the Bureau of Public Health Nursing and the head of the Bureau of Maternal and Infant Hygiene were also present. Over the course of several meetings the midwife leaders presented their members' complaints about unreasonable age limits, too much paperwork, too much supervision of cases, and too many meetings with insultingly elementary instructions from public health nurses. One of the midwife leaders indicated that the Japanese Midwife Association kept up with current obstetric trends and members

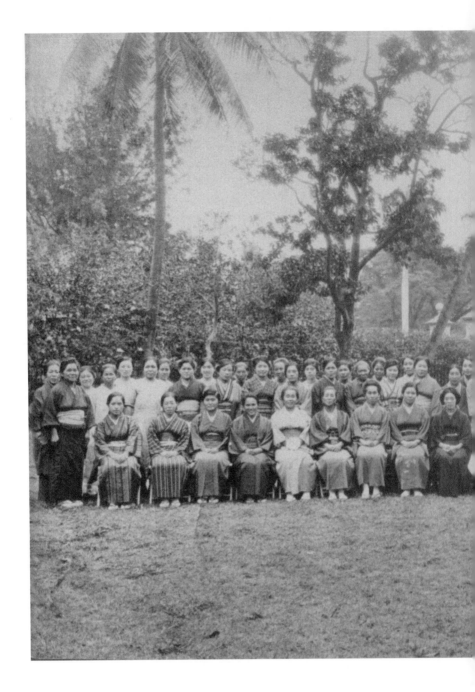

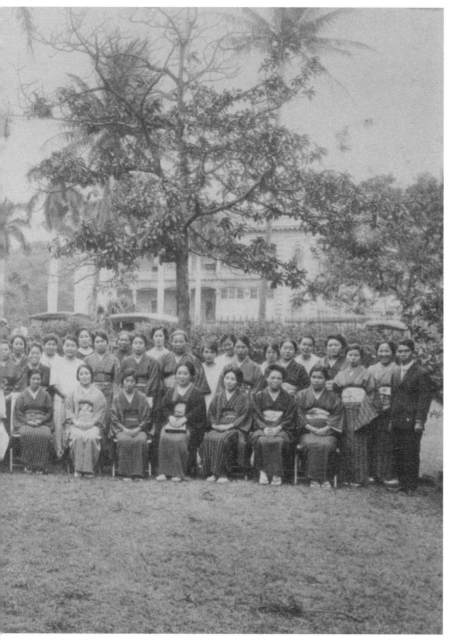

Gathering of the Japanese Midwife Association in Honolulu, with Iolani Palace in the background. Courtesy of Yukio Tanji.

should not be required to attend the annual midwife institute sponsored by the board of health. As the leaders of the association complained, they already met one hour each month with the midwife club and did not want to attend more meetings, especially when they involved instruction like aseptic glove technique and scrubbing their hands, information they already knew. They particularly feared the loss of patients when nurses directed birthing women to doctors for prenatal care. Midwives depended on patients for their livelihood and did not want competition from doctors, and moreover they were wary of nurses for a number of reasons.[121]

Like other targets of welfare state policy, the *sanba* succeeded in altering some of the policies directed at them. Alice did not accede to all midwife demands, but she did convince the board to make some changes. For example, she maintained that trained Japanese midwives still needed to be drilled in the fundamental principles rather than receive the advanced education they wanted. She also believed that until everyone used good aseptic techniques, the midwives should continue to get the same message over and over. But she did support the request to increase the age limit for licensed midwives from 60 to 65. The midwives' association argued that older women still needed to earn a living and that Japanese families preferred to engage the same midwife for all their births. Alice also agreed to urge the board to eliminate the time-consuming requirement that midwives submit case reports on every birth. The board agreed to both alterations. Midwives then had to report only complicated or abnormal cases. Alice also drew on midwife requests when she created the official midwife manual in 1940 to standardize procedures. Together, Japanese midwives and the midwife supervisor struggled to construct mutually acceptable midwife regulations in Hawai'i.[122]

Midwifery, Island Health Politics, and Alice's Appointment

Why did officials in Hawai'i put so much more effort into regulating midwifery than officials did in West Coast states like California and Washington where Japanese immigrant midwives were also prominent birth attendants? As in the Deep South, the territorial government was interested in controlling midwifery because midwives attended so many births, at least one-fourth. Also, health officials considered Hawai'i's infant and maternal mortality rates to be too high. Hawai'i had higher infant and maternal mortality rates than some western states, even though not as high as some southern states. In 1938, for example, Hawai'i's infant mortality rate was 48 deaths per 1,000 live births, compared to Washington's rate of 38 and Alabama's rate of 60. Although Hawai'i's rate was in large measure a result of the poverty

of plantation workers and native Hawaiians, and not the skills of island midwives, midwives became a target of government action.[123]

Furthermore, midwife regulation in Hawai'i was shaped by the plantation economy. Many of the midwives' clients labored on plantations where the white elite's desire to secure future agricultural laborers motivated at least some minimal health and welfare provisions. It was important to reproduce a healthy agricultural labor force, and therefore even the babies of immigrants and the poor, the midwives' typical clients, mattered. The board of health sought to eliminate midwives on plantations because most had little or no formal training, especially as the Japanese left the plantations. Instead, it wanted all plantation workers to utilize the services of the plantation doctors and hospitals.

Moreover, even though Hawai'i was made up of islands, geographic distances were manageable, with small populations concentrated on plantations and in Honolulu. In contrast to West Coast states like California, officials in Hawai'i believed it was possible to make contact with every licensed midwife. In fact, Alice Young visited midwives across the islands, aided by local public health nurses. Although Alice knew where to find most licensed midwives, she had to rely on information from public health nurses, plantation nurses, plantation doctors, private doctors, and licensed midwives to find the unlicensed midwives and tell them to stop practicing. Alice believed that she did not find most of them, but she hoped that public education about the need for quality care during childbirth would steer patients away.

Finally, we cannot overlook the role of public health officials in the promotion of midwife regulation. A public health system was well underway when midwifery reform began in Hawai'i, and thus there was an incentive and a means to act. Public health nurses from the Territorial Board of Health in the 1930s and 1940s were far more active in regulating the practice of midwifery than doctors who served on West Coast medical boards in the 1910s and 1920s. In states like California and Washington, the government placed midwifery directly under medical control through its regulation by the State Board of Medical Examiners, a sign of the degree of power that the medical profession held in these states. Even so, the physicians relied on new licensing requirements alone to ensure the quality of childbirth attendants. All they did was register midwives through an examination process and little else. In contrast, in Hawai'i the Territorial Board of Health placed midwifery under the control of the Bureau of Maternal and Infant Hygiene, as in the American South. Its placement was a sign of the power of public health officials on the islands. Public health nurses, trained to take an ac-

tive approach, did more than simply hope that midwives who did not get a license would stop practicing. Instead, they sought out untrained midwives to get them to stop and tried to improve the care that licensed midwives provided through various types of supervision and education programs. From the perspective of midwives, in trying to advance public health in Hawai'i, nurses interfered with the practice of midwives more directly than physicians did in California and Washington.

Which brings us back to Alice. How is it that an Asian American nurse obtained a supervisory position, and one where most of the people to be monitored were Japanese immigrants, even though she did not know the Japanese language? Certainly Alice was a qualified public health nurse with a proven track record. So was her friend Luella Ekern, however, the Japanese American who studied with her at the same nursing schools and worked in public health for the board at the same locations, and who spoke Japanese in addition. Public health nurse Harriet Kuwamoto would also have been a reasonable choice for the job, according to nurse Esther Stubblefield. At the same time that Alice was sent to train as a nurse-midwife, the board selected Harriet Kuwamoto to study methods of venereal disease control. "Of course, you know, government is real strange," noted Esther. "They had scholarships or grants to send two nurses away, one in [a] venereal disease program, control program, and one in midwifery, and the Japanese girl got the V.D. program and Alice got the midwifery." Esther continued, "Well, it seemed to me that the reverse would have been much better because Harriet Kuwamoto . . . spoke Japanese quite fluently."[124] Alice herself even observed in later years, "You know I have always felt because the majority [of midwives] were Japanese that they should [have] sent a Japanese nurse." She believed that Luella Ekern should have been selected and trained for the role of midwife supervisor. It remains a bit of a mystery why Dr. F. E. Trotter, president and executive officer of the board of health, and Mabel Smyth, nursing supervisor, specifically selected Alice to become midwife supervisor.[125]

We should not overlook Alice's own interests and effort to gain the position of midwife supervisor. She was an ambitious woman, eager for greater authority and a new challenge. In nursing school, she had been interested in obstetrics and she was well liked as a public health nurse. According to various interviews conducted with friends, family, and Alice herself, Alice was an excellent manager and organizer, committed to providing service to all people of Hawai'i. She was quite willing to supervise midwives of all ethnic backgrounds, including the Japanese who repeatedly insisted that they did not need it. Indeed, Alice proved to be an excellent choice for the job, and she demonstrated her ability to negotiate island health politics.

Racial politics also had an influence on Alice's appointment. Supervisory positions rarely went to people of color at the board of health, but there were exceptions. For example, Dr. Richard Kui Chi Lee, a Chinese American from Honolulu, who earned his medical degree from Tulane University and a doctorate in public health from Yale University, had an illustrious public health career in Hawai'i. He worked as deputy commissioner of health from 1936 to 1943, director from 1943 to 1953, and president of the board of health from 1953 to 1960. But when Dr. Trotter died in 1939, leaving Dr. Lee in charge of the board of health, there was much controversy. Because of his ethnic background, officials at the U.S. Public Health Service and other government authorities saw him as a weak, inappropriate leader. As a result, he did not receive the director position until 1943. In contrast, Alice was acceptable for the job of midwife supervisor in the 1930s because few midwives were white and therefore she would not have authority over white people. Furthermore, the job as midwife supervisor entailed supervising what authorities viewed as low-status health workers, not health professionals, and so they did not object to putting an Asian American in charge.[126]

Finally, Alice's position was itself a product of midwife agency, spearheaded by Japanese immigrant midwives. After midwife licensing began in 1931, public health nurses were supposed to meet with each midwife in the district who had requested a new license or a renewal. For new midwife applicants, the nurse was to visit each mother the midwife delivered to ensure that a physician had witnessed her perform the delivery and could attest to her skills. For renewals, the nurse was to investigate all the midwife's births from the previous year and inspect the midwife's bag for inclusion of proper and sterile equipment. In response, Japanese midwives insisted that only a nurse who was at least as qualified as they were should supervise them. According to Alice, "there was a great deal of resentment from the midwives themselves, at the time, because they felt that the nurse did not have as much training as they did."[127] Thus, midwives' complaints about inadequately trained nurses supervising them contributed to the creation of the position of midwife supervisor and eventually Alice's appointment.[128] Midwife negotiations with government officials were difficult but possible during peacetime. As we see in the next chapter, however, war elevated government power to an entirely new level.

MILITARIZATION, MIDWIFERY,
AND WORLD WAR II

On 7 December 1941, midwife Misao Tanji was not at home. Misao had left the night before to deliver a baby at a plantation near Pearl Harbor, not far from Honolulu. "In the morning when I prepared to leave," she recalled, "I heard machine guns. I thought the military was practicing." But "when I returned home, bullets sprayed the corrugated iron roof tops; then I knew something was very wrong."[1] War had come to Hawai'i.

A month later and more than 2,000 miles away, midwife Toku Shimomura of Seattle wrote in her diary of the "horrible war" between Japan and the United States. She expressed concern for the future of her "compatriots," perhaps referring to those living in Japan or Japanese immigrants like herself or perhaps both. It was a terrible time for Misao Tanji, Toku Shimomura, and other Japanese Americans. Toku described the war as a "lonesome and fearful thing." The first sign of trouble ahead came when she learned that there would be a "strict registration" of all "enemy country aliens." Registering her fingerprints became just one of the many war-related measures she faced. She heard on the radio that "there are loud cries demanding that all Japanese should be relocated to the hinterlands." She worried because she did not know what would happen to her and her family. She was fearful as she learned that many Japanese immigrant or Issei men were rounded up by the Federal Bureau of Investigation (FBI) and interned. "The world is dark," she lamented.[2]

The Pacific War affected all Americans, but it had a very specific impact on the Issei and their families. After two or more decades of living in the United States, Toku and many Issei felt an attachment to both warring countries. In early 1941, for example, Toku went to see a Japanese film. "I was deeply impressed and cried at the movie that celebrated 2,600 years of Japanese history. I was thankful that I had received life in such a precious country."

Exactly one year after the start of the war she wrote: "We who share in the benefits from both countries pray for an early peace."[3] Jeanne Wakatsuki Houston aptly portrayed this sentiment in describing her father's wartime experience in her autobiography, *Farewell to Manzanar*. Like many Issei men, her father Ko Wakatsuki was sent to a Justice Department camp, in his case to Fort Lincoln in Bismarck, North Dakota, where he was held for nine months. There an interrogator, testing Ko's loyalty, repeatedly asked him who he wanted to win the war. After trying to evade the question Ko finally replied in frustration: "When your mother and your father are having a fight, do you want them to kill each other? Or do you just want them to stop fighting?"[4]

Japanese immigrant midwives faced many challenges during World War II. Most notably, the war marked the beginning of the end for Japanese American midwifery. Why did war change the way babies were born? Why did birthing women increasingly turn from home to hospital births? The history of midwifery, like other aspects of Japanese American women's history, demonstrates that the war accelerated transformations that had already begun. The link between war and social change is a complex one, although often wartime developments are the result of attitudes that had also existed before the war.[5] In the case of childbirth, the U.S. wartime state limited birthing options, mandated hospital deliveries, and curtailed the practice of midwifery. Yet it also increased maternal health care for the wives of servicemen. Furthermore, generational preferences influenced the history of childbirth. The American-born or Nisei women had their own ideas about appropriate birth attendants.

Government records from the Territorial Board of Health in Hawai'i and the War Relocation Authority on the mainland demonstrate that the war contributed to the transformation of Japanese American childbirth practices because of racial politics and militarization. By militarization I mean the dynamic process by which military thinking, values, and actions influence society and shape civilian life, often in the name of national security. Militarization permeated private life in wartime through a range of formal policies and informal practices, including martial law in Hawai'i and Executive Order 9066 on the West Coast.[6]

Militarization does not necessarily lead to limitations on the practice of midwifery, but in the case of Japanese American midwifery during World War II, a militarized state had a profound impact on childbirth and health-care practices.[7] Militarization, carried out by politicians, government bureaucrats, public health authorities, and military personnel, had some affect on all residents of Hawai'i and the Pacific Coast, but especially on people

of Japanese descent. They encountered it most profoundly in terms of re-
strictions on their movements. Without freedom of movement, the *sanba,*
or Japanese midwives, like Misao Tanji in Hawai'i found it very difficult,
and at times impossible, to get to clients. Like midwives in other warring
nations, the *sanba* had to adapt their birthing practices to cope with the
disruptions of war, including curfews and blackouts.[8] Misao, like all island-
ers, lived under martial law. Toku, like other Japanese Americans on the
West Coast, endured the consequences of Executive Order 9066, including
forced removal from her home and incarceration in a government camp.
Furthermore, in each setting, wartime policies generated by state authori-
ties in public health and the military moved birth out of the home, where
most midwives delivered babies, and into the hospital, where doctors and
nurses presided.

Personal accounts of the Issei and Nisei indicate an additional cause for
the changes in birthing practices. They show that the shift from home to
hospitalized births and the move away from midwives also originated within
Japanese American communities. By 1940 most of the Japanese American
women of childbearing age were the adult children of the immigrants, and
midwifery meant something different to them. Like other American women,
Nisei women viewed midwives as old-fashioned childbirth attendants, much
as the *sanba* in Japan had viewed the traditional midwife, the *toriagebaba.*
American women in general wanted doctor-attended hospital births because
of the promises of safety and scientifically advanced health care.[9] As a result
of the interests of the new generation of birthing women, the advancing age
and poor health of some of the *sanba,* and the adverse wartime conditions,
most of the *sanba* stopped delivering babies in the 1940s. It was too frustrat-
ing during the war and not worth the trouble, because client demand was
no longer sufficient. The American *sanba* saw that providing this Japanese
cultural practice was no longer necessary or wise. The Issei way of birth
was coming to an end.

Martial Law and Army Rule in Hawai'i

As historian John Dower demonstrates in his book, *War Without Mercy,* the
Pacific War was in part a race war. Distorted ideas about race, he argues,
shaped public responses to the war, military policy, and the conduct of war
itself. He shows that governments justified the war crimes committed on
both sides in the Pacific theater of World War II by the use of unflatter-
ing racial stereotypes. The Americans, as well as the British, depicted the
Japanese as thoroughly militaristic, uncommonly treacherous, and savage

fanatics, while portraying themselves as fundamentally peaceful, democratic, and rational. American propaganda, according to Dower, rarely portrayed the Japanese as "human beings of a generally comparable and equal sort." In the European theater of World War II, Hitler and the Nazi regime—but not all German people—were seen as the enemy, whereas all Japanese people were cast as a nearly subhuman enemy.[10] Meanwhile, Japanese leaders depicted the Allies in general and Americans in particular as fundamentally selfish, greedy individualists. They argued that Japan was "fighting a holy war against a demonic foe" to defend itself and other Asians against economic and military strangulation by western imperialists. As Dower notes, racism was not simply wartime propaganda but framed the terms on which the war was fought.[11]

The war produced government intrusion into all aspects of Hawaiian life in the name of national security, most notably with the introduction of martial law. Martial law or military rule lasted from December 1941 to October 1944, when President Franklin Roosevelt terminated it.[12] More than 150,000 Hawai'i Japanese, or one-third of Hawai'i's population, faced life under martial law along with the rest of the islanders. Hawai'i saw "the intervention of the state in a form more direct and powerful than in any other American community during the war," assert historians Beth Bailey and David Farber.[13] To fight the war, American officials expanded dramatically the size and scope of the federal government, including its role in Hawai'i. The military was one arm of that state power. "The Army and Navy are not here to protect the population," warned civil defense planners, but "to defend Hawaii as one of the most vital parts of the American Defense system."[14] After the Japanese bombed Pearl Harbor, Americans feared an invasion by Japan. In response to this concern and at the insistence of the army, Territorial Governor Joseph B. Poindexter, "a cautious, elderly ex-federal judge," invoked the newly created Hawaii Defense Act and placed the islands under martial law and in the hands of a military governor.[15]

Martial law was controversial. It was at best "unpopular and by a general consensus continued longer than any military necessities warranted."[16] Hawai'i's two major newspapers were divided over the issue of martial law, although the mainland press was generally critical. Many Democrats and labor unions objected to the loss of civil liberties and workers' rights. Many Republicans, business leaders, and planters endorsed martial law because they felt safer in the midst of so many people of Japanese descent and felt reassured that their labor force would be secured. Once the military took control, it was reluctant to release its reign over the islands. J. Garner Anthony, the attorney general of Hawai'i during the war, argued that martial

law continued as long as it did because of "military fears that, having assumed a fictitious title of military governor and having erected a military government without legal sanction, the Army would lose prestige if it were to admit its error."[17]

The American military governed the islands like an occupying army in a heavily militarized zone. As a branch of the federal government, the military had long been an institutional presence that owned land, controlled resources, and affected daily life on the islands. Since the late nineteenth century when the first permanent American military garrison arrived, the military's extensive power in Hawai'i had been based on imperialist notions of protection and security.[18] Military rule during World War II saw the full realization of the military's plans for the islands.

Martial law changed everything. "The general orders issued by the military governor of Hawaii," explained Anthony, "were probably the most comprehensive orders of punitive martial law ever promulgated on American soil." The powers may have been even more sweeping than those imposed on the South during the Civil War.[19] The Office of the Military Governor generated policies that produced curfews and blackouts; censorship of the media, mail, and long-distance phone calls; trial by military judges; a requirement to carry identification cards at all times; and many restrictions on civil rights, with criminal sanctions and severe punishments for those who violated the rules.[20] One of the restrictions that directly affected the Issei was a ban on many Japanese cultural practices, including speaking the Japanese language in public.[21] The army also issued orders that affected health and welfare services, including public health, sanitation, medical personnel, and hospitals. Like other Issei organizations, the Japanese Midwives Association in Honolulu was forced to close with the outbreak of war. It did, however, reemerge after the war.[22]

Martial law was a response not just to the enemy abroad, but also to the perceived enemy within. Racism affected the way the war played out not only against the Japanese in Japan, but also on the home front against Japanese Americans. As one white woman explained, "we had had stories as far back as 1940 & all thru 1941 that the [local] Japs . . . were all set to kill or poison every haole [white person] in the islands the moment war struck."[23] In sum, although martial law may have applied to everyone, historian Gary Okihiro asserts that it was "fundamentally an anti-Japanese act . . . executed specifically to contain the 'Japanese problem.'"[24] Territorial Governor Poindexter justified the move to military rule on the grounds that Hawai'i had unusual security problems because it could not trust people of Japanese ancestry. In fact, the extreme wartime measures had been planned

by the military since the 1920s to thwart the alleged threat from Japanese settlement on the islands.[25] In effect, the enactment of martial law meant that all islanders paid a price for military, government, and planter distrust of Japanese immigrants.

Wartime measures affected everyone, though they had their most dramatic impact on the Issei, including Issei doctors. The government perceived the Issei to be potential enemies of the United States. During the war, many Issei doctors were among the community leaders rounded up by the FBI, the police, and the army as national security risks. Among those arrested and taken to Sand Island military camp were Dr. Iga Mōri, the doctor who had helped run the Japanese hospital in Honolulu.[26] The Nisei doctors, as American citizens, were not taken into custody unless they had had recent activities in Japan. Among the Hawai'i Japanese who were arrested and interned, more than 60 percent were Issei and most of the remaining were Kibei, Japanese Americans born in the United States but raised and educated in Japan. In this sense, the FBI made distinctions between the Issei and Nisei. Meanwhile, army personnel set up first-aid stations in nearly half of the forty-eight hospitals in Hawai'i. Among the hospitals used by the military was the Japanese Hospital in Honolulu, where the army converted half the building into a military hospital. Apparently, the Issei staff members destroyed many hospital records because of fears that the Issei would be deported or interned.[27]

Wartime policies reinforced existing trends among the Hawai'i Japanese and elevated Nisei leadership. For example, once the FBI rounded up many of the Issei doctors from the Japanese hospital and the Japanese Medical Association in Honolulu, the Nisei doctors took charge. In fact, by 1940 Nisei leadership in the hospital had become increasingly apparent. In 1942 one of the reforms the Nisei made was to rename the hospital after the street upon which it was located, and it became Kuakini Hospital. Choosing a Hawaiian name, and one originally from Hawaiian royalty, seemed preferable to the dangers of appearing to sympathize with Japan. The Nisei also changed the official language of all oral and written communication, including hospital business and client contact, from Japanese to English. In rapid fashion they attempted to "Americanize" the hospital in order to prove their loyalty and protect the hospital and themselves.[28] Meanwhile, wartime restrictions contributed to the decline in patient interest in Japanese hospitals on the island of Hawai'i. "During the war it was more difficult to travel to make house calls," explained a Japanese doctor in Hawai'i, "and the Japanese became more Americanized. Prior to the war, my patients refused to go to Hilo Memorial [Hospital], but after the war, they were more

accepting of American ways."[29] No doubt at least some Issei believed they had little choice.

Japanese Midwifery and the Board of Health in Wartime Hawai'i

After the attack on Pearl Harbor, public health nurses, doctors, and emergency personnel were immediately called on to offer assistance. Honolulu's two radio stations, KGU and KGMS, broadcast the news flash: "Civilians stay off the streets! Civilians stay off the streets! All army, navy, marine, and first-aid station personnel report to your stations at once! All firemen and policemen report to your stations at once!"[30] Alice Young, the midwife supervisor at the board of health, recalled the time vividly. "I was part of the Civil Defense team, and . . . we were prepared for emergencies of that type and so on the morning of Pearl Harbor, here I was a Red Cross nurse, and over the radio 'All of the Red Cross nurses report to Pearl Harbor.' I was dying to get out there, you know. But my nursing director, Miss Williams said, 'Alice, you come right down to the Health Department; we need you, you've got to take care of your midwives, you know, you can't go out to Pearl Harbor.'" Needless to say, Alice was disappointed. On 7 December instead of being where the action was, she spent five hours helping to organize a First Aid Unit at the board of health and preparing obstetrical packs for emergency use.[31]

Racial politics, exacerbated by the Japanese attack, became an acceptable reason for making nursing assignments. In contrast to the order Alice received, the nursing director sent public health nurse Esther Stubblefield to help out in the area that had been attacked. She reassigned Esther from venereal disease control to district nursing in Pearl Harbor and Hickam Field. The nursing director sent Esther to replace Clara Sakamoto, a Nisei nurse who had been working in that area. The military did not want Clara there. Esther explained in later years that she was sympathetic to the military's perspective. "The military requested that they have a Caucasian nurse out there because the feeling was so fraught and they didn't think it was fair," she explained. "And it really wasn't, to have a Japanese nurse working in an area where there was lots of military."[32] American sentiment made little distinction between the Japanese enemy and a Japanese American.

Hawai'i provides an ideal case study of the impact of war on midwifery. Wartime policies not only had negative repercussions for nurses of Japanese descent, but also for midwives. Under martial law, civilians were not allowed out on the streets from dusk to dawn unless they had an official pass, and

only American citizens were permitted to get one. As "enemy aliens," the *sanba* were not eligible. Restrictions on travel were especially severe on Oahu, the most populated of the islands and the location of most military personnel. Physicians limited their house calls at night, but midwives could not simply wait until morning when a baby was on the way. Leaders of the board of health knew right away that birthing women would be adversely affected by restrictions on the movements of midwives. They sent three of their public health nurses, Esther Stubblefield, a Nisei nurse, and another woman, for training in midwifery at nearby Queen's Hospital, Honolulu's largest hospital. The nurses watched deliveries and asked lots of questions and, as Esther put it, "we left hoping to God that nobody ever depended on us."[33]

Military policy called for birth to move into hospitals. According to Alice Young, midwives were not permitted to do deliveries because "the military government issued an edict, an order, that all [pregnant women] . . . were to go into the hospital for delivery."[34] At the start of the war there were about seventy licensed midwives, most of whom were Japanese, including thirty-two of the thirty-six licensed midwives in Honolulu.[35] The government did not want the Issei out at night, but what were health officials to do about the midwives? As Dr. O. Lee Schattenburg, head of the Bureau of Maternal and Child Health in Hawai'i, stated: "war or no war, women will keep right on having babies and they must also receive adequate care."[36] Officials had to do something.

Alice and the leaders of the board of health tried to help the midwives. Late in December 1941, M. F. Haralson wrote to Major W. F. Steer, military police company commander of the Honolulu Police Station. Haralson requested identification cards for the licensed midwives to attend births at night. "While we are unable to vouch for the alien midwives individually, our experience with them has been quite satisfactory," he noted. "They have, as a group, abided by the regulations and cooperate very closely with the Board of Health." Furthermore, he noted that the midwife supervisor "is of the opinion that all of the alien midwives will comply with any instructions of a restrictive nature which may be issued."[37] Even in wartime, Alice continued to mediate between the midwives and government authorities. The permits were issued but were revoked after only two weeks. Apparently, someone in the military government objected to having any Japanese people, even midwives visiting clients, out on the streets at night.

Alice held three meetings with Oahu midwives in December to provide instructions on how to conduct deliveries under blackout conditions. Through Alice, the board directed Oahu midwives to refer all patients to the hospital.

When that was not possible and they had to be out at night to do a delivery, they had to request a police escort. Because most midwives and their clients were Japanese, this policy was directed at Issei women.[38] Alice indicated in her monthly report to the board that the midwives agreed to send all cases at night to the hospital unless they could stay at the patient's home from 6:00 P.M. to 6:00 A.M.[39]

By all official accounts, the midwives cooperated with the new rules. Dr. Schattenburg informed the territorial commissioner of Public Health in 1942, "We are at present not having any serious difficulties keeping our midwives in line under present military rule."[40] According to Alice's reports to the board of health, from December 1941 through August 1942 licensed midwives sent more than seventy of their patients to the hospital for delivery in response to the restrictions. Families were expected to cover the extra costs associated with hospital births, except for servicemen's wives, who received government assistance. From July 1941 to June 1942, the thirty-six licensed midwives on Oahu still attended more than 1,000 births, many of which took place after the war began. In January alone midwives delivered eighty-four babies. The two registered lying-in homes run by Japanese midwives also remained busy during the war.[41]

Arranging police escorts for midwives was a complex issue, especially in Honolulu. Midwives in rural Oahu had more access to police escorts, perhaps because of their smaller caseload.[42] Dr. Samuel M. Wishik, director of the Bureau of Maternal and Child Health in 1943, notified Honolulu midwives that Honolulu's chief of police affirmed that the police "will transport alien midwives after curfew hours when this is necessary." He advised, however, that "It is expected that the midwives will try not to call upon the police for this courtesy unless they have no other means of offering service to the patient. If the midwife expects a patient to go into labor it would be wise for the midwife to go to the patient's home before blackout starts." He also said midwives should not expect the police to take them back home. They should wait until daylight. Finally, he warned, "If the midwives become unreasonable and make too many demands for this service, the Police Department will not be able to continue it."[43]

The new rules produced special challenges for midwives. On the one hand, midwives could accommodate the requirement that they remain overnight because that had long been a part of the cultural practice of midwifery. On the other hand, midwives were expected to somehow know in advance when a woman was going to deliver. Although midwives had a good idea of a woman's due date, it was asking the impossible to have midwives know exactly which night they might be needed.

Even when a midwife was able to get to a delivery at night, performing one under blackout conditions was no simple task, as we can surmise from some of the descriptions presented by public health nurses working during the crisis. One public health nurse at a hospital in rural Oahu wrote, "It was a strange experience indeed, working through long, black hours with the feeble assistance of blue-covered flashlights which cast a weird light on the faces of men." Another rural nurse stated, "When I visited a maternity patient, I found she had attempted to black out her room for a home delivery. Knowing the rigid rules for blackout I was sure it would not get by. I mooched some black paper from the home defense office so that the husband could finish the job."[44] The cars driven at night also had to be prepared for blackout conditions. "Headlights on all of our cars were properly painted with the prescribed black and blue paint, in case we should be called out at night," explained nurses Virginia Jones and Mildred Byers. "We have all been fingerprinted and enumerated, and we have been issued more passes and cards than our purses hold. We have made up a supply of sterile obstetrical packs for home deliveries, and we have a supply of kerosene lanterns, painted blue, for the use of nurses who may have to be out at night for a home delivery, or for care of a premature infant."[45] Jones, in particular, found the evening of 7 December, when she was called to duty, to be quite extraordinary. "Driving in complete darkness without lights was somewhat slow and complicated. We were stopped at almost every block and asked who we were and where we were going; for by this time every place was guarded by regular police, home guards, R.O.T.C. men, and recruited volunteers—and they did not stand for any foolishness. Their guns were cocked for use." As she explained, "one gets much more tired and tense living under blackout and martial law conditions."[46]

One can well imagine the effects the new wartime regulations had on the Japanese midwives, who already felt under suspicion and surveillance after Japan's attack. Some midwives were reluctant to seek out the police in order to attend births. As Alice's reports to the board of health indicate, many midwives decided not to do deliveries and referred their cases to hospitals. Seven midwives resigned because of the blackout restrictions, lack of work, or poor health. By mid-1942, Dr. Schattenburg announced, "The increasing demand for physician and hospital deliveries, coupled with stringent wartime regulations, has resulted in a decrease in midwife activities. Handicaps of non-citizenship, travel difficulties and other factors have apparently discouraged midwifery as a profession. The number of registered midwives in the Territory dropped to 57, as compared with 72 last year and 187 in 1934."[47] Midwives attended about 15 percent of all births as of mid-1941,

but only 5 percent in 1945 at the close of the war. In the words of midwife supervisor Alice Young, midwives in Hawai'i were "wiped out" during the war.[48]

Nonetheless, a few midwives hung on through it all. Midwifery did not simply disappear. Several *sanba* managed to attend deliveries, despite the complications in getting to patients. Nurse Esther Stubblefield believed that some midwives still did births at home but reported them as "unattended births" or did not report them at all. "[W]e knew that some home deliveries were done," Alice Young also admitted. "[T]hey were either unreported, [or] reported as unattended, but later on some of the nurses told us . . . they found out that some home deliveries were done." Alice conceded that regardless of the military government's new rules, the board could not fully control what the midwives did.[49]

Alice tried to find a way to provide a place for midwives, if not midwifery, in the changing health-care system. One suggestion from the board of health was for midwives to become home-care nurses who made daytime home visits to the mother and baby after birth. Losing attendance at labor and delivery, though, was losing the very thing that made one a midwife. Still, the board promoted this use of midwives as a way to deal with new hospital policies. Hospitals now sent women home sooner after giving birth. According to an interview with Alice, she and other leaders at the board of health "came up with the idea that as long as the patient was going back into the homes so soon, the midwives can go into the homes and help the mothers with taking care of the mother and baby." Apparently this idea was popular with some patients. Alice remembered that "there wasn't enough midwives to go around. I mean, a midwife, once she goes into a home, she not only takes care of the baby and the mother, she cleans the house, she does the cooking, and she is an all-around person." Performing such household tasks, if indeed the midwives did do that, marked a change for at least the more professionalized *sanba*. Still, perhaps some work was better than no work. As for the clients, women who had hospitalized births may have been interested in hiring someone to provide postpartum and newborn care, now that they were released so quickly from the hospital. To keep beds available in increasingly crowded obstetric wards, women were now released only twenty-four hours after delivery instead of after the usual week or two. In this way, hospitals were not isolated from the effects of war. They were crowded, understaffed, and subject to blackout rules. Militarization had an impact on hospital births as well as on home births.[50]

Midwife Misao Tanji was one of the few *sanba* who delivered babies throughout the war. She remembered how war affected all aspects of her

life. For one thing, she and her husband Takeo lost all their savings. They had deposited it into a bank through a *tanomoshi,* a rotating credit pool that functioned as a private Japanese savings and loan for a small group of people, and the government froze all Issei accounts in branches of Japanese banks. In addition, her husband made his living as a photographer and the government confiscated his camera. He moved into photo finishing, however, and his business flourished during the war. She also continued to get clients, despite the difficulties during wartime. As she put it, "War is war; but babies still are born and I was busy."[51]

More than forty years after the war, Misao remembered how difficult it was to be a Japanese midwife at that time. In addition to being out on a delivery the day of the attack, she had a case on a plantation the day after. "I did not want to go but the patient insisted she preferred me to the hospital." She recalled that it was a scary time for the Issei living in Hawai'i. At least with her clients, being a midwife protected her from some of the anti-Japanese sentiments. "I went to the home of a Filipino family," she recalled. "They knew I was Japanese, but the husband had a cane knife and kept saying, 'If any Japanese comes here, I am going to use this knife.' Apparently he did not consider me Japanese, but a midwife."[52] Her eldest son Tom, a teenager during the war, remembered the shifts in her practice. She was called to deliver babies in distant places, even the other end of the island, whereas previously she had just worked in the nearby area of Waipahu. Even local deliveries, however, were hard for her to get to. Misao remarked, "I could not leave the home because I was an alien. The police had to drive me to and from the patient." As a midwife in rural Oahu, she was among the more fortunate ones able to get police assistance. Nonetheless, she explained, "Gradually I began to dislike the frustration." According to Misao, her sister-in-law Matsu Tanji ended her practice during the war "after [her son] Mitsuo's death on the European front."[53] He was one of the 23,000 Nisei men and 100 Nisei women from Hawai'i and the mainland who served in the military during the war.[54] Unlike Matsu, Misao continued to work as a midwife into the postwar years, but she was one of the few who did.

Nisei Women and Hospital Births in Hawai'i

The number of midwife-attended births in Hawai'i dropped during the war, but not only because of restrictions produced by militarization and racial politics. Another factor was the change in demand from birthing women. In only one generation, midwifery ceased to be an attractive option for

most women within Japanese American communities. According to historian Yukiko Kimura, "Practically all the Hawaii-born women resorted to physicians and hospitals for care during pregnancy and childbirth. 'Nisei all go to doctors' was the major complaint among the midwives in the 1930s. Thus, their clientele shrank as Issei women passed the child-bearing age."[55] The war accelerated the trend away from midwives that had begun for the Nisei even earlier.

Some of the changes in childbirth were inspired by health messages that continued to draw on earlier themes of "scientific motherhood" and the benefits of accepting medical direction. For example, Dr. Richard Kui Chi Lee, a Chinese American who served as director of the board of health, gave a radio address in 1943 in which he urged all women to go to the hospital for childbirth. As he explained, "At the hospital the mother receives the protection of special technique, cleanliness, professional training, and equipment which is kept ready for any possible emergency. It is never possible to predict before a delivery which person may have some sudden unexpected complication."[56]

Childbirth patterns reflected these views. By 1947 the remaining twenty-five licensed midwives delivered only 3 percent of all births. That same year Dr. Barbara Ann Hewell of the board of health reported, "The midwife program is gradually terminating, as no new midwives are being licensed." By 1951 the board's annual report indicated that "the number of midwives requesting re-licensing each year is steadily decreasing." The board proudly provided an overview of the increasing rate of hospitalized childbirth in Hawai'i, charting the transformation from 10 percent of all births in 1931 to about 40 percent in 1936, 75 percent in 1941, 90 percent in 1946, and 98 percent in 1951.[57]

There were fewer midwives available in the 1930s and 1940s because some of them retired as a result of illness or old age. As client demand dropped, some midwives became caregivers to elderly white patients, worked in domestic service, or returned to Japan.[58] Furthermore, there were no new midwives to replace them. Motome Morita of Kauai was the rare exception. She was a Nisei woman who grew up in Hawai'i but went to Japan to become a school-trained midwife. She graduated in 1936, worked for three months at the Ogata Women's Hospital, and then returned to Kauai, where she practiced midwifery.[59] Most Nisei women who entered health-care occupations, however, went into nursing. By 1940 they could train at several hospitals in Honolulu, the Japanese Hospital, Queen's Hospital, and St. Francis Hospital among them.[60]

The personal accounts of nurses, midwives, and midwives' family members

confirm that the Nisei in Hawai'i gradually turned away from midwifery. Much of the transition from midwives to doctors on the island of Hawai'i, for example, took place in the 1930s and 1940s as doctors delivered more Nisei women than midwives did. Nisei women turned either to Japanese doctors or to white plantation doctors. Yoshiko Higa of Hilo worked as a nurse at Dr. Matayoshi's hospital and had four of her five children there. In 1947 the daughter of Mrs. Nobuyo Nowaki of Hilo gave birth with the aid of the same midwife that Mrs. Nowaki had used, but the only reason she did was that Dr. Theodore Oto did not arrive on time. Another Nisei woman on the island remembered that Dr. Bergin, the plantation doctor for the Laupahoehoe area, began to take over from the midwives and attend the deliveries in their area in the early 1940s. Still another Nisei woman from Keaau remembered that the midwives delivered babies until the mid-1930s and then plantation doctors began to attend the births.[61]

The term "modern midwife" had become an oxymoron as the meaning of midwifery shifted over time among people of Japanese descent. The Nisei in Hawai'i, like immigrants on the mainland, had been the targets of an Americanization crusade in the post–World War I years. In the early twentieth century and into the interwar years, various programs in schools, factories, and unions tried to turn immigrants and their children away from "foreign" customs. Childbirth was one area in which Nisei acculturation and generational transformations were apparent. As Flora Ozaki, a maternity nursing consultant for the board of health from 1944 to 1954, observed, "the picture was changing."[62] Alice Young explained that "the younger families went to the hospital, went to the doctors."[63] Alice noted that women in the postwar years no longer feared going to hospitals and wanted access to medical advances. Esther Stubblefield, who supervised the *sanba* for a time in the 1940s, said that by that decade it was predominantly the Nisei who were having the babies. According to Esther, Nisei women wanted hospital births because unlike the immigrant generation they had gone to school in Hawai'i, knew English, and wanted modern practices.[64] Most white women already went to hospitals for their births and now Japanese American women did too.

Misao Tanji was among the very last licensed midwives to deliver babies in Oahu in the postwar years. Misao was the final midwife still in the directory for the city and county of Honolulu, appearing in the publications for 1958 and 1959–1960. She continued until her youngest son completed dental school because she needed the money to pay for his education. Mrs. Ogawa's sons also benefited from her midwifery practice. She put them through medical school with the money she made at the Ogawa Lying-in

Home. After Misao's son graduated, she stopped doing deliveries. She could have worked even longer because a few women still called on her. People who requested midwives by this point were those who could not afford doctors and hospitals or did not have insurance to cover the costs.[65]

By the postwar years Misao encouraged women to look elsewhere for care. "After the war I limited my practice and urged the women to go to the hospital," she explained, "where they could receive free services which I couldn't provide."[66] At this time, hospitals enticed patients with their medical technology, diagnostic tools, and insurance plans. In addition, Esther argued, "The wages on the plantation were low before the war so the patients could not afford much. After the war when wages became higher, the patients were able to pay a little more." She also indicated that even though workers won major strikes in 1946 and 1947 in the sugar and pineapple industries, they ended up losing free medical services and nurses on the plantations.[67] For a variety of reasons, birthing women were moving into the hospitals.

Tom Tanji, midwife Misao's eldest son, remarked that by the time the Nisei like himself had their children, they wanted hospitals because they offered more security. "There was no need for midwives," he explained. It was, in fact, his mother who encouraged his wife to go to a doctor. Misao did not offer to deliver the baby, although she did examine his wife to note the progress of the pregnancy. Tom said they did not use his mother's services because she was no longer active and doctors were better trained than midwives. Instead, his wife went to a family doctor in Waipahu. Tragically, Tom and his wife lost their first child. There were complications during the delivery and a doctor had to perform a cesarean section. The baby died two days later. It was a terrible loss. Misao must have been frustrated and upset. She may have even felt guilty for not insisting on doing the delivery of her own grandchild, after having provided decades of excellent care to others. Tom recalled that she was very critical of the doctor's care. She told him that there was no excuse for a doctor to miss his wife's pelvic problem. As a result, Tom's wife went to an obstetrician for her second birth, hoping a specialist would help. The next baby was fine.[68]

In this case, the midwife had passed the torch to a doctor as the new expert in normal childbirth, yet it was not an expertise doctors necessarily had. Furthermore, despite the promises of improved safety, the doctor could not guarantee a perfect birth and a child safely delivered, even in a hospital. In response, Tom, like other patients, looked to obstetricians as the specialists within the field of medicine. Japanese midwifery, with its long history of expertise in childbirth, was over in Hawai'i.

Executive Order 9066 and Government Camps
on the American Mainland

Meanwhile, the war with Japan led to government intrusion into the lives of Japanese Americans on the mainland, particularly along the West Coast. Japanese Americans encountered extraordinary and severe wartime restrictions on the grounds that they represented a threat to national security. In one of the first signs of the changes that lay ahead, the FBI conducted unannounced searches of Japanese American homes. Any alien Japanese with books, letters, diaries, and other items written in the Japanese language, or objects like the Japanese flag, would be suspect and could be apprehended. People burned and destroyed many of their belongings and family treasures out of fear. In addition, the government froze the bank accounts of the Issei, leaving them with no access to their money. Finally, Japanese Americans were put under an evening curfew and not allowed to be out of their homes at night.[69]

Just as militarization shaped private life in Hawai'i, it also affected life for Japanese Americans in California, Oregon, and Washington, who faced a harrowing process of what the government called "evacuation" and "relocation" from the coast. In February 1942 President Franklin Delano Roosevelt signed Executive Order 9066. In effect, it turned all alien enemies on the West Coast and anyone of Japanese birth or ancestry over to the military control of the Western Defense Command. Later that year Hawai'i's Attorney General J. Garner Anthony responded critically to the developments on the West Coast, just as he had in Hawai'i. He referred to the appalling actions on the West Coast as nothing less than "a form of martial law."[70] First, military personnel removed Japanese Americans to one of fifteen detention centers, euphemistically called "assembly centers." The centers were along the West Coast at racetracks and fairgrounds. People were told to bring only what they could carry, and families were issued identification numbers. Second, several months later they were moved inland to one of ten government camps, euphemistically called "relocation centers." The War Relocation Authority (WRA), a newly established federal, civilian agency, was responsible for the "residents" once they arrived in these prisonlike camps. The WRA camps were different from the camps run by the Immigration and Naturalization Service in the Justice Department, camps for potentially dangerous enemy aliens.[71] The army carried out this forced migration and military police guarded the WRA camps, which resembled army camps with row after row of barracks. Historian Roger Daniels argues that politicians were the driving force when they "used a false doctrine of

'military necessity' as a rationale for their political decision."[72] Indeed, state and local politicians and bureaucrats urged these acts, although only the federal government could authorize them.

The relocation and incarceration of nearly 120,000 Japanese Americans, 70,000 of whom were American citizens, was "*the* central event of Japanese American history," asserts Daniels.[73] As he and other scholars of the wartime experience have demonstrated, people of Japanese descent were imprisoned without cause by their own government, with no charges laid and no trials. Singled out for mass evacuation, Japanese Americans experienced feelings of anxiety, anger, shame, confusion, and resignation.[74] They encountered nothing less than "humiliating segregation" at the hands of the U.S. government and the military.[75]

Even as the government built these WRA camps, investing millions of dollars, they were to serve as mere way stations. Focused on winning the war, the federal government wanted WRA officials to resettle as many Japanese Americans as they could outside the West Coast and get them working to support the war effort.[76] The federal government, which had forced people into camps in the first place, did not want to be responsible for the so-called evacuees any longer than it had to. One of the greatest fears of officials at the WRA headquarters was that the camps might turn Japanese Americans into wards of the state just as government-created reservations had supposedly made American Indians dependent on the federal government.[77]

President Roosevelt had wanted to isolate people of Japanese descent in Hawai'i as well, but the Hawai'i Japanese constituted more than one-third of the population and many were skilled metal workers, carpenters, and longshoremen. Their absence would have wreaked havoc on the economy and disabled America's war effort, whereas on the West Coast Japanese Americans were direct competitors with white Americans in commercial fishing and farming. Furthermore, the imposition of martial law meant that mass incarceration was unnecessary. Still, more than 1,200 people, mostly Issei men, were interned in Hawai'i, mostly in a military camp on Sand Island off the coast of Honolulu. Hundreds of Hawai'i Japanese were also sent to mainland camps, some to the WRA camps and some to Justice Department camps.[78]

The treatment of Japanese Americans during World War II remains a cautionary tale about sacrificing civil liberties in the name of national security. As an African American writer in *The Crisis*, the journal of the National Association for the Advancement of Colored People (NAACP), argued in 1942: "the barbarous treatment of these Americans is the result of the color line."[79] People of Japanese descent were forced into the WRA

camps on the grounds that their loyalty could not be guaranteed. The U.S. government treated Japanese immigrants and their American-born children and grandchildren as parties to the conflict in the Pacific War with Japan. Decades later, scholars and Japanese American activists demonstrated that the incarceration was neither just nor necessary. Ultimately, as a later presidential commission concluded, this government action was the result of "race prejudice, war hysteria and a failure of political leadership."[80]

Midwives and the Health Care System in the WRA Camps

At the same time that martial law and the Territorial Board of Health sharply curtailed Japanese midwifery in Hawai'i, the health care policies of the WRA camps contributed to its erasure on the mainland. According to evidence from several camps, there simply was no place for the practice of midwifery in the health-care system.[81] Instead, health policy mandated that all births take place in camp hospitals. Still, we can catch occasional glimpses of midwives in the government records and, when combined with information from midwife Toku Shimomura's diary and interviews with family and friends of midwives, we can get a better picture of the midwives in the camps.

World War II was full of ironies for Japanese Americans. Within the barbed-wire boundaries of each WRA camp, they encountered not only repressive warfare state action but also public welfare provisions.[82] Although services in the camps were never adequate, they were enough to prompt some politicians and members of the public to accuse the WRA of pampering Japanese Americans. "To hell with any further coddling of these damned, deceitful, arrogant rats," wrote Seattle resident B. M. Perry to President Roosevelt.[83] In response to such criticisms, government health officials justified their services by emphasizing that the camps were full of American citizens, as well as their immigrant parents, and that the government provided only the essentials of living.[84]

According to government records, health care was the centerpiece of public provisions within the camps. Camp health-care services mirrored those for U.S. military forces, which sometimes equaled or exceeded those available to civilians.[85] Inside each camp, which held from about 8,000 to nearly 20,000 people, the government constructed and staffed a hospital. Officials represented such health-care resources as a sign of government concern for the welfare of those incarcerated and an indication that they were treated humanely. In 1944 Charles E. Irwin, the chief medical officer at Heart Moun-

tain Relocation Center in Wyoming, declared, "In my judgement, the people of this center have more ready access to medical care and more prompt service than is available to the people of many outside communities."[86] Dr. Irwin's point was one repeated by government officials associated with the WRA in order to mute any criticisms of the incarceration. Although one medical director stated defensively that the camps offered "free medicine," not "socialized medicine," the result was the same—federally funded health care.[87] Here many Japanese Americans, especially from rural areas, received more professional health care than ever before. Furthermore, they obtained more free health care than residents of most American communities at the time. Indeed, Dr. Irwin argued that some of the people who were released early from camp to take jobs elsewhere, including farmwork, "applied for reinduction" because they needed medical care and could not afford it.[88]

In the process of providing public health care, the federal government contributed to an increased "hospital consciousness." The federal government promoted the hospital as a sign of modernity. By the 1920s the hospital had changed from its nineteenth-century role as a stigmatized site of public charity for the poor to its twentieth-century role as the celebrated center of modern science. The hospital had become essential to the practice of medicine.[89] During the war, the government funded hospital and medical care for the families of servicemen as a way to "boost morale" for servicemen to the benefit of the military. The wartime Emergency Maternal and Infant Care program (EMIC) provided health care near military bases to more than a million women and children—near the bases in Hawai'i as well. As part of this program, the government paid for, and therefore encouraged, women to give birth in hospitals.[90] Inside each WRA camp, much of the government's health-care resources went toward constructing and staffing a hospital. Modeled after U.S. Army hospitals, built by the Army Corps of Engineers, and furnished by the army, the camp hospital became the primary locale for health-care work.[91]

How should we interpret the provision of these health-care services? How was rhetoric about health care used to justify the loss of civil liberties? What minimum health-care provisions were deemed necessary for "enemy aliens"? Although historians of medicine have examined aspects of the impact of World War II on the health of soldiers, medical and nursing personnel, and prisoners of war in the Pacific theater, they have paid little attention to the health consequences of the war at home.[92] My work joins that of a number of scholars from various disciplines who have provided a better understanding of the story of health care during the incarceration of Japanese Americans.[93] This scholarship demonstrates that the government response to Japanese

Americans produced a health-care crisis of enormous proportions that was averted only because of the efforts of Japanese Americans themselves. The forced relocation created a situation in which a health-care system had to be built from scratch to care for a vast population placed in desolate locations. Despite the benefits of medical care, the government provided it in a physical and political environment that contributed to poor health. In the end, the most defining influence on health-care provisions to detained Japanese Americans proved to be the constraints imposed by life in camp.

Much like today, gender, racial, and medical hierarchies shaped health-care work within the camps. Each camp employed a white male physician as the medical director in charge of all camp health-care services and staff. Doctors were situated securely at the top of the health-care hierarchy. Although doctors held the most authority, each camp also had a white female chief nurse who supervised the nurses and nurses' aides. The government had hoped to recruit many white nurses and doctors as staff members, but the needs of the military, along with civilian employment, made it extremely difficult for camp officials to recruit them in sufficient numbers. Since potential applicants had better employment options, they did not find employment appealing in places like the Arizona desert and Arkansas swampland.[94] Consequently, a few of the doctors and nurses who worked in the camps had outdated knowledge or poor bedside manner and had been rejected elsewhere. Furthermore, wartime racial politics contributed to a constant problem in staffing the health-care system in the camps. Many people did not want to work with Japanese Americans. One nurse proved to be particularly troublesome because, according to other health workers, "she openly expressed anti-Japanese attitudes and ideas in the presence of Japanese patients and nurse aides."[95] Residents in a community near the Manzanar camp in California increased the hiring difficulties when they accused camp employees of being traitors and "Jap lovers."[96] In sum, only a few white health workers opted to work in one of the government camps.

Ultimately, the federal government carried out its responsibility for the health of those incarcerated through the labor of Issei and Nisei health workers. The government attempted to secure the services of all evacuated Japanese American health-care personnel, an approach that successfully recruited workers because it was coercive. The government relied upon the expertise of these physicians, surgeons, dentists, optometrists, pharmacists, nurses, and nurses' aides and then paid them the extraordinarily low wages of less than $20 per month, at a time when a white nurse working in camp earned $150 a month.[97]

At least one physician managed to avoid going to a WRA camp. Dr. Sakaye Shigekawa, a Nisei woman, graduated in 1940 from the Stritch School of Medicine of Loyola University in Chicago. Sakaye had applied to the University of Southern California, but in 1935 it failed to accept any women as medical students. She also faced gender discrimination in seeking an internship until finally she became only the second woman accepted at Bay City Hospital in Michigan. In 1941 she returned to Los Angeles and had just begun an internship at Los Angeles County General Hospital when the war started. She ended up in the Santa Anita Assembly Center and was supposed to go next to Heart Mountain Relocation Center in Wyoming. Instead, she wrote half a dozen letters to the government informing the authorities that she would not go and, she warned, even if they sent her she would not work. She received no response. Eventually a government official visited her at the assembly center. He was shocked to discover that the doctor was a woman. Ultimately, he agreed that she did not have to go to the WRA camp because she had a place to go away from the West Coast. She went to Chicago where she knew people from her days in medical school. Dr. Shigekawa practiced medicine with another woman physician in Chicago until 1948, when she returned to Los Angeles. In the midst of wartime racial hostility, her challenge of the "relocation" process represents an act of bravery by a woman not yet thirty years old.[98]

Most Japanese American doctors and nurses, however, had little choice but to enter one of the WRA camps where their working conditions were far from ideal. They were incredibly overworked because of staffing shortages. Much of the equipment, supplies, and medicine provided by the army was inadequate and outdated, some dating from World War I.[99] Health care staff, along with the rest of those incarcerated, lived in poor housing with little privacy. Furthermore, the camps were located in environments of extreme temperatures, either incredible heat in arid deserts, severe cold in northern climates, or swampland.

Japanese American health workers built the best health-care system possible under the circumstances. Despite the hardships and restrictions of camp life, they used their pivotal role in the camp health-care system to benefit the camp residents. They turned confinement into a chance to provide as much health care as possible to the residents. For example, complaints from several camp officials suggest that the Japanese American personnel performed elective surgeries or provided medicines that the government did not consider essential. Furthermore, officials complained, the residents were too reliant on the hospital for "trivial ailments."[100] In the crowded living conditions, the hospital was one of the few places that camp residents could

rest and recover from the health problems they developed at the camps, such as stress, heat exhaustion, and extreme fatigue.[101] The WRA made the hospital the center of health care and then complained when people used it to meet the full range of their health-care needs.

Although camp officials relied upon and exploited Japanese American health-care workers, they realized that there were not enough nurses and doctors among the detainees to meet the health-care needs of such large camp populations. In fact, they discovered this problem early in the evacuation process when initial registration procedures identified only about 80 licensed physicians and surgeons, 130 pharmacists, 35 optometrists, and 130 registered nurses to provide health care to more than 100,000 people. Medical opinion at the time suggested that the average civilian population required 1 physician for every 1,500 people.[102] The number of Issei and Nisei doctors in camp might have been adequate, since it exceeded this ratio. The camps were not, however, typical civilian settings. Furthermore, although the government attempted to distribute these health workers evenly throughout the ten camps, it was difficult to do so, and most health-care programs remained severely understaffed. Even though urban Japanese Americans often had a sufficient number of health-care providers in the cities they came from, the rural Japanese American population did not. Furthermore, the health-care providers did not stay in the camps as long as many of the other camp residents. As early as 1943, the WRA lifted travel restrictions and began a resettlement program to the Midwest and eastern United States The result was that by fall 1943, there were only 43 physicians, 19 nurses, and 10 student nurses left to provide care.[103]

Faced with a critical shortage of staff, health officials turned to lay workers, mostly the Nisei, and trained them as nurses' aides. Camp authorities reported that the hospitals, outpatient clinics, and public health programs were totally dependent on them.[104] After 1943 a few Issei women were allowed to take the nurses' aide training classes too. Health authorities preferred Nisei workers, stating that the Issei women who were willing to work were less satisfactory because of their physical limitations and their difficulties with the English language. The question of loyalty and alien citizenship may have also been a factor. Officials even asked Nisei nurses' aides to supervise Issei nurses' aides, although Joy Barragrey Stuart, the WRA nursing consultant in Washington, D.C., admitted, "we are careful not to let the Isseis become aware of this."[105] She and others knew Issei women would have been offended by such surveillance.

Despite the health-care labor shortage, camp authorities by and large ignored the several hundred Issei women who at some point had been licensed

to practice midwifery on the West Coast. This source of potential professionals was ignored even though "midwifery and practical nurse" was a category on the WRA list of occupations one could indicate during the government registration process. More than a hundred women selected this category as their primary occupation, about seventy of whom were Issei. Among the midwives from Seattle who were incarcerated, Toku Shimomura and Tome Yasutake ticked off this category as their occupation, although Sawa Beppu did not. Given the significance of midwifery to the Issei, it seems likely that most, perhaps all, of the Issei women in this category were midwives. An additional twenty-six Issei women selected "trained nurse," and many of them may have also been trained as midwives, since nursing and midwifery training was often combined in Japan earlier in the century. In spite of all that, not a single midwife was employed as a childbirth attendant within the ten government camps. The *sanba* faced employment restrictions because officials saw no advantages in using older, Japanese-speaking women and, most important, because of the type of health-care expertise they possessed. Officials did not welcome Japanese cultural practices.[106]

Brief glimpses of the *sanba* in the WRA records suggest something of the untapped health-care resources in the camps. In addition to the Seattle midwives, Mrs. Eiko M., a 53-year-old Issei woman at Topaz camp in Utah, was a midwife. The intake records at Manzanar camp in the California high desert included the names and employment histories of several California midwives, all born in Japan. In addition to Suyeno Hamaguchi, there was Masai Maeda, who was a mere 35 years old. Masai trained in nursing and midwifery at Kaisei Hospital in Japan. At the outbreak of the war she was working in general nursing at the Japanese Hospital in Los Angeles, where several of the midwives included in the Manzanar intake list also had worked. Toshi Toguchi, born in 1902, trained and worked in nursing and midwifery for five years at Kenritsu Hospital in Okinawa in her late teens and early twenties. Then Toshi moved to the United States and worked from 1925 to 1928 in general duty nursing at the Southern California Japanese Hospital, the first Japanese hospital in Los Angeles. She became a licensed midwife in California in 1928. Then from 1929 to 1932 she worked at another Japanese Hospital in Los Angeles. Finally, from 1932 to 1941, she worked as a private nurse in New York before returning to work at the Los Angeles Japanese Hospital. Tsune Takahashi, age 57, trained at the nursing school at Hazuyama Hospital and did midwifery training at Ogata Hospital in Japan. Tsune worked at a hospital in Japan from 1903 to 1910 and was a member of both the Nurses' Club and the Midwife Club in Kyoto. She then moved to Hawai'i and worked as a nurse at the Japanese Hospital

in Honolulu from 1918 to 1922. Finally she worked as a general nurse at the Southern California Japanese Hospital from 1922 to 1927.[107] The fact that the names of these women do not appear in the reports of health-care activities by Manzanar's health staff reinforce the point that the camps provided midwives with very few opportunities to use their health-care skills and none to perform deliveries.

Health-care policy and scholarship today frequently suggest that home care is preferable to institutional health care.[108] The history of Japanese Americans during the war, however, demonstrates that there were severe limitations to home care in places of confinement. Their situation reminds us to avoid facile understandings of both home and care. Japanese Americans in these assembly centers and WRA camps lived with appalling housing conditions. Yoshiko Uchida, for example, a Nisei woman who became a well-known writer, remembered the difficulties in caring for her sister when she was ill at Tanforan Assembly Center, a racetrack just south of San Francisco. Yoshiko, who at the time was a young woman about to graduate from the University of California, recalled that members of her family were frequently ill, especially with stomach disorders. She attributed some of their ailments to their awful living quarters, which could never offer the comforts they had left behind. Instead, "I felt degraded, humiliated, and overwhelmed with a longing for home," she explained.[109] Her family lived for nearly five months in a horse stall where "dust, dirt, and wood shavings covered the linoleum that had been laid over manure-covered boards, the smell of horses hung in the air, and the whitened corpses of many insects still clung to the hastily white-washed walls."[110]

Even in the controlled environment of WRA camps, health officials worried that people would attempt births at home. The issue of midwifery care appeared most distinctly in the surviving records of the Colorado River Relocation Center. It was the largest and hottest of the camps and located on the Colorado River Indian Reservation at Poston in the Arizona desert. The topic of home births came up early in the history of Poston. No doubt prompted by some query, the camp's director, Mr. Wade Head, contacted Ralph B. Snavely, the medical director, in August as the camp was getting set up. "If home delivery by midwives is to be permitted, adequate supervision is to be maintained," Head asserted.[111] Several weeks later Snavely responded to Head: "The subject of 'midwives' and obstetric care was discussed. Owing to crowded conditions and other considerations, the home is entirely unsuited to delivery service. Consequently it was suggested that the Board of Health issue a regulation requiring all obstetric care in the hospital. Miss Gerkin suggested a plan for utilizing the services of the 'midwives' in pre

and post natal care. Dr. Kawaichi knows of at least three 'midwives' and suggests that they be utilized in the public health program to furnish pre and post natal care, but that they first be given special instruction and that they work under supervision."[112] These comments laid out the restrictions on midwives' health contributions in this camp. A few midwives might be allowed to provide care to women before and after birth, but not during.

Surviving records suggest that only two of the ten camps used midwives in a health-care capacity, one of which was Poston and the other Tule Lake. Elizabeth Vickers, Poston's chief nurse, was unusual among the white nurses who worked in the camps in that she showed a high degree of respect and sympathy for the *sanba*. Vickers, a graduate of Union Memorial Hospital School of Nursing in Baltimore and Teachers College at Columbia University, had been director of the school of nursing and nursing service at the General Hospital in Greenville, South Carolina, before she went to Poston. She made it possible for midwives Kinko Yanamoto and Torano Matsuoka to work in the camp. These midwives from California worked as "public health assistants," especially for postpartum care and well-baby clinics.[113] They joined a few other Japanese nurses, "all of whom are graduates of hospital nursing schools in Japan and speak very little English." As I have written elsewhere, Poston also hired a few African American nurses to relieve the constant nursing shortage, in part at nurse Vickers's urging.[114]

Just as the Territorial Board of Health encouraged the Hawai'i *sanba* to become home care nurses for birthing women following their return from hospital, the health authorities in Poston and Tule Lake camps allowed midwives to provide similar care for mothers and infants after their release from the camp hospital. Camp hospitals typically allowed the new mother and infant to remain in the hospital for fourteen days after delivery, but then they were sent back into the barracks.[115] One midwife at Poston worked at the well-baby clinic, where she checked the baby's weight and offered infant feeding information. According to nurse Elma Rood, "Typewritten directions are given in both English and Japanese for her guidance [and] to give to mothers to take home. Mothers bring empty bottles for refills of cod liver oil." As nurse Rood continued: "Every newborn baby is visited twice in the home during the first month after discharge from the hospital; once by the Japanese midwife, and once by a Public Health Visitor." In September 1943 another midwife, Torano Matsuoka, began to provide assistance at Poston. Nurse R. N. Crawford explained that "She has been given the responsibility of finding prenatals early and instructing them in the importance of periodic examinations by a physician. She is also responsible for the management of the Well Baby Clinic every Friday morning." In her report two months

later, nurse Crawford stated that after the mother and baby returned from the camp hospital, "Mrs. Matsuoka demonstrates the baby's bath, instructs mother how to prepare the formula, aids mother in getting help to do the baby's laundry and in getting adequate equipment for baby's needs. She visits the mother and baby for 3 consecutive days. On the fourth day, the mother demonstrates the bath to her." Nurse Crawford, and apparently the mothers as well, had nothing but praise for Torano's work. "Five prenatal clinics were held by Mrs. Matsuoka. She is a very keen observer and does a splendid piece of instructional work. The prenatals enjoy her professional attitude and have faith in her ability to give them adequate care." In 1944 midwife Kinko Yanamoto provided similar service in the camp and visited all newborn babies within the first month of each baby's birth.[116]

Maternal and child health, as well as general home care needs, were the responsibility of the camp's public health branch. It was this health-care arena in which a few midwives were able to contribute their skills, as was evident at Poston. Doctors were too busy to provide home care. According to Edna A. Gerken, a health education specialist with the U.S. Indian Service who visited the camp, the health organization was divided into two branches, the hospital and clinical services and the public health services. "Large numbers of calls came in to the hospital for medical home visits—calls in excess of what could be met by the limited medical staff" even though "training in infant care and in home care of the sick were never more needed."[117] According to a Poston camp official, "The restriction on home visits by physicians is consistent with modern practice throughout the country. There is almost no type of emergency in which the patient cannot be safely moved to the hospital."[118] All the same, a few midwives were asked to provide home care.

The use of midwives as home care nurses reveals not only people's unmet health-care needs but also the denigration of home care nursing by the early 1940s. Home care work in the camps was turned over to public health nurses and a few midwives in line with the long history of these occupations. Home care work was, of course, very valuable to patients. Still, at a time when hospital care had gained such prestige for all health-care services, including childbirth, providing home care was a sign of low status. Home care had lost much of its appeal to nurses because of its low wages and its work environment, and most sought work in hospitals.[119] From the perspective of camp health authorities, even the sympathetic nurse Vickers, the *sanba* made excellent candidates for home care work because officials saw their midwifery skills as of little use in the contemporary health-care system. Midwives were also used in community care at Tule Lake camp, located on

a dry lake bed near the Lava Beds National Monument in northern California. The Tule Lake chapter of the American Red Cross decided to train six midwives in the camp to assist in the camp's public health program in order to provide home care for the elderly, postsurgery cases, and general home care nursing.[120] Although providing various home care services was important health-care work, the *sanba* were still restricted from delivering babies.

Toku Shimomura and Informal Caregiving

The care provided by the formal health-care system was not the only health-care work that mattered. Government records are extremely useful sources for understanding the formal health-care system, but they are limited in what they can reveal about informal caregiving. "The nature of the evidence," explains historian Peregrine Horden, "conceals informal activities because they need no administration and hence create no records."[121] Therefore, we must turn to personal accounts with an eye toward uncovering what caregiving looked like outside the hospital walls. What we see is that doctors and nurses attended to little of the caregiving needs of Japanese Americans during their wartime incarceration. A "mixed economy of care" operated in the camps, in which public provisions supplemented but did not replace informal care.[122]

Caregiving is a theme that uncovers a great deal about the texture of everyday life. It includes a wide range of activities that contribute to the health and welfare of people. Attention to informal care reveals a health-care landscape that is less exclusively centered on hospital nursing and regular medicine. Some scholars might be tempted to regard informal caregiving activity as peripheral to the operation of the camps and those who did it as marginal figures.[123] My contention is that one cannot understand the full scope of community health care, including the emotional and psychological dimensions of health and well-being, without investigating informal activity. Indeed, some problems simply never appeared at the hospitals because people would not go there and instead turned to trusted family, friends, and other healers. In addition, informal care was important because Japanese traditions promoted the role of family members in caring for the sick, even in hospitals.[124] Furthermore, as we have seen, many Issei women had married men who were ten to fifteen years older, and some of these men developed ailments that required extra care in the camps.[125] Informal care, whether it is labeled home care, domestic care, family care, or community care, has been, and continues to be, mostly women's work.[126]

It is not surprising that government records tell us little about the *sanba*'s role in such informal health care, but Toku Shimomura's diary provides evidence of her participation in such caregiving. By 1940 the entries in Toku's diary show that she had stopped delivering babies in Seattle. Although she had a busy midwifery practice in the 1910s and 1920s, after 1935 she performed very few deliveries. After at least twenty-eight years of midwifery practice, Toku had retired.[127] Her diary reveals how she and her friends found ways to make life in camp bearable. They exchanged food items and shared other resources. At one point Toku dyed the hair of her friend, midwife Sawa Beppu, and at another point her friend Mrs. Naito came to help her with her hair. These personal care activities made the women feel better and helped them to cope.[128]

In the 1940s Toku's own health problems consumed her. She suffered from several chronic physical health problems, which the stresses of wartime exaggerated. She had hypertension and neuralgia, a condition in which pain radiates along the nerves. She often had difficulty sleeping because of headaches or pain in her hands and legs.[129] At fifty-three, she was starting to feel the effects of aging. We might draw inferences from an entry in her diary after taking her car in for service in April 1941, the year the war began: "Much like a human body, when a car gets old, it has body troubles."[130]

To treat her ailments, Toku combined western medicine with *kanpō*, traditional Japanese healing techniques, both before the war and in the camps. For example, she took drugs prescribed by doctors, such as her family physician Dr. Paul Suzuki, to reduce her high blood pressure. Dr. Suzuki was an Issei physician who graduated from an American medical school, Creighton University, in Omaha, Nebraska. To relieve various aches and pains she received massages, sometimes from friends, but also from Dr. James M. Unosawa, an Issei osteopath who earned his medical degree in Missouri in 1928, and Dr. Fujii, "a massage specialist."[131] In addition, she received moxibustion treatments, a technique in which small cones of herbs are burned on the skin at specific points to promote healing.[132]

Camp health authorities responded to unorthodox healing practices with interest, caution, and sometimes a ban. For example, nurse Elizabeth Vickers at Poston camp commented on the Issei propensity to combine American health care with Japanese traditions, including massage and bathing more than once a week. Massage, she noted with evident curiosity, involved having "their bodies rubbed, pounded, and manipulated in various ways when they were ill."[133]

Bathing became an issue in the camps because the Issei constructed wooden tubs, or *ofuros*. The camps provided only showers, to the great

disappointment of Issei men and women who wished to have a soak in hot water after washing themselves. At Minidoka camp, for example, several Nisei leaders in the camps defended the creation of hot tubs. They pointed out to Dr. L. M. Neher, the chief medical officer, that soaking in hot water was a worthwhile Japanese cultural practice. They wrote in response to the doctor's decision to discontinue the use of these tubs that Issei men had built in the men's washroom. They appealed to the doctor's interests in promoting health. "As you know, the older Japanese have been accustomed to taking daily dips in these so-called 'ofuro.' They believe these daily dips in a hot tub are beneficial to their health. When residing in Seattle or elsewhere, they have been even paying to bathe in the public Japanese baths which were licensed by the city. . . . Before entering the tub, a person washes himself thoroughly under the shower and rinses off the soap completely. Then he dips into the tub filled with very hot water which is constantly overflowing from the top." The Nisei leaders continued, "Many of our residents can not understand why these tubs should be condemned here when they have been licensed by health officials even in large cities such as Seattle, Tacoma and Portland. They have also heard that these tubs are being used in Tule Lake and Fort Missoula under the sanction of respective health officials." Dr. Neher replied that he was sorry, but the tubs had to go. "I appreciate the fact that the older Japanese, as you put it, have been accustomed to their daily dips in the 'o-furos.' Although they may believe that these hot dips are beneficial to their health, I believe that the good points are offset by the bad." He explained that the tubs could not be cleaned well and that it wasted water to keep it running continuously.[134] Although these were important concerns, it seems clear that he also objected because he did not accept the hot tubs' value and he did not care that they were part of Issei health culture.

Camp authorities were also wary of unorthodox health-care practitioners. The policy at Heart Mountain camp was summed up in the minutes of a meeting of medical staff: "If any 'irregulars' wish to work in the health staff, they should be under the physician's orders and guidance. (Chiropractors, naturopaths in some centers working as masseurs, physiotherapists, etc.) But absolute exclusion of these irregulars must be handled with tact and prudence. As the Army does not recognize osteopaths, however, the WRA has some moral support in refusing to recognize such irregular practitioners of medicine."[135]

Despite camp restrictions on certain types of practitioners and despite Toku's own health problems, she provided a range of informal care to friends and family during the war and in the camps. Toku's personal and

community identity as a midwife and her role as a caregiver continued, even when she no longer delivered babies. The consistency with which she made house calls or visits to the hospital in the 1940s indicates that her health work, which was no longer performed for a fee, was still meaningful and important. She now pursued it almost exclusively out of friendship and concern for loved ones. In early 1941, even before the war began, Toku wrote in her diary that she and her husband Yoshitomi Shimomura went to visit their daughter Fumi, who had recently had a baby. Toku taught Fumi various things about infant care. She also performed the midwife's typical ritual and gave the baby a bath. She also paid several visits to the sick at home and in hospitals in Seattle before the start of the war.[136]

Toku continued to visit the sick even after she entered Puyallup Assembly Center. In April 1942 Toku and her family, along with other Japanese American residents from Seattle, had to leave their homes and go to Puyallup, on the state fairgrounds south of Seattle. Here some 8,000 to 10,000 people lived as captives.[137]

Toku's friend Sawa Beppu was also sent to Puyallup. Toku noted in her diary that she was sorry Sawa was placed in a different section of the center because she did not see her as much as she would have liked.[138] Sawa, for her part, had performed her last deliveries in Seattle under the blackout conditions of World War II, which began soon after the war broke out. She had to travel without lights at night and she delivered babies with the windows blacked out with sheets or blankets to keep the light out. At the point Sawa entered Puyallup Assembly Center her midwifery practice had grown quite small. She did no childbirth deliveries in camp or after her release.[139] Furthermore, like Toku, she had health problems now that she was in her mid-fifties. For one thing, her teeth were giving her trouble. Most important, according to her daughter-in-law Teru Beppu, Sawa was recovering from an operation for ovarian cancer. She was thin and weak and in no condition to work.[140] Like many Issei women, especially those engaged in farmwork, she was no doubt relieved that camp life gave her a break from endless labor.

At Puyallup Assembly Center, Toku's diary entries indicate that she made numerous house calls to visit the sick, especially other Issei women. For example, in July 1942 she wrote, "Between the rain showers in the afternoon, I made inquiries on the sick people in section 1 and 2. Mrs. Takiguchi's condition has become much better and we rejoiced." Later that month she indicated that "I heard Masako Nomura was not feeling well so I visited her and gave her an enema."[141] Two days later she wrote, "Setsuko Tanagi entered the hospital and I visited her. It was so hot in the rooms! It reminded

me of the bathing rooms. It was more than the patients could bear." She visited Setsuko at the hospital again later that week and wrote, "I was happy to hear that her condition was progressing favorably."[142] At one point her three-year-old grandson Roger became sick, possibly with the chicken pox, and he was put into an isolation ward in the hospital for one week. When she visited him there, she found the ward to be nothing but a "miserable" jail. It was "truly pitiful," she remarked.[143]

Toku's diary also offers evidence that she was still a midwife at heart. Her interest in maternal and infant care had not disappeared. For instance, she kept track of when babies were born in the Puyallup camp hospital, noting each birth in her diary.[144] On 1 August 1942, she even went to the hospital to check on a birthing woman. "I heard that Sally Ida was having a difficult delivery. We were all very worried but she delivered a boy and we were all pleased."[145] It is not surprising that she never once suggested that these women would have been better off with a home birth in one of the shacks. She also did not imply that a midwife should have delivered the babies. Midwives were only rarely childbirth attendants among Japanese Americans by this time, but their contributions to health promotion did not cease. For instance, Mary Jio, a Nisei woman who gave birth at the Santa Anita Assembly Center in California, remembered a midwife who provided valuable breastfeeding guidance to new mothers.[146]

Several months after entering the Puyallup Assembly Center, Toku and the other detainees were forced to relocate once more, this time from Washington State to Idaho. "Once again we have to move as exiles," recorded Toku.[147] In August 1942, the military moved Toku, Sawa, and thousands of people to Minidoka Relocation Center in the sun-baked terrain of southern Idaho. Idaho was a big shock for the Seattle residents. Here dust storms reigned and temperatures regularly exceeded 100°F.[148] Toku was not content, though, to be idle at Minidoka. Like other Issei women, Toku cleaned her room in the barracks, did laundry, took up knitting, visited with friends and family, took English classes, and went to choir practice, prayer meetings, and Bible classes.[149]

Like the sites of the assembly centers, the environment and housing facilities of the relocation centers or WRA camps were not conducive to healthy living. For instance, ill health followed Yoshiko Uchida's family from Tanforan Assembly Center to the Central Utah Relocation Center, known as Topaz, the so-called Jewel of the Desert. About 8,000 people lived in this camp, which was 140 miles south of Salt Lake City.[150] "None of us felt well during our incarceration in Topaz," recalled Yoshiko. "We all caught frequent colds during the harsh winter months and had frequent

stomach upsets." A white teacher in the camp also reported that "everyone seems to have diarrhea, heat exhaustion, or colds."[151] The constant dust, in particular, made camp life unpleasant and unhealthy. The fine white dust from the sand, which was like flour or talcum powder, had a high silicon content and got into one's nose, mouth, and lungs.[152]

Heart Mountain Relocation Center, near Yellowstone National Park in Wyoming, provided an equally unhealthy environment for its 10,000 residents. Heart Mountain camp was an arid place where only sage and cactus grew. There were severe dust storms and cold winters. As in all the camps, the living quarters were rudimentary and modeled after army barracks. Velma Kessel, a white nurse who worked in the camp hospital for several years, wrote that the barracks "were so drafty with cold floors and uneven heat, it was surprising that we didn't have even more sick children."[153]

Despite the health-care services in each camp, many residents never sought the professional care they needed or received the care they sought. Even though Yoshiko's family barracks were located near the Topaz camp hospital, Yoshiko's mother was reluctant to seek health care because it was such a frustrating experience to go there. Yoshiko explained, "My mother once went to the hospital hoping to be examined for a lingering cough, but after waiting for several hours, came home unattended." The doctors were too busy to see her and so she never went back.[154] Mary (Tsuneta) Hida, a Nisei woman from southern California, worked as a receptionist at an outpatient clinic at Heart Mountain. She remembered that it was often difficult to get the care wanted. Patients were always complaining because they had to wait a very long time and they had to return several times. They also frequently did not get to see the doctor they preferred.[155]

The informal caregiving of women like Toku Shimomura helped to meet some of the health-care needs. In late August 1942, for instance, Toku's daughter Fumi and Toku's friend Masako came to see her. "I gave them a simple physical examination," she wrote. She also took care of her husband Yoshitomi, who shortly after their arrival "suddenly got stomach trouble. . . . He vomited and had diarrhea. I was busy the whole day taking care of him," she recorded in her diary.[156] In addition, she regularly visited friends who were sick in the camp hospital.

Friends and family also looked after Toku when she became sick, even after she was hospitalized. Only a month after arriving in Idaho, she had to be hospitalized because her neuralgia and hypertension were causing her problems. While in the hospital ward she looked around and recognized sixteen of her friends in the nearby beds. Camp life was clearly taking its toll on the Issei. She also made observations about her caregivers, indicating

that the nurses' aides were very kind. As for the trained nurses, "The sight of the nurses reminded me of past days when I was young and my heart was full," she revealed.[157] She was not left to the care of strangers, however. She had such a large community of friends and family that while in the hospital for one week she became worn out from so many visitors.[158]

Toku was ever the observant health-care specialist. While she was hospitalized, she noted that a case of food poisoning, likely caused by a can of blueberries, sent forty-five people to the hospital. Upon release from the hospital, she also remarked that the state of sanitation in the camp was very poor, with flies swarming around the outhouse. Public health experts warned that flies carried germs and could contaminate food or water supplies. Apparently she had warned Dr. Suzuki, her family physician, that there would be problems. Not long after she expressed her concern there was an epidemic of diarrhea, she noted disconcertedly.[159]

Toku labored to help others because people responded positively and it gave her satisfaction. As historian Emily Abel so beautifully illustrates in her study of women's informal caregiving, despite the burdens of giving care, it benefits not only the patients, but also the caregivers themselves.[160] It is not entirely surprising that a mere four days after Toku's release from the hospital, she was back making house calls to others in their sickbeds, even at the hospital. She did not let up over the following months. She recorded in her diary when a friend was sick or had diarrhea and when she gave someone a physical examination. At one point she made a call on Mrs. Hara, who "was suffering from a dislocated leg."[161] In December she wrote, "I made a call on Sister Sasaki's sickbed. I also visited Mrs. Kimura and Mrs. Tsugawa's sickbed." Toku was a comfort to people not only because she knew something about health care, but also because she had intimate relationships with them and responded to them as individuals. Her visiting addressed not only physical needs but also the emotional and spiritual dimensions of caregiving.[162]

The formal health-care system in the camps operated with a limited definition of caregiving needs, with the result that most mental health concerns were addressed at home or went unattended. The times when mental health problems came to the attention of professional health-care personnel were moments when the needs simply became too great for families. For example, as the camps began to close near the end of the war, anxieties escalated, aggravating existing health problems. At Heart Mountain, nurse Kessel observed that stress and depression were especially evident in the Issei, some of whom ended up hospitalized. In 1944 she wrote that the hospital

had many older patients. "I was sure that some here had genuine physical problems," she noted, "but others were simply so depressed that they had made themselves ill."[163] The chief medical officer at Topaz reported that mentally disturbed patients in the hospital increased in number and severity once the government decision to close the camps became known. At least four people were sent to state hospitals. In addition, hypertension was aggravated by fears about reestablishing life outside the camps. Moreover, as Faith Terasawa explained, the hospitals saw only a fraction of the cases. As an Issei woman who worked as a translator in the hospital and performed house calls at Topaz camp, Faith observed that family members dealt with most of the mental health cases on their own.[164]

In summary, even with a hospital in every camp, the government did not meet the health needs of those incarcerated. In an environment of centralized, public health care, which the camps represented to an unusual degree, there was an enormous, although little officially documented, layer of informal care. As was typical of life outside the camps, family, friends, and neighbors filled in the gaps in the formal health-care system. Such caregiving activity was welcomed and introduced an emotional dimension that helped make the camps livable.

Despite Toku's informal caregiving activity, she still grew bored with the monotony of camp life and was eager to find something more to do. In October 1942, after complaining that her blood pressure had gone sky high after she moved into camp, she remarked, "I'm starting to feel that I would like to work with sick people since I myself am in such bad condition."[165] Clearly, she had been attending to sick people all along! What she meant was that she wanted a job. Shortly after this she went to the job placement office and applied for one. A month later she was offered a position. Sadly, Toku, who had spent over three decades working in the health-care field, was told she could be a "checker" at the mess hall in the camp hospital. Her diary entries reveal nothing of the disappointment she might have felt. Instead, she took the job and wrote that it made her "feel like a worthy person again." The next day she remarked, "I found work interesting and finished feeling happy." After only four days, however, the job placement office told her she could no longer work at the mess hall. Toku's diary entries tell us little about why she had to leave. Her only comment was "There seemed to be some mistakes made in this whole procedure." The reason the office gave her for letting her go was that the position had been promised to someone else. Undaunted, Toku later returned to the placement office to apply for another job. A month later she noted with disappointment that she had still

not been offered any work.[166] It is likely that a younger person was given priority in job placement. As an older Issei woman, it appears that she was not wanted as a worker in the camp, even with her health-care skills.

By 1945, after the war ended, Toku was back in Seattle, where childbirth briefly reemerged in her life, although her identity as a midwife had never left her. Her diary offers few details, but on 13 January 1945, she attended a gathering of four Seattle midwives at Sawa Beppu's house. It is not clear whether this was a midwife association meeting, like those held in the prewar years, or simply a gathering of friends, but in her diary entry she identified each woman by the title *sanba*. Then, two days later, Toku delivered the baby of Mrs. Nakano. This delivery was probably the last one she ever did. One would like to know why she agreed to do it, but her diary is silent on the issue. Chances are good that the woman was an Issei, among the youngest of her generation. It would have been very unusual for a Nisei woman to request a midwife at that point in time.[167]

Nisei Women and Hospital Births in Camp and After on the Mainland

In conducting interviews with the Nisei friends and family members of the Issei midwives, I was struck by two contradictory things: first, their profound respect for the *sanba* and, second, their incredulous response to my queries about whether they had wanted midwife birth attendants for their own deliveries. It was clear that by the time most of the Nisei had their babies, especially on the mainland, Japanese Americans did not consider midwifery a desirable option. Midwifery was an Issei affair and one largely rejected by the next generation. Apparently, even as militarization and wartime government policies limited midwifery practice, they were not the only factors facilitating its demise. Change also came from within Japanese American communities as the Nisei began to give birth.

American values, medical culture, and schooling all had an impact on the Nisei perspective. The birthing practices embraced by the Nisei, most of whom were born between 1910 and 1940, paralleled those of other Americans in their cohort. By 1940 American birthing women increasingly accepted the messages promoted by health officials, nurses, and doctors that childbirth was safer in hospitals under physician and nursing care. Health education programs promoted medicine as the best safeguard against the death of mother and child and stigmatized midwives as poor people's birth attendants. As historian Judith Walzer Leavitt demonstrates, throughout the history of childbirth women have sought safety for themselves and their

infants. After 1940 more births took place in hospitals than in homes because they promised the benefits of science.[168] By 1945 about 80 percent of all births in the United States were physician deliveries in hospitals. Many new hospitals were built in small towns and rural areas with federal money through the 1946 Hill-Burton Act. In contrast with the cases of Britain, parts of Europe, and Japan, U.S. birth moved into the hospital but U.S. midwives did not. They were not recognized as professional health-care providers in the United States.[169]

By 1940 childbirth had become a Nisei event. Although the Nisei generation was not a monolithic group, at the start of the war most of the Nisei were under thirty-five years old, while fewer than 10 percent of the Issei were under thirty-five and more than half were over fifty. Nisei women gave birth to nearly 90 percent of the babies born in the WRA camps. Some 5,300 babies were born to Nisei women and 660 babies to Issei women in these government camps. Of the approximately 6,000 babies born in the camps, it appears that all of them were delivered in the hospital. Women gave birth in obstetrical wards, where beds included arm straps and foot stirrups, which were intended to ensure that women did not contaminate the sterile environment. They made deliveries easier for doctors, but they were uncomfortable for birthing women. No doubt the lack of privacy within the cramped living quarters, with slender partitions separating tiny rooms, made hospitals look attractive. As Dell Uchida, who was sent to Minidoka camp, explained, the shacks they lived in were completely inappropriate for giving birth. The barracks had very thin walls, and a woman would not purposely have a baby where everybody would hear every little sound. There was also no bathroom or running water in the residential barracks.[170]

Camp life was especially hard on birthing women and babies. Alyce Yamaguchi, the daughter of midwife Kimi Yamaguchi of California, entered Poston camp with a two-week-old baby. "It was terrible for me because she had to go into the hospital the first day at camp," Alyce explained. The baby was suffering from a heat rash and the perineal stitches Alyce had received after her delivery had broken open after the train ride from California to the Arizona camp. She also remembered how frightened she was when a woman on her block of barracks lost her baby and then died from hemorrhaging. The people on the block all went to the hospital to give blood but the staff could not save her. Finally, she recalled how stressful it was to deal with a baby in camp. The barracks were so close together that the man next to them would bang on the wall and yell "keep the baby quiet." She would have to take the baby outside and carry her around. Also, when the dust storms hit the camp she had to hang sheets on the windows and cover

the baby's crib with a wet towel to protect the baby from suffocating in the dust.[171]

It was more than just the appalling camp housing conditions that sent Nisei birthing women into the hospitals. Their cultural and health-care attitudes, combined with the realities of camp life, led them away from home births with midwives. For the Nisei, the *sanba*'s knowledge of the Japanese language and birthing customs was not needed, while the safety promised by modern medicine in hospitals was. Toku Toshiko, an Issei client of midwife Toku Shimomura, explained that Nisei women did not even consider having midwives. Masoko Osada, one of the few Issei women who gave birth at a camp, explained why she had her two babies in the hospital. A midwife would have cost money, but the camp hospital did not, and so that was where she went.[172]

Consider the birthing history of Teru Beppu, the daughter-in-law of midwife Sawa Beppu. Teru, who was born in Seattle in 1913, gave birth to her first child with Sawa's assistance. Teru's family had long known Sawa, even though they lived in a white neighborhood instead of the Japanese section of town where Sawa lived. In 1916 Sawa delivered Teru's sister. As we saw previously, after Teru married Lincoln Beppu in 1937 they lived with his parents, Sawa and Hisuji Beppu. Teru knew many midwives, including Toku Shimomura, and she had great admiration for the *sanba*. Like most Nisei, she preferred to have a doctor deliver her babies in a hospital, but her husband wanted to honor his mother by allowing her to do the delivery of their first child. He did not want his mother to think that he believed she was not good enough for his family. As a dutiful daughter-in-law and wife, Teru did not object, and so Sawa delivered her grandson at home.[173] In parallel fashion, Toku Shimomura also delivered her first grandchild, Roger.

By the time Teru Beppu was pregnant again in 1943, she was living in Minidoka camp. It never occurred to Teru to request Sawa's assistance because they were in camp. Teru believed she had no choice but to use the hospital where Japanese American doctors did the deliveries. When it was time to deliver, she gave birth to her daughter with the aid of her family physician, Dr. Paul Suzuki. Teru acknowledged that she might have gone to Dr. Suzuki for this second birth anyway, even without the camp regulations. Even with her own physician, giving birth in camp was not pleasant. "It was an experience," Teru noted with much understatement.[174] Her forced removal to a camp prevented her from achieving the ideal childbirth experience even with a hospital birth.

There were several reasons that giving birth in a camp hospital was frequently not a positive experience. The word hospital today evokes the notion

of a safe, modern health-care institution, however unfulfilled those ideals may be. A camp hospital could mean anything from a well-equipped, professionally run institution to a simple wooden structure with some outdated supplies and inadequately trained staff. The staff did the best they could under the circumstances, but occasionally infants died in camp hospitals, sometimes from the extreme heat.[175]

Briefly trained nurses' aides provided much of the care in the hospitals. Alice Yasutake, daughter-in-law of midwife Tome Yasutake, worked for three years as a nurses' aide at Tule Lake camp. She recalled that "We were doing most of the work because we only had one registered nurse on the station." She also delivered a baby by herself once. The woman was having her ninth baby and had warned Alice that the baby would come fast. There was only one doctor on call in the evening and the doctor's response to Alice's request for help was "do whatever you can." Alice tried her best to help as the woman "popped it out quick."[176]

In addition to the prominent role of nonprofessional staff in the camp hospitals, camp deliveries could be unpleasant because some doctors turned camp hospitals into teaching hospitals at the patient's expense. Dr. Reece M. Pedicord, head of the medical staff at Tule Lake Relocation Center, stated at a meeting that he had been informed "that all too often forceps are being used where there is no indication for them." He asked the staff to justify each use to him. Dr. K. Togasaki, a Nisei woman who was the head of obstetrics and did many of the deliveries in camp, explained why she used forceps so often. According to the minutes of the medical staff meeting, Dr. Togasaki indicated "that she frequently uses them when there is no indication for their use for the expressed purpose of teaching the junior men on service how they should be used when the occasion requires it. Doctor Pedicord agreed that it is a fine idea and that in such instances no notification need be given." A better trained staff would benefit all patients, but unnecessary procedures were used on these particular individuals. In other words, the hospital was serving the interests of the medical staff, not the patients.[177]

Despite the problems some women encountered with hospital births, even in the postwar years, the Nisei were convinced that hospitals were the only reasonable choice. When I asked Alice Yasutake whether her midwife mother-in-law had delivered any of her children, her response was emphatic—"Heavens, no!" Dell Uchida, a Seattle Nisei whose mother and aunt had been midwives, declared that Nisei women did not want midwives because the whole country had moved away from them. "I don't think I would have dreamed of going to a midwife," Dell insisted. By the time she had her first child in 1946, midwifery had become too old-fashioned. "No-

body went to a midwife" she explained. Billee Yoshioka Kimura, another Nisei woman from Seattle, said, "In our generation we wouldn't think of having a midwife." She said she "wouldn't trust them" because "you just didn't know" what might go wrong. Alyce Yamaguchi, whose mother was midwife Kimi Yamaguchi of California, had her first baby in 1942 and also would not have wanted her mother to do the delivery. Midwifery, she explained, was "not modernized." She admits that her mother would have said that she never lost a baby, but Alyce pointed out, "midwives don't use any medicine or instruments, they just listen and touch."[178]

Nisei childbirth patterns reflected the fact that the Nisei, as health-care consumers, chose doctors. Midwives went out of style among Japanese American patients, rather than doctors actively eliminating them. According to Dell Uchida, doctors attended Nisei births because "everybody had such respect for medical science." The mid-twentieth century witnessed the rise of both medical authority and patient entitlement.[179]

Japanese Americans were not alone in this trend. African Americans, who had a long tradition of midwife care, also turned away from midwives after World War II when they could afford to. In a context in which government officials had ignored black health needs and denied black rights, many African American women in the South did not resist the medicalization of childbirth but embraced it as a positive development for themselves and black communities. After 1950 young black women rarely felt a calling to become midwives, and few sought midwife birth attendants. After decades of black health activism, African American women sought the status and equal health-care rights associated with having their babies delivered by physicians in hospitals.[180]

Like black and white Americans, Japanese Americans wanted not just a doctor delivery, but one in a "germ-free" hospital. The germ theory of disease permeated popular understandings of appropriate health care. Until 1940 most births in the United States took place in the birthing woman's home, even when the birthing attendant was a physician. In fact, the national trend toward physician-attended births at home was evident by 1900, well before the move to hospital births.[181] By the 1940s, however, attitudes toward home births had changed significantly. As Dell explained, "It was considered really unsanitary to have your baby someplace else because it's so sterile in the hospital." As historian Nancy Tomes argues, modern disease consciousness or "germ beliefs" not only changed surgical and medical practice, they also transformed everyday life. The home environment came to be seen as an unsanitary place. Health reformers from 1880 to 1920 had promoted the belief in germs as part of the credo of modern living. Germ

beliefs helped to save lives, but this "private side of public health" also had negative consequences for home births.[182]

Dr. Sakaye Shigekawa, the Nisei physician who defied the government during the war, benefited from the mid-twentieth century interest in doctor-attended hospital births. Like Dr. Rose Goong Wong, a Chinese American female physician who began practicing medicine in San Francisco's China-town in 1927, Dr. Shigekawa believed that she drew clients who wished to have a female birth attendant and saw a woman physician as a compromise between a female midwife and a male doctor. After the war ended, Dr. Shigekawa returned to California and opened a medical practice on Santa Monica Boulevard in Los Angeles. She remembered that in the postwar years a few of the *sanba* resumed their midwifery practices, including Mrs. Kato, but most birthing women went to doctors. At least some Nisei women did not reject all aspects of Issei women's childbirth culture. For instance, Dr. Shigekawa observed that some of her Nisei patients still wore the *hara obi*, or pregnancy sash, because their mothers told them they should. "I'd tell them I saw no reason for them to use that," she explained. Although she dismissed this Japanese cultural practice, she did recall that other pregnant women in the 1940s and 1950s sometimes wore a type of girdle to provide back support and that some of her Nisei patients wore that as an acceptable alternative. Over the next forty years she delivered thousands of babies in Los Angeles, mostly Japanese, but also many Filipino, Chinese, and white, and a few Mexican and African American.[183]

Nisei health-care decisions emerged in a specific racial and political context. Their views did not merely reflect dominant American childbirth practices. Nisei women turned away from home births with midwives and embraced the modern American way of birth at a time when it would have been too risky not to. The Nisei understood well the dangers of not ap-pearing to be part of the American mainstream. As recent scholars have emphasized, they did not simply reject Japanese ways and embrace Ameri-canization. By the 1930s many tried to act as a bicultural bridge between Japan and the United States, yet after the war they were careful to appear to conform. Roger Shimomura, the grandson of Toku, recalled that he grew up with little Japanese influence on his life. He explained that his Nisei parents were afraid of having Japanese things. After what happened during the war, his parents did not want to look too Japanese. Even his grandmother and grandfather, Toku and Yoshitomi, who lived right across the street when he grew up, had few things that were Japanese.[184]

The experience of the camps continued to haunt the Nisei after the war. Bacon Sakatani, who was a teenager at Heart Mountain camp, asserted that

it was the Issei who felt the greatest impact of the camps. "It's our parents that suffered," he observed. "They lost everything. I didn't lose anything." Despite his protest, as our interview progressed it was clear that he had paid a price too. When he left the camp, he felt as if he had been treated as the enemy. He recalled feeling like a meek and defeated person. He ended up finishing high school in Pomona, California, and still remembered a speech he gave in his civics class. It was entitled "I Am an American Too." In it he asserted that even though his skin color was different from Caucasians he was still an American and should be treated as one.[185] After everything that had happened to Japanese Americans during the war, it was extremely important to the Nisei that they be fully accepted as the Americans they were.

As in several aspects of adult life, Nisei women did not follow the Issei generation's frequent reliance on midwives. Because of the elevated place of medicine and stigmatized role of ethnic difference in American society at mid-century, it is not surprising that so many Nisei associated midwifery with the foreign ways of their mothers and rejected it. Generational differences, long an important theme in Japanese American history, emerged among women over the issue of childbirth. Most of the Nisei saw midwifery as a Japanese approach that had influenced the Issei way of birth, but it was not their cultural practice.

Conclusions

World War II contributed to health policies and military measures that changed the context of childbirth, restricted birthing options, and transformed the labor of midwives. Wartime restrictions in Hawai'i and on the mainland had very specific effects on a range of cultural practices among Japanese Americans, including midwifery. After all, it was not just any war, but in part a war against Japan. As a result, midwifery was an important aspect of Issei women's culture that came under attack. On the few occasions when health authorities even considered using midwives, midwives were directed toward home nursing rather than home births. Health-care policies gutted midwifery by taking away labor and delivery, leaving midwives with only postpartum and neonatal care.

In the process of redefining the work of midwives, wartime health policies resulted in nothing less than state promotion of hospitalized birth. Such policies not only distorted the meanings of midwifery, they also stripped the home of its value as a site for health-care work. The history of Japanese American midwifery extends the argument that the increasing prominence of

the hospital played a key role in changing women's options for reproductive health care in the twentieth century.[186]

Nonetheless, war affected the pace of change in the history of Japanese American midwifery, not the direction. Changes in childbirth were already well underway in the 1930s because of the influence of the birthing women of the next generation, the Nisei. Like other children of immigrants, the Nisei wanted the American way of birth. Furthermore, because of the history of American racial politics, there was even more at stake for the offspring of Japanese immigrants. Nisei organizations, such as the Japanese American Citizens League (JACL), organized by the Nisei in 1930, stressed Americanization in response to anti-Japanese sentiment.[187] Finally, as the product of both American and Japanese cultures obsessed with modernity, science, and progress, the Nisei rejected midwifery because they did not see it as modern, scientific, or American.

How did this change in the meanings of midwifery and the work of the American *sanba* happen in only one generation? The answer is that the drive for change came not only from the Nisei, but also from the Issei, who influenced the Nisei in ways that were not readily apparent. Issei women learned not to pass on the value of midwifery to their adult children and even the *sanba* encouraged the Nisei interest in hospital births. In the end, that they did so is not so surprising. After all, many of the *sanba* had been trained in a Japanese health-care system that was not static but gravitated to the latest in modern western science. Furthermore, many of the *sanba* had trained in hospitals as part of their midwifery school education and accepted their value in childbirth. Midwives also learned to refer birthing women to physicians when their health needs warranted it. Even in the 1910s and 1920s, American *sanba* like Toku occasionally called doctors into the birthing room. As women who had long understood themselves to be pioneers in the promotion of modern health-care practices and improved safety for birthing women and babies, the *sanba* encouraged women's efforts to seek the best professional care available. When medicine and hospitals promised to provide services and benefits that midwives could not, midwives like Misao Tanji of Hawai'i sent their patients to them. In this sense, the American *sanba* also contributed to the Nisei, as well as Issei, way of birth.

CONCLUSION

Throughout the early twentieth century, Japanese American midwives responded to the health-care needs of their communities. They played a vital role as health-care providers for Issei women, a few Nisei women, and sometimes women of other ethnic backgrounds. Nonetheless, their health-care work was transformed over time, sometimes by choice and, especially in time of war, by decree.

This study began with the question of what the impact of American health politics on Japanese American midwives was. To answer that question required an understanding of how health work was shaped by gender relations, racial politics, international relations, and militarization. When the *sanba* immigrated to the American mainland, they witnessed tensions in U.S.-Japan relations that affected their lives in the United States and eventually led to war. They encountered an anti-Japanese movement that treated them as a racialized nationality and racial minority. They faced racism in subtle and direct forms, including restrictions on the right to naturalized citizenship, marriage, land ownership, immigration, housing, and hospitals.

The American *sanba* also encountered a health-care environment that was skeptical of the skills and value of midwives. Still, Japanese American midwifery was not eradicated directly by organized medicine, individual doctors, or government regulations. Instead, it remained a distinct health-care occupation, relatively undisturbed throughout the early twentieth century. On the West Coast, midwives faced relatively little government interference, even though midwife licensing began in the 1910s. Japanese immigrant midwives in Hawai'i saw greater government intervention in their work, but not until the 1930s when the meanings of midwifery were already starting to shift. In addition, licensing laws had little impact on

childbirth practices in rural areas. Government regulations did reach more urban midwives, but even they were not closely or regularly monitored to ensure compliance. Military measures and health policies during World War II, however, had a dramatic effect on Japanese American midwifery and contributed to a decline in midwife-attended births. War, though, was not the only factor shaping midwifery's future. As the childbirth choices of Nisei women show, health-care consumers also had an influence.

In addition, gender relations in the family and the gendered nature of the work affected Japanese American midwifery. The stories of individual midwives in Seattle suggest that Japanese immigrant midwives in urban areas used their midwifery work to carve out autonomy for themselves and escape some of the constraints on Japanese womanhood. In the case of the Seattle *sanba,* they operated within a social network of midwives and helped to create community among Issei women.

This study also examined the question of what Japanese American midwifery reveals about the history of American midwifery. As we have seen, the story of the American *sanba* reminds us that American midwifery has an even richer multicultural history than scholars previously revealed. It also indicates that midwives were not a monolithic group, even among a single ethnic group. Some Japanese immigrant midwives were traditional midwives, trained by apprenticeship, while many others had graduated from midwife training schools and were steeped in the latest views of modern science. Furthermore, even these urban and rural midwives with similar educational backgrounds in Japan developed very different types of midwifery practices in the U.S. West and Hawai'i, depending on whether they settled in urban and rural areas. Finally, historians sometimes confuse the fact that the number of midwife deliveries declined with the idea that midwives disappeared, but of course they did not. Instead, even as health officials and Japanese Americans redefined midwifery, the American *sanba* retained a midwife identity, and some, like Toku Shimomura, continued to care for others.

This study also illustrates the cultural meanings embedded in health-care approaches. It shows that midwifery was both a cultural practice and a health-care occupation and that the American *sanba* were cultural workers as well as health-care workers. Like other health-care providers, they operated under a particular set of cultural assumptions, in this case about pregnancy, labor and delivery, and maternal and infant health. The American *sanba* were products and producers of Issei culture in the process of their caregiving work. They were not only cultural preservers but also agents of cultural change for the Issei and later Nisei. When the Nisei embraced

hospital-based medicine and rejected home-based midwifery, they did so because they saw midwifery not only as unscientific but also as an ethnic marker. Both the cultural meaning and health-care meaning of midwifery had altered in one generation.

In many ways, the American government's wartime response to midwifery under martial law in Hawai'i and in the WRA camps on the mainland presaged postwar trends in which midwifery was redefined elsewhere, both in the United States and abroad. In Mississippi, for example, in 1951 health officials at the Mississippi State Board of Health explained to a member of the U.S. Children's Bureau, "We are attempting at the present time to redirect the efforts of the midwives away from delivery service to the kind of services which she is fitted to render, such as antepartum care, nursing in the home when the mother is in the hospital for delivery service, postpartum care of the mother on her return from the hospital, and as a baby-sitter while the mother is in the hospital."[1] In Europe, too, there were some changes. For example, German-speaking communities in northern Italy turned midwives into mere assistants in outpatient clinics.[2]

American health politics even affected the *sanba* in Japan as part of the modernization and Americanization of the nation after World War II, when the U.S. military occupied Japan. Nurses with the American occupation bureaucracy, known as Supreme Commander for the Allied Powers (SCAP), responded to Japanese midwifery from the perspective of an American health-care culture in which midwifery was no longer acceptable. American occupation nurses tried to turn midwifery into merely a field of nursing. Ironically, in the name of promoting women's rights and autonomy, the nurses tried to remake midwives, who were independent practitioners, into nurses, who worked under (male) doctor supervision. American nursing, more than Japanese medicine, threatened the independence of Japanese midwifery in Japan in the postwar years.[3] The history of American nurses' activities in occupied Japan is an underexamined aspect of the history of American health care, nursing, and women's history in the post–World War II years. Despite the influence of Americans, however, midwifery remained a major health-care field in Japan throughout the 1940s and 1950s. Midwives continued to hold primary responsibility for pregnant women, labor and delivery, and newborn babies. They delivered about 90 percent of all babies born throughout the period of the U.S. occupation.[4]

Midwives remained active longer in Japan than in the United States because of the slower rate of hospitalized births and, most notably, the fact that midwives moved into hospitals. Indeed, it is not hospitals per se that limit the autonomy of women health workers, but whether they can act

independently.[5] Most births in postwar Japan continued to take place in the birthing woman's home, with only a few occurring in the midwife's home, a birthing center, or a maternity hospital. Births that took place in a general hospital did so because there were unusual conditions. Gradually, the number of midwives delivering babies in hospitals and birthing centers increased. As a result, in Japan in 1950 only 5 percent of all births took place in hospitals, in 1960 half of all births, and in 1970 well over 90 percent. Even in hospitals, though, midwives still provided much of the care in normal deliveries throughout this span of time and well into the 1990s.[6]

The move to hospital births in the United States and elsewhere was part of the ongoing search for the "modern" in twentieth-century health care. Then, in the second half of the century, hospitalized birth became the focus of critiques and challenges by birthing women and some health professionals. Too often hospitals offered the latest in medical science and modern technology, but staff within them lost sight of human needs. They were not able to offer the kind of health-care culture that birthing women had come to expect. In response to consumer demands and health staff assessments, the late twentieth century witnessed changes again to the approach to childbirth, especially for those with financial resources. Women still wanted the type of personalized attention, emotional support, and continuity of care that midwives, like the American *sanba,* long had provided.[7]

NOTES

Introduction

1. Throughout this book names are provided with the surname or family name last instead of following the Japanese custom of giving the family name first and the given name second.

2. Toku Shimomura's diary, 17 January 1914, photocopy of the original in my possession. Access to the original volumes of Toku Shimomura's diary was courtesy of Roger Shimomura of Lawrence, Kansas. I am deeply indebted to Febe Pamonag, Valerie Henitiuk, and Teko Gardener of Edmonton, and to Ms. Okano, employed by the Japan Foundation at the Kansai Language Institute in Osaka, Japan, for their translation assistance. In addition, Ed Wagner, Valerie Henitiuk, and Febe Pamonag provided translations of published historical accounts in Japanese.

3. There is no agreement among scholars over whether to capitalize the words "Issei" and "Nisei" nor whether to italicize them as foreign words. I have chosen to capitalize them, but I use italics only for Japanese words that have not entered into English usage.

4. Toku Shimomura's diary, 26 January 1914. On the volcano and earthquakes, see University of North Dakota, "Volcano World" and "The Great 1914 Sakura-jima Eruption," n.d., http://volcano.und.nodak.edu/vw hyperexchange/sakura-jima .html (accessed 4 November 2002).

5. Toku Shimomura's diary, 10 April and 27 May 1914; Kazuo Ito, *Issei: A History of Japanese Immigrants in North America*, translated by Shinichiro Nakamura and Jean S. Gerard (Seattle: Japanese Community Service, 1973), 8–10.

6. Julie M. Rousseau, "Enduring Labors: The 'New Midwife' and the Modern Culture of Childbearing in Early Twentieth Century Japan" (Ph.D. diss., Columbia University, 1998), 9, 10, 22.

7. I use the apostrophe in my spelling of Hawai'i, except when proper names or published titles do not, in recognition that the word is from the Hawaiian language and is the form preferred by many of its citizens and scholars.

8. There is brief mention of Japanese immigrant midwifery in the following: Ito, *Issei,* 856, 859–60; Yuji Ichioka, *The Issei: The World of the First Generation*

Japanese Immigrants, 1885–1924 (New York: Free Press, 1988), 172; Michiko Tanaka, *Through Harsh Winters: The Life of a Japanese Immigrant Woman,* as told to Akemi Kikumura (Novato, Calif.: Chandler & Sharp, 1981), 120; Evelyn Nakano Glenn, *Issei, Nisei, War Bride: Three Generations of Japanese American Women in Domestic Service* (Philadelphia: Temple University Press, 1986), 74; Mei Nakano, *Japanese American Women: Three Generations, 1890–1990* (Berkeley, Calif.: Mina Press, 1990), 40; Wendy Mitchinson, *Giving Birth in Canada, 1900–1950* (Toronto: University of Toronto Press, 2002), 101. For an important study that includes discussion of the history of Japanese immigrant midwives in Los Angeles, see Jennifer Lisa Koslow, "Eden's Underbelly: Female Reformers and Public Health in Los Angeles, 1889–1932" (Ph.D. diss., University of California, Los Angeles, 2001), 127–69.

9. Laura McEnaney, *Civil Defense Begins at Home: Militarization Meets Everyday Life in the Fifties* (Princeton, N.J.: Princeton University Press, 2000), 8.

10. Hilary Marland and Anne Marie Rafferty, eds., introduction to *Midwives, Society, and Childbirth: Debates and Controversies in the Modern Period* (New York: Routledge, 1997). There is an extensive literature on the history of midwifery in the U.S. An excellent starting point is Judith Barrett Litoff, "Midwives and History," in *Women, Health, and Medicine in America: A Historical Handbook,* edited by Rima D. Apple (New York: Garland, 1990), 443–58.

11. Anne Thompson, "Establishing the Scope of Practice: Organizing European Midwifery in the Inter-War Years 1919–1938," in *Midwives, Society and Childbirth: Debates and Controversies in the Modern Period,* edited by Hilary Marland and Anne Marie Rafferty (New York: Routledge, 1997), 14–37.

12. The quotation is from Charlotte G. Borst, *Catching Babies: The Professionalization of Childbirth, 1870–1920* (Cambridge, Mass.: Harvard University Press, 1995), 3. See also Charlotte G. Borst, "The Training and Practice of Midwives: A Wisconsin Study," *Bulletin of the History of Medicine* 62 (1988): 606–27.

13. Borst, *Catching Babies,* 5.

14. Borst, "Training and Practice of Midwives," 606; Frances E. Kobrin, "The American Midwife Controversy: A Crisis of Professionalization," *Bulletin of the History of Medicine* 40 (1966): 350–63; Judith Barrett Litoff, *American Midwives, 1860 to the Present* (Westport, Conn.: Greenwood Press, 1978). Litoff's book examines six northeastern and southern states but no western ones.

15. Molly C. Dougherty, "Southern Midwifery and Organized Health Care: Systems in Conflict," *Medical Anthropology* 6 (Spring 1982): 113–26.

16. Irvine Loudon, "Midwives and the Quality of Maternal Care," in *Midwives, Society, and Childbirth: Debates and Controversies in the Modern Period,* edited by Hilary Marland and Anne Marie Rafferty (New York: Routledge, 1997), 189. On the value of oral history for clarifying cultural authority, see Nancy Tomes, "Oral History in the History of Medicine," *Journal of American History* 78, no. 2 (September 1991): 607–17, esp. 610.

17. Zeina Omisola Jones, "Knowledge Systems in Conflict: The Regulation of African American Midwifery," *Nursing History Review* 12 (2004): 167–84; Fran

Leeper Buss, *La Partera: Story of a Midwife* (Ann Arbor: University of Michigan Press, 1980); Sandra Schackel, *Social Housekeepers: Women Shaping Public Policy in New Mexico, 1920–1940* (Albuquerque: University of New Mexico Press, 1992), 29–59; Elizabeth Ewen, *Immigrant Women in the Land of Dollars: Life and Culture on the Lower East Side, 1890–1925* (New York: Monthly Review Press, 1985), 33, 130, 134; Linda V. Walsh, "Midwives As Wives and Mothers: Urban Midwives in the Early Twentieth Century," *Nursing History Review* 2 (1994): 52. On nursing parallels, see Darlene Clark Hine, *Black Women in White: Racial Conflict and Cooperation in the Nursing Profession, 1890–1950* (Bloomington: Indiana University Press, 1989); and Patricia D'Antonio, "Revisiting and Rethinking the Rewriting of Nursing History," *Bulletin of the History of Medicine* 73 (1999): 268–90, esp. 273, 280, 283.

18. Sylvia Junko Yanagisako, "Transforming Orientalism: Gender, Nationality, and Class in Asian American Studies," in *Naturalizing Power: Essays in Feminist Cultural Analysis*, edited by Sylvia Yanagisako and Carol Delaney (New York: Routledge, 1995): 275–98.

19. Barbara Fields, "Ideology and Race in American History," in *Region, Race, and Reconstruction: Essays in Honor of C. Vann Woodward*, edited by J. Morgan Kousser and James M. McPherson (New York: Oxford University Press, 1982), 143–77; Michael Omi and Howard Winant, *Racial Formation in the United States from the 1960s to the 1990s*, 2d ed. (New York: Routledge, 1994); Tomás Almaguer, *Racial Fault Lines: The Historical Origins of White Supremacy in California* (Berkeley: University of California Press, 1994), 4, 7.

20. Roger Daniels, *Asian America: Chinese and Japanese in the United States since 1850* (Seattle: University of Washington Press, 1988), xiv, 6; Ronald Takaki, *Strangers from a Different Shore: A History of Asian Americans* (Boston: Little, Brown, 1989), 4, 12.

21. On the value of comparative studies, see Moon-Ho Jung, "The Influence of the 'Black Peril' on 'Yellow Peril' in Nineteenth-Century America," in *Privileging Positions: The Sites of Asian American Studies,* edited by Gary Y. Okihiro, Marilyn Alquizola, Dorothy Fujita Rony, and K. Scott Wong (Pullman: Washington State University Press, 1995), 349–63; Paulla Ebron and Anna Lowenhaupt Tsing, "In Dialogue? Reading across Minority Discourses," in *Women Writing Culture,* edited by Ruth Behar and Deborah A. Gordon (Berkeley: University of California Press, 1995), 390–411.

22. Glenn, *Issei, Nisei, War Bride*; Valerie J. Matsumoto, "Japanese American Women during World War II," in *Unequal Sisters: A Multicultural Reader in U.S. Women's History,* edited by Ellen Carol Du Bois and Vicki L. Ruiz (New York.: Routledge, 1990), 373–86. For an excellent study of Chinese American women, see Judy Yung, *Unbound Feet: A Social History of Chinese Women in San Francisco* (Berkeley: University of California Press, 1995).

23. Yanagisako, "Transforming Orientalism," 275–98. Recent work on Asian Americans, health, and the West include Susan Craddock, *City of Plagues: Disease,*

Poverty, and Deviance in San Francisco (Minneapolis: University of Minnesota Press, 2000); and Nayan Shah, *Contagious Divides: Epidemics and Race in San Francisco's Chinatown* (Berkeley: University of California Press, 2001).

24. Bertha Parker, quoted in Valerie Lee, *Granny Midwives and Black Women Writers: Double-Dutched Readings* (New York: Routledge, 1996), 158; see also 5 and 157. Scholars disagree over what term best describes midwives who learned their skills outside the formal education provided in midwifery schools. I have chosen to use the term traditional midwife, rather than indigenous or lay midwife, because it most clearly captures the contrast I wish to make to the modern midwife.

25. Elizabeth Jameson, "Toward a Multicultural History of Women in the Western United States," *Signs* 13, no. 4 (Summer 1988): 761–91; Judith Walzer Leavitt, "Medicine in Context: A Review Essay of the History of Medicine," *American Historical Review* 95, no. 5 (December 1990), 1478 n. 19; Sucheng Chan, "Western American Historiography and Peoples of Color," in *Peoples of Color in the American West,* edited by Sucheng Chan, Douglas Henry Daniels, Mario T. Garcia, and Terry P. Wilson (Lexington, Mass.: D. C. Heath, 1994), 11.

26. The interviews that I conducted were tape-recorded, one and one-half hours long; they are in my possession.

27. In the 1970s, Roger Shimomura received the diaries and had a few of the World War II ones translated, volumes that described Toku's experience in a government "relocation center." He took twenty diary entries and turned them into twenty-five paintings and a seven-act performance piece. From 1998 to 2002 he organized a traveling exhibition of a new series of paintings based on Toku's diary. His exhibition, called "An American Diary," traveled to twelve venues across the country, including the Smithsonian National Museum of American History in Washington, D.C. It was sponsored by the Civil Liberties Public Education Fund. In 2002 it won the College Art Association's Award for Most Distinguished Body of Work in America. It was accompanied by a lithograph series of images called "Memories of Childhood," which recounted Roger's memories from Camp Minidoka during the war: Roger Shimomura, interview by author, tape recording, Lawrence, Kansas, 16 June 1998. See also William W. Lew, "Journey to Minidoka: The Paintings of Roger Shimomura," *Weber Studies* 1 (Spring 1984), 1–14; article provided by Roger Daniels.

28. Misao Tanji's son Tom Tanji graciously agreed to an interview, and Yukio Tanji provided me with photographs of Misao and his mother Matsu. I also had access to a transcript of an interview conducted by Charlotte Tanji, Misao's niece by marriage, and a videotaped interview of her by Bethany Thompson [Thomas] of Leeward Community College, *Mrs. Takeo Tanji, Waipahu Midwife,* videotape, interviewed and produced by Bethany Thompson [Thomas], translation by Hideo Okada, Leeward Community College, Pearl City, Hawai'i, 1977 or 1980, production date is unclear.

29. Unprocessed papers of Alice Young Kohler, possession of her daughter Katharine Kohler. The Hawaii State Archives in Honolulu has few or no remaining records

of the Bureau of Maternal and Child Health, but Alice's papers include many documents from this bureau.

30. I found the papers of Alice Young Kohler only because of the aid of another Alice, Alice Chai, a women's studies scholar whose film on Asian picture brides of Hawai'i I had seen at a Berkshire women's history conference. It was Alice Chai who urged me to visit a woman in Honolulu named Katharine Kohler whose mother had worked with midwives. Kohler, a name that never appeared in the records of government archives, turned out to be Alice Young's married name. Letter from Alice Chai to author, 10 October 1994, in my possession. See also *Picture Brides: Lives of Hawaii's Early Immigrant Women from Japan, Okinawa, and Korea*, slide show videotape, produced by Alice Yun Chai and Barbara Kawakami, Honolulu, 1985.

31. See Judith Walzer Leavitt, *Brought to Bed: Childbearing in America, 1750 to 1950* (New York: Oxford University Press, 1986), 9; Arthur A. Hansen, "Oral History and the Japanese American Evacuation," *Journal of America History* 82, no. 2 (September 1995): 625–39; and Tomes, "Oral History in the History of Medicine," 607–17.

32. Chan, "Western American Historiography and Peoples of Color," 11. See also Daniels, *Asian America*, xv; Tomes, "Oral History in the History of Medicine," 610.

33. Yuji Ichioka, "Beyond National Boundaries: The Complexity of Japanese-American History," *Amerasia Journal* 23 no. 3 (Winter 1997–1998): xi. See also Roger Daniels, "American Historians and East Asian Immigrants," *Pacific Historical Review* 43 (November 1974): 449–72; Akira Iriye, ed., *Mutual Images: Essays in American-Japanese Relations* (Cambridge, Mass.: Harvard University Press, 1975), 23; Gail M. Nomura, "Significant Lives: Asia and Asian Americans in the History of the U.S. West," *Western Historical Quarterly* 25, no. 1 (Spring 1994): 69–88.

34. William Cronon, "A Place for Stories: Nature, History, and Narrative," *Journal of American History* 78, no. 4 (March 1992): 1364.

35. Ronald Takaki, *Pau Hana: Plantation Life and Labor in Hawaii, 1835–1920* (Honolulu: University of Hawai'i Press, 1983), 24–29; Daniels, *Asian America*, 100–101; David J. O'Brien and Stephen S. Fugita, *The Japanese American Experience* (Bloomington: Indiana University Press, 1991), 12, 16.

36. Alan Takeo Moriyama, *Imingaisha: Japanese Emigration Companies and Hawaii, 1894–1908* (Honolulu: University of Hawai'i Press, 1985), xvii.

37. Japanese historical periods are designated by official reign names: Meiji (1868–1912), Taishō (1912–1926), Showa (1926–1989).

38. Kumiko Fujimura-Fanselow and Atsuko Kameda, eds., *Japanese Women: New Feminist Perspectives on the Past, Present, and Future* (New York: Feminist Press at the City University of New York, 1995), xi–xiii. The publication of this volume was an important step in providing English translations of Japanese-language scholarship in women's history.

39. Ronald Takaki, "They Also Came: The Migration of Chinese and Japanese

Women to Hawaii and the Continental United States," in *Chinese America: History and Perspectives* (San Francisco: Chinese Historical Society of America, 1990), 3–19; I thank Carol Forster for providing this article.

40. Susan L. Smith, *Sick and Tired of Being Sick and Tired: Black Women's Health Activism in America, 1890–1950* (Philadelphia: University of Pennsylvania Press, 1995), 118–48.

Chapter 1

1. I conform to the western calendar when indicating the years in Japan. For example, the first year of the Meiji Period (Meiji 1) is 1868 in the western system and, as in this example, Meiji 40 is 1907. Special thanks to Ed Wagner, Valerie Henitiuk, and Febe Pamonag for English translations of published historical accounts in Japanese.

2. Interview with Shin Tanaka in Kiyoko Okamoto, "Josanpu katsudo no rekishi-teki igi. Meiji jidai o chushin ni" [The Historical Significance of Midwifery: Meiji Period], *Josanpu Zasshi* [(Japanese) Journal for Midwives] 35, no. 8 (August 1981): 38. See also Mugiko Nishikawa, "The Modern *Sanba* (Midwife) and the Transformation of Childbirth at the Local Level in Japan," Berkshire Women's History Conference, Connecticut, June 2002, 5, paper in my possession. See also Mugiko Nishikawa, *Aru Kindai Sanba no Monogatari: Noto-Takeshima Mii no katari-yori* [A Story of a Modern *Sanba*: From the Narrative of Mii Takeshima from Noto] (Japan: Katura Publishers, 1997).

3. On the history of midwifery in Japan, see Okamoto, "Josanpu katsudo," 21; Sumiko Takaoka and Sumie Furusaki, "Sanba no jissen katsudo to ayumi kara gakubu koto (4)" [A Study of the Practices and Developmental Course of Midwives (4)], *Josanpu Zasshi* [(Japanese) Journal for Midwives] 41, no. 8 (August 1987): 44; Brigitte Steger, "From Impurity to Hygiene: The Role of Midwives in the Modernisation of Japan," *Japan Forum* 6, no. 2 (October 1994): 175–87 [a summary of Steger's 1991 master's thesis at the University of Vienna]; and Julie M. Rousseau, "Enduring Labors: The 'New Midwife' and the Modern Culture of Childbearing in Early Twentieth Century Japan" (Ph.D. diss., Columbia University, 1998), vi. Rousseau is currently a practicing midwife in New York City. See also Satō Kayo, *Nihon Josanpushi Kenkyū: Sono Igi to Kadai* [A Study of the History of Japanese Midwives: Their Significance and Challenges] (Tokyo: Higashi Ginza Shuppansha, 1997); Yuki Terazawa, "Gender, Knowledge, and Power: Reproductive Medicine in Japan, 1790–1930" (Ph.D. diss., University of California, Los Angeles, 2001). Aya Homei, "Modernising Midwifery: The History of a Female Medical Profession in Japan, 1868–1931" (Ph.D. diss., University of Manchester, 2003).

4. Susan L. Burns, "Constructing the National Body: Public Health and the Nation in Nineteenth-Century Japan," in *Nation Work: Asian Elites and National Identities*, edited by Timothy Brook and Andre Schmid (Ann Arbor: University of Michigan Press, 2000), 17–49; Carol Gluck, "Asia in World History," in *Asia in Western and*

World History, edited by Ainslie T. Embree and Carol Gluck (Armonk, N.Y.: M.E. Sharpe, 1997), 211.

5. Sheldon Garon, *Molding Japanese Minds: The State in Everyday Life* (Princeton, N.J.: Princeton University Press, 1997), 114; Walter LaFeber, *The Clash: U.S.-Japanese Relations throughout History* (New York: Norton, 1997), 17, 25, 29–30, 35–36; William J. Miller, "The World of Japan," in *The World of Asia,* 2d ed., edited by Akira Iriye, Edward J. Lazzerini, David S. Kopf, William J. Miller, and J. Norman Parmer (Wheeling, Ill.: Harlan Davidson, 1995), 169, 179, 181, 184; Mikiso Hane, *Modern Japan: A Historical Survey* (Boulder, Colo.: Westview Press, 1992), 85–87, 111, 187–88.

6. LaFeber, *Clash,* xviii, 8, 12, 13, 25, 29–30, 32; Miller, "World of Japan," 169, 171, 176, 178; Hane, *Modern Japan,* 66–67, 70, 80–83, 111, 143.

7. LaFeber, *Clash,* 79–80; Miller, "World of Japan," 184.

8. Daikichi Irokawa, *The Culture of the Meiji Period,* translated by Marius Jansen (Princeton, N.J.: Princeton University Press, 1985), 212–18; Hane, *Modern Japan,* 85, 157, 161, 178, 195; Miller, "World of Japan," 179, 184–88; LaFeber, *Clash,* 36, 52, 108.

9. Donald Calman, *The Nature and Origins of Japanese Imperialism: A Reinterpretation of the Great Crisis of 1873* (New York: Routledge, 1992), 10.

10. Quoted in LaFeber, *Clash,* 49.

11. Iwamoto Zenji (also known as Yoshihiru) quoted in Kumari Jayawardena, *Feminism and Nationalism in the Third World* (London: Zed Books, 1986), 230; see also 234; Okamoto, "Josanpu katsudo," 24; Sharon H. Nolte and Sally Ann Hastings, "The Meiji State's Policy toward Women, 1890–1910," in *Recreating Japanese Women, 1600–1945,* edited by Gail Lee Bernstein (Berkeley: University of California Press, 1991), 151–74.

12. Okamoto, "Josanpu katsudo," 24; Jayawardena, *Feminism and Nationalism,* 230, 234; Nolte and Hastings, "Meiji State's Policy toward Women." See also Febe Pamonag, "'A Japanese Woman with Education': Ume Tsuda's Correspondence with Adeline Lanman," in *Across Time and Genre: Reading and Writing Women's Texts,* edited by Janice Brown and Sonja Arntzen (Department of East Asian Studies, University of Alberta, 2002), 149–52.

13. Ardath W. Burks, "The Role of Education in Modernization," in *The Modernizers: Overseas Students, Foreign Employees, and Meiji Policy,* edited by Ardath W. Burks (Boulder, Colo.: Westview Press, 1985): 254–64; Hane, *Modern Japan,* 94, 102–3; Jayawardena, *Feminism and Nationalism,* 234–35.

14. Martha Caroline Tocco, "School Bound: Women's Higher Education in Nineteenth-Century Japan (Ph.D. diss., Stanford University, 1994), chapter 5; Mioko Fujieda, "Japan's First Phase of Feminism," in *Japanese Women: New Feminist Perspectives on the Past, Present, and Future,* edited by Kumiko Fujimura-Fanselow and Atsuko Fujieda (New York: Feminist Press at the City University of New York, 1995), 329.

15. Garon, *Molding Japanese Minds,* 47, 63; Jayawardena, *Feminism and Na-*

tionalism, 235; Hane, *Modern Japan*, 105–9, 133–34; LaFeber, *Clash*, 91. On the role of Christianity in modernity and its indigenization in China, see Ryan Dunch, *Fuzhou Protestants and the Making of Modern China* (New York: Oxford University Press, 2001).

16. Ishihara Akira, "Kampō: Japan's Traditional Medicine," *Japan Quarterly* 9 (1962): 429–37; Ranzaburō Ōtori, "The Acceptance of Western Medicine in Japan," *Monumenta Nipponica* 19 (1964), 20–40; Emiko Ohnuki-Tierney, *Illness and Culture in Contemporary Japan: An Anthropological View* (Cambridge, England: Cambridge University Press, 1984), 91; Shigehisa Kuriyama, "Moxibustion," in *Encyclopedia of the History of Science, Technology, and Medicine in Non-Western Cultures*, edited by Helaine Selin (Dordrecht, Netherlands: Kluwer Academic, 1997), 748.

17. Yū Fujikawa, *Japanese Medicine*, translated by John Ruhrah (New York: Paul B. Hoeber, 1934), ix; Charles Leslie, ed., *Asian Medical Systems: A Comparative Study* (Berkeley: University of California Press, 1976), 3; Hane, *Modern Japan*, 84, 89, 90, 126, 129–30; Rousseau, "Enduring Labors," 50.

18. Ishizuki Minoru, "Overseas Study by Japanese in the Early Meiji Period," in *The Modernizers: Overseas Students, Foreign Employees, and Meiji Policy*, edited by Ardath W. Burks (Boulder, Colo.: Westview Press, 1985), 161–86; Thomas Neville Bonner, "The German Model of Training Physicians in the United States, 1870–1914: How Closely Was It Followed?" in *Sickness and Health in America: Readings in the History of Medicine and Public Health*, 3d ed. rev., edited by Judith Walzer Leavitt and Ronald Numbers (Madison: University of Wisconsin Press, 1997), 189–99; W. F. Bynum, *Science and the Practice of Medicine in the Nineteenth Century* (Cambridge, England: Cambridge University Press, 1994), 102, 115; Okamoto, "Josanpu katsudo," 22; Rousseau, "Enduring Labors," 14, 27, 33, 42.

19. Irvine Loudon, *The Tragedy of Childbed Fever* (Oxford: Oxford University Press, 2000), 131; Irvine Loudon, *Death in Childbirth: An International Study of Maternal Care and Maternal Mortality, 1800–1950* (Oxford, England: Clarendon Press, 1992); Barbara Montgomery Dossey, *Florence Nightingale: Mystic, Visionary, Healer* (Springhouse, Penn.: Springhouse Corporation, 2000), 311; Rousseau, "Enduring Labors," 33–34, 36.

20. Rousseau, "Enduring Labors," 37 n. 56, 40, 89; Garon, *Molding Japanese Minds*, 19.

21. Ginko Ogino, "Experiences of the First Woman Physician in Modern Japan," *Japan Evangelist* 1, no. 2 (December 1893): 88–91; Ogino, "The Past and the Present of Japanese Woman Physicians," translated from the *Jogaku Zasshi* [Journal of Women's Education] by Nakamura Chonosuke in *Japan Evangelist* 1, no. 4 (April 1894): 209–11; Rousseau, "Enduring Labors," 89, 186; Jayawardena, *Feminism and Nationalism*, 235; Hilary Marland, "'Pioneer Work on All Sides': The First Generations of Women Physicians in the Netherlands, 1879–1930," *Journal of the History of Medicine and Allied Sciences* 50 (1995): 443 n. 13.

22. Rousseau, "Enduring Labors," 2, 88, 117–18; Jayawardena, *Feminism and*

Nationalism, 233, 239–41, 244–46, 251; Garon, *Molding Japanese Minds*, 115, 118; Nolte and Hastings, "Meiji State's Policy," 154–57; Noriyo Hayakawa, "Feminism and Nationalism in Japan, 1868–1945," *Journal of Women's History* 7, no. 4 (Winter 1995): 108–19; Sachiko Kaneko, "The Struggle for Legal Rights and Reforms: A Historical View," in *Japanese Women: New Feminist Perspectives on the Past, Present, and Future*, edited by Kumiko Fujimura-Fanselow and Atsuko Kameda (New York: Feminist Press at the City University of New York, 1995), 4; Fujieda, "Japan's First Phase of Feminism," 324–26.

23. Okamoto, "Josanpu katsudo," 42; Rousseau, "Enduring Labors," xv, 4–5, 7, 9, 16–17, 28, 32 n. 46; Fujikawa, *Japanese Medicine*, 38–39; Tsutomu Ishihara, "Development of Obstetrics and Gynecology in Japan and Resemblances to Western Counterparts," in *History of Obstetrics: Proceedings of the 7th International Symposium on the Comparative History of Medicine—East and West*, edited by Teizo Ogawa (Osaka, Japan: Taniguchi Foundation, 1983), 243; I thank Judith Walzer Leavitt for giving me this article.

24. Okamoto, "Josanpu katsudo," 22, 26, 41; Malia Sedgewick Johnson, "Margaret Sanger and the Birth Control Movement in Japan, 1921–1955," (Ph.D. diss., University of Hawai'i, 1987), 48, 50, 93; Rousseau, "Enduring Labors," 21–22, 95. On the history of abortion and infanticide, see William R. LaFleur, *Liquid Life: Abortion and Buddhism in Japan* (Princeton, N.J.: Princeton University Press, 1992).

25. Anne Løkke, "The 'Antiseptic' Transformation of Danish Midwives, 1860–1920," in *Midwives, Society, and Childbirth: Debates and Controversies in the Modern Period*, edited by Hilary Marland and Anne Marie Rafferty (New York: Routledge, 1997), 115; Charlotte G. Borst, *Catching Babies: The Professionalization of Childbirth, 1870–1920* (Cambridge, Mass.: Harvard University Press, 1995), 24–25; M. J. Van Lieburg and Hilary Marland, "Midwife Regulation, Education, and Practice in the Netherlands during the Nineteenth Century," *Medical History* 33 (1988): 315, table 7; Arleen M. Tuchman, "'The True Assistant to the Obstetrician': State Licensing of Midwives in Nineteenth-Century Germany," American Association for the History of Medicine conference, Toronto, May 1998, paper in my possession; and Lynne Fallwell, "Labor Pains: Midwifery and the Professionalization of Modern Childbirth in Germany," American Association for the History of Medicine conference, Kansas City, April 2002, paper in my possession.

26. Okamoto, "Josanpu katsudo," 26, 28, 30–34; Michiko Ōbayashi, "Josanpu shokuno no hensen o saguru. Nihon sanba kangofu hokenfu kyokai setsuritsu zenshi" [Searching for Transitions in the Function of Midwives: The History Prior to the Establishment of the Japanese Society for Midwives, Nurses, and Public Health Nurses], *Josanpu Zasshi* [(Japanese) Journal for Midwives] 39, no. 2 (February 1985): 84–88; Mary W. Standlee, *The Great Pulse: Japanese Midwifery and Obstetrics through the Ages* (Tokyo: Charles E. Tuttle, 1959), 137; Okamoto, "Josanpu katsudo," 29, Rousseau, "Enduring Labors," 41, 66, 118, 122–23.

27. Steger, "From Impurity to Hygiene," 179–81.

28. Rousseau, "Enduring Labors," viii; see also vii and xvii.

29. Narita Ryūichi, "Mobilized from Within: Women and Hygiene in Modern Japan," in *Women and Class in Japanese History*, edited by Hitomi Tonomura, Anne Walthall, and Wakita Haruko (Ann Arbor: Center for Japanese Studies, University of Michigan, 1999), 259; Rousseau, "Enduring Labors," xvii, 11 n. 13, 46.

30. Dossey, *Florence Nightingale*, 312–14, 321.

31. Mary Ellen Doona, "Linda Richards and Nursing in Japan, 1885–1890," *Nursing History Review* 4 (1996): 99–128; Stella Goostray, "Linda Richards," in *Notable American Women: A Biographical Dictionary*, edited by Edward T. James, Janet Wilson James, and Paul S. Boyer (Cambridge, Mass.: Belknap Press, 1971), 148–50; Rachel Baker, *America's First Trained Nurse: Linda Richards* (New York: Julian Messner, 1962), 65, 72, 82, 111, 116–17, 132; Masako Takahashi, "'Fujin kotobukigusa' to 'toriagebaba kokoro e gusa' ni miru josanpu no sugata" [A Portrait of Midwives seen in "Writings on Women's Longevity" and "Writings on Rules for Midwives"], *Kango Kyōiku* [Nursing Education] 24, no. 8 (August 1983): 496–99.

32. Eiko Shinotsuka, "Japanese Care Assistants in Hospitals, 1918–88," in *Japanese Women Working*, edited by Janet Hunter (New York: Routledge, 1993), 155; Rousseau, "Enduring Labors," 183; Kay K. Hisama, "Florence Nightingale's Influence on the Development and Professionalization of Modern Nursing in Japan," *Nursing Outlook* 44, no. 6 (1996): 284–88.

33. Nolte and Hastings, "Meiji State's Policy," 159–63; Rousseau, "Enduring Labors," 176, 183; LaFeber, *Clash*, 52.

34. Quoted in Rousseau, "Enduring Labors," 67; see also 70; Judith Walzer Leavitt, *Brought to Bed: Childbearing in America, 1750 to 1950* (New York: Oxford University Press, 1986), 64–86; Loudon, *Tragedy*, 165; Wendy Mitchinson, *Giving Birth in Canada, 1900–1950* (Toronto: University of Toronto Press, 2002), 53, 160–61.

35. Okamoto, "Josanpu katsudo," 25–26; Standlee, *Great Pulse*, 132; Rousseau, "Enduring Labors," 22, 24–25.

36. Rousseau, "Enduring Labors," 27, 90, 92, 98.

37. Okamoto, "Josanpu katsudo," 24, 26; Rousseau, "Enduring Labors," 4, 72, 91, 113.

38. Standlee, *Great Pulse*, 137; Okamoto, "Josanpu katsudo," 26; Rousseau, "Enduring Labors," 115.

39. Okamoto, "Josanpu katsudo," 39; Rousseau, "Enduring Labors," 97, 98 n. 29.

40. Dossey, *Florence Nightingale*, 314, 381; Rousseau, "Enduring Labors," 101.

41. Interview with Sachi Torii in Sumiko Takaoka and Sumie Furusaki, "Sanba no jissen katsudo to ayumi kara gakubu koto (2)" [A Study of the Practices and Developmental Course of Midwives (2)], *Josanpu Zasshi* [(Japanese) Journal for Midwives] 41, no. 6 (June 1987): 50–51.

42. Takaoka and Furusaki, "Sanba no jissen katsudo (4)," 44; Okamoto, "Josanpu katsudo," 34–39, 39; Rousseau, "Enduring Labors," 118.

43. Kazuharu Shima, "Tanaka shin monogatari: owari naki ryo" [Journey without End: The Story of Shin Tanaka] *Josanpu Zasshi* [(Japanese) Journal for Midwives] 37, no. 12 (December 1983), 81; Takaoka and Furusaki, "Sanba no jissen katsudo (4)," 44; Okamoto, "Josanpu katsudo," 39; Emiko Ochiai, "Modern Japan through the Eyes of an Old Midwife: From an Oral Life History to Social History," translated by Mio Neuse, in *Gender and Japanese History*, vol. 1, edited by Wakita Haaruko, Anne Bouchy, and Ueno Chizuko, with translation editor Gerry Yokota-Murakimi (Osaka, Japan: Osaka University Press, 1999), 269.

44. Okamoto, "Josanpu katsudo," 30–31, 41; Rousseau, "Enduring Labors," xi, 29–30, 133–36. On the importance of journals in constructing culture, see Susan Hamilton, *Criminals, Idiots, Women, and Minors: Nineteenth-Century Writing by Women on Women* (Peterborough, Ont.: Broadview Press, 1995), introduction.

45. Interview with Nami Murakami in Hidetoshi Ochiai, "Kobe de iki kamisama to shimpō sareta sanba san" [A Midwife Believed to Be a Living Saint of Kobe], *Josanpu Zasshi* [(Japanese) Journal for Midwives] 27 (March 1973): 48–52.

46. Kazu Tanaka, quoted in Steger, "From Impurity to Hygiene," 182.

47. Rousseau, "Enduring Labors," 76.

48. Interview with Akino Uenaka in Sumiko Takaoka and Sumie Furusaki, "Sanba no jissen katsudo to ayumi kara gakubu koto (1)" [A Study of the Practices and Developmental Course of Midwives (1)], *Josanpu Zasshi* [(Japanese) Journal for Midwives] 41, no. 5 (May 1987), 52; Steger, "From Impurity to Hygiene," 182.

49. Okamoto, "Josanpu katsudo," 39; Takaoka and Furasaki, "Sanba no jissen katsudo (4)," 44; Steger, "From Impurity to Hygiene," 183–83; Rousseau, "Enduring Labors," 86.

50. Takaoka and Furasaki, "Sanba no jissen katsudo (4)," 44; Kazuharu Shima, "Tanaka shin monogatari: owari naki ryo" [Journey without End: The Story of Shin Tanaka], *Josanpu Zasshi* [(Japanese) Journal for Midwives] 37, no. 3 (March 1983), 72; Standlee, *Great Pulse*, 148; Rousseau, "Enduring Labors," 62, 79.

51. Takaoka and Furusaki, "Sanba no jissen katsudo (2)," 49; (4), 44.

52. Interview with Akino Uenaka in Takaoka and Furusaki, "Sanba no jissen katsudo (1)," 52.

53. Interview with Yoshi Aoki in Takaoka and Furusaki, "Sanba no jissen katsudo (1)," 53.

54. Takaoka and Furusaki, "Sanba no jissen katsudo (1)," 53; (2), 48; (4), 43; Kazuharu Shima, "Tanaka shin monogatari: owari naki ryo" [Journey without End: The Story of Shin Tanaka], *Josanpu Zasshi* [(Japanese) Journal for Midwives] 37, no. 4 (April 1983), 73; Standlee, *Great Pulse*, 146.

55. Takaoka and Furusaki, "Sanba no jissen katsudo (4)," 45; interview with Nobukazuko Sakamoto and Tatsue Hishida in Takaoka and Furusaki, "Sanba no jissen katsudo (1)," 55–56; interview with Tami Yamada in Takaoka and Furusaki, "Sanba no jissen katsudo (2)," 48–49.

56. Ohnuki-Tierney, *Illness and Culture,* 35–38; Takaoka and Furusaki, "Sanba no jissen katsudo (1)," 53; (2), 48; (4), 43; Steger, "From Impurity to Hygiene," 175–76.

57. Nishikawa, *"Aru Kindai Sanba,"* 1, 3, 5, 6, 8.

58. Okamoto, "Josanpu katsudo," 24, 42; Rousseau, "Enduring Labors," 159.

59. Irokawa, *Culture of the Meiji Period,* 151–71; Hane, *Modern Japan,* 3, 94, 139; Miller, "World of Japan," 191; Calman, *Nature and Origins of Japanese Imperialism,* 176; Takaoka and Furusaki, "Sanba no jissen katsudo (4)," 45; Steger, "From Impurity to Hygiene," 181.

60. Steger, "From Impurity to Hygiene," 183; see also 181; Okamoto, "Josanpu katsudo," 38–39; Ōbayashi, "Josanpu shokuno," 84–88; Nishikawa, "Modern *Sanba* (Midwife) and the Transformation of Childbirth," 2, 3, 8; Rousseau, "Enduring Labors," 109, 162–64.

61. Interview with Nami Murakami in Ochiai, "Kobe de iki kamisama," 48–52; Okamoto, "Josanpu katsudo," 38.

62. Interview with Yoshi Aoki in Takaoka and Furusaki, "Sanba no jissen katsudo (1)," 54.

63. Kazuko Miyazato, "Philosophy and Nature of Childbirth As Seen in Traditions and Customs," in *History of Obstetrics: Proceedings of the 7th International Symposium on the Comparative History of Medicine—East and West,* edited by Teizo Ogawa (Osaka, Japan: Taniguchi Foundation, 1983), 262–263; Takaoka and Furusaki, "Sanba no jissen katsudo (4)," 43; (1), 53–54.

64. Interview with Akino Uenaka in Takaoka and Furusaki, "Sanba no jissen katsudo (1)," 53; interview with Tami Yamada in Takaoka and Furusaki, "Sanba no jissen katsudo (2)," 48–49.

65. E. Patricia Tsurumi, *Factory Girls: Women in the Thread Mills of Meiji Japan* (Princeton, N.J.: Princeton University Press, 1990); Steger, "From Impurity to Hygiene," 177; Hane, *Modern Japan,* 144. On parallel changes in domestic service, see Faye E. Dudden, *Serving Women: Household Service in Nineteenth-Century America* (Middleton, Conn.: Wesleyan University Press, 1983).

Chapter 2

1. Alyce Yamaguchi, interview by author, tape recording, East San Gabriel Valley Japanese Community Center, West Covina, California, 18 March 1998. My thanks to Mary Hida for facilitating this interview; thanks also to Susan Hamilton for her helpful insights on this narrative. See also Michiko Tanaka, *Through Harsh Winters: The Life of a Japanese Immigrant Woman* (Novato, Calif.: Chandler & Sharp, 1981), 27, 34; and Eileen Sunada Sarasohn, *Issei Women: Echoes from Another Frontier* (Palo Alto, Calif.: Pacific Books, 1998), 146. Sarasohn's analysis is based on evidence from Issei women included in the 200 interviews in the Issei Oral History Project at the Sacramento History Center Archives in California.

2. Interview with Alyce Yamaguchi.

3. Interview with Alyce Yamaguchi; Harry H. L. Kitano and Roger Daniels, *Asian Americans: Emerging Minorities*, 2d ed. (Englewood Cliffs, N.J.: Prentice-Hall, 1995), 56.

4. Koyoshi Uono, "The Factors Affecting the Geographical Aggregation and Dispersion of the Japanese Residences in the City of Los Angeles" (master's thesis, University of Southern California, 1927), 13; Tanaka, *Through Harsh Winters*, 29, 119; Evelyn Nakano Glenn, *Issei, Nisei, War Bride: Three Generations of Japanese American Women in Domestic Service* (Philadelphia: Temple University Press, 1986), 68–71; Roger Daniels, *Asian America: Chinese and Japanese in the United States since 1850* (Seattle: University of Washington Press, 1988), 100–154.

5. Interview with Alyce Yamaguchi.

6. Midge Ayukawa, "Good Wives and Wise Mothers: Japanese Picture Brides in Early Twentieth-Century British Columbia," in *Rethinking Canada: The Promise of Women's History*, 3d ed., edited by Veronica Strong-Boag and Anita Clair Fellman (Toronto: Oxford University Press, 1997), 243; Alan Takeo Moriyama, *Imingaisha: Japanese Emigration Companies and Hawaii, 1894–1908* (Honolulu: University of Hawai'i Press, 1985), 2–3.

7. Gordon G. Nakayama, *Issei: Stories of Japanese Canadian Pioneers* (Toronto: NC Press, 1984), 12–13; Richard L. Forstall, "Population of Counties by Decennial Census: 1900 to 1990, 27 March 1995, http://www.census.gov/population/cencounts/ca190090.txt (accessed 2 November 2002).

8. Sarasohn, *Issei Women*, 26.

9. Glenn, *Issei, Nisei, War Bride*, 74; Mei Nakano, *Japanese American Women: Three Generations, 1890–1990* (Berkeley, Calif.: Mina Press, 1990), 43–48.

10. Interview with Alyce Yamaguchi; Sucheta Mazumdar, "General Introduction: A Woman-Centered Perspective on Asian American History," in *Making Waves: An Anthology of Writings by and about Asian American Women*, edited by Asian Women United of California (Boston: Beacon Press, 1989), 9; Linda Tamura, *The Hood River Issei: An Oral History of Japanese Settlers in Oregon's Hood River Valley* (Urbana: University of Illinois Press, 1993), 53.

11. The quotation is from Tanaka, *Through Harsh Winters*, 32; see also 33, 87; Tamura, *Hood River Issei*, xxvi, xxxi, 53–55, 60; Sarasohn, *Issei Women*, 29.

12. Interview with Alyce Yamaguchi; Tanaka, *Through Harsh Winters*, 9; Sylvia Junko Yanagisako, *Transforming the Past: Tradition and Kinship among Japanese Americans* (Stanford, Calif.: Stanford University Press, 1985), 105–8.

13. Interview with Alyce Yamaguchi; Glenn, *Issei, Nisei, War Bride*, 44; Kikumura in Tanaka, *Through Harsh Winters*, 90, 123; Sarasohn, *Issei Women*, 62, 87; Tamura, *Hood River Issei*, 16–18.

14. Alyce remembered with pleasure and pride that when she married, her mother gave her a special gift—Kimi borrowed a friend's instrument and played it beautifully for Alyce's wedding. Alyce's married name was Yamamoto, but after her divorce she returned to using her maiden name: interview with Alyce Yamaguchi.

15. Tanaka, *Through Harsh Winters*, 25.

16. Tanaka, *Through Harsh Winters*, 34; see also 3. See also Japanese American Citizens' League, San Mateo Chapter, *1872–1942: A Community Story* (San Mateo, Calif.: Japanese American Citizens' League, San Mateo Chapter, 1981), 57 (thanks to Richard Nakanishi for providing this article); Ayukawa, "Good Wives and Wise Mothers," 238–52.

17. Tanaka, *Through Harsh Winters*, 3, 15, 18, 30–31, 41, 43.

18. Tanaka, *Through Harsh Winters*, 4; see also 86; interview with Alyce Yamaguchi.

19. Texas, Nevada, New Mexico, Colorado, Nebraska, and Delaware passed similar anti-Japanese land laws. U.S. Department of State, *Report of the Honorable Roland S. Morris on Japanese Immigration and Alleged Discriminatory Legislation against Japanese Residents in the United States* (New York: Arno Press, 1978), 13 [hereafter *Morris Report*]; Kitano and Daniels, *Asian Americans,* 60; Ruthanne Lum McCunn, *Chinese American Portraits: Personal Histories, 1828–1988* (Seattle: University of Washington Press, 1988), 63–64, 78–87, 159; Tamura, *Hood River Issei,* 85.

20. Sucheng Chan, *Asian Americans: An Interpretive History* (Boston: Twayne, 1991), 81–100; Peggy Pascoe, "Miscegenation Law, Court Cases, and Ideologies of 'Race' in Twentieth-Century America," *Journal of American History* 83, no. 1 (June 1996): 44–69; Peggy Pascoe, "Ophelia Paquet, a Tillamook Indian Wife: Miscegenation Laws and the Privileges of Property," in *Women's America: Refocusing the Past,* 5th ed., edited by Linda K. Kerber and Jane Sherron De Hart (New York: Oxford University Press, 2000), 278–83.

21. Kitano and Daniels, *Asian Americans,* 57. See also Walter LaFeber, *The Clash: U.S.–Japanese Relations throughout History* (New York: Norton, 1997), 78, 98.

22. The Chinese Exclusion Act was extended in 1892 and made "permanent" in 1902. Kitano and Daniels, *Asian Americans,* 13–14; Daniels, *Asian America,* 112.

23. Daniels, *Asian America,* 115 (table 4.1); Iriye, *Mutual Images,* 76, cites 35,000 total.

24. Daniels, *Asian America,* 103, 153 (table 4.4).

25. Daniels, *Asian America,* 115 (table 4.1), 157.

26. LaFeber, *Clash,* 88, 105, 120.

27. Alan M. Kraut, *Silent Travelers: Germs, Genes, and the 'Immigrant Menace'* (Baltimore: Johns Hopkins University Press, 1994), x, 3, 65, 78–79, 107, 188–89; Susan Craddock, *City of Plagues: Disease, Poverty, and Deviance in San Francisco* (Minneapolis: University of Minnesota Press, 2000); Nayan Shah, *Contagious Divides: Epidemics and Race in San Francisco's Chinatown* (Berkeley: University of California Press, 2001), 1–2.

28. Roger Daniels, *The Politics of Prejudice: The Anti-Japanese Movement in California and the Struggle for Japanese Exclusion* (Berkeley: University of California Press, 1962), 65–78, esp. 68.

29. Item #49, "Report on the National Oriental Committee of the American Legion," Fifth Annual Convention of the American Legion, San Francisco, 1923, box

24, Survey of Race Relations Records, 1924–1927, Hoover Institution Archives, Stanford University, Stanford, California.

30. LaFeber, *Clash,* 91.

31. John N. Hawkins, "Politics, Education, and Language Policy: The Case of Japanese Language Schools in Hawaii," *Amerasia Journal* 5, no. 1 (1978): 39–54.

32. Yuji Ichioka, *The Issei: The World of the First Generation Japanese Immigrants, 1885–1924* (New York: Free Press, 1988), 1, 6, 153, 211, 244; Ronald Takaki, *Strangers from a Different Shore: A History of Asian Americans* (Boston: Little, Brown, 1989), 14; Linda K. Kerber, "The Meanings of Citizenship," *Journal of American History* 84, no. 3 (December 1997), 833–54, esp. 836, 841, 843; Mae N. Ngai, "The Architecture of Race in American Immigration Law: A Reexamination of the Immigration Act of 1924," *Journal of American History* 86, no. 1 (June 1999): 67–92. A few Issei World War I veterans of the U.S. Armed Forces were allowed to become naturalized U.S. citizens.

33. Daniels, *Politics of Prejudice,* 31–45; both quotations are from LaFeber, *Clash,* 89.

34. Japanese Association of the Pacific Northwest, *Japanese Immigration: An Exposition of Its Real Status* (San Francisco: R and E Research Associates, 1972), 1, 10, 12–13, 17, 19, 21, 26, 37, 40–42; Daniels, *Asian America,* 103; LaFeber, *Clash,* 89.

35. Daniels, *Asian America,* 149; LaFeber, *Clash,* 90, 93. Canada signed a similar agreement in 1908. Ayuka, "Good Wives and Wise Mothers," 242.

36. LaFeber, *Clash,* 89. Chinese children were segregated in San Francisco schools until the late 1920s and in Mississippi schools until the 1954 U.S. Supreme Court decision in *Brown v. Board of Education:* Judy Yung, *Chinese Women of America: A Pictorial History* (Seattle: University of Washington Press, 1986), 48.

37. Daniels, *Asian America,* 94, 125–26. See also *Morris Report,* 4; Mazumdar, "General Introduction," 7; Paul Spikard, *Japanese Americans: The Formation and Transformations of an Ethnic Group* (New York: Twayne, 1996), 33–35; Malve von Hassell, "Issei Women between Two Worlds: 1875–1985," (Ph.D. diss., New School for Social Research, 1987), 85–86, 113; Kitano and Daniels, *Asian Americans,* 60.

38. Daniels, *Asian America,* 153, table 4.5; Ichioka, *Issei,* 5, 173; von Hassell, "Issei Women," 86; Kikumura in Tanaka, *Through Harsh Winters,* 112; Takaki, *Strangers from a Different Shore,* 47.

39. Roger Daniels, *Guarding the Golden Door: American Immigration Policy and Immigrants since 1882* (New York: Hill and Wang, 2004).

40. Spikard, *Japanese Americans,* 60; von Hassell, "Issei Women," 86; Ichioka, *Issei,* 173–75. This action was reminiscent of the Page Law of 1875, by which Congress attempted to halt the immigration of women of "disreputable character" as a way to stop the traffic in Chinese women for the purposes of prostitution. Sucheng Chan, ed., *Entry Denied: Exclusion and the Chinese Community in America, 1882–1943* (Philadelphia: Temple University Press, 1991), 94–146.

41. Takaki, *Strangers from a Different Shore*, 7, 209; Daniels, *Asian America*, 149; Ngai, "Architecture of Race," 80–81.

42. Daniels, *Asian America*, 149; Yanagisako, *Transforming the Past*, 5.

43. William J. Miller, "The World of Japan," in *The World of Asia*, 2d ed., edited by Akira Iriye et al. (Wheeling, Ill.: Harlan Davidson, 1995), 193.

44. Charlotte G. Borst, *Catching Babies: The Professionalization of Childbirth, 1870–1920* (Cambridge, Mass.: Harvard University Press, 1995), 4, 43; Judith Barrett Litoff, *American Midwives, 1860 to the Present* (Westport, Conn.: Greenwood Press, 1978), 34, 77; Fran Leeper Buss, *La Partera: Story of a Midwife* (Ann Arbor: University of Michigan Press, 1980); Sandra Schackel, *Social Housekeepers: Women Shaping Public Policy in New Mexico, 1920–1940* (Albuquerque: University of New Mexico Press, 1992), 29–59; Susan L. Smith, *Sick and Tired of Being Sick and Tired: Black Women's Health Activism in America, 1890–1950* (Philadelphia: University of Pennsylvania Press, 1995), 118–48; Gertrude Jacinta Fraser, *African American Midwifery in the South: Dialogues of Birth, Race, and Memory* (Cambridge, Mass.: Harvard University Press, 1998). On midwifery in Canada, see Wendy Mitchinson, *Giving Birth in Canada, 1900–1950* (Toronto: University of Toronto Press, 2002), 69–103.

45. Ethel Watters to Mary Riggs Noble, 1923, Central Files, 1921–1924, box 190, file 4–10–4–2, Record Group 102, U.S. Children's Bureau, National Archives, College Park Branch, College Park, Maryland; Litoff, *American Midwives*, 27, 58; Valerie Lee, *Granny Midwives and Black Women Writers: Double Dutched Readings* (New York: Routledge, 1996), 6. In 1931 a White House conference on children's health reported that there were 47,000 midwives attending births in the U.S.: Louis S. Reed, *Midwives, Chiropodists, and Optometrists: Their Place in Medical Care* (Chicago: University of Chicago Press, 1932), 4.

46. Maternal and Child Health Services, Progress Reports, Central Files, 1937–1940, box 754, file 4–7–4, RG 102; Litoff, *American Midwives*, 113, 141.

47. For examples of these studies, see the review essay by Judith Barrett Litoff, "Midwives and History," in *Women, Health, and Medicine in America: A Historical Handbook*, edited by Rima D. Apple (New York: Garland, 1990), 443–58. See also Litoff, *American Midwives*, 21, 28, 29, 77–78.

48. Hilary Marland and Anne Marie Rafferty, eds., *Midwives, Society, and Childbirth: Debates and Controversies in the Modern Period* (New York: Routledge, 1997), esp. introduction and 180–81; Arleen M. Tuchman, "'The True Assistant to the Obstetrician': State Licensing of Midwives in Nineteenth-Century Germany," American Association for the History of Medicine conference, Toronto, May 1998, paper in my possession.

49. Faye D. Ginsburg and Rayna Rapp, Introduction to *Conceiving the New World Order: The Global Politics of Reproduction*, edited by Faye D. Ginsburg and Rayna Rapp (Berkeley: University of California Press, 1995), 1; Rena Haig, *The Development of Nursing under the California State Department of Public Health* (New York: National League for Nursing, 1959), 5; Litoff, *American Midwives*,

53, 92; Deborah Dwork, *War Is Good for Babies and Other Young Children: A History of the Infant and Child Welfare Movement in England 1898–1918* (London: Tavistock, 1987); Cynthia R. Comacchio, *Nations Are Built of Babies: Saving Ontario's Mothers and Children, 1900–1940* (Montreal: McGill-Queen's University Press, 1993); Alisa Klaus, *Every Child a Lion: The Origins of Maternal and Infant Health Policy in the United States and France, 1890–1920* (Ithaca, N.Y.: Cornell University Press, 1993).

50. Litoff, *American Midwives*, 32–37, 42, 50, 91; Borst, *Catching Babies*, 24–34; Molly Ladd-Taylor, *Mother-Work: Women, Child Welfare, and the State, 1890–1930* (Urbana: University of Illinois Press, 1994), 167–96.

51. M. Theophane Shoemaker, *History of Nurse-Midwifery in the United States* (New York: Garland, 1984), 5–6; Jennifer Lisa Koslow, "Eden's Underbelly: Female Reformers and Public Health in Los Angeles, 1889–1932," (Ph.D. diss., University of California, Los Angeles, 2001), 124–69, esp. 124.

52. Nicky Leap and Billie Hunter, *The Midwife's Tale: An Oral History from Handywoman to Professional Midwife* (London: Scarlet Press, 1993), ix–x, 1, 4; Barbara Montgomery Dossey, *Florence Nightingale: Mystic, Visionary, Healer* (Springhouse, Penn.: Springhouse Corporation, 2000), 314.

53. Robyn Muncy, *Creating a Female Dominion in American Reform, 1890–1935* (New York: Oxford University Press, 1991), 115–19, 202 n. 134; Ladd-Taylor, *Mother-Work*, 173–75; Sandra Lee Barney, *Authorized to Heal: Gender, Class, and the Transformation of Medicine in Appalachia, 1880–1930* (Chapel Hill: University of North Carolina Press, 2000), 2, 9; Ellen More, *Restoring the Balance: Women Physicians and the Profession of Medicine, 1850–1995* (Cambridge, Mass.: Harvard University Press, 1999), 70–94, 148–81; Borst, *Catching Babies*, 35, 38–39.

54. Frances E. Kobrin, "The American Midwife Controversy: A Crisis of Professionalization," *Bulletin of the History of Medicine* 40 (1966): 350–63; Litoff, *American Midwives*, 21, 64, 82, 137, 138, 140; Leslie J. Reagan, *When Abortion Was a Crime: Women, Medicine, and Law in the United States, 1867–1973* (Berkeley: University of California Press, 1997), 290 n. 56.

55. Litoff, *American Midwives*, 100–101; Kriste Lindenmeyer, *"A Right to Childhood": The U.S. Children's Bureau and Child Welfare, 1912–46* (Urbana: University of Illinois Press, 1997), 96–97.

56. Linda Gordon, *Pitied but Not Entitled: Single Mothers and the History of Welfare, 1890–1935* (Cambridge, Mass.: Harvard University Press, 1994), 94; see also 88, 93; Litoff, *American Midwives*, 56, 99–100; Molly Ladd-Taylor, "'Grannies' and 'Spinsters': Midwife Education under the Sheppard-Towner Act," *Journal of Social History* 22 (Winter 1988): 255–75; Richard A. Meckel, *Save the Babies: American Public Health Reform and the Prevention of Infant Mortality, 1850–1929* (Baltimore: Johns Hopkins University Press, 1990), 210; Muncy, *Creating a Female Dominion*, 93–123.

57. On European immigrant midwives, see Litoff, *American Midwives*, 29, 33; Elizabeth Ewen, *Immigrant Women in the Land of Dollars: Life and Culture on the*

Lower East Side, 1890–1925 (New York: Monthly Review Press, 1985), 33, 130; Eugene Declercq and Richard Lacroix, "The Immigrant Midwives of Lawrence: The Conflict between Law and Culture in Early Twentieth-Century Massachusetts," *Bulletin of the History of Medicine* 59 (1985): 232–46, esp. 241–43; Judith Walzer Leavitt, *Brought to Bed: Childbearing in America, 1750 to 1950* (New York: Oxford University Press, 1986), 114; and Charlotte G. Borst, "The Training and Practice of Midwives: A Wisconsin Study," *Bulletin of the History of Medicine* 62 (1988): 606–27.

58. Quoted in Ewen, *Immigrant Women*, 134.

59. Judith Barrett Litoff, *The American Midwife Debate: A Sourcebook on Its Modern Origins* (Westport, Conn.: Greenwood Press, 1986), 5; Litoff, *American Midwives*, 109–11.

60. On African American midwives and nineteenth-century slavery, see Leslie A. Schwalm, *A Hard Fight for We: Women's Transition from Slavery to Freedom in South Carolina* (Urbana: University of Illinois Press, 1997), 31, 43, 61; and Sharla M. Fett, *Working Cures: Healing, Health, and Power on Southern Slave Plantations* (Chapel Hill: University of North Carolina Press, 2002), esp. 36–59. For African American midwives in the twentieth century, see Molly C. Dougherty, "Southern Midwifery and Organized Health Care: Systems in Conflict," *Medical Anthropology* 6 (Spring 1982): 113–26; Sharon A. Robinson, "A Historical Development of Midwifery in the Black Community: 1600–1940," *Journal of Nurse-Midwifery* 29 (July/August 1984): 247–50; Linda Janet Holmes, "African American Midwives in the South," in *The American Way of Birth*, edited by Pamela S. Eakins (Philadelphia: Temple University Press, 1986), 273–91; Ladd-Taylor, "'Grannies' and 'Spinsters,'" 255–75; Debra Ann Susie, *In the Way of Our Grandmothers: A Cultural View of Twentieth-Century Midwifery in Florida* (Athens: University of Georgia Press, 1988); Smith, *Sick and Tired*, 118–48; Fraser, *African American Midwifery in the South*; and Lee, *Granny Midwives*.

61. Vanessa Northington Gamble, *Making a Place for Ourselves: The Black Hospital Movement, 1920–1945* (New York: Oxford University Press, 1995), 46. See also Smith, *Sick and Tired*, 76; Spencie Love, *One Blood: The Death and Resurrection of Charles R. Drew* (Chapel Hill: University of North Carolina Press, 1996), esp. 217–57.

62. Florence Kraker to William Nicholson, December 1924, Central Files, 1921–1924, box 190, file 4–10–4–2, RG 102; Marie Campbell, *Folks Do Get Born* (New York: Rinehart, 1946), 8; Emily Herring Wilson, *Hope and Dignity: Older Black Women of the South* (Philadelphia: Temple University Press, 1983), 39; Susie, *In the Way of Our Grandmothers*, 35; Edward H. Beardsley, *A History of Neglect: Health Care for Blacks and Mill Workers in the Twentieth-Century South* (Knoxville: University of Tennessee Press, 1987), 39; Ladd-Taylor, *Mother-Work*, 182; Smith, *Sick and Tired*, 119.

63. Smith, *Sick and Tired*, 121, 124, 126; Irvine Loudon, "Midwives and the Quality of Maternal Care," in *Midwives, Society, and Childbirth: Debates and*

Controversies in the Modern Period, edited by Hilary Marland and Anne Marie Rafferty (New York: Routledge, 1997), 187.

64. Onnie Lee Logan, *Motherwit: An Alabama Midwife's Story* (New York: E. P. Dutton, 1989).

65. See correspondence on midwifery in RG 102, esp. for the years 1925, 1937, 1946, and 1948.

66. Campbell, *Folks Do Get Born,* 40.

67. Gail Caldwell, "Author Toni Morrison Discusses Her Latest Novel *Beloved,*" in *Conversations with Toni Morrison,* edited by Danill Taylor-Guthrie (Jackson: University Press of Mississippi, 1994), as quoted in Lee, *Granny Midwives,* 180 n. 2.

68. Central Files 1921–24, box 190, File 4–10–4–2, RG 102; *General Laws of Oregon* (Salem, Ore.: State Printing Department, 1919), 431–32, Oregon State Archives, Salem.

69. On California club women's efforts, see Dr. Pinkham to Dr. W. J. Poole, 28 April 1923, General Subject Files, State Board of Medical Examiners, folder F3760:504, "midwives correspondence," and Minutes of the California State Board of Public Health, 1918, 396, both in California State Archives, Sacramento. On Washington State, see W. V. Tanner, *Session Laws of the State of Washington, Fifteenth Session, 1917* (Olympia, Wash.: Frank M. Lamborn, Public Printer, 1917); Dr. Mabelle Lu Park, president of the Medical Woman's Club of the Seattle Federation of Women's Clubs to Ernest Lister, 16 March 1917, Governor Ernest Lister's Papers, subject and correspondence files, 1917–1919, "midwifery," both in Washington State Archives, Olympia; and "Medical Notes," *Northwest Medicine* 4, no. 6 (June 1906): 209.

70. Kimi Yamaguchi was not among the more than 100 names of midwives listed as licensed by California: "Physicians and Midwives," Finding Aid folder, California State Board of Medical Examiners.

71. The quotation is from Dr. F. W. Almond, director of the Idaho Bureau of Child Hygiene, to Dr. Ethel M. Watters, Children's Bureau, 6 March 1923. See Dr. Hazel Dell Bonness, director of the Montana Division of Child Welfare, to Dr. Ethel M. Watters, 9 March 1923, and Dr. G. S. Luckett, director of the New Mexico Bureau of Public Health, to Dr. Ethel M. Watters, 13 March 1923, all in Central Files, 1921–1924, box 190, folder 4–10–4–2, RG 102. Also on New Mexico, see Sarah Deutsch, *No Separate Refuge: Culture, Class, and Gender on an Anglo-Hispanic Frontier in the American Southwest, 1880–1940* (New York: Oxford University Press, 1987), 186; Buss, *Partera*; Schackel, *Social Housekeepers,* 29–59.

72. On federal and state power in the West, see Donald Worster, *Rivers of Empire: Water, Aridity, and the Growth of the American West* (New York: Pantheon Books, 1986), 131; Carl Abbott, "The Federal Presence," in *The Oxford History of the American West,* edited by Clyde A. Milner II, Carol A. O'Connor, and Martha A. Sandweiss (New York: Oxford University Press, 1994), 469–99.

73. Dr. Albert B. Tonkin, a Wyoming state health officer, to Dr. Ethel M. Wat-

ters, 15 March 1923; Dr. Wilford W. Barber, director of the Utah Bureau of Child Hygiene, to Dr. Ethel M. Watters, 18 March 1923; Maude Howe, director of the Arizona Child Hygiene Division, to Dr. Ethel M. Watters, 23 March 1923; the first quotation is from Estelle N. Matthews, executive secretary of the Colorado Child Welfare Bureau, to Dr. Ethel M. Watters, 23 March 1923, RG 102—all in Central Files, 1921–1924, box 190, folder 4-10-4-2, RG 102. The second quotation is from Maude Howe to Dr. Blanche M. Haines, 20 October 1925, Central Files, 1921–1928, box 323, folder 11-4-1, RG 102.

74. New Mexico's high infant and maternal mortality rates led officials to regulate and supervise the predominantly Hispanic midwife population. Deutsch, *No Separate Refuge*, 186; Buss, *Partera*. San Francisco and Los Angeles, where there were sizable Japanese American populations, also saw some active midwife regulation. On Los Angeles, see Koslow, "Eden's Underbelly," 124–69. On San Francisco, see Central Files, 1937–1940, box 754, file 4-7-4, RG 102.

75. Finding Aid, California State Board of Medical Examiners; chapter 81 in the *Statutes of California and Amendments to the Codes* [hereafter *Statutes of California*] (Sacramento: California State Printing Office, 1917), 93–115, California State Archives.

76. Finding Aid and Minutes of the California State Board of Medical Examiners (1937), 6253, and *Statutes of California* (1917), chapter 81; "Collected Clippings on Medical Law Enforcement," *California State Journal of Medicine* 18, no. 6 (February 1920): 65–66; "Medical Items in California Press," *California State Journal of Medicine* 18, no. 6 (June 1920): 233; and Reagan, *When Abortion Was a Crime*, 80–112.

77. Minutes of the California State Board of Public Health (1918), 361; Minutes of the California State Board of Medical Examiners (1918), 1097. See also Litoff, *American Midwives*, 51. California's State Board of Public Health was one of the first in the nation, established in 1870. See "From 1870 to 1970: California Has Come a Long Way in Public Health," *California's Health* (April 1970): 15.

78. Finding Aid, California State Board of Medical Examiners; Kenneth M. Ludmerer, *Learning to Heal: The Development of American Medical Education* (Baltimore: Johns Hopkins University Press, 1985), 95.

79. Minutes of the California State Board of Medical Examiners (1917), 992; Jennifer Lisa Koslow, "Delivering the City's Children: Municipal Programs and Midwifery in Los Angeles," *Canadian Bulletin of Medical History* 19, no. 2 (2002): 1–33; Uono, "Factors Affecting the Geographical Aggregation," 54 (table viii).

80. Finding Aid and Minutes of the California State Board of Medical Examiners (1919), 1369.

81. "Minutes of Special Meeting Held June 11, 12, 13, 1917, by Board of Medical Examiners, Los Angeles, California," 989–90, 1020; Uono, "Factors Affecting the Geographical Aggregation," 54 (table viii). On the impact of World War I, see Shin Hasegawa, *Nihon Dasshutsuki: Rosanjerusuno Tashiro Dokut A* [Exodus

from Japan: Dr. Tashiro of Los Angeles] (Tokyo: n.p., 1978), part 2, chapter 1, with special thanks to Teko Gardener for her translation assistance.

82. Minutes of the California State Board of Medical Examiners (1919), 1369–70; and Minutes of the California State Board of Medical Examiners (1920), 1664, 1683, 1832–34; "Japanese Must Speak English," *California State Journal of Medicine* 18, no. 9 (September 1920): 345.

83. Minutes of the California State Board of Medical Examiners (1918), 1098, and (1921), 2293–94.

84. California Bureau of Child Hygiene, 1923, Central Files, 1921–1924, box 190, file 4–10–4–2, RG 102; General Subject Files, California State Board of Medical Examiners, folder F3760:504, "midwives correspondence"; Koslow, "Eden's Underbelly," 164.

85. Material on Haruyo Nishioka is in 93.43.15 to 93.43.21 and 93.43.28, archival collection, Japanese American National Museum, Los Angeles, Gift of Chisato Nishioka Watanabe. Thanks to Norma Smith, for her research assistance. Information from John J. Sippy, health officer of San Joaquin County, General Subject Files, California State Board of Medical Examiners, folder F3760:504, "midwives correspondence."

86. Mitchell P. Postel, *San Mateo: A Centennial History* (San Francisco: Scottwall Associates in cooperation with the San Mateo County Historical Association, n.d.), 142 (thanks to Reiko Million for supplying the article); Japanese American Citizens' League, *1872–1942*, 58–59.

87. Paul E. Dolan quoted in a letter from Charles B. Pinkham to W. R. Musgrave, 6 October 1924; General Subject Files, California State Board of Medical Examiners, folder F3760:504, "midwives correspondence"; Hattie Lezynsky and Dr. Adelaide Brown, "Infant Mortality in San Francisco in 1919," *California State Medical Journal* 18, no. 8 (August 1920): 296–301; Troy Tashiro Kaji, "The Japanese-American Physicians and Japanese Hospitals of California before World War II" (M.D. thesis, University of California, Davis, 1986), 9; thanks to Dr. Troy Kaji for providing the article. Chinese immigrant midwives are mentioned in Shah, *Contagious Divides*, 217.

88. H. G. Henderson to Dr. Pinkham, 26 December 1923, and Dr. Pinkham to Dr. Hassler, 17 June 1924, General Subject Files, California State Board of Medical Examiners, folder F3760:504, "midwives correspondence."

89. Dr. Pinkham to Emma Jamison, Stanford University, 16 March 1923, General Subject Files, California State Board of Medical Examiners, folder F3760:504, "midwives correspondence."

90. Report by Dr. Adelaide Brown, 1922 Minutes of the California State Board of Public Health, 667.

91. California published the leaflet "Advice for Expectant Mothers" in Spanish. Dr. Stadtmuller to Grace Abbott, 7 June 1926, Public Health—Child Hygiene Records, 1926–1941, California State Archives.

92. "Why Not Solve Some Real Problems?" *California State Journal of Medicine* 22, no. 1 (January 1924): 26; "When a State Puts the Stamp of Approval upon Midwives," *California and Western Medicine* 22, no. 8 (August 1924): 386–87. The journal changed its name from the *California State Journal of Medicine* to *California and Western Medicine* in 1924, when it added coverage of Utah and Nevada.

93. "How Many Midwives Are There in California?" *California and Western Medicine* 22, no. 10 (October 1924): 517, reprinted in the *Journal of the American Medical Association* 83, no. 18 (1 November 1924): 1436–37.

94. "On Being 'Overdoctored,'" *California and Western Medicine* 22, no. 10 (October 1924): 516.

95. Dr. C. B. Pinkham to National Midwives Association, 4 May 1923, General Subject Files, California State Board of Medical Examiners, folder F3760:504, "midwives correspondence." I could find no further information on this association.

96. California Report on Sheppard-Towner Funds, July 1929, and photo of Ellen Stadtmuller in the *Stanford Illustrated Review,* box 11, Correspondence and Reports, 1917–1954, RG 102. See also Public Health—Child Hygiene Records, 1926–1941, and Minutes of the California State Board of Public Health, 1941, 2794, California State Archives.

97. Dr. Adelaide Brown, Minutes of the California State Board of Public Health (1922), 666, California State Archives; California Report on Sheppard-Towner Funds, July 1924, box 11, Correspondence and Reports, 1917–1954, RG 102; "State Bureau of Child Hygiene," *California State Journal of Medicine* 18, no. 2 (February 1920): 36.

98. Japanese American Citizens' League, *1872–1942,* 59; Alice Yasutake, interview by author, tape recording, Seattle, Washington, 20 February 1997; Dr. Sakaye Shigekawa, interview by author, tape recording, Los Angeles, California, 20 March 1998.

99. Minutes of the California State Board of Public Health (1925), 869; Minutes of the California State Board of Public Health (1926), 903, 913, 979; Minutes of the California State Board of Public Health (1927), 1000. The quotation is from Dr. Stadtmuller to Grace Abbott, 7 June 1926; see also Stadtmuller to Abbott, 11 June 1927—both in Public Health—Child Hygiene Records, 1926–1941. For information on other states, see U.S. Department of Labor, Children's Bureau, *The Promotion of the Welfare and Hygiene of Maternity and Infancy,* publication no. 203 (Washington, D.C.: Government Printing Office, 1931), 15.

100. On homes for unwed mothers, see Reagan, *When Abortion Was a Crime,* 28–29, 105–6. On maternity homes, see U.S. Department of Labor, *Promotion of Welfare and Hygiene,* 15; "Maternal Mortality in Oregon," *Northwest Medicine* 30, no. 4 (April 1931): 188; Laurel Halladay, "'We'll See You Next Year': Maternity Homes in Southern Saskatchewan in the First Half of the Twentieth Century" (master's thesis, Carleton University, Ottawa, Ont., 1996)—thanks to Dawn Nickel, who drew this work to my attention.

101. Ellen Stadtmuller to Grace Abbott, 21 July 1924, Correspondence and Reports, 1917–1954, box 11, RG 102.

102. Children's Bureau records suggest that Oregon's law was passed in 1915, although I was not able to confirm that in the records in Oregon. By 1919, however, the state law did mention that midwives should register with the local registrar. Central Files, 1921–1924, box 190, 4–10–4–2, RG 102, Children's Bureau; *General Laws of Oregon* (Salem, Oregon: State Printing Department, 1919), Oregon State Archives.

103. Oregon used Sheppard-Towner funds to provide more education to local physicians. It used medical students to help with prenatal classes, sent prenatal letters to urge women to employ a physician, and sent postnatal letters to urge women to breastfeed. The quotations are from Estella F. Warner to Children's Bureau, 14 March 1923, Central Files, 1921–1924, box 190, File 4–10–4–2; and Central Files, 1937–1940, box 754, file 4–7–4, both in RG 102; meeting, 9 May 1922, 238, Minutes of the Oregon Department of Health, 1903–1945, Oregon State Archives.

104. Washington State used Sheppard-Towner funds to do education work with doctors and encourage rural physicians to provide prenatal care. It also provided well-baby clinics for mothers and promoted breastfeeding. "Percentage of Births Attended by Physicians and by Midwives and Others, in United States, As Reported by State Bureaus of Child Hygiene," 1925, Central Files, 1925–1928, box 274, 4–10–4–2; Dr. Paul A. Turner to Dr. Ethel Watters, 12 March 1923, Central Files, 1921–1924, box 190, file 4–10–4–2; Charles Maybury, Department of Licenses, to Roslyn Carli, Department of Health, 22 October 1925, Central Files, 1925–1928, box 275, file 4–10–4–2; Washington State, July 1929 Sheppard-Towner Report, box 26, Correspondence and Reports, 1917–1954, all in RG 102. See also W. V. Tanner, *Session Laws of the State of Washington, Fifteenth Session, 1917* (Olympia, Wash.: Frank M. Lamborn, Public Printer, 1917), chapter 160, 717–21; Register of the State Medical Examination Board, 1915–1921, both in Washington State Archives; and 300–485 Superior Court—County Clerk, Index of Licenses of Physicians, Optometrists, Chiropodists, and Midwives, 1890–1980, volume 1 of 1, King County Archives, Seattle.

105. Bruce Bellingham and Mary Pugh Mathis, "Race, Citizenship, and Biopolitics of the Maternalist Welfare State: 'Traditional' Midwifery in the American South under Sheppard-Towner Act, 1921–1929," *Social Politics* 1 (Summer 1994): 180–81 n. 1.

106. "Percentage of Births Attended by Physicians and by Midwives and Others, in United States, As Reported by State Bureaus of Child Hygiene," 1925, Central Files, 1925–1928, box 274, 4–10–4–2, RG 102; "Infant Death Rates in the United States, by States, for 1938 and Prior Years," *Public Health Reports* 55, no. 14 (5 April 1940): 602–3; U.S. Department of Commerce, Bureau of the Census, *Abstract of the Fourteenth Census of the United States, 1920* (Washington, D.C.: Government Printing Office, 1923), 14, 119.

107. "Percentage of Live Births That Occurred in Hospitals in Each State, United States, 1939," Vital Statistics File, 1932–1940, box 56, Maternal and Child Health Section, Records of the Oregon Department of Health, Oregon State Archives.

108. Frances Rothert to Ruby Jones, 21 February 1929, Central Files, 1929–1932, box 380, file 4–7–4, RG 102.

109. Interview #383, "Dr. Gladys Shahovitch, county health officer, Los Angeles County," 3 February 1925, box 36, Survey of Race Relations Records, 1924–1927, Hoover Institution Archives.

110. The "model minority" concept was critiqued by Roger Daniels in 1965. Daniels, *Asian America*, 317–44; Takaki, *Strangers from a Different Shore*, 474–84; Ronald Takaki, "Race As a Site of Discipline and Punish," in *Privileging Positions: The Sites of Asian American Studies*, edited by Gary Y. Okihiro, Marilyn Alquizola, Dorothy Fujita Rony, and K. Scott Wong (Pullman: Washington State University Press, 1995), 338–42.

111. Material on Haruyo Nishioka is in 93.43.15 to 93.43.21 and 93.43.28 in the archival collection, Japanese American National Museum.

112. Bacon Sakatani, interview by author, tape recording, West Covina, California, 19 March 1998; interview with Alyce Yamaguchi; Tanaka, *Through Harsh Winters*, 43; Tomás Almaguer, *Racial Fault Lines: The Historical Origins of White Supremacy in California* (Berkeley: University of California Press, 1994), 183–204; Brian Niiya, ed., *Japanese American History: An A-to-Z Reference from 1868 to the Present* (New York: Facts on File, 1993), 130–31.

113. Interview with Alyce Yamaguchi. See also Ichioka, *Issei*, 172; Chan, *Asian Americans*, 110; Kazuo Ito, *Issei: A History of Japanese Immigrants in North America*, translated by Shinichiro Nakamura and Jean S. Gerard (Seattle: Japanese Community Service, 1973), 250; and Ayukawa, "Good Wives and Wise Mothers," 245. Rural white women had a similar birthing experience, especially in the nineteenth century: Leavitt, *Brought to Bed*, 79.

114. Interview with Alyce Yamaguchi.

Chapter 3

1. Diary of Toku Shimomura, 27 January 1927, translated by Febe Pamonag; a photocopy of the original is in my possession. I am deeply indebted to Febe Pamonag, Valerie Henitiuk, and Teko Gardener of Edmonton, and Ms. Okano of the Japan Foundation at the Kansai Language Institute in Osaka, Japan, for translations of Toku's diaries. In particular, Febe, my Ph.D. student and graduate research assistant, helped me to better understand Toku's life. Access to the original volumes of Toku Shimomura's diary was courtesy of Roger Shimomura of Lawrence, Kansas. Toku wrote a diary from 1912 until her death in 1968. I have examined 22 of the 37 years of Toku's diaries that Roger has in his possession. He also has her midwife bag, scrapbooks, and photo albums, including photographs of many of the children that she delivered. Roger speculates that it was customary to give the midwife a photo

when the child reached a certain age. Letter from Roger Shimomura to author, 18 March 1996.

2. Toku and her husband Yoshitomi had three children, Kazuo, or Eddie (born 1913), Fumi (born 1918), and Michio (born 1923).

3. For critiques of this image, see Monica Sone's autobiography, *Nisei Daughter* (Seattle: University of Washington Press, 1953); and Malve von Hassel, "Issei Women between Two Worlds: 1875–1985," (Ph.D. diss., New School for Social Research, 1987), 4–5, 32, 35, 110.

4. Roger Shimomura, interview by author, tape recording, Lawrence, Kansas, 16 June 1998; S. Billee Yoshioka Kimura [hereafter Billee Kimura] and Sam Kimura, interview by author, tape recording, Seattle, Washington, 21 February 1997; Teru Beppu, interview by author, tape recording, Seattle, Washington, 15 June 1995. Teru agreed to the interview to honor her late husband, who was always very proud of his midwife mother.

5. My thinking has been informed by the work of Elizabeth Ewen on European immigrant midwives in *Immigrant Women in the Land of Dollars: Life and Culture on the Lower East Side, 1890–1925* (New York: Monthly Review Press, 1985), 130.

6. For early scholarship on midwifery, see Frances E. Kobrin, "The American Midwife Controversy: A Crisis of Professionalization," *Bulletin of the History of Medicine* 40 (1966): 350–63; Judith Barrett Litoff, *American Midwives, 1860 to the Present* (Westport, Conn.: Greenwood Press, 1978), 27, 58; Ewen, *Immigrant Women in the Land of Dollars*, 131–32.

7. Toku Shimomura dated the midwife photo as 7 January 1918: Kazuo Ito, *Issei: A History of Japanese Immigrants in North America*, translated by Shinichiro Nakamura and Jean S. Gerard (Seattle: Japanese Community Service, 1973), 8. Dell Uchida loaned the same photo to the Wing Luke Asian Museum in Seattle for an exhibit in 1992: Dell Uchida, interview by author, tape recording, Seattle, Washington, 18 February 1997. No one I interviewed could tell me why some of the midwives are wearing dark colors and some light; it may have to do with different midwifery school uniforms.

8. Photograph of the Seattle Midwives Association, dated 1913, courtesy of Roger Shimomura.

9. Item #289, "Present estimated Japanese population in Los Angeles City and County, by Masao Dodo, of USC," box 31, Survey of Race Relations Records, 1924–1927, Hoover Institution Archives, Stanford University, Stanford, California; Roger Daniels, *Asian America: Chinese and Japanese in the United States since 1850* (Seattle: University of Washington Press, 1988), 158. The *Japanese-American Medical Journal* was published from 1924 to at least 1927. Issues for 1926 and 1927 are available at the National Library of Medicine in Maryland. My thanks to Louis Fiset for informing me of the existence of this journal.

10. W. V. Tanner, *Session Laws of the State of Washington, Fifteenth Session, 1917* (Olympia, Wash.: Frank M. Lamborn, Public Printer, 1917), chapter 160, 717–21,

NOTES TO PAGES 62–64

Washington State Archives, Olympia; "Senate Bill 96," *Northwest Medicine* 16, no. 7 (July 1917): 208. Washington State passed a law in 1981 to once more regulate and license midwives. Jane Elizabeth Baird, "A Demographic Study of Washington State Licensed Midwives" (master's thesis, University of Washington, 1987), 7.

11. Toku Shimomura, quoted in Ito, *Issei,* 859. See also the interview with Dell Uchida.

12. Such a large fine suggests that she may have been suspected of performing an abortion, but I found no evidence of that. *State of Washington Second Report of the Department of Licenses Covering the Period from 1923 to 1924* (Olympia, Wash.: Frank M. Lamborn, Public Printer, 1925), 16 [hereafter, *Washington Dept. of Licenses, 1923 to 1924*].

13. "Medical Practice Act of 1890," *Northwest Medicine* 16, no. 7 (July 1917): 206; Charles Maybury, Washington State Department of Licenses, to Roslyn Carli, Washington Department of Health, 22 October 1925, Central Files, 1925–1928, box 275, file 4–10–4–2, RG 102, Children's Bureau, U.S. National Archives, College Park Branch, College Park, Maryland; *Washington Dept. of Licenses, 1923 to 1924*, p. 12; Register of Physicians and Accoucheurs, 1890–1895, 1906–1911, Department of Licensing; Register of the State Medical Examination Board, State of Washington, 1915–1921, Licensing Department; *State of Washington First Biennial Report of the State Department of Health covering the period from January 1, 1921 to December 31, 1922* [hereafter *Washington State Department of Health*] (Olympia, Wash.: Frank M. Lamborn, Public Printer, 1923), 159–60, all in Washington State Archives. See also 300–485 Superior Court—County Clerk, Index of Licenses of Physicians, Optometrists, Chiropodists, and Midwives, 1890–1980, volume 1 of 1, King County Archives, Seattle; *Seattle City Directory* (Seattle: R. L. Polk, 1920), on the shelves of the Seattle Public Library. In 1904 there were about 800 doctors in Washington, about 267 of whom were in Seattle: *Northwest Medicine* 2, no. 4 (April 1904): 161–62, and 2, no. 9 (September 1904): 413. There were more than 20 women physicians in Seattle by 1906 and they formed the Medical Woman's Club. See "Medical Notes," *Northwest Medicine* 4, no. 6 (June 1906): 209.

14. Toku Shimomura described a farewell party for a midwife in her diary entry of 7 February 1918.

15. On the issue of midwife isolation, see Litoff, *American Midwives,* 107.

16. Michiko Tanaka as told to Akemi Kikumura, *Through Harsh Winters: The Life of a Japanese Immigrant Woman* (Novato, Calif.: Chandler & Sharp, 1981), 124–25; Malve von Hassell, "Issei Women between Two Worlds: 1875–1985" (Ph. D. diss., New School for Social Research, 1987), 20.

17. Interviews in the Race Relations Project, Hoover Institution, Stanford University, and also microfilm copy at the University of Oregon in Eugene. See also S. Frank Miyamoto, *Social Solidarity among the Japanese in Seattle* (Seattle: University of Washington Press, 1984), 46; Eileen Sunada Sarasohn, *Issei Women: Echoes from Another Frontier* (Palo Alto, Calif.: Pacific Books, 1998), 27, 62, 70; von Hassell, "Issei Women," 93; Tanaka, *Through Harsh Winters,* 18, 25; and Mioko Fujieda,

"Japan's First Phase of Feminism," in *Japanese Women: New Feminist Perspectives on the Past, Present, and Future,* edited by Kumiko Fujimura-Fanselow and Atsuko Kameda (New York: Feminist Press at the City University of New York, 1995), 329.

18. On class status, see Kikumura in Tanaka, *Through Harsh Winters,* 122.

19. U.S. Department of Commerce, Bureau of the Census, *Abstract of the Fourteenth Census of the United States, 1920* (Washington, D.C.: Government Printing Office, 1923), 581; S. Frank Miyamoto, "An Immigrant Community in America," in *East across the Pacific: Historical and Sociological Studies of Japanese Immigration and Assimilation,* edited by Hilary Conroy and T. Scott Miyakawa (Santa Barbara, Calif.: Clio Press, 1972), 217–43; Miyamoto, *Social Solidarity,* introduction; Ito, *Issei,* 916; Daniels, *Asian America,* 153 (table 4.4); Sylvia Junko Yanagisako, *Transforming the Past: Tradition and Kinship among Japanese Americans* (Stanford, Calif.: Stanford University Press, 1985), 3–4.

20. *Washington State Department of Health, 1921–1922* (Olympia, Wash.: Frank M. Lamborn, Public Printer, 1923), 42, 158, 160. See also *Washington State Department of Health, 1917–1918,* 46–49.

21. Interview 45, Mrs. Toyo Shinowara, 4 June 1924, Seattle, box 24, Survey of Race Relations Records, 1924–1927, Hoover Institution Archives.

22. Interviews conducted in the 1920s, boxes 24, 25, 26, 29, Survey of Race Relations Records, 1924–1927, Hoover Institution Archives; Miyamoto, "Immigrant Community," 238.

23. Charlotte G. Borst, *Catching Babies: The Professionalization of Childbirth, 1870–1920* (Cambridge, Mass.: Harvard University Press, 1995), 68–89.

24. Register of the State Medical Examination Board, 1915–1921; Professions, Midwife Applications, Accession #92-8-919, Box 1, Department of Licensing, both in Washington State Archives, Olympia. See also *Seattle City Directory* (Seattle: R. L. Polk, 1915). More research is needed on midwifery and cross-ethnic relations among these various nationalities.

25. My thinking has been influenced by a comment made by Paul Spickard at the Japanese American Experience conference, Willamette University, Salem, Oregon, 18–19 September 1998. See also Paul R. Spickard, *Japanese Americans: The Formation and Transformations of an Ethnic Group* (New York: Twayne, 1996).

26. Linda V. Walsh, "Midwives As Wives and Mothers: Urban Midwives in the Early Twentieth Century," *Nursing History Review* 2 (1994): 51–65; Patricia D'Antonio, "Revisiting and Rethinking the Rewriting of Nursing History," *Bulletin of the History of Medicine* 73 (1999): 272, 274, 284–85.

27. Dr. Paul A. Turner to Dr. Ethel Watters, 1923, Central Files, 1921–1924, box 190, file 4-10-4-2; Charles Maybury to Roslyn Carli, 22 October 1925, Central Files, 1925–1928, box 275, file 4-10-4-2; Washington State, July 1929 Sheppard-Towner Report, box 26, Correspondence and Reports, 1917–1954, all in RG 102.

28. Yūko Nishikawa, "Diaries As Gendered Texts," in *Women and Class in Japa-*

nese History, edited by Hitomi Tonomura, Anne Walthall, and Wakita Haruko (Ann Arbor: Center for Japanese Studies, University of Michigan, 1999): 241–55, esp. 243. On American diaries, see Margo Culley, ed., *A Day at a Time: The Diary Literature of American Women from 1764 to the Present* (New York: Feminist Press at the City University of New York, 1985).

29. Ito, *Issei.*

30. Laurel Thatcher Ulrich, *A Midwife's Tale: The Life of Martha Ballard, Based on Her Diary, 1785–1812* (New York: Knopf, 1990), 8–9.

31. Sarasohn, *Issei Women,* 157.

32. Interview with Roger Shimomura; Toku Shimomura's diary, 25 and 26 June 1939.

33. Nishikawa, "Diaries As Gendered Texts," 244–45, 250; interview with Roger Shimomura.

34. Interview with Roger Shimomura; Toshi Yamamoto, interview by author, tape recording, Los Angeles, California, 26 June 1998; Nishikawa, "Diaries As Gendered Texts," 244; e-mail message from Yuki Terazawa to Susan L. Smith, 16 December 2003.

35. Ulrich, *Midwife's Tale,* 9. See also Judith Walzer Leavitt, "Medicine in Context: A Review Essay of the History of Medicine," *American Historical Review* 95, no. 5 (December 1990): 1471–84, esp. 1483.

36. For information on Toku Shimomura's early life, see Ito Kazuo, *Zoku Hokubei Hyakunen-Zakura,* vol. 2 (Seattle: Hokubei Hyakunen-zakura Jikkō Iinkai, 1968), English translation courtesy of Roger Shimomura. Roger believes that his father gave Toku's 1912 diary to Kazuo Ito. The entries for January to March 1912 have been commented on and reprinted in Ito's book, *Issei,* pages 8–11. See also Register of the State Medical Examination Board, State of Washington, 1917, Licensing Department, Washington State Archives. See excerpts of Toku's diary in Donald Keene, *Modern Japanese Diaries: The Japanese at Home and Abroad As Revealed through Their Diaries* (Henry Holt, 1995), 321–26, and in Franklin Odo, ed., *The Columbia Documentary History of the Asian American Experience* (New York: Columbia University Press, 2002), 274–80.

37. Toku Shimomura's diary, 12 January 1912.

38. Toku Shimomura's diary, 21 February 1912.

39. Tanaka, *Through Harsh Winters,* 27. See also Linda Tamura, *The Hood River Issei: An Oral History of Japanese Settlers in Oregon's Hood River Valley* (Urbana: University of Illinois Press, 1993), 37, 43.

40. Toku Shimomura's diary, 5 March 1912.

41. Toku Shimomura's diary, 7 March 1912.

42. Toku Shimomura's diary, 19 March 1912; interview with Roger Shimomura.

43. Yuji Ichioka, *The Issei: The World of the First Generation Japanese Immigrants, 1885–1924* (New York: Free Press, 1988), 167–68; Sarasohn, *Issei Women,*

146; Michiko Tanaka, *Through Harsh Winters,* 25; von Hassell, "Issei Women," 113.

44. Toku Shimomura's diary, January to March 1912; interview with Roger Shimomura; Sarasohn, *Issei Women,* 70, 146. See also interviews conducted in the 1920s, boxes 24, 25, 26, 29, Survey of Race Relations, Hoover Institution Archives; von Hassell, "Issei Women," 92; Midge Ayukawa, "Good Wives and Wise Mothers: Japanese Picture Brides in Early Twentieth-Century British Columbia," in *Rethinking Canada: The Promise of Women's History,* 3d ed., edited by Veronica Strong-Boag and Anita Clair Fellman (Toronto: Oxford University Press, 1997), 243.

45. Excerpts of Toku Shimomura's 1912 diary in Ito, *Zoku Hokubei Hyakunen-Zakura,* English translation.

46. Interview with Roger Shimomura; Miyamoto, "Immigrant Community," 232–4; Ito, *Issei,* 274, 908; Tamura, *Hood River Issei,* 51, 126–29. Toku's photograph collection suggests that the only time that she returned to Japan, in the 1930s, was through her affiliation with a Christian group in Japan.

47. Toku Shimomura's diary, 31 December 1913.

48. Information on Yoshitomi Shimomura courtesy of Roger Shimomura; Miyamoto, *Social Solidarity,* 18.

49. Toku Shimomura's diary, 1 July 1923; interview with Roger Shimomura; Yanagisako, *Transforming the Past,* 48.

50. Toku Shimomura, quoted in Ito, *Issei,* 860.

51. Toku Shimomura's diary, August and October 1913, 1922–1923, 1926; Toku quoted in Ito, *Issei,* 250, 859.

52. Toku's diary, 1 May 1922; *Northwest Medicine* 19, no. 2 (February 1920): 55; Ito, *Issei,* 631–32, 858; Eugene Declercq and Richard Lacroix, "The Immigrant Midwives of Lawrence: The Conflict between Law and Culture in Early Twentieth-Century Massachusetts," *Bulletin of the History of Medicine* 59 (1985): 243; Wendy Mitchinson, *Giving Birth in Canada, 1900–1950* (Toronto: University of Toronto Press, 2002), 63.

53. According to the number of births recorded in Toku's diary, she delivered about 10 births in the 1910s, peaked at 50 births in 1922, down to about 25 births in 1926, to 16 births in 1929, 14 in 1932, 8 in 1934, and 3 in 1935, at which point she retired.

54. Interview with Billee and Sam Kimura.

55. Interview with Toshi Yamamoto.

56. Japanese names are highly idiosyncratic and have any number of possible readings. In each case, however, the translator provided her best-informed guess for the spelling. Toku Shimomura's diary, 13 December 1913; Toku Shimomura's diary, November 1913.

57. Toku Shimomura's diary, 11 July 1913; John F. Embree, *Acculturation among the Japanese of Kona, Hawaii* (Menasha, Wisc.: American Anthropological Association, 1941), 12, 73.

58. Toku Shimomura's diary, 23 January 1913, mentions that she visited clients for two weeks after the baby's birth. On 11 October 1913 a client requested an additional week.

59. Toku Toshiko, interview by author with interpreter assistance from Chiyohi Creef and Tazuko Herren, tape recording, Seattle, Washington, 11 June 1995. Toshiko arrived in Seattle in 1918 when about eighteen years old. She married in Seattle about 1923 or 1924. She worked in a hotel or rooming house with Japanese clients.

60. Interview 46, Mrs. Suie Murakami, 4 June 1924, Seattle, box 24, Survey of Race Relations Records, 1924–1927, Hoover Institution Archives; *Seattle City Directory* (Seattle: R.L. Polk, 1920).

61. Mary Hida, interview by author, tape recording, West Covina, California, 18 March 1998; Tamura, *Hood River Issei*, 102.

62. Tanaka, *Through Harsh Winters*, 31.

63. Interview with Masoko (Jinguji) Osada, interview by author with interpreter assistance from Chiyohi Creef and Mary Ikeda, tape recording, Tacoma, Washington, 10 June 1995.

64. Interview with Toku Toshiko; e-mail message from Yuki Terazawa to Susan L. Smith, 16 December 2003.

65. Interview with Toku Toshiko. On the *hara obi*, see Albert W. Palmer, *The Human Side of Hawaii: Race Problems in the Mid-Pacific* (Boston: Pilgrim Press, 1924); Yū Fujikawa, *Japanese Medicine,* translated by John Ruhrah (New York: Paul B. Hoeber, 1934); Embree, *Acculturation*; Mary W. Standlee, *The Great Pulse: Japanese Midwifery and Obstetrics through the Ages* (Tokyo: Charles E. Tuttle, 1959), 81–82; Margaret M. Lock, *East Asian Medicine in Urban Japan* (Berkeley: University of California Press, 1980); and Kittredge Cherry, *Womansword: What Japanese Words Say about Women* (New York: Kodansha International, 1987), 82–83; e-mail message from Yuki Terazawa to Susan L. Smith, 16 December 2003.

66. Toku Shimomura's diary, 10 February and 10 April 1913.

67. Interview with Masoko Osada; Tanaka, *Through Harsh Winters*, 44; Mitchinson, *Giving Birth in Canada*, 140.

68. Toku Shimomura's diary, 31 October 1913, 10 March 1926.

69. Susan M. Reverby, *Ordered to Care: The Dilemma of American Nursing, 1850–1945* (Cambridge, England: Cambridge University Press, 1987), 96; Judith Walzer Leavitt, *Brought to Bed: Childbearing in America, 1750 to 1950* (New York: Oxford University Press, 1986), 87–115, esp. 87.

70. *Session Laws of the State of Washington, 1917,* chapter 160, 717–21.

71. Toku Shimomura's diary, 27 September 1913; see also 21 December 1913 and 29 May 1922. The doctor's name could be read as Keimatsu, Uematsu, or Uyematsu. A Dr. Y. Uyematsu of Seattle was licensed by the state. See Register of Physicians and Accoucheurs, volume 5, Licensing Department, Washington State Archives.

72. Toku Shimomura's diary, 18 February 1925. Stillbirths also occurred on 29 May 1922, although it is not clear that this baby was one she delivered, and on 9 July 1922. On 4 June 1920 there is the possibility that one of Toku's clients, Mrs.

Shōji, died from bleeding during childbirth. My translators could not, however, confirm this. A few times Toku provided medication, such as in 1925 when she gave a patient an injection of "notame" to induce labor because the labor pains were very weak. Toku Shimomura's diary, 14 January 1925. According to Dennis Worthern, the medication is likely ergot, whose official Japanese name was ergometrine maleate: e-mail message from Worthern to Roger Daniels, forwarded by Daniels to Susan L. Smith, 30 December 2003.

73. Toku Shimomura's diary, 4 June 1920, 9 July 1922, and 2 January 1923.

74. Toku Shimomura's diary, 18 February, 20 March, and 20 April 1913.

75. Toku Shimomura's diary, 24 March 1939; *Seattle City Directory* (Seattle: R. L. Polk, 1935); selection from *The Japanese American Directory* (San Francisco: Japanese American News, 1941), 552, Panama Hotel Collection, Wing Luke Asian Museum. Some European immigrant midwives also continued to deliver babies for family and friends, and advertise in the city directory, well into the 1930s. Declercq and Lacroix, "Immigrant Midwives of Lawrence," 245.

76. Dr. Ben Uyeno, interview by author, tape recording, Seattle, 21 February 1997.

77. Interview with Teru Beppu; interview with Dell Uchida; Register of the State Medical Examination Board, State of Washington, 1917, Licensing Department, Washington State Archives; Kiyoko Okamoto, "Josanpu katsudo no rekishiteki igi. Meiji jidai o chushin ni" [The Historical Significance of Midwifery: Meiji Period], *Josanpu Zasshi* [(Japanese) Journal for Midwives] 35, no. 8 (August 1981): 33.

78. John Reddin, "Four Beppu Sons Named for Presidents," news clipping from a Seattle newspaper, publication date and newspaper unknown, possession of Teru Beppu; interview with Teru Beppu; interview with Billee Kimura; interview with Toshi Yamamoto.

79. Interview with Teru Beppu; Borst, *Catching Babies,* 68.

80. Quoted in Ito, *Issei,* 250.

81. Yanagisako, *Transforming the Past,* 48.

82. Interview with Teru Beppu; Sarasohn, *Issei Women,* 23, 64; Cherry, *Womans-word,* 85; Sachiko Kaneko, "The Struggle for Legal Rights and Reforms: A Historical View," in *Japanese Women: New Feminist Perspectives on the Past, Present, and Future,* edited by Kumiko Fujimura-Fanselow and Atsuko Kameda (New York: Feminist Press at the City University of New York, 1995), 4–5.

83. Lincoln Beppu was active in the sport fishing business and opened a business called "Linc's Tackle" in Seattle: interview with Teru Beppu; Glenn, *Issei, Nisei, War Bride.*

84. Register of the State Medical Examination Board, 1917, Washington State Archives.

85. Interview with Teru Beppu; Reddin, "Four Beppu Sons."

86. Interview with Teru Beppu; interview with Billee Kimura and Sam Kimura. Among the Japanese American babies she delivered in 1917 was the future author and community leader Bill Hosokawa.

87. Interview with Dr. Ben Uyeno; interview with Teru Beppu; Paul Starr, *The Social Transformation of American Medicine* (New York: Basic Books, 1982), 69–70.

88. Interview with Roger Shimomura; interview with Teru Beppu. For another example of a place where midwives were the first women to drive and own cars, see Christoph Brezinka, "The End of Home Births in the German Language Islands of Northern Italy," in *Midwives, Society, and Childbirth: Debates and Controversies in the Modern Period,* edited by Hilary Marland and Anne Marie Rafferty (New York: Routledge, 1997), 201–17, esp. 214.

89. Virginia Scharff, *Taking the Wheel: Women and the Coming of the Motor Age* (Albuquerque: University of New Mexico Press, 1992), 25, 26, 52, 55, 56, 109, 112, 117, 135; Frank Coffey and Joseph Layden, *America on Wheels, the First 100 Years: 1896–1996* (Los Angeles: General Publishing Group, 1996); Norbert MacDonald, *Distant Neighbours: A Comparative History of Seattle and Vancouver* (Lincoln: University of Nebraska Press, 1987), 11.

90. Reddin, "Four Beppu Sons"; Alice Yasutake, interview by author, tape recording, Seattle, 20 February 1997; Walsh, "Midwives As Wives and Mothers," 56.

91. Interview with Dr. Ben Uyeno.

92. Interview with Teru Beppu.

93. Tanaka, *Through Harsh Winters,* 41, quote 43; Cherry, *Womansword,* 86; Susan McKay, *The Courage Our Stories Tell: The Daily Lives and Maternal Child Health Care of Japanese American Women at Heart Mountain* (Powell, Wyo.: Western History Publications, 2002), 138–39.

94. Interview with Teru Beppu.

95. Interview with Teru Beppu; von Hassell, "Issei Women."

96. Interview with Teru Beppu.

97. Interview with Toku Toshiko.

98. In the mere ten days of her visit, Margaret Sanger gave thirteen public lectures and, allegedly, an astonishing five hundred interviews, generating great publicity. Malia Sedgewick Johnson, "Margaret Sanger and the Birth Control Movement in Japan, 1921–1955," (Ph.D. diss., University of Hawai'i, 1987), preface, 66, 68, 71.

99. Ito, *Issei,* 250.

100. Koto was born in 1877 and Michi was born four years later. Interview with Dell Uchida; Register of the State Medical Examination Board, 1917, Washington State Archives.

101. Register of the State Medical Examination Board, 1917; Register of Physicians and Accoucheurs, 1907, volume 5, Licensing Department; both in Washington State Archives. See also *Seattle City Directory* (Seattle: R. L. Polk, 1915).

102. On Chinese hospitals, see the Minutes of the California State Board of Public Health, 1941, 2646–54, California State Archives, Sacramento; James Clark Fifield, *American and Canadian Hospitals* (Minneapolis: Midwest Publisher Company, 1933), 158; Nayan Shah, *Contagious Divides: Epidemics and Race in San Francisco's Chinatown* (Berkeley: University of California Press, 2001), 211–14.

103. On Japanese hospitals, see Item #350, "Classified Japanese Institutions (Japanese American Directory, 1918)," box 36, Survey of Race Relations Records, 1924–1927, Hoover Institution Archives; Minutes of the California State Board of Public Health, 1926, 903, 913, 958–59, 979, California State Archives; Fifield, *American and Canadian Hospitals*, 139–40; Troy Tashiro Kaji, "The Japanese-American Physicians and Japanese Hospitals of California before World War II" (M.D. thesis, University of California, Davis, 1986)—copy provided by Dr. Troy Kaji; Brian Niiya, ed., *Japanese American History: An A-to-Z Reference from 1868 to the Present* (New York: Facts on File, 1993), 188–89; "Nippon Hospital," www .ohp.parks.ca.gov/5Views/5views4h61.htm (accessed 21 October 2002); thanks to Dawn Nickel for the website information.

104. Moritoshi Fukuda, *Legal Problems of Japanese-Americans: Their History and Development in the United States* (Tokyo: Keio Tsushin, 1980), 188–91; Shin Hasegawa, *Exodus from Japan: Dr. Tashiro of Los Angeles* (Tokyo: n.p., 1978), part 2, chapters 1 and 2, translated by Teko Gardener; Kaji, "Japanese-American Physicians"; Cecilia Rasmussen, "Hospital a Pillar to Japanese Americans," *Los Angeles Times*, 1 February 1998, Metro section, clipping supplied courtesy of Norma and Carole Smith.

105. On African American doctors, see Vanessa Northington Gamble, *Making a Place for Ourselves: The Black Hospital Movement, 1920–1945* (New York: Oxford University Press, 1995). On Japanese immigrant doctors, see Uono, "Factors Affecting the Geographical Aggregation," 54, table viii; Masajiro Miyazaki, quoted in Gordon G. Nakayama, *Issei: Stories of Japanese Canadian Pioneers* (Toronto: NC Press, 1984), 148–49; see also 55–69, 147–52, 167.

106. Toku Shimomura's diary, 17 May 1941; Hasegawa, *Exodus from Japan*, part 2, chapter 2; Rasmussen, "Hospital a Pillar"; Michael M. Okihiro, "Japanese Doctors in Hawai'i," *Hawaiian Journal of History* 36 (2002): 105–17, esp. 111–12.

107. Toku Shimomura's diary, 19 April 1913; interview with Ben Uyeno; "Hospital for Japanese Patients," compiled by Ryo M. Tsai from a number of sources, 9066 Collection, Wing Luke Asian Museum. My thanks to Ed Seguro for showing me this material. The preferred reading of the client's name is Ogishima: e-mail from Yuki Terazawa to Susan L. Smith, 6 April 2004.

108. Toku Shimomura's diary, 21 April 1914; interview with Sam Kimura; e-mail from Yuki Terazawa to Susan L. Smith, 6 April 2004.

109. Interview with Dell Uchida.

110. Interview with Dell Uchida.

111. Interview with Dell Uchida; interview with Sam Kimura.

112. Interview with Sam Kimura; interview with Dell Uchida; Miyamoto, "Immigrant Community," 238; Yanagisako, *Transforming the Past*, 40–41; Ayukawa, "Good Wives and Wise Mothers," 245.

113. Interview with Dell Uchida. The children were probably still in Japan, and so no one else was hurt in the fire.

114. H. E. Bass and G. D. Carlyle Thompson, "Incidence of Tuberculosis in Japa-

nese-Americans," *American Review of Tuberculosis* 52, no. 1 (July 1945): 46–50; Sone, *Nisei Daughter*, 136–43; Sheila M. Rothman, *Living in the Shadow of Death: Tuberculosis and the Social Experience of Illness in American History* (Baltimore: Johns Hopkins University Press, 1994), part 4.

115. Interview with Dell Uchida. Dell did not say how her mother died.

116. Interview with Dell Uchida.

117. Seattle Nisei built the Keiro nursing home for the Issei in 1975, with expansions in 1985, because they realized that the immigrant generation needed a place that provided care in the Japanese language and Japanese food. Today the Nisei also utilize the services of the home: interview with Dr. Ben Uyeno, who in the 1990s still attended patients there.

118. Cherry, *Womansword*, 86–87, quotes 86; Ito, *Issei*, 250. For various ethnic practices in the United States, see Molly Ladd-Taylor, *Mother-Work: Women, Child Welfare, and the State, 1890–1930* (Urbana: University of Illinois Press, 1994), 26–27.

119. Tanaka, *Through Harsh Winters*, 32, quote 44; interview with Toku Toshiko; interview with Masoko Osada.

120. Koto Takeda was listed in the Seattle City Directory until 1934; interview with Dell Uchida.

121. Interview with Alice Yasutake; interview with Toshi Yamamoto; Register of the State Medical Examination Board, State of Washington, 1915–1921, Licensing Department, Washington State Archives.

122. Interview with Alice Yasutake; Sharon H. Nolte and Sally Ann Hastings, "The Meiji State's Policy toward Women, 1890–1910," in *Recreating Japanese Women, 1600–1945*, edited by Gail Lee Bernstein (Berkeley: University of California Press, 1991), 159–63; Julie M. Rousseau, "Enduring Labors: The 'New Midwife' and the Modern Culture of Childbearing in Early Twentieth Century Japan" (Ph.D. diss., Columbia University, 1998), 183; Akira Iriye, "Japan As a Competitor, 1895–1917," in *Mutual Images: Essays in American-Japanese Relations*, edited by Akira Iriye (Cambridge, Mass.: Harvard University Press, 1975), 73–99, esp. 76.

123. The children were Tomo (born in 1913), Toshi (born in 1915), George (born in 1922), and also the younger children Toki, Molly, and Fran: interview with Toshi Yamamoto; interview with Alice Yasutake, who was married to George.

124. My thanks to Febe Pamonag for her assistance with identifying this expression.

125. Interview with Toshi Yamamoto; interview with Alice Yasutake.

126. It was the Nisei who became Democrats, including, much to Hisuji's irritation, his daughter Molly, who became active in the Democratic party: interview with Toshi Yamamoto. See also Ito, *Issei*, 858; Tamura, *Hood River Issei*, 71.

127. Interview with Toshi Yamamoto; interview with Alice Yasutake.

128. Interview with Toshi Yamamoto; Peggy Pascoe, *Relations of Rescue: The Search for Female Moral Authority in the American West, 1874–1939* (New York:

Oxford University Press, 1990), introduction, esp. xv; Mei Nakano, *Japanese American Women: Three Generations, 1890–1990* (Berkeley, Calif.: Mina Press, 1990), 40.

129. Interview with Toshi Yamamoto.

130. Interview with Toshi Yamamoto; Dr. Sakaye Shigekawa, interview by author, tape recording, Los Angeles, California, 20 March 1998; Nakano, *Japanese American Women*, 40.

131. The quotation is from Pascoe, *Relations of Rescue*, xvi; see also xxii, 73–76, 95–97; Judy Yung, *Unbound Feet: A Social History of Chinese Women in San Francisco* (Berkeley: University of California Press, 1995), 34–37, 84–85.

132. Photograph of the Fujin Home for Women, with an accompanying description, circa 1910, Amano Family Collection, Wing Luke Asian Museum; Ito, *Issei*, 656–57, 773; Ayukawa, "Good Wives and Wise Mothers," 246–47; Franklin Odo and Kazuko Sinoto, *A Pictorial History of the Japanese in Hawai'i, 1885–1924* (Honolulu: Bishop Museum, 1985), 192; Eileen H. Tamura, *Americanization, Acculturation, and Ethnic Identity: The Nisei Generation in Hawaii* (Urbana: University of Illinois Press, 1994), 25.

133. Ichioka, *Issei*, 169–70.

134. Interview with Toshi Yamamoto.

135. Gerda Lerner, *The Creation of Feminist Consciousness: From the Middle Ages to Eighteen-seventy* (New York: Oxford University Press, 1993), 276.

136. Interview with Toshi Yamamoto. In Hawai'i, a Japanese immigrant nurse, Luella Ekern, told the same thing to her daughter Karen. Karen Ekern, interview by author, tape recording, Hilo, Hawai'i, 6 May 1997.

137. Interview with Dell Uchida; interview with Toshi Yamamoto; interview with Alice Yasutake.

138. Toku Shimomura's diary, 12 October 1918; interview with Toshi Yamamoto. For a fictional account of an Issei woman in San Francisco during the epidemic, see Yoshiko Uchida, *Picture Bride* (New York: Simon and Schuster, 1987), 54–61.

139. Interview with Teru Beppu; interview with Toshi Yamamoto; Alfred W. Crosby, *America's Forgotten Pandemic: The Influenza of 1918* (Cambridge, England: Cambridge University Press, 1989); Richard C. Berner, *Seattle in the Twentieth Century* (Seattle: Charles Press, 1991), 247, 266, 276; e-mail from Yuki Terazawa to Susan L. Smith, 6 April 2004, identifies Toku's diary entry of 30 November 1918 on influenza in Seattle.

140. Interview with Alice Yasutake; interview with Toshi Yamamoto.

141. Interview with Toshi Yamamoto; Yanagisako, *Transforming the Past*, 6 n. 6; Tamura, *Hood River Issei*, 113; Niiya, ed., *Japanese American History*, 129–30.

142. Office of the Director of Public Health in the City and County of San Francisco, "Japanese and Chinese Births in San Francisco," *California and Western Medicine* 52, no. 5 (1940): 246.

143. Interview with Alice Yasutake; interview with Toshi Yamamoto

144. Interview with Roger Shimomura; interview with Toshi Yamamoto.

145. Yanagisako, *Transforming the Past*, 11, 13, 22, 243; von Hassell, "Issei Women," 2, 183, 208.

146. See, for example, interview with Mary Hida.

147. Evelyn Nakano Glenn, *Issei, Nisei, War Bride: Three Generations of Japanese American Women in Domestic Service* (Philadelphia: Temple University Press, 1986), 75; von Hassell, "Issei Women," 95; Ichioka, *Issei*, 168.

148. The quotation is from Yanagisako, *Transforming the Past*, 57; see also 51.

149. On housing discrimination in Seattle, see Sone, *Nisei Daughter*, 112–15, Miyamoto, "Immigrant Community," 238.

Chapter 4

1. Katharine Kohler, interview by author, tape recording, Honolulu, Hawai'i, 7 August 1995.

2. Luella (Tanner) Ekern (1910–1981) was born in Yokohama, Japan, the youngest of five children. She came to Hawai'i as a teenager to live with a missionary family. Karen Ekern, interview by author, tape recording, Hilo, Hawai'i, 6 May 1997.

3. Esther Stubblefield, interview by author, tape recording, Honolulu, Hawai'i, 5 May 1997 [hereafter interview with Esther Stubblefield]. Esther was born in 1911 in North Dakota, graduated from high school in Minnesota, in 1934 graduated from the University of Oregon School of Nursing, and moved to Hawai'i in 1935. See also Esther Stubblefield, interview by Ruth Smith for the oral history project "Public Health Services and Family Health on Kauai, 1920–1955," 16 March 1982, written transcript, Grove Farm Homestead museum, Kauai, Hawai'i [hereafter Ruth Smith interview with Esther Stubblefield].

4. Some of the immigrant women, including the Japanese, could also be considered nurse-midwives in that they had training in both nursing and midwifery. Although I had access to Alice's narrative reports, I did not see Alice's private records: unprocessed papers of Alice Young Kohler [hereafter Alice Young Kohler Papers], in possession of her daughter Katharine Kohler, Oahu, Hawai'i; interview with Karen Ekern. See also Susan L. Smith, "Alice Young Kohler," *American Nursing: A Biographical Dictionary*, vol. 3, edited by Vern L. Bullough and Lilli Sentz (New York: Springer, 2000), 167–69.

5. Dr. Vivia Appleton, "Report of Work Done under the Federal Maternity and Infancy Act, 1926–1927," Correspondence and Reports, 1917–1954, box 13, Record Group 102, Children's Bureau, National Archives, College Park Branch, College Park, Maryland; U.S. Department of Labor, Children's Bureau, *The Seven Years of the Maternity and Infancy Act* (Washington, D.C.: Government Printing Office, 1931), 5; Richard Kui Chi Lee, "History of Public Health in Hawaii," *Hawaii Medical Journal* 15, no. 4 (March–April 1956): 334.

6. See, for example, *Annual Report of the President of the Board of Health of the Territory of Hawaii for the Fiscal Year Ending June 30, 1933* [hereafter *Annual*

Report of the Board of Health] (printed by the *Honolulu Star-Bulletin*, 1934), 7, in the Hawai'i State Archives, Honolulu; and "Lax Practice by Midwives Is Deplored," *Honolulu Advertiser*, 7 January 1931, 2. See also "Midwives Deliver One-Fourth Babies Born in Territory," *Hawaii Sentinel*, 29 June 1939; Alice Young to acting director of the Bureau of Maternal and Infant Hygiene, 3 January 1939; and Jeanne Ambrose, "Midwifery Declined after Wartime Role Changed," *Honolulu Star-Bulletin*, 23 March 1984, A-12—all in Alice Young Kohler Papers. In addition, see Hawai'i folder 0243 in box 205, and folder 0620, including report by Professor Ira V. Hiscock, in box 206, Group III-States, 1936–1944, Record Group 90, U.S. Public Health Service, National Archives, College Park Branch, Maryland; and Central Files, 1937–1940, File 4–7–4, box 754, RG 102.

7. Elizabeth Jameson, "Toward a Multicultural History of Women in the Western United States," *Signs* 13, no. 4 (Summer 1988): 761–91. The first quotation is from p. 773; the second quotation is from Sucheng Chan, "Western American Historiography and Peoples of Color," in *Peoples of Color in the American West*, edited by Sucheng Chan, Douglas Henry Daniels, Mario T. Garcia, and Terry P. Wilson (Lexington, Mass.: D. C. Heath, 1994), 10; see also 11.

8. Evelyn Nakano Glenn, *Unequal Freedom: How Race and Gender Shaped American Citizenship and Labor* (Cambridge, Mass.: Harvard University Press, 2002), 207–8.

9. "Midwives Deliver One-Fourth," Alice Young Kohler Papers.

10. Romanzo Adams, *The Peoples of Hawaii* (Honolulu: University of Hawai'i Press, 1933), 23.

11. Dennis M. Ogawa, *Jan Ken Po: The World of Hawaii's Japanese Americans* (Honolulu: University of Hawai'i Press, 1973); Ronald Takaki, *Strangers from a Different Shore: A History of Asian Americans* (Boston: Little, Brown, 1989); Gary Y. Okihiro, *Cane Fires: The Anti-Japanese Movement in Hawaii, 1865–1945* (Philadelphia: Temple University Press, 1991); Eileen H. Tamura, *Americanization, Acculturation, and Ethnic Identity: The Nisei Generation in Hawaii* (Urbana: University of Illinois Press, 1994).

12. Roger Daniels, *Asian America: Chinese and Japanese in the United States since 1850* (Seattle: University of Washington Press, 1988), 127, table 4.2; Sylvia Junko Yanagisako, *Transforming the Past: Tradition and Kinship among Japanese Americans* (Stanford, Calif.: Stanford University Press, 1985), 8.

13. Hilary Conroy, *The Japanese Frontier in Hawaii, 1868–1898* (Berkeley: University of California Press, 1953), 15–31; John E. Van Sant, *Pacific Pioneers: Japanese Journeys to America and Hawaii, 1850–80* (Urbana: University of Illinois Press, 2000), 97–116.

14. Takaki, *Strangers from a Different Shore*, 46; Sucheta Mazumdar, "General Introduction: A Woman-Centered Perspective on Asian American History," in *Making Waves: An Anthology of Writings by and about Asian American Women*, edited by Asian Women United of California (Boston: Beacon Press, 1989), 6, 9; Daniels,

Asian America, 127, table 4.2; Alan Takeo Moriyama, *Imingaisha: Japanese Emigration Companies and Hawaii, 1894–1908* (Honolulu: University of Hawai'i Press, 1985), 17, table 4; Tamura, *Americanization*, 38.

15. Sucheng Chan, "Asian American Historiography," *Pacific Historical Review* 65, no. 3 (August 1996): 363–99, quote 384. See also Glenn, *Unequal Freedom*, 190–92.

16. Edward D. Beechert, *Working in Hawaii: A Labor History* (Honolulu: University of Hawai'i Press, 1985), 60; Ronald Takaki, *Pau Hana: Plantation Life and Labor in Hawaii, 1835–1920* (Honolulu: University of Hawai'i Press, 1983), 22–29; Van Sant, *Pacific Pioneers*, 98–99.

17. Clarence E. Glick, *Sojourners and Settlers: Chinese Migrants in Hawaii* (Honolulu: Hawaii Chinese History Center and the University of Hawai'i Press, 1980), 1–44; Moriyama, *Imingaisha*, 17, table 4, 97, table 15; Takaki, *Pau Hana*, 24–28, Daniels, *Asian America*, 100–101; Sucheng Chan, *Asian Americans: An Interpretive History* (Boston: Twayne, 1991), 37.

18. Beechert, *Working in Hawaii*, 197, 204; Chan, *Asian Americans*, 81–100; slogan appears on 86.

19. Moriyama, *Imingaisha*, xvi, 203 n. 4.

20. The first quotation is from Victoria Wyatt, "Alaska and Hawai'i," in *The Oxford History of the American West*, edited by Clyde A. Milner II, Carol A. O'Connor, and Martha A. Sandweiss (New York: Oxford University Press, 1994), 565; the second quotation is from John Whitehead, "Hawai'i: The First and Last Far West?" *Western Historical Quarterly* 23 (May 1992): 156.

21. Patricia Nelson Limerick, *The Legacy of Conquest: The Unbroken Past of the American West* (New York: W. W. Norton, 1987); Noel J. Kent, *Hawaii: Islands under the Influence* (Honolulu: University of Hawai'i Press, 1993).

22. Conroy, *Japanese Frontier*, esp. 14, 139–41; LaFeber, *Clash*, 61–62.

23. E. M. Winslow, *The Pattern of Imperialism: A Study in the Theories of Power* (New York: Columbia University Press, 1948), 3; Nupur Chaudhuri and Margaret Strobel, *Western Women and Imperialism: Complicity and Resistance* (Bloomington: Indiana University Press, 1992), 2; Fred Nash, *Meta-Imperialism: A Study in Political Science* (Aldershot, England: Avebury, Ashgate, 1994), 281.

24. Okihiro quotes from the commission report in *Cane Fires*, 96; see also xiv, 104–5, 119; Takaki, *Pau Hana*, 123, 157; Tamura, *Americanization*, 23; Yuji Ichioka, *The Issei: The World of the First Generation Japanese Immigrants, 1885–1924* (New York: Free Press, 1988), 5.

25. Beechert, *Working in Hawaii*, 123; Ronald Takaki, "They Also Came: The Migration of Chinese and Japanese Women to Hawaii and the Continental United States," in *Chinese America: History and Perspectives* (San Francisco: Chinese Historical Society of America, 1990), 16; Okihiro, *Cane Fires*, 120, 129.

26. For information on Alice Young and her work, see Alice Young Kohler, interview by Ruth Smith and Barnes Riznik, oral history project on "Public Health Services and Family Health on Kauai, 1920–1955," 6 August 1985, written transcript,

Grove Farm Homestead museum, Kauai, Hawai'i; Jeanne Ambrose, "Midwifery Declined after Wartime Role Changed," *Honolulu Star-Bulletin*, 23 March 1984, A-12; David Foster and Tiffany Coleman, "Nurse-Midwifery Week Proclaimed," *Molokai News*, 1 November 1986, all in Alice Young Kohler Papers. Katharine told me that her mother was interviewed on a cable television show in the 1980s, but she was unable to locate her videotaped copy.

27. *Annual Report of the President of the Board of Health of the Territory of Hawaii for the Fiscal Year Ending June 30, 1952* [hereafter *Annual Report of the Board of Health*] (printed by the *Honolulu Star-Bulletin*, 1953), 9.

28. Ruth Smith and Barnes Riznik interview with Alice Young Kohler; interview with Katharine Kohler.

29. Glick, *Sojourners and Settlers*, 39; Ruthanne Lum McCunn, *Chinese American Portraits: Personal Histories, 1828–1988* (Seattle: University of Washington Press, 1988), 63–64, 72, 78–87.

30. Ruth Smith and Barnes Riznik interview with Alice Young Kohler; interview with Katharine Kohler; interview with Karen Ekern; and biographical material on Alice in folder labeled "University of Hawaii Alumni Award" and on photo of 1933 graduating class in public health nursing at the University of Hawai'i, Alice Young Kohler Papers.

31. Esther McClure Stubblefield, "A History of the Development of Public Health Nursing in the Territory of Hawaii" (May 1953), 10, 18, unpublished manuscript provided courtesy of Esther Stubblefield; Alice Young Kohler Papers; Paula Rath, "Palama Settlement: 100 Years of Serving a Neighborhood's Needs," *Hawaii Medical Journal* 54, no. 11 (November 1995): 774–75; *Annual Report of the Board of Health, 1938*, 164.

32. Interview with Karen Ekern; Emmett Cahill, *Yesterday at Kalaupapa: A Saga of Pain and Joy* (Honolulu: Editions Limited, 1990).

33. Other Asian American public health nurses mentioned in Alice Young's monthly reports to the board of health are Mrs. Kawahigashi, Miss S. Sasaki, Miss H. Okamoto, Mrs. Ching, Miss Chong, and Miss Ikuwa: Alice Young Kohler Papers; Evelyn Nakano Glenn, "From Servitude to Service Work: Historical Continuities in the Racial Division of Paid Reproductive Labor," *Signs* 18, no. 1 (Autumn 1992): 1–43, esp. 26–27.

34. In 1939, the board of health nurse Clara Sakamoto was to study maternity nursing at the Chicago Maternity Center in preparation for a "Home Delivery Service" provided by the board. There is no indication the service was ever put into place. Alice Young to director of the Bureau of Maternal and Infant Hygiene, 7 September 1939, Alice Young Kohler Papers. See also interview with Esther Stubblefield, interview with Karen Ekern, and Fred T. Foard, regional consultant, United States Public Health Service [hereafter USPHS], 19 February 1941, Hawai'i folder, Group III-States, 1936–1944, box 205, RG 90.

35. Information in Alice Young Kohler Papers; Stubblefield, "History of the Development of Public Health Nursing," 21; Judith Barrett Litoff, *American Midwives*,

1860 to the Present (Westport, Conn.: Greenwood Press, 1978), 123, 126; e-mail message from Laura Ettinger to Susan L. Smith, 14 August 2003; and see Laura Ettinger, "The Birth of a New Professional: The Nurse-Midwife in the United States, 1925–1955" (Ph.D. diss., University of Rochester, 1999).

36. M. Theophane Shoemaker, *History of Nurse-Midwifery in the United States* (New York: Garland, 1984), 2, 11, 17, 20, 29–30, 35; Litoff, *American Midwives*, 122–25; Ettinger, "The Birth of a New Professional"; and Laura Ettinger, "American Nurse-Midwifery and the Mass Media, 1925–1955," American Association for the History of Medicine conference, Williamsburg, Virginia, 5 April 1997, 8, in my possession.

37. The nurse-midwifery schools were the Manhattan Midwifery School (opened in 1928), the Preston Retreat School of Midwifery in Philadelphia (opened in 1923 but began training nurse-midwives in 1933), the Frontier Nursing Service (began training nurse-midwives in 1940), the Tuskegee School of Nurse-Midwifery (opened 1941), the Flint Goodridge School of Nurse-Midwifery in New Orleans (1942–1943), and the Catholic Maternity Institute and School for Nurse-Midwifery in Santa Fe, New Mexico, which was established by the Medical Mission Sisters from Philadelphia (opened 1944). See RG 102; Shoemaker, *History of Nurse-Midwifery*, 37, 38, 40, 42–45, 51; Litoff, *American Midwives*, 126–27; Laura E. Ettinger, "Mission to Mothers: Nuns, Latino Families, and the Founding of Santa Fe's Catholic Maternity Institute," in *Women, Health, and Nation: Canada and the United States since 1945*, edited by Georgina Feldberg, Molly Ladd-Taylor, Alison Li, and Kathryn McPherson (Montreal: McGill-Queens University Press, 2003), 144–60.

38. Dr. Blanche Haines to Grace Abbott, 12 December 1926, folder 4-10-4-2, Central Files, 1925–1928, box 274, RG 102; Shoemaker, *History of Nurse-Midwifery*, 32; Litoff, *American Midwives*, 122–34.

39. Drew Kohler (1911–1985), originally from Minnesota, worked as a linguist for Naval Intelligence in Pearl Harbor after Japan's attack in 1941. Drew and Alice had three children, Katharine, Stephanie, and Paul. The children were delivered by a Japanese American obstetrician, Dr. Richard Sakamoto. After the war, the family moved to Tokyo, where Drew served on the committee of the U.S. Strategic Bombing Survey: Drew Kohler's memorial service program, Grove Farm Homestead, Kauai; interview with Katharine Kohler; interview with Karen Ekern; Ruth Smith and Barnes Riznik interview with Alice Young Kohler.

40. Thanks to Charlotte Borst for urging me to clarify my thinking.

41. Dennis M. Ogawa, *Kodomo no tame ni, For the Sake of the Children: The Japanese American Experience in Hawaii* (Honolulu: University of Hawai'i Press, 1978), 15; Franklin Odo and Kazuko Sinoto, *A Pictorial History of the Japanese in Hawai'i, 1885–1924* (Honolulu: Bishop Museum, 1985), 26, 74; M. Lela Goodell, "Plantation Medicine in Hawaii, 1840 to 1964: A Patient's Perspective," *Hawaii Medical Journal* 54, no. 11 (November 1995): 787; Eriko Yamamoto, "The Evolution of an Ethnic Hospital in Hawaii: An Analysis of Ethnic Processes of Japanese

Americans in Honolulu through the Development of the Kuakini Medical Center" (Ph.D. diss., University of Hawai'i, 1988), 29.

42. Moriyama, *Imingaisha*, 94; Okihiro, *Cane Fires*, 25–26; Yamamoto, "Evolution of an Ethnic Hospital," 52–56, 83, 221; Yukiko Kimura, *Issei: Japanese Immigrants in Hawaii* (Honolulu: University of Hawai'i, 1988), 123, with thanks to Michaelyn P. Chou, retired librarian at the University of Hawai'i Library, for directing me to this source.

43. Beechert, *Working in Hawaii*, 191–93; Amy Hamane, "Japanese Hospitals of Hilo," unpublished manuscript, 3 December 1980, 5, Lyman House Memorial Museum, Hilo, Hawai'i; manager to American Factors, 19 January 1930, folder 13, box 14, Puna Sugar Company Plantation, Hawaiian Sugar Planters' Association Plantation Archives, Hamilton Library, University of Hawai'i at Manoa; Tamura, *Americanization*, 11.

44. Quoted in Sam R. Aspen, "Plantations: Health and Recreation Assisted," *Honolulu Star-Bulletin*, 18 January 1936, 42, container 560, Department of Health, Director's Office, Series 325, Director's Correspondence, 1920–1985, Hawai'i State Archives, Honolulu. See also Todd L. Savitt, "Black Health on the Plantation: Masters, Slaves, and Physicians," in *Sickness and Health in America: Readings in the History of Medicine and Public Health*, 3d rev. ed., edited by Judith Walzer Leavitt and Ronald L. Numbers (Madison: University of Wisconsin Press, 1997), 363.

45. Anna Heisler, Regional Public Health Nursing Consultant, 1938, Hawai'i folder, Group III-States, 1936–1944, box 205, RG 90; Rodman Miller, "Plantation Doctor," *Hawaii Medical Journal* 54, no. 11 (November 1995): 791–92; Tsuneichi Yamamoto, "Kuakini Got Start As Charity Hospital," *Hawaii Sunday Star Bulletin and Advertiser*, 16 June 1968, D-16.

46. Fred T. Foard, Regional Consultant, USPHS, 19 February 1941, Hawai'i folder, Group III-States, 1936–1944, box 205, RG 90.

47. Plans for Infancy and Maternity Work for 1925–1925, 21 March 1925, Correspondence and Reports, 1917–1954, box 12, RG 102; Dr. Otto Lee Schattenburg, "Survey to Determine Needs of Maternity Hospital Beds in the City of Honolulu and Rural Oahu, 1931 to 1941," container 558, Department of Health, Director's Office; Miller, "Plantation Doctor," 791; Frances R. Hegglund Lewis, *History of Nursing in Hawaii* (Node, Wyo.: Germann-Kilmer, 1969), 79.

48. Information in file 4, box 61, Puna Sugar Company plantation, Hawaiian Sugar Planters' Association Plantation Archives, Hamilton Library, University of Hawai'i at Manoa. On the dual health-care system of enslaved African Americans in the nineteenth-century American South, see Todd L. Savitt, *Medicine and Slavery: The Diseases and Health Care of Blacks in Antebellum Virginia* (Urbana: University of Illinois Press, 1978); Sharla M. Fett, *Working Cures: Healing, Health, and Power on Southern Slave Plantations* (Chapel Hill: University of North Carolina Press, 2002).

49. Jiro Nakano, *Kona Echo: A Biography of Dr. Harvey Saburo Hayashi* (Kona,

Hawai'i: Kona Historical Society, 1990); Hamane, "Japanese Hospitals of Hilo," 5. The quotation is from Kimura, *Issei*, 124–25.

50. Tamura, *Americanization*, 11; Goodell, "Plantation Medicine," 787; Okihiro, *Cane Fields*, 59, 185.

51. Yamamoto, "Evolution of an Ethnic Hospital," 10.

52. Vanessa Northington Gamble, *Making a Place for Ourselves: The Black Hospital Movement, 1920–1945* (New York: Oxford University Press, 1995). Queen's hospital, the oldest civilian hospital, was named after Queen Emma of Hawai'i. Robert C. Schmitt, "Hawaii's Hospitals, 1831–1956," *Hawaii Medical Journal* 15, no. 4 (1956): 339; Lewis, *History of Nursing*, 54; Roland Maruyama, "Kuakini Strives for Excellence," *Hawaii Herald*, 8 May 1969, 2.

53. David J. Rothman, *Strangers at the Bedside: A History of How Law and Bioethics Transformed Medical Decision Making* (New York: Basic Books, 1991), 124–25; Alan M. Kraut, *Silent Travelers: Germs, Genes, and the 'Immigrant Menace'* (Baltimore: Johns Hopkins University Press, 1994), 206–7; Gamble, *Making a Place for Ourselves*; Carol K. Coburn and Martha Smith, *Spirited Lives: How Nuns Shaped Catholic Culture and American Life, 1836–1920* (Chapel Hill: University of North Carolina Press, 1999), 189–219.

54. Yoshiko Higa, interview by author, tape recording, Hilo, Hawai'i, 6 May 1997; Leon H. Bruno, *The Private Japanese Hospital: A Unique Social Phenomenon on Hawaii, 1907–1960* (Hilo, Hawai'i: Lyman House Memorial Museum, 1985), 1–4; Nancy M. Horikawa, "The Transition from Japanese Hospital to Kuakini Hospital," *Social Process in Hawaii* 21 (1957): 54–57; Hamane, "Japanese Hospitals of Hilo," 1–8; Kimura, *Issei*, 54.

55. Hamane, "Japanese Hospitals of Hilo," 1–8.

56. A school of nursing and a retirement home were created at the hospital in the interwar years. Yamamoto, "Evolution of an Ethnic Hospital," 7, 9, 10, and 304–43; "Hospitals of Hawaii," *Modern Hospital* 18, no. 6 (June 1922): 495. On the Chinese hospital, see McCunn, *Chinese American Portraits*, 69.

57. McCunn, *Chinese American Portraits*, 68–69. See also James C. Mohr, *Plague and Fire: Battling Black Death and the 1900 Burning of Honolulu's Chinatown* (New York: Oxford University Press, 2005).

58. Ernest K. Wakukawa, *A History of the Japanese People in Hawaii* (Honolulu: Toyo Shoin, 1938), 112, in the book collection at Lyman House, Hilo; Lewis, *History of Nursing*, 74–76; Horikawa, "Transition from Japanese Hospital," 54–57; Masaichi Tasaka and Richard Suehiro, "The Immigrants' Hospital: Kuakini Medical Center," *Hawaii Medical Journal* 44, no. 8 (August 1985): 291–93; Maruyama, "Kuakini Strives for Excellence," 2; McCunn, *Chinese American Portraits*, 69–72.

59. "First AJA Dentist Bridges Issei, Nisei," *Hawaiian Reporter*, 12 May 1960, 11; Betty Katsuki, "Medical Men Who Helped to Shape Hawaii," *Hawaii Medical Journal* 40, no. 10 (September 1981): 280; Moriyama, *Imingaisha*, 91, 94. See Dr.

Mōri in photograph of Japanese doctors in Honolulu in 1899, in Odo and Sinoto, *Pictorial History,* 101.

60. Robert C. Schmitt, "Health Personnel in Hawaii, 1820–1974," *Hawaii Medical Journal* 34, no. 2 (February 1975): 53; Lewis, *History of Nursing,* 43, 45.

61. There is conflicting evidence about when the rules changed and interpreters were no longer permitted, some information pointing to 1914 and some to 1918. "Hospitals of Hawaii," 494–95; Bruno, *Private Japanese Hospital,* 1; Yamamoto, "Evolution of an Ethnic Hospital," 57.

62. Kimura, *Issei,* 125; Yamamoto, "Evolution of an Ethnic Hospital," 221; Michael M. Okihiro, "Japanese Doctors in Hawai'i," *Hawaiian Journal of History* 36 (2002): 105–17, esp. 107–9.

63. Dr. Trotter to Philip Spalding, 19 August 1938, container 559, Department of Health, Director's Office; "48 Midwives Registered Here," *Honolulu Advertiser,* 1 January 1932, 6; interview with Yoshiko Higa.

64. Misao Tanji, interview conducted by Charlotte Tanji, Waipahu, Hawaii, 11 February and 1 March 1984, written transcript in my possession. See also Kimura, *Issei,* 126.

65. Charlotte Tanji interview with Misao Tanji.

66. Beechert, *Working in Hawaii,* 146, 204, 237; Chan, *Asian Americans,* 85, 87; Okihiro, *Cane Fields,* 59, 185.

67. Charlotte Tanji interview with Misao Tanji; Tom Tanji, interview by author, tape recording, Waipahu, Hawai'i, 9 August 1995; memorial service program, Misao Tanji, 23 January 1990, copy of program provided courtesy of Tom Tanji.

68. Charlotte Tanji interview with Misao Tanji; Minutes of the Board of Health, 17 March 1938, container 536, Department of Health, Director's Office; *Husted's Directory of Honolulu and the Territory of Hawaii* (Honolulu: Polk-Husted Directory, 1925). On European immigrant midwives as entrepreneurs, see Charlotte G. Borst, *Catching Babies: The Professionalization of Childbirth, 1870–1920* (Cambridge, Mass.: Harvard University Press, 1995), 68–89.

69. Misao Tanji [Mrs. Takeo Tanji], *Mrs. Takeo Tanji, Waipahu Midwife,* videotape, interviewed and produced by Bethany Thompson [Thomas], translation by Hideo Okada, Leeward Community College, Pearl City, Hawai'i (1977 or 1980, date is unclear); Charlotte Tanji interview with Misao Tanji; interview with Tom Tanji; memorial service program for Misao Tanji.

70. Charlotte Tanji interview with Misao Tanji; attendance list in Alice Young Kohler Papers.

71. Charlotte Tanji interview with Misao Tanji.

72. Interview with Yoshiko Higa, daughter of Uto Nakamatsu; Kimura, *Issei,* 126. Okinawans were from the Ryukyu Islands and were independent of Japan until the 1870s, when they became the southernmost prefecture. About 20,000 Okinawans emigrated to Hawai'i in the early twentieth century. The Japanese stigmatized them as hairy, dirty, inferior people, a prejudice shared by nurse Luella Ekern: interview

NOTES TO PAGES 122-23

with Karen Ekern; Eleanor C. Nordyke and Y. Scott Matsumoto, "The Japanese in Hawaii: A Historical and Demographic Perspective," *Hawaiian Journal of History* 11 (1977): 164; Kimura, *Issei*, 55; Dorothy Ochiai Hazama and Jane Okamoto Komeiji, *Okage Sama De: The Japanese in Hawai'i* (Honolulu: Bess Press, 1986), 71, 74; Joyce Chapman Lebra, *Women's Voices in Hawaii* (Boulder: University Press of Colorado, 1991), 5, 55, 130, 162, 168, 178–81, 232, 241–42, 254, 269.

73. Ethnic Studies Oral History Project, *Waialua and Haleiwa: The People Tell Their Story* (Manoa [Honolulu]: University of Hawai'i at Manoa, 1977): Vivian Lee interview with Chen Shee Chun, vol. 1, 54–57; Vivian Lee interview with Hook Chen Lew, vol. 1, 91; Vivian Lee interview with Thomas Lee, vol. 2, 26–28; Norma Carr interview with Alfredo Santiago, vol. 2, 158–60; Vivian Lee interview with Faustino Baysa, vol. 3, 26–35; Chad Taniguchi interview with Antone Camacho, vol. 8, 32–36; Chad Taniguchi interview with Lucy Robello, vol. 9, 211–20. See also Ethnic Studies Oral History Project, *Remembering Kakaako: 1910–1950* (Manoa [Honolulu]: University of Hawai'i at Manoa, 1978); Perry Nakayama interview with Eleanor W. Heavey, vol. 1, 376; Gael Gouveia interview with Virginia Mansinon, vol. 2, 770.

74. Quoted in Okihiro, *Cane Fires*, 32; Alice Young to director, Bureau of Maternal and Infant Hygiene, 21 December 1939, Alice Young Kohler Papers.

75. Interview with Yoshiko Higa.

76. Unlike West Coast states that were admitted to the U.S. Registration Area for Births in the late 1910s, Hawai'i was not admitted until 1930. According to Charles Cassedy, special deputy attorney general, midwife registration began as part of the "provisions of Section 1224B of the Revised Laws of Hawaii 1925 as enacted by Act 67 of the Session Laws of 1931": Charles Cassedy to Dr. F. E. Trotter, 12 May 1931, Minutes of the Board of Health, 17 June 1931, box 5, Department of Health, Series 259, Hawai'i State Archives, Honolulu; Dr. F. E. Trotter, president and executive officer of the board of health, to Dr. Blanche M. Haines, Children's Bureau, 25 May 1931, container 531, box 8, Department of Health, Director's Office; *Journal of the House of Representatives of the Sixteenth Legislature of the Territory of Hawaii, Regular Session of 1931* (Honolulu: New Freedom Press, 1931), 366.

77. Vivia B. Appleton was a graduate of Johns Hopkins Medical School and taught at the University of California Medical School before coming to Hawai'i: Appleton, "Report of Work Done . . . , 1925–1926," Correspondence and Reports, 1917–1954, box 13, RG 102; "Big Shake-up in Board of Health Is Ordered during Absence of Dr. F. E. Trotter," *Honolulu Advertiser*, 11 June 1927, 2, Hawaii State Library, Honolulu.

78. *Annual Report of the Board of Health*, 1927, 225.

79. Letter from Dr. Irwin (addressee unknown) in folder 13, box 14, Puna Sugar Company Plantation, Hawaiian Sugar Planters' Association Plantation Archives, Hamilton Library, University of Hawai'i at Manoa; Narrative Reports in Alice Young Kohler Papers.

80. Ruth G. Taylor to Hazel Corbin, 25 March 1937, on the letter from Dr. Fred K. Lam, director of the Bureau of Materal and Infant Hygiene, to Children's Bureau, Central Files, 1937–1940, box 727, RG 102; *Annual Report of the Board of Health, 1938,* 174; Minutes of the Board of Health, 19 May 1937, 174, box 5, Department of Health, Series 259; news clippings, including "Midwives Deliver One-Fourth," and "89 Midwifery Licenses Out," *Hilo Tribune Herald,* 17 October 1938, all in Alice Young Kohler Papers.

81. Kiyugo Yanase was a licensed midwife on Oahu in 1939. Frances Scott White, advisory maternal and child health nurse, to director of the Bureau of Maternal and Infant Hygiene, 2 June 1937, container 559, Department of Health, Director's Office; Minutes of the Board of Health, 7 August 1931, 178–81, box 5, Department of Health, Series 259; Alice Young to director of the Bureau of Maternal and Infant Hygiene, 8 February and 10 July 1939, Alice Young Kohler Papers. On Filipino men as birth attendants, see the quotation from Dr. William T. Dunn in 1938 in Nils P. Larsen, "100 Years of Plantation Medicine," *Hawaii Medical Journal* 15, no. 4 (March–April 1956): 327.

82. "Lax Practice by Midwives," 2; Ambrose, "Midwifery Declined"; "Midwives Deliver One-Fourth"; Alice Young to director of the Bureau of Maternal and Infant Hygiene, 3 January and 9 May 1939, all in Alice Young Kohler Papers.

83. Minutes of the Board of Health, 17 March 1938, container 536, Department of Health, Director's Office; interview with Esther Stubblefield; Alice Young to director of the Bureau of Maternal and Infant Hygiene, 9 August 1939 and 9 January 1941, both in Alice Young Kohler Papers.

84. *Annual Report of the Board of Health, 1935,* 83.

85. Mabel L. Smyth, "Report of Work Done under the Federal Maternity and Infancy Act, 1927–1928," Correspondence and Reports, 1917–1954, box 13, RG 102.

86. Appleton, "Report of Work Done . . ., 1925–1926," Correspondence and Reports, 1917–1954, box 13, RG 102.

87. Appleton, "Report of Work Done . . ., 1926–1927," Correspondence and Reports, 1917–1954, box 13, RG 102; Smyth, "Report of Work Done . . ., 1927–1928"; Smyth, "Report of Work Done . . ., 1928–1929," Correspondence and Reports, 1917–1954, box 13, RG 102.

88. Appleton, "Report of Work Done . . ., 1925–1926"; Smyth, "Report of Work Done . . ., 1927–1928"; and Smyth, "Report of Work Done . . ., 1928–1929"; *Annual Report of the Board of Health, 1927,* 104; *Annual Report of the Board of Health, 1929,* 152.

89. Alice Young to director of the Bureau of Maternal and Infant Hygiene, 21 December 1939 and 3 October 1940, both in Alice Young Kohler Papers.

90. Dr. Vivia B. Appleton to Dr. Blanche M. Haines, 22 December 1925, Central Files, 1925–1928, box 274, RG 102; O. A. Bushnell, *The Gifts of Civilization: Germs and Genocide in Hawai'i* (Honolulu: University of Hawai'i Press, 1993),

67, 74; June Gutmanis, *Kahuna La'au Lapa'au: The Practice of Hawaiian Herbal Medicine* (Aiea, Hawaii: Island Heritage Publishing, 1976), 14, 36–37, 40; Lewis, *History of Nursing*, 28; interview with Karen Ekern.

91. "Midwives Deliver"; and Alice Young to acting director of the Bureau of Maternal and Infant Hygiene, 3 January 1939, both in Alice Young Kohler Papers. For a similar pattern in Wisconsin, see Borst, *Catching Babies*, 32–33.

92. "Islands Have Record Low on Mortality," *Honolulu Advertiser*, 14 August 1936, 1. There were 187 licensed midwives in 1934 and 93 in 1939: *Annual Report of the Board of Health, 1941*, 74; *Husted's Directory of Honolulu and the Territory of Hawaii, 1937/1938* (Honolulu: Polk-Husted Directory, 1938).

93. Alice Young to director of the Bureau of Maternal and Infant Hygiene, 14 November 1938, Alice Young Kohler Papers. On social policy as the product of negotiations, see Linda Gordon, "The New Feminist Scholarship on the Welfare State," in *Women, the State, and Welfare*, edited by Linda Gordon (Madison: University of Wisconsin Press, 1990), 23–30.

94. Alice Young to director of the Bureau of Maternal and Infant Hygiene, 4 April 1939, and 22 June 1939, Alice Young Kohler Papers.

95. According to Ruthanne Lum McCunn, "In 1946 Robert Ripley featured her in his syndicated newspaper column, 'Believe It or Not,' for the highest record of delivery [over 6,000] of any private practitioner": McCunn, *Chinese American Portraits*, 75; see also 68–69, 74–75. See also Margaret Makekau's reminiscences in "Talk Story" (1986), and Alice Young to acting director of the Bureau of Maternal and Infant Hygiene, 3 January 1939, both in Alice Young Kohler Papers.

96. From reminiscences of Margaret Makekau in "Talk Story" (1986), 6, Alice Young Kohler Papers.

97. Ruth Smith and Barnes Riznik interview with Alice Young Kohler.

98. Ruth Smith and Barnes Riznik interview with Alice Young Kohler.

99. Theodora Floyd to director of Public Health Nursing, 15 July 1938, Alice Young Kohler Papers.

100. Ruth Smith interview with Esther Stubblefield.

101. The quotation is from Alice Young Kohler in Ruth Smith and Barnes Riznik interview with Kohler. See also Alice Young to director of the Bureau of Maternal and Infant Hygiene, 7 October and 14 November 1938, Alice Young Kohler Papers.

102. Alice Young to director of the Bureau of Maternal and Infant Hygiene, 7 October 1939, 25 March 1940, and 12 December 1941, Alice Young Kohler Papers.

103. Meeting with officers of [Japanese] Midwife Club, 10 November 1938; Alice Young to director of the Bureau of Maternal and Infant Hygiene, 20 December 1939, 25 March 1940, and 3 May 1941, all in Alice Young Kohler Papers.

104. Alice Young to director of the Bureau of Maternal and Infant Hygiene, 26 June 1939 and 27 June 1940, Alice Young Kohler Papers.

105. Judith Walzer Leavitt, *Brought to Bed: Childbearing in America, 1750 to*

1950 (New York: Oxford University Press, 1986), 161–62; Nancy Tomes, *The Gospel of Germs: Men, Women, and the Microbe in American Life* (Cambridge, Mass.: Harvard University Press, 1998).

106. Appleton, "Report of Work Done . . ., 1925–1926," Correspondence and Reports, 1917–1954, box 13, RG 102.

107. Interview with Esther Stubblefield; Ruth Smith and Barnes Riznik interview with Alice Young Kohler; Narrative Reports in Alice Young Kohler Papers.

108. Litoff, *American Midwives*, 101; Judith Barrett Litoff, *The American Midwife Debate: A Sourcebook on Its Modern Origins* (Westport, Conn.: Greenwood Press, 1986), 10.

109. Charlotte Tanji interview with Misao Tanji.

110. Charlotte Tanji interview with Misao Tanji; Pauline G. Stitt to president of the board of health, 21 July 1944, container 558, Department of Health, Director's Office; Alice Young to director of the Bureau of Maternal and Infant Hygiene, 9 January 1941, Alice Young Kohler Papers.

111. Alice Young to director of the Bureau of Maternal and Infant Hygiene, 21 December 1939, 18 April 1940, 4 November 1940, all in Alice Young Kohler Papers; *Mrs. Takeo Tanji, Waipahu Midwife*; interview with Karen Ekern; interview with Yoshiko Higa; Edward Norbeck, *Pineapple Town* (Berkeley: University of California Press, 1959), 91.

112. Alice Young to director of the Bureau of Maternal and Infant Hygiene, 7 March 1939, 20 December 1939, 25 March 1940, 3 May 1941, all in Alice Young Kohler Papers; Samuel M. Wishik to president of the board of health, 15 May 1945, container 559, Department of Health, Director's Office.

113. Dr. May Borquist to territorial commissioner of Public Health, 1 June 1939; Dr. Trotter to Sui Ishida, 28 July 1938; and Dr. O. Lee Schattenburg to Territorial Commission of Public Health, 14 July 1939, all in container 559, Department of Health, Director's Office; Minutes of the Board of Health, 16 August 1938, 18 and 20 June 1939, 204–7, both in box 5, Department of Health, Series 259; interview with Karen Ekern. On midwives, abortion, and adoption, see Leslie J. Reagan, *When Abortion Was a Crime: Women, Medicine, and Law in the United States, 1867–1973* (Berkeley: University of California Press, 1997), 46–79; and Linda Gordon, *The Great Arizona Orphan Abduction* (Cambridge, Mass.: Harvard University Press, 1999), 10, 119.

114. Interview with Karen Ekern; interview with Esther Stubblefield.

115. Alice Young to Bureau of Maternal and Infant Hygiene, 4 April 1939, Alice Young Kohler Papers; Ruth Smith and Barnes Riznik interview with Alice Young Kohler.

116. Alice Young to Bureau of Maternal and Infant Hygiene, 4 April and 9 May 1939; meeting with officers of [Japanese] Midwife Club, 10 November 1938, all in Alice Young Kohler Papers.

117. Ichioka, *Issei,* 157; Kimura, *Issei,* 125; and Yamamoto, "Evolution of an Ethnic Hospital," 81.

118. Frances Scott White, "Midwives—History Story," October 1936, unpublished manuscript, container 559, Department of Health, Director's Office; Ruth Smith and Barnes Riznik interview with Alice Young Kohler; Ruth Smith interview with Esther Stubblefield; Narrative Reports, Alice Young Kohler Papers; interview with Yoshiko Higa. See also the newspaper story in the *Hawaii Hochi*, 3 May 1985, about Misao Tanji, with a photo of the midwives' association meeting on 15 May 1925 (clipping provided courtesy of Tom Tanji; headline and page missing).

119. Meeting with officers of the [Japanese] Midwife Club, 10 November 1938, and Alice Young to director of the Bureau of Maternal and Infant Hygiene, 9 May and 9 August 1939, all in Alice Young Kohler Papers.

120. Narrative Reports, Alice Young Kohler Papers; interview with Esther Stubblefield. On European immigrant midwives, see Reagan, *When Abortion Was a Crime*, 98–99.

121. Meeting with officers of [Japanese] Midwife Club, 10 November 1938; Alice Young to Bureau of Maternal and Infant Hygiene, 4 April and 9 May 1939, all in Alice Young Kohler Papers.

122. Dr. Uyehara of Waipahu was supposed to translate the midwife manual into Japanese, but it is not clear that he did: Alice Young to director of the Bureau of Maternal and Infant Hygiene, 14 November 1938, 4 April 1939, 9 May 1939, 22 June 1939, 26 June 1939, and 18 December 1939, all in Alice Young Kohler Papers.

123. "Infant Death Rates in the United States, by States, for 1938 and Prior Years," *Public Health Reports* 55, no. 14 (5 April 1940): 602–3; *Annual Report of the Board of Health, 1940*, 41; Appleton, "Report of Work Done . . ., 1926–1927," Correspondence and Reports, 1917–1954, box 13, RG 102.

124. Interview with Esther Stubblefield.

125. Ruth Smith and Barnes Riznik interview with Alice Young Kohler; F. E. Trotter to Grace Abbot, 3 September 1927, Correspondence and Reports, 1917–1954, box 12, RG 102; acting surgeon general to Governor Joseph P. Poindexter, 17 August 1939, Hawaii, Group III-States, 1936–1944, box 205, RG 90; Lee, "History of Public Health in Hawaii," 336; Lewis, *History of Nursing*, 110–16. Mabel Leilani Smyth, born in Honolulu in 1892, worked as a public health nurse for the Palama Settlement in the 1910s. In 1927 she was appointed a supervisor of maternal and infant hygiene and public health nurses at the board of health, where she worked until her death in 1936. Dr. Trotter was president of the board of health and territorial commissioner from 1920 to 1939.

126. Medical director for the USPHS in San Francisco to Surgeon General Thomas Parran, 5 September 1939, Hawaii, Group III-States, 1936–1944, box 205, RG 90; Lee, "History of Public Health in Hawaii," 331–37; Jacques Cutless Press, ed., *American Men and Women of Science: Medical and Health Sciences, 1977* (New York: R. R. Bowker, 1977), 743–44.

127. Ruth Smith and Barnes Riznik interview with Alice Young Kohler.

128. Ruth Smith and Barnes Riznik interview with Alice Young Kohler; Dr. Fred K. Lam to field supervisor, 3 May 1935, container 559, Department of Health, Director's Office; *Annual Report of the Board of Health, 1936,* 135.

Chapter 5

1. Misao Tanji, interview conducted by Charlotte Tanji, Waipahu, Hawaii, 11 February and 1 March 1984, written transcript, copy in my possession. See also *Mrs. Takeo Tanji, Waipahu Midwife,* videotape, interviewed and produced by Bethany Thompson [Thomas], translation by Hideo Okada, Leeward Community College, Pearl City, Hawaii (1977 or 1980, date is unclear).

2. Toku Shimomura's diary, 2 February 1941, 3 February 1941, 4 February 1941, 9 February 1941, 8 March 1941, 7 January 1942. Toku Shimomura's diaries, including the English translation of 1941 and 1942, provided courtesy of Roger Shimomura. My thanks to Febe Pamonag for her insights and translation assistance with the wartime diaries.

3. Toku Shimomura's diary, 2 March 1941, 7 December 1942.

4. Jeanne Wakatsuki Houston and James D. Houston, *Farewell to Manzanar* (New York: Bantam Books, 1973), 46.

5. Valerie Matsumoto, "Japanese American Women during World War II," in *Unequal Sisters: A Multicultural Reader in U.S. Women's History,* edited by Ellen Carol Du Bois and Vicki L. Ruiz (New York: Routledge, 1990), 373–86, esp. 384. On war and social change, see John F. McClymer, *War and Welfare: Social Engineering in America, 1890–1925* (Westport, Conn.: Greenwood Press, 1980); Arthur Marwick, "Problems and Consequences of Organizing Society for Total War," in *Mobilization for Total War: The Canadian, American and British Experience, 1914–1918, 1939–1945* (Waterloo: Wilfred Laurier University Press, 1981), 3–4; Harold L. Smith, ed., *War and Social Change: British Society in the Second World War* (Manchester, England: Manchester University Press, 1986), x.

6. Alfred Vagts, *A History of Militarism: Civilian and Military,* rev. ed. (New York: Free Press, 1959), 17; Michael S. Sherry, *In the Shadow of War: The United States since the 1930s* (New Haven, Conn.: Yale University Press, 1995), x–xi; Laura McEnaney, *Civil Defense Begins at Home: Militarization Meets Everyday Life in the Fifties* (Princeton, N.J.: Princeton University Press, 2000), 5–6, 157 n. 6, 158 n. 7. Special thanks to Laura McEnaney for helping me to clarify my thinking.

7. Mark Harrison, "The Medicalization of War—The Militarization of Medicine," *Social History of Medicine* 9, no. 2 (August 1996): 267–76; Christina Romlid, "Swedish Midwives and Their Instruments in the Eighteenth and Nineteenth Centuries," in *Midwives, Society, and Childbirth: Debates and Controversies in the Modern Period,* edited by Hilary Marland and Anne Marie Rafferty (New York: Routledge, 1997), 38–60.

8. On the British midwife's wartime experience, see Nicky Leap and Billie Hunter,

The Midwife's Tale: An Oral History from Handywoman to Professional Midwife (London: Scarlet Press, 1993), 118–31, esp. 124.

9. Judith Barrett Litoff, *American Midwives, 1860 to the Present* (Westport, Conn.: Greenwood Press, 1978), 72; Judith Walzer Leavitt, *Brought to Bed: Childbearing in America, 1750 to 1950* (New York: Oxford University Press, 1986), 142–95.

10. John W. Dower, *War Without Mercy: Race and Power in the Pacific War* (New York: Pantheon Books, 1986), 4, 9, 33, 77, 81–84; quote 99.

11. Dower, *War Without Mercy*, x, 294; quote 68.

12. J. Garner Anthony, *Hawaii under Army Rule* (Stanford, Calif.: Stanford University Press, 1955), ix–x. See also Harry N. Scheiber and Jane L. Scheiber, "Constitutional Liberty in World War II: Army Rule and Martial Law in Hawaii, 1941–1946," *Western Legal History* 3, no. 2 (1990): 341–78.

13. Beth Bailey and David Farber, *The First Strange Place: The Alchemy of Race and Sex in World War II Hawaii* (New York: Free Press, 1992), 29.

14. The quotation is from Anthony, *Hawaii under Army Rule*, 2. See also Leisa D. Meyer, *Creating GI Jane: Sexuality and Power in the Women's Army Corps during World War II* (New York: Columbia University Press, 1996), 1.

15. Anthony, *Hawaii under Army Rule*, 4; see also 3–6, 8–9, 118.

16. John J. Stephan, *Hawaii under the Rising Sun: Japan's Plans for Conquest after Pearl Harbor* (Honolulu: University of Hawai'i Press, 1984), 4. See also Anthony, *Hawaii under Army Rule*, 5, 8.

17. Anthony, *Hawaii under Army Rule*, 98; see also 41, 59, 107, 109, 118; DeSoto Brown, *Hawaii Goes to War: Life in Hawaii from Pearl Harbor to Peace* (Honolulu: Editions Limited, 1989), 70.

18. Kathy Ferguson, Phyllis Turnbull, and Mehmed Ali, "Rethinking the Military in Hawai'i," in *Hawai'i: Return to Nationhood*, edited by Ulla Hasager and Jonathan Friedman, Document no. 75 (Copenhagen, Denmark: International Work Group for Indigenous Affairs, 1994), 183; Gary Y. Okihiro, *Cane Fires: The Anti-Japanese Movement in Hawaii, 1865–1945* (Philadelphia: Temple University Press, 1991), 190, 225; and Anthony, *Hawaii under Army Rule*, 1.

19. Anthony, *Hawaii under Army Rule*, 34.

20. Bailey and Farber, *First Strange Place*, 29; Anthony, *Hawaii under Army Rule*, 34; Brown, *Hawaii Goes to War*, 84.

21. Noriko Shimada, "Wartime Dissolution and Revival of the Japanese Language Schools in Hawai'i: Persistence of Ethnic Culture," *Journal of Asian American Studies* 1 n. 2 (June 1998): 121–51, esp. 122; Okihiro, *Cane Fires*, 271.

22. Anthony, *Hawaii under Army Rule*, 26, 151, 157; Yukiko Kimura, *Issei: Japanese Immigrants in Hawaii* (Honolulu: University of Hawai'i Press, 1988), 127. See photographs of Japanese midwife meetings in late 1940s and 1950s, Bishop Museum archives, Honolulu.

23. Brown, *Hawaii Goes to War*, 67.

24. The quotation is from Okihiro, *Cane Fires*, 209; see also 125, 271; Brown, *Hawaii Goes to War*, 74–75.

25. Anthony, *Hawaii under Army Rule,* 9, 92, 107, 118.

26. Eriko Yamamoto, "The Evolution of an Ethnic Hospital in Hawaii: An Analysis of Ethnic Processes of Japanese Americans in Honolulu through the Development of the Kuakini Medical Center," (Ph.D. diss., University of Hawai'i, 1988), 311–16; Okihiro, *Cane Fires,* 209; Michael M. Okihiro, "Japanese Doctors in Hawai'i," *Hawaiian Journal of History* 36 (2002): 105–17, esp. 112–13.

27. Yamamoto, "Evolution of an Ethnic Hospital," 308, 311–16, 320; Letter from Gary K. Kajiwara, president and chief executive officer, Kuakini Health System, to Susan L. Smith, 14 April 1997; Nancy M. Horikawa, "The Transition from Japanese Hospital to Kuakini Hospital," *Social Process in Hawaii* 21 (1957): 54–57; Frances R. Hegglund Lewis, *History of Nursing in Hawaii* (Node, Wyo.: Germann-Kilmer, 1969), 77, 103; Anthony, *Hawaii under Army Rule,* 26.

28. Yamamoto, "Evolution of an Ethnic Hospital," 304–43; Horikawa, "Transition from Japanese Hospital," 54, 56; Lewis, *History of Nursing,* 77, 103; Anthony, *Hawaii under Army Rule,* 26.

29. Quoted in Amy Hamane, "Japanese Hospitals of Hilo," unpublished manuscript, 3 December 1980, 5, Lyman House Memorial Museum, Hilo, Hawai'i.

30. Quoted in Virginia A. Jones and Mildred D. Byers, "Public Health Nursing in Hawaii at War," *Public Health Nursing* 34, no. 4 (April 1942): 179. On doctors, see Yamamoto, "Evolution of an Ethnic Hospital," 309, 318. See also Brown, *Hawaii Goes to War,* 32.

31. The quotation is from Alice Young Kohler, interview by Ruth S. Smith and Barnes Riznik, 6 August 1985, Grove Farm Homestead Museum, Kauai; Alice Young to acting director of Bureau of Maternal and Child Health, January 1942, Narrative Reports, unprocessed papers of Alice Young Kohler [hereafter Alice Young Kohler Papers], in possession of her daughter Katharine Kohler, Oahu, Hawai'i.

32. Esther Stubblefield, interview by author, tape recording, Honolulu, Hawai'i, 5 May 1997 [hereafter interview with Esther Stubblefield]. Japanese American nurse Luella Ekern, meanwhile, was allowed to remain working at Queen's Hospital during the war: Karen Ekern, interview by author, tape recording, Hilo, Hawai'i, 6 May 1997.

33. The quotation is from the interview with Esther Stubblefield; Ah Chin L. Lam, "Medical Practice during the First Eighteen Months of the War," *Social Process in Hawaii* 9–10 (1945): 64–74, esp. 66; Gwenfread Allen, *Hawaii's War Years, 1941–1945* (Honolulu: University of Hawai'i Press, 1950), 113, 338; Brown, *Hawaii Goes to War,* 30, 74.

34. Smith and Riznik interview with Alice Young Kohler.

35. "List of Certified Midwives, Fiscal Year Ending June 30, 1941," container 559, Department of Health, Director's Office, Series 325, Director's Correspondence, 1920–1985, Hawai'i State Archives, Honolulu; "Health Services in Hawaii," *Child* 6, no. 11 (May 1942): 292, in Hawaii War Records Depository, Hamilton Library, University of Hawai'i at Manoa.

36. Dr. O. Lee Schattenburg, "Obstetrics in Wartime," *Journal of the American*

Medical Association 118 (4 April 1942): 1191. See also Dr. O. Lee Schattenburg, "Obstetrics during Major Disaster," *Hawaii Medical Journal* 1, no. 3 (January 1942): 176–77.

37. M. F. Haralson to Major W. F. Steer, 23 December 1941, container 559, Department of Health, Director's Office.

38. Interview with Esther Stubblefield; Schattenburg, "Obstetrics in Wartime," 1190, 1192.

39. Alice Young to acting director of Bureau of Maternal and Child Health, 10 January 1942, Narrative Reports, Alice Young Kohler Papers.

40. Dr. O. Lee Schattenburg to territorial commissioner of Public Health, 31 March 1942, container 531, Department of Health, Director's Office.

41. Alice Young to acting director of Bureau of Maternal and Child Health, 10 January, 9 February, 21 April, and 31 August 1942, Narrative Reports, Alice Young Kohler Papers.

42. Alice Young to acting director of Bureau of Maternal and Child Health, 9 February 1942, Narrative Reports, Alice Young Kohler Papers.

43. Dr. Samuel M. Wishik, Notice to Midwives, 12 November 1943, container 559, Department of Health, Director's Office.

44. Quoted in Jones and Byers, "Public Health Nursing," 179, 181. For the experience of local physicians, see Lam, "Medical Practice," 64–74.

45. Jones and Byers, "Public Health Nursing," 182.

46. Virginia A. Jones, "A Letter from Honolulu," *Public Health Nursing* 34 (April 1942): 238. See also Brown, *Hawaii Goes to War*, 72.

47. *Annual Report of the President of the Board of Health of the Territory of Hawaii for the Fiscal Year Ending June 30, 1942* [hereafter *Annual Report of the Board of Health*] (printed by the *Honolulu Star-Bulletin*, 1943), 74, in the Hawai'i State Archives, Honolulu. See also Schattenburg, "Obstetrics in Wartime," 1192.

48. Alice Young Kohler quoted in Jeanne Ambrose, "Midwifery Declined after Wartime Role Changed," *Honolulu Star-Bulletin*, 23 March 1984, A-12, Alice Young Kohler Papers; *Annual Report of the Board of Health, 1941*, 74; *Annual Report of the Board of Health, 1945*, 112; Mildred Byers, "Public Health Nursing in Hawaii at War," *Hawaii Health Messenger* 1, no. 1 (1941): 3, Hawaii State Archives.

49. Interview with Esther Stubblefield; Smith and Riznik interview with Alice Young Kohler.

50. The quotations are from Smith and Riznik interview with Alice Young Kohler. Additional information is from Schattenburg, "Obstetrics in Wartime," 1191; Schattenburg, "Obstetrics during Major Disaster," 176; interview with Esther Stubblefield; Allen, *Hawaii's War Years*, 338–39.

51. The quotation is from the Charlotte Tanji interview with Misao Tanji; additional information is from Franklin Odo and Kazuko Sinoto, *A Pictorial History of the Japanese in Hawai'i, 1885–1924* (Honolulu: Bishop Museum, 1985), 155.

52. Charlotte Tanji interview with Misao Tanji.

53. The quotations are from the Charlotte Tanji interview with Misao Tanji;

additional information is from Tom Tanji, interview by author, tape recording, Waipahu, Hawai'i, 9 August 1995.

54. "The Problem of Student Nurses of Japanese Ancestry," *American Journal of Nursing* 43 (1943): 895; Roger Daniels, *Asian America: Chinese and Japanese in the United States since 1850* (Seattle: University of Washington Press, 1988), 253; Meyer, *Creating GI Jane*, 63, 67, 75.

55. Kimura, *Issei*, 127.

56. Radio talk on "Maternal Health," Richard Kui Chi Lee, director of Public Health, Board of Health, Territory of Hawai'i, 21 November 1943, Station KGU, Honolulu, Hawai'i War Records Depository, Hamilton Library, University of Hawai'i at Manoa; Rima D. Apple, *Mothers and Medicine: A Social History of Infant Feeding, 1890-1950* (Madison: University of Wisconsin Press, 1987).

57. *Annual Report of the Board of Health, 1947*, 123; *Annual Report of the Board of Health, 1951*, 13.

58. See narrative reports by midwife supervisor Alice Young, such as Alice Young to director of the Bureau of Maternal and Infant Hygiene, 9 January 1941, Alice Young Kohler Papers.

59. Alice Young to director of the Bureau of Maternal and Infant Hygiene, 20 December 1939, Alice Young Kohler Papers.

60. Yamamoto, "Evolution of an Ethnic Hospital," 300; interview with Tom Tanji.

61. Yoshiko Higa, interview by author, tape recording, 6 May 1997, Hilo, Hawai'i; research notes shared by Junko Nowaki, who conducted interviews with Mrs. Nobuyo Nowaki, Mrs. Ayako Hamada, Mrs. Shizuko Akamine, and Mrs. Avis Nomura, the island of Hawai'i, 1 May 1997, University of Hawai'i, Hilo, summary notes supplied by Junko Nowaki and in my possession.

62. Flora Ozaki quoted in Ambrose, "Midwifery Declined," A-12; Eileen H. Tamura, *Americanization, Acculturation, and Ethnic Identity: The Nisei Generation in Hawaii* (Urbana: University of Illinois Press, 1994), xiii, 49, 55. See also McClymer, *War and Welfare*, 74, 79.

63. Smith and Riznik interview with Alice Young Kohler.

64. Interview with Esther Stubblefield; Ambrose, "Midwifery Declined," A-12.

65. Esther Stubblefield, interview by Ruth Smith, oral history project on "Public Health Services and Family Health on Kauai, 1920-1955," 16 March 1982, written transcript, Grove Farm Homestead museum, Kauai, Hawai'i [hereafter Ruth Smith interview with Esther Stubblefield]; interview with Tom Tanji; *Polk's Directory of City and Count of Honolulu* (Honolulu: Polk) for the years 1957, 1958, and 1959-1960.

66. Charlotte Tanji interview with Misao Tanji. See also *Mrs. Takeo Tanji, Waipahu Midwife*; interview with Tom Tanji.

67. Esther McClure Stubblefield, "A History of the Development of Public Health Nursing in the Territory of Hawaii," unpublished manuscript, May 1953, copy in my possession.

68. Interview with Tom Tanji.

69. Kimie Kawahara and Yuriko Hatanaka, "The Impact of War on an Immigrant Culture," *Social Process in Hawaii* 8 (1943): 38–40; Daniels, *Asian America,* 206–7; Eileen Sunada Sarasohn, *Issei Women: Echoes from Another Frontier* (Palo Alto, Calif.: Pacific Books, 1998), 157; Susan McKay, *The Courage Our Stories Tell: The Daily Lives and Maternal Child Health Care of Japanese American Women at Heart Mountain* (Powell, Wyo.: Western History Publications, 2002), 54.

70. Anthony, *Hawaii under Army Rule,* 26; Daniels, *Asian America,* 214; Estelle Rebec and Martin Rogin, *Preliminary Inventory of the Records of the War Relocation Authority, Record Group 210,* repr. (Washington, D.C.: National Archives and Records Administration, 1993), 1; Greg Robinson, *By Order of the President: FDR and the Internment of Japanese Americans* (Cambridge, Mass.: Harvard University Press, 2001), 4–7, 260–61.

71. The War Relocation Authority camps were concentration camps that operated in violation of the constitutional rights of American citizens. Roger Daniels argues convincingly that, despite common usage, they were not "internment camps." Instead, he explains, that term more properly refers to the camps run by the Immigration and Naturalization Service in the Justice Department. The Justice Department detained some 2,000 Issei, mostly male, business and community leaders. The INS camps involved at least some due process and the semblance of international law. Roger Daniels, "Relocation, Redress, and the Report: A Historical Appraisal," in *Japanese Americans: From Relocation to Redress,* rev. ed., edited by Roger Daniels, Sandra C. Taylor, and Harry H. L. Kitano (Seattle: University of Washington Press, 1991), 6; Daniels, *Asian America,* 202.

72. Daniels, *Asian America,* 202.

73. Ibid., 201.

74. Daniels, *Asian America,* 218. There is an extensive literature on the history of the WRA camps. Among the major works are Roger Daniels, *Concentration Camps USA: Japanese Americans and World War II* (New York: Holt, Rinehart and Winston, 1971); and Michi Weglyn, *Years of Infamy: The Untold Story of America's Concentration Camps* (New York: Morrow Quill, 1976).

75. Estelle Ishigo, *Lone Heart Mountain* (Los Angeles: Anderson, Ritchie, and Simon, 1972), 15, copy provided by Bacon Sakatani of West Covina, California.

76. Commission on the Wartime Relocation and Internment of Civilians, *Personal Justice Denied* (Washington, D.C.: Government Printing Office, 1982), 165, 180, 183–84. See also Valerie J. Matsumoto, *Farming the Home Place: A Japanese American Community in California, 1919–1982* (Ithaca, N.Y.: Cornell University Press, 1993), 119–48.

77. Commission on Wartime Relocation, *Personal Justice Denied,* 165, 184.

78. Edward D. Beechert, *Working in Hawaii: A Labor History* (Honolulu: University of Hawai'i Press, 1985), 288; Anthony, *Hawaii under Army Rule,* 19; Daniels, *Concentration Camps USA,* 72–72; Okihiro, *Cane Fires,* 267; Ronald Takaki, *Strangers from a Different Shore: A History of Asian Americans* (Boston: Little, Brown,

1989), 379–84; Dennis M. Ogawa and Evarts C. Fox Jr., "Japanese Internment and Relocation: The Hawaii Experience," in *Japanese Americans,* edited by Daniels, Taylor, and Kitano, 135–38; Robinson, *By Order of the President,* 149–57.

79. Harry Paxton Howard, "Americans in Concentration Camps," *Crisis* 49 (1942): 284. See also Cheryl Greenberg, "Black and Jewish Responses to Japanese Internment," *Journal of American Ethnic History* 14, no. 2 (Winter 1995): 3–37.

80. Commission on Wartime Relocation, *Personal Justice Denied,* 18; Roger Daniels, "Incarceration of the Japanese Americans: A Sixty-Year Perspective," *History Teacher* 35, no. 3 (May 2002): 297.

81. Information on health care is in the War Relocation Authority records in separate boxes and preserved in Record Group 210, National Archives, Washington, D.C. I draw mostly on the surviving documentation from Tule Lake, Manzanar, Minidoka, Heart Mountain, Topaz, Poston, and Granada, with little from the records for Gila River in Arizona and the two Arkansas camps, Rohwer and Jerome.

82. For the story of health care in assembly centers, see Louis Fiset, "Public Health in World War II Assembly Centers for Japanese Americans," *Bulletin of the History of Medicine* 73 (1999): 565–84.

83. B. M. Perry to President Franklin Roosevelt, 31 October 1943, box 140, Headquarters, General Files, RG 210. See also Jessie A. Garrett and Ronald C. Larson, eds., *Camp and Community: Manzanar and the Owens Valley* (Fullerton, Calif.: California State University, Oral History Program, Japanese American Oral History Project, 1977), 12, 64; Daniels, *Concentration Camps USA,* 93.

84. Edna A. Gerken, "Health Education in a War Relocation Project," *American Journal of Public Health* 33 (April 1943): 357–61, esp. 359.

85. Susan McKay, "Maternal Health Care at a Japanese American Relocation Camp, 1942–1945: A Historical Study," *Birth* 24 (1997): 193; James H. Cassedy, *Medicine in America: A Short History* (Baltimore: Johns Hopkins University Press, 1991), 126.

86. Charles E. Irwin, chief medical officer, to M. Anderson, 15 January 1944, box 159, Records of Relocation Centers, General Files, 1942–1946, Heart Mountain Relocation Center, RG 210. See also Commission on Wartime Relocation, *Personal Justice Denied,* 162; Susan L. Smith, "Women Health Workers and the Color Line in the Japanese American 'Relocation Centers' of World War II," *Bulletin of the History of Medicine* 73 (Winter 1999): 585–601.

87. Memo from W. T. Carstarphen, chief medical officer, 21 June 1943, box 155, Records of the Relocation Centers, 1942–1946, General Files, Granada Relocation Center, Colorado, RG 210.

88. Charles E. Irwin to M. Anderson, 15 January 1944, box 159, Records of Relocation Centers, General Files, 1942–1946, Heart Mountain Relocation Center, RG 210.

89. Morris J. Vogel, *The Invention of the Modern Hospital, Boston, 1870–1930* (Chicago: University of Chicago Press, 1980); Charles E. Rosenberg, *The Care of Strangers: The Rise of America's Hospital System* (Baltimore: Johns Hopkins University Press, 1987).

90. [Territory of Hawaii] *Annual Report of the Board of Health, 1943,* 88; Edward Beardsley, *A History of Neglect: Health Care for Blacks and Mill Workers in the Twentieth-Century South* (Knoxville: University of Tennessee Press, 1987), 174; Kriste Lindenmeyer, *"A Right to Childhood": The U.S. Children's Bureau and Child Welfare, 1912–46* (Urbana: University of Illinois Press, 1997), 4, 260; Rosemary Stevens, *In Sickness and in Wealth: American Hospitals in the Twentieth Century* (Baltimore: Johns Hopkins University Press, 1999), 210–11.

91. War Relocation Authority, *First Quarterly Report, March 18 to June 30, 1942* (Washington, D.C.: Government Printing Office, 1942), 29; Michelle Gutierrez, "Medicine in a Crisis Situation: The Effect of Culture on Health Care in the World War II Japanese American Detention Camps" (master's thesis, California State University, Fullerton, 1989), 8.

92. Elizabeth Norman, *We Band of Angels: The Untold Story of American Nurses Trapped on Bataan by the Japanese* (New York: Random House, 1999), and Charles G. Roland, *Long Night's Journey into Day: Prisoners of War in Hong Kong and Japan, 1941–1945* (Waterloo, Ont.: Wilfrid Laurier University Press, 2001).

93. Gutierrez, "Medicine in a Crisis"; Gwenn M. Jensen, "The Experience of Injustice: Health Consequences of the Japanese American Internment" (Ph.D. diss., University of Colorado, 1997); McKay, "Maternal Health Care"; McKay, "'The Problem' of Student Nurses of Japanese Ancestry during World War II," *Nursing History Review* 10 (2002): 49–67; McKay, *Courage Our Stories Tell*; Louis Fiset, "A View of the Hospital and Health Care Program at the Central Utah (Topaz) Relocation Center," *Journal of the West* 38, no. 2 (1999): 34–44; Dennis Worthen, "Nisei Pharmacists in World War II," *Pharmacy in History* 45, no. 2 (2003): 58–65. See also Louis Fiset, "Public Health in World War II Assembly Centers for Japanese Americans," Gwenn M. Jensen, "System Failure: Health-Care Deficiencies in the World War II Japanese American Detention Centers," and Smith, "Women Health Workers"—all in the special issue of the *Bulletin of the History of Medicine* 73 (Winter 1999).

94. "Nurses Needed for Relocation Centers," *American Journal of Nursing,* 42 (1942): 1339; "War Relocation Projects: Nurses Pioneer in Historic Wartime Operations," *American Journal of Nursing,* 43 (1943): 61; Elizabeth Vickers, "Nursing in a Relocation Center: Pioneering with WRA at Poston, Arizona," *American Journal of Nursing,* 45 (1945): 26; Velma B. Kessel, *Behind Barbed Wire: Heart Mountain Relocation Camp* (privately published, 1992), 36–37. Kessel's publication is drawn from her diary written during the thirty-one months she worked at Heart Mountain Relocation Center Hospital. My copy was provided by Bacon Sakatani.

95. Ralph Snavely to Dr. Pressman, 30 April 1943, and Ralph Snavely to Sallie Jeffries, 30 April 1943, box 461, Record Group 75, Bureau of Indian Affairs, Phoenix Area Office, Department of Health, Correspondence Related to Japanese Resettlement Camps, 1942–1944, Regional Archives of the National Archives—Pacific Region, Laguna Niguel, California; Pamela Iwasaki, "A Look at Health Care in

the Japanese American Internment Camps" (M.D. thesis, University of California, San Diego, 1988), 13, 32.

96. Arthur Hansen and David Bertagnoli, "Anna T. Kelley Interview," in *Camp and Community,* edited by Garrett and Larson, 63.

97. War Relocation Authority, *First Quarterly Report,* 30; "Japanese Nurses at Assembly Centers," *American Journal of Nursing* 42 (1942): 831; "War Relocation Projects: Nurses Pioneer in Historic Wartime Operations," *American Journal of Nursing* 43 (1943): 62; Arthur Hansen, "Robert Brown Interview," in *Camp and Community,* edited by Garrett and Larson, 41; Kessel, *Behind Barbed Wire;* Daniels, *Concentration Camps USA,* 89; Matsumoto, "Japanese American Women," 377.

98. Sakaye Shigekawa, interview by author, tape recording, 20 March 1998, Los Angeles, California; e-mail from Dennis Worthern to Susan L. Smith, 22 April 2004.

99. "Report of the Health Committee," no date, box 117, Records of Relocation Centers, 1942-1946, General Files, Colorado River Relocation Center, Poston, Arizona, RG 210; Iwasaki, "Look at Health Care," 29-30, 45; Commission on Wartime Relocation, *Personal Justice Denied,* 163-62.

100. W. Ray Johnson to W. T. Carstarphen, 25 March 1944, and Community Council to James Lindley, 1 February 1943, both in box 155, Records of the Relocation Centers, 1942-1946, General Files, Granada Relocation Center, Colorado, RG 210. See also Records of the Relocation Centers, 1942-1946, General Files, box 159, Heart Mountain Relocation Center, Wyoming, RG 210.

101. Numerous entries in Toku Shimomura's wartime diaries illustrate this point, for example, in her description of her own visit to the hospital in 1942 and in her description of its use by her Issei friends.

102. "WRA Form 26: Evacuee Summary Data," electronic dataset, Record Group 210, War Relocation Authority, Center for Electronic Records, National Archives, College Park Branch, College Park, Maryland; U.S. Department of the Interior, War Relocation Authority [hereafter WRA], *The Evacuated People: A Quantitative Description* (Washington, D.C.: Government Printing Office, 1946), 70. On the ideal ratio, see "Alien Physicians," *Northwest Medicine* 41, no. 8 (August 1942): 261.

103. G. D. Carlyle Thompson, chief medical officer of the WRA, to Dillon S. Myer, director of the WRA, 13 November 1943, box 368, Headquarters, General Files, RG 210; Matsumoto, "Japanese American Women," 381; Sarasohn, *Issei Women,* 189, 190.

104. Semi-Annual Report, 1 July to 31 December 1943, 71, box 368, Headquarters, General Files, RG 210; Memo from C. E. Irwin, chief medical officer, to Guy Robertson, project director, and M. O. Anderson, assistant project director, 20 January 1944, box 158, Records of the Relocation Centers, General Files, 1942-1946, Heart Mountain Relocation Center, RG 210; Ruth E. Hudson, "Health for Japanese Evacuees," *Public Health Nursing* 35 (November 1943): 620.

105. Joy Barragrey Stuart to Wade Head, 3 June 1943, and Guy Robertson, project

director, to Jean E. Sutherland, nursing consultant for the WRA, 3 September 1943, both in box 373, Headquarters, General Files, RG 210; Semi-Annual Report, 1 July to 31 December 1943, 71, box 368, Headquarters, General Files, RG 210.

106. Among the 111 women who selected this occupation category, 68 were Issei women, and 2 Issei men also selected this category. "WRA Form 26: Evacuee Summary Data," RG 210, WRA, Center for Electronic Records; WRA, *Evacuated People,* 71.

107. Mrs. Eiko M. is mentioned in box 98, Records of the Relocation Centers, General Files, 1942–1946, Central Utah Relocation Center, RG 210; midwives from California are mentioned in June 1942 intake information on health personnel, folder 62.015, box 226, Records of the Relocation Centers, General Files, 1942–1946, Manzanar Relocation Center, RG 210.

108. Emily K. Abel, "Family Caregiving in the Nineteenth Century: Emily Hawley Gillespie and Sarah Gillespie, 1858–1888," *Bulletin of the History of Medicine* 68, no. 4 (1994): 597; Jane Lewis, "Family Provision of Health and Welfare in the Mixed Economy of Care in the Late Nineteenth and Twentieth Centuries," *Social History of Medicine* 8, no. 1 (1995): 12–16; Peregrine Horden and Richard Smith, Introduction to *Locus of Care: Families, Communities, Institutions, and the Provision of Welfare since Antiquity,* edited by Peregrine Horden and Richard Smith (New York: Routledge, 1998), 2.

109. Yoshiko Uchida, *Desert Exile: The Uprooting of a Japanese-American Family* (Seattle: University of Washington Press, 1982), 71; see also 91.

110. Uchida, *Desert Exile,* 70. See also Mine Okubo, *Citizen 13660* (Seattle: University of Washington Press, 1983), 35.

111. Wade Head to Ralph B. Snavely, 18 August 1942, box 117, Records of the Relocation Centers, General Files, 1942–1946, Colorado River Relocation Center, RG 210.

112. Ralph B. Snavely to W. Wade Head, project director, 11 September 1942, box 117, Colorado River Relocation Center, RG 210.

113. Elma Rood to Dr. Pressman, 25 September 1943, and R. N. Crawford to Dr. Snavely, 1 November 1943, and health staff to Lou E. Butler, Family Welfare Division, 17 April 1944, all in box 117, Records of the Relocation Centers, General Files, 1942–1946, Colorado River Relocation Center, RG 210; Gerken, "Health Education," 357; Gutierrez, "Medicine in a Crisis," 130. Biographical information on Elizabeth Vickers is in "News Here and There," *American Journal of Nursing* 44, no. 4 (April 1944): 404.

114. Elizabeth Vickers, Report on the Organization and Growth of the Poston Health Service, 1944, box 117, Records of the Relocation Centers, General Files, 1942–1946, Colorado River Relocation Center, RG 210; Smith, "Women Health Workers," 593–94.

115. Minutes of the Medical Staff Meeting, 31 October 1942, box 159, Records of the Relocation Centers, General Files, 1942–1946, Heart Mountain Relocation Center, Wyoming, RG 210.

116. The first quotation is from Elma Rood to Dr. Pressman, 25 September 1943; the second quotation is from R. N. Crawford, supervisor of Public Health Nursing, to Dr. Pressman, director of Health and Sanitation, 11 October 1943; the third quotation is from Crawford to Dr. Snavely, 1 November 1943; the fourth quotation is from Crawford to Elma Rood, 11 January 1944. The Yamamoto information is from Elma Rood to Dr. J. F. West, 15 June 1944. All are in box 117, Records of the Relocation Centers, General Files, 1942–1946, Colorado River Relocation Center, RG 210. See also Headquarters, General Files, box 373, RG 210.

117. Gerken, "Health Education," 359 and 360.

118. Memo from John W. Powell, box 117, Records of the Relocation Centers, General Files, 1942–1946, Colorado River Relocation Center, RG 210.

119. Barbara Melosh, *"The Physician's Hand": Work Culture and Conflict in American Nursing* (Philadelphia: Temple University Press, 1982), 77–113; Susan M. Reverby, *Ordered to Care: The Dilemma of American Nursing, 1850–1945* (Cambridge, England: Cambridge University Press, 1987), 95–117; Karen Buhler-Wilkerson, *No Place like Home: A History of Nursing and Home Care in the United States* (Baltimore: Johns Hopkins University Press, 2001), esp. 167–82.

120. Minutes of the Medical Staff Meeting, 3 October 1942, box 287, Records of the Relocation Centers, General Files, 1942–1946, Tule Lake Relocation Center, RG 210.

121. Peregrine Horden, "Household Care and Informal Networks: Comparisons and Continuities from Antiquity to the Present," in *The Locus of Care: Families, Communities, Institutions, and the Provision of Welfare since Antiquity,* edited by Peregrine Horden and Richard Smith (New York: Routledge, 1998), 29.

122. Some of the information in this section is drawn from my essay "Caregiving in Camp: Japanese American Women and Community Health in World War II," in *Guilt by Association: Essays on Japanese Settlement, Internment, and Relocation in the Rocky Mountain West,* edited by Mike Mackey (Powell, Wyo.: Western History Publications, 2001), 187–201. See also Lewis, "Family Provision"; Peregrine Horden and Richard Smith, Introduction to *The Locus of Care,* edited by Horden and Smith, 9–10; Horden, "Household Care," 23, 29; and Emily K. Abel, *Hearts of Wisdom: American Women Caring for Kin, 1850–1940* (Cambridge, Mass.: Harvard University Press, 2000).

123. For parallels in international politics, see Cynthia Enloe, *Bananas, Beaches, and Bases: Making Feminist Sense of International Politics* (Berkeley: University of California Press, 1990), 1, 10.

124. Gutierrez, "Medicine in a Crisis," 128; Leon H. Bruno, *The Private Japanese Hospital: A Unique Social Phenomenon on Hawaii, 1907–1960* (Hilo, Hawai'i: Lyman House Memorial Museum, 1985), 3.

125. Malve von Hassell, "Issei Women between Two Worlds: 1875–1985" (Ph.D. diss., New School for Social Research, 1987), 156; Sarasohn, *Issei Women,* 146, 157; Mei Nakano, *Japanese American Women: Three Generations, 1890–1990* (Berkeley, Calif.: Mina Press, 1990), 62.

126. Abel, "Family Caregiving," 574, 576, 596–98; Horden, "Household Care," 31, 39; Carol Baines, Patricia Evans, Sheila Neysmith, "Caring: Its Impact on the Lives of Women," in *Women's Caring: Feminist Perspectives on Social Welfare,* edited by Carol Baines, Patricia Evans, Sheila Neysmith (Toronto: McClelland & Stewart, 1991), 28.

127. Toku Shimomura's diary entries in the 1930s and 1940s; Toku Toshiko, interview by author with interpreter assistance from Chiyohi Creef and Tazuko Herren, tape recording, Seattle, Washington, 11 June 1995; S. Billee Yoshioka Kimura and Sam Kimura, interview by author, tape recording, Seattle, Washington, 21 February 1997; Roger Shimomura, interview by author, tape recording, Lawrence, Kansas, 16 June 1998.

128. Toku Shimomura's diary, 5 September and 4 November 1942.

129. Toku Shimomura's diary, 13 February 1941, 10 April 1941, 1 May 1941, 23 August 1941, 21 October 1942; William Caudill, "The Cultural and Interpersonal Context of Everyday Health and Illness in Japan and America," in *Asian Medical Systems: A Comparative Study,* edited by Charles Leslie (Berkeley: University of California Press, 1976), 159–77.

130. Toku Shimomura's diary, 26 April 1942.

131. Toku Shimomura's diary, 29 January 1941, 13 February 1941, 23 August 1941, 29 August 1941, 17 June 1942, 17 September 1942, 23 November 1942, 6 December 1942; Ito, *Issei,* 631–32; Dr. Ben Uyeno, interview by author, tape recording, Seattle, 21 February 1997. In the 1950s, Dr. Unosawa was accused of performing abortions, leading to a court trial: interview with Roger Shimomura.

132. Toku Shimomura's diary, 2–5 January 1941. On moxibustion, see Ishihara Akira, "Kampō: Japan's Traditional Medicine," *Japan Quarterly* 9 (1962): 429–37; Shigehisa Kuriyama, "Moxibustion," in *Encyclopedia of the History of Science, Technology, and Medicine in Non-Western Cultures,* edited by Helaine Selin (Dordrecht, Netherlands: Kluwer Academic, 1997), 748.

133. Elizabeth Vickers, Report on the Organization and Growth of the Poston Health Service, 1944, box 117, Records of the Relocation Centers, General Files, 1942–1946, Colorado River Relocation Center, RG 210.

134. Letter from six block managers to Dr. L. M. Neher, chief medical officer, 5 February 1943, and Dr. Neher to block managers, 11 February 1943, box 240, Records of Relocation Centers, 1942–1946, General Files, Minidoka Relocation Center, RG 210.

135. Minutes of the Medical Staff Meeting, 7 February 1943, box 159, Records of the Relocation Centers, General Files, 1942–1946, Heart Mountain Relocation Center, Wyoming, RG 210. There were 23 internees who identified themselves as chiropractors, 19 of whom were Issei. WRA, *Evacuated People,* 70.

136. Toku Shimomura's diary, 26 March, 17 May, and 10 June 1941. On nursing parallels, see Patricia D'Antonio, "Revisiting and Rethinking the Rewriting of Nursing History," *Bulletin of the History of Medicine* 73 (1999): 285.

137. Toku Shimomura's diary, 28 April, 11 May, 16 May, and 16 September 1942;

Monica Sone, *Nisei Daughter* (Seattle: University of Washington Press, 1953),173, 177, 179.

138. Toku Shimomura's diary, 9 May, 27 July, and 29 July 1942.

139. Teru Beppu, interview by author, tape recording, Seattle, Washington, 15 June 1995; John Reddin, "Four Beppu Sons Named for Presidents," clipping from a Seattle newspaper article, date, headline, and newspaper name omitted, in possession of Teru Beppu. On the blackouts in Seattle, see Toku Shimomura's diary, 8, 9, and 10 December 1941.

140. Sawa Beppu died in 1957 of cancer; her husband Hisuji had died in 1950: Toku Shimomura's diary, 5 October 1942; Reddin, "Four Beppu Sons"; interview with Teru Beppu; interview with Ben Uyeno.

141. Toku Shimomura's diary, 16 and 24 July 1942; see also 22 July 1942.

142. Toku Shimomura's diary, 26 and 29 July 1942.

143. Toku Shimomura's diary, 13, 14, 16, and 24 June 1942.

144. Toku Shimomura's diary, 12 July, 13 July, and 1 August 1942.

145. Toku Shimomura's diary, 1 August 1942.

146. McKay, *Courage Our Stories Tell,* 141.

147. Toku Shimomura's diary, 10 August 1942.

148. Toku Shimomura's diary, 23 August and 4 September 1942; Sone, *Nisei Daughter,* 188–189, 192.

149. Toku Shimomura's diary, 14 May, 25 May, 26 May, 4 June, 10 June, 12 June, 16 June, 27 June, 14 July, 30 July, 28 August, and 10 September 1942; Sone, *Nisei Daughter,* 195.

150. Uchida, *Desert Exile,* 105, 109; Sandra C. Taylor, *Jewel of the Desert: Japanese American Internment at Topaz* (Berkeley: University of California Press, 1993), 91; Brian Niiya, ed., *Japanese American History: An A-to-Z Reference from 1868 to the Present* (New York: Facts on File, 1993), 331.

151. The quotation is from Uchida, *Desert Exile,* 114. See also Taylor, *Jewel of the Desert,* 95.

152. Memo from the medical staff to project director, 16 November 1942, box 98, Records of Relocation Centers, 1942–1946, General Files, Central Utah Relocation Center, RG 210; Uchida, *Desert Exile,* 109; Taylor, *Jewel of the Desert,* 91.

153. Kessel, *Behind Barbed Wire,* 42. See also Nakano, *Japanese American Women,* 143; Rita Takahashi Cates, "Comparative Administration and Management of Five War Relocation Authority Camps: America's Incarceration of Persons of Japanese Descent during World War II," (Ph.D. thesis, University of Pittsburgh, 1980), 187, 189.

154. Uchida, *Desert Exile,* 106, 133, quote 133; Kessel, *Behind Barbed Wire,* 73; Gutierrez, "Medicine in a Crisis," 124–25.

155. Mary Hida, interview by author, tape recording, West Covina, California, 18 March 1998.

156. Toku Shimomura's diary, 24 and 26 August 1942; see also 14 September 1942.

157. Toku Shimomura's diary, 19 September 1942; see also 18 September 1942.

158. Toku Shimomura's diary, 20 and 21 September 1942.

159. Toku Shimomura's diary, 23 September and 3 October 1942.

160. Abel, *Hearts of Wisdom*, 1, 8, 267, 269.

161. The quotation is from Toku Shimomura's diary, 20 November 1942; see also 29 September, 17 October, 20 October, and 23 October 1942.

162. The quotation is from Toku Shimomura's diary, 28 December 1942; Abel, *Hearts of Wisdom*, 4–5.

163. Kessel, *Behind Barbed Wire*, 85–86. See also Cates, "Comparative Administration," 603; Taylor, *Jewel of the Desert*, 209; Sarasohn, *Issei Women*, 166.

164. Taylor, *Jewel of the Desert*, 161; D. R. Collier, chief medical officer, to Raymond P. Sanford, assistant project director, 19 March 1945; and D. R. Collier to Dillon S. Myer, director of the WRA, 10 May 1945, both in box 370, Headquarters, General Files, RG 210.

165. Toku Shimomura's diary, 21 October 1942.

166. Toku Shimomura's diary, 5 November, 6 November, 7 November, 10 November, 11 November, 14 November, and 16 December 1942.

167. Toku Shimomura's diary, 13 and 15 January 1945. In 1944 Toku and her husband joined son Kazuo and his family, including Roger, in Chicago, before returning to Seattle in 1945.

168. Litoff, *American Midwives*, 72; Leavitt, *Brought to Bed*, 114, 171–95, esp. 171, 173–77; Charlotte G. Borst, *Catching Babies: The Professionalization of Childbirth, 1870–1920* (Cambridge, Mass.: Harvard University Press, 1995), 11, 67, 89; Jere Takahashi, *Nisei/Sansei: Shifting Japanese American Identities and Politics* (Philadelphia: Temple University Press, 1997), 31, 44, 48.

169. U.S. Summary of Vital Statistics, 1945, in Central Files, 1945–1948, box 104, Record Group 102, Children's Bureau, National Archives, College Park Branch, College Park, Maryland; Hilary Marland and Anne Marie Rafferty, Introduction to *Midwives, Society, and Childbirth*; Stevens, *In Sickness and in Wealth*, 218–19.

170. Dell Uchida, interview by author, tape recording, Seattle, Washington, 18 February 1997; Alice Yasutake, interview by author, tape recording, Seattle, 20 February 1997; WRA, *The Evacuated People*, 70, 138–42; Dorothy Swaine Thomas and Richard S. Nishimoto, *The Spoilage* (Berkeley: University of California Press, 1946), 4; Daniels, *Concentration Camps USA*, 104; McKay, *Courage Our Stories Tell*, 133; Takahashi, *Nisei/Sansei*, 7.

171. Alyce Yamaguchi, interview by author, tape recording, East San Gabriel Valley Japanese Community Center, West Covina, California, 18 March 1998.

172. Interview with Toku Toshiko; interview with Masoko (Jinguji) Osada, interview by author with interpreter assistance from Chiyohi Creef and Mary Ikeda, tape recording, Tacoma, Washington, 10 June 1995.

173. Interview with Teru Beppu.

174. Interview with Teru Beppu; "Obstetrical Cases," August 1943, box 240,

Records of Relocation Centers, 1942–1946, General Files, Minidoka Relocation Center, RG 210.

175. William H. Robing, hospital administrator, to Ray D. Johnston, project director, 8 February 1944, box 258, Records of Relocation Centers, 1942–1946, General Files, Rohwer Relocation Center, Arkansas, RG 210; A. Pressman, "Report on the Organization, Function, and Services Offered by the Department of Health and Sanitation," box 117, Records of Relocation Centers, 1942–1946, General Files, Colorado River Relocation Center, RG 210; McKay, *Courage Our Stories Tell*, 147.

176. Interview with Alice Yasutake.

177. Minutes of the Medical Staff, 23 January 1943, box 287, Records of Relocation Centers, 1942–1946, General Files, Tule Lake Relocation Center, RG 210.

178. Interview with Alice Yasutake; interview with Dell Uchida; interview with S. Billee Yoshioka Kimura and Sam Kimura; interview with Alyce Yamaguchi; interview with Mary Hida.

179. Interview with Dell Uchida; Nancy Tomes, "Merchants of Health: Medicine and Consumer Culture in the United States, 1900–1940," *Journal of American History* 88, no. 2 (September 2001): 519–47, esp. 522. See also Borst, *Catching Babies*, 11.

180. Gertrude Jacinta Fraser, "Modern Bodies, Modern Minds: Midwifery and Reproductive Change in an African American Community," in *Conceiving the New World Order: The Global Politics of Reproduction*, edited by Faye D. Ginsburg and Rayna Rapp (Berkeley: University of California Press, 1995), 44, 54, 57; Susan L. Smith, *Sick and Tired of Being Sick and Tired: Black Women's Health Activism in America, 1890–1950* (Philadelphia: University of Pennsylvania Press, 1995), 80–82, 147, 169.

181. Leavitt, *Brought to Bed*, 12 (graph).

182. Nancy Tomes, *The Gospel of Germs: Men, Women, and the Microbe in American Life* (Cambridge, Mass.: Harvard University Press, 1998), xv, 2, 6. See also Leavitt, *Brought to Bed*, 161–62.

183. Dr. Shigekawa claims to have delivered 20,000 babies. Interview with Sakaye Shigekawa; Leavitt, *Brought to Bed*, 114; Nayan Shah, *Contagious Divides: Epidemics and Race in San Francisco's Chinatown* (Berkeley: University of California Press, 2001), 217.

184. Interview with Roger Shimomura; Takahashi, *Nisei/Sansei*, 49, 104, 204; Lon Kurashige, "The Problem of Biculturalism: Japanese American Identity and Festival before World War II," *Journal of American History* 86, no. 4 (March 2000): 1632–54, esp. 1633–34.

185. Bacon Sakatani, interview by author, tape recording, West Covina, California, 19 March 1998. See also Sone, *Nisei Daughter*, and Robert G. Lee, "Introduction," in Mary Kimoto Tomita, *Dear Miye: Letters Home from Japan, 1939–1946* (Stanford, Calif.: Stanford University Press, 1995), 3.

186. Leavitt, *Brought to Bed*, 171–95, esp. 195; Leslie J. Reagan, *When Abortion*

Was a Crime: Women, Medicine, and Law in the United States, 1867–1973 (Berkeley: University of California Press, 1997), 160–92, esp. 173–81. See also Linda V. Walsh, "Midwives As Wives and Mothers: Urban Midwives in the Early Twentieth Century," *Nursing History Review* 2 (1994): 59.

187. Leavitt, *Brought to Bed*, 4; Daniels, *Asian America*, 179–81.

Conclusion

1. D. Galloway and Louise Holmes to Lucille Marsh, 3 December 1951, Record Group 51, Mississippi Department of Health, Box 36, folder 1, Mississippi Department of Archives and History, Jackson, Mississippi.

2. Christoph Brezinka, "The End of Home Births in the German Language Islands of Northern Italy," in *Midwives, Society, and Childbirth: Debates and Controversies in the Modern Period*, edited by Hilary Marland and Anne Marie Rafferty (New York: Routledge, 1997), 211–16.

3. Mary W. Standlee, *The Great Pulse: Japanese Midwifery and Obstetrics through the Ages* (Rutland, Vt.: Charles E. Tuttle, 1959), 139.

4. Michiko Ōbayashi, "Josanpu shokuno no hensen o saguru. Nihon sanba kangofu hokenfu kyokai setsuritsu zenshi" [Searching for Transitions in the Function of Midwives: The History Prior to the Establishment of the Japanese Society for Midwives, Nurses, and Public Health Nurses], *Josanpu Zasshi* [(Japanese) Journal for Midwives] 39, no. 2 (February 1985): 86. Thanks to Ed Wagner and Febe Pamonag for translation assistance. See also Standlee, *Great Pulse*, 141; Reiko Shimazaki Ryder, "Nursing Reorganization in Occupied Japan, 1945–1951," *Nursing History Review* 8 (2000): 84, 87.

5. Carol K. Coburn and Martha Smith, *Spirited Lives: How Nuns Shaped Catholic Culture and American Life, 1836–1920* (Chapel Hill: University of North Carolina Press, 1999), 2, 189, 201–2, 219.

6. Nursing Section, Medical Affairs Bureau, Japanese Ministry of Health and Welfare, *Report on Nursing and Midwifery in Japan* (Tokyo: Ministry of Health and Welfare, 1953), 30; interview with Haruko Hashimoto in Kiyoko Okamoto, "Josanpu katsudo no rekishiteki igi. Meiji jidai o chushin ni" [The Historical Significance of Midwifery: Meiji Period], *Josanpu Zasshi* [(Japanese) Journal for Midwives] 35, no. 8 (August 1981): 39; Standlee, *Great Pulse*, 141; Deborah Cordero Fiedler, "Authoritative Knowledge and the Territorialization of Birth in Contemporary Japan," in *Childbirth and Authoritative Knowledge: Cross-Cultural Perspectives*, edited by Robbie E. Davis-Floyd and Carolyn F. Sargent (Berkeley: University of California Press, 1997), 159–82.

7. Judith Walzer Leavitt, *Brought to Bed: Childbearing in America, 1750 to 1950* (New York: Oxford University Press, 1986), 211–18.

SELECTED BIBLIOGRAPHY

Manuscript Collections

California State Archives, Sacramento, California
 State Board of Medical Examiners
 State Board of Public Health
 Public Health Records
 Public Health–Child Hygiene
Hawai'i State Archives, Honolulu
 Department of Health, Director's Office, Series 325, Director's Correspondence, 1920–1985
 Board of Health, Department of Health, Series 259
Hoover Institution Archives, Stanford University, Stanford, California
 Survey of Race Relations
Japanese American National Museum, Los Angeles, California
 Haruyo Nishioka Collection
King County Archives, Seattle
 300–485 Superior Court—County Clerk, Index of Licenses of Physicians, Optometrists, Chiropodists, and Midwives, 1890–1980, volume 1 of 1
Lyman House Memorial Museum, Hilo, Hawai'i
 Amy Hamane, "Japanese Hospitals of Hilo," unpublished manuscript, 3 December 1980
National Archives, College Park Branch, Maryland
 Record Group 90, United States Public Health Service [cited in Notes as RG 90]
 Record Group 102, United States Children's Bureau [cited in Notes as RG 102]
 Record Group 210, War Relocation Authority, "WRA Form 26: Evacuee Summary Data," electronic dataset, Center for Electronic Records [cited in Notes as RG 210, Center for Electronic Records]
National Archives, Washington, D.C.
 Record Group 210, War Relocation Authority [cited in Notes as RG 210]

National Archives—Pacific Region, Laguna Niguel, California
 Record Group 75, Bureau of Indian Affairs, Phoenix Area Office, Department
 of Health, Correspondence Related to Japanese Resettlement Camps [cited
 in Notes as RG 75]
Oregon State Archives, Salem
 Oregon Department of Health
Washington State Archives, Olympia
 Governor Ernest Lister's Papers
 Register of the State Medical Examination Board
 Register of Physicians and Accoucheurs
 Professions, Midwife Applications
Wing Luke Asian Museum, Seattle
 Amano Family Collection
 Panama Hotel Collection
 9066 Collection
University of Hawai'i at Manoa, Hamilton Library
 Hawaiian Sugar Planters' Association Plantation Archives
 Hawaii War Records Depository

Unprocessed Personal Papers

Papers of Alice Young Kohler, possession of Katharine Kohler, Hawai'i.
Diaries of Toku Shimomura, possession of Roger Shimomura, Lawrence, Kansas.

Interviews

Beppu, Teru. Interview by author, tape recording, Seattle, Washington, 15 June
 1995.
Ekern, Karen. Interview by author, tape recording, Hilo, Hawai'i, 6 May 1997.
Hida, Mary. Interview by author, tape recording, East San Gabriel Valley Japanese
 Community Center, West Covina, California, 18 March 1998.
Higa, Yoshiko. Interview by author, tape recording, Hilo, Hawai'i, 6 May 1997.
Kimura, S. Billee and Sam Kimura. Interview by author, tape recording, Seattle,
 Washington, 21 February 1997.
Kohler, Alice Young. Interview by Ruth Smith and Barnes Riznik, oral history project
 on "Public Health Services and Family Health on Kauai, 1920–1955," 6 August
 1985, written transcript, Grove Farm Homestead museum, Kauai, Hawai'i.
Kohler, Katharine. Interview by author, tape recording, Honolulu, Hawai'i, 7 Au-
 gust 1995.
Osada, Masoko. Interview by author with interpreter assistance from Chiyohi Creef
 and Mary Ikeda, tape recording, Tacoma, Washington, 10 June 1995.
Sakatani, Bacon. Interview by author, tape recording, West Covina, California, 19
 March 1998.

Shigekawa, Dr. Sakaye. Interview by author, tape recording, Los Angeles, California, 20 March 1998.

Shimomura, Roger. Interview by author, tape recording, Lawrence, Kansas, 16 June 1998.

Stubblefield, Esther. Interview by author, tape recording, Honolulu, Hawai'i, 5 May 1997.

Stubblefield, Esther. Interview by Ruth Smith, oral history project on "Public Health Services and Family Health on Kauai, 1920–1955," 16 March 1982, written transcript, Grove Farm Homestead museum, Kauai, Hawai'i.

Tanji, Misao. Interview by Charlotte Tanji, Waipahu, Hawai'i, 11 February 1984 and 1 March 1984, written transcript in English, author's possession.

Tanji, Misao [Mrs. Takeo Tanji]. *Mrs. Takeo Tanji, Waipahu Midwife,* videotape, interviewed and produced by Bethany Thompson [Thomas], translated by Hideo Okada, Leeward Community College, Pearl City, Hawai'i, 1977 or 1980 (date unclear).

Tanji, Tom. Interview by author, tape recording, Waipahu, Hawai'i, 9 August 1995.

Toshiko, Toku. Interview by author with interpreter assistance from Chiyohi Creef and Tazuko Herren, tape recording, Seattle, Washington, 11 June 1995.

Uchida, Dell. Interview by author, tape recording, Seattle, Washington, 18 February 1997.

Uyeno, Dr. Ben. Interview by author, tape recording, Seattle, Washington, 21 February 1997.

Yamaguchi, Alyce. Interview by author, tape recording, East San Gabriel Valley Japanese Community Center, West Covina, California, 18 March 1998.

Yamamoto, Toshi. Interview by author, tape recording, Los Angeles, California, 26 June 1998.

Yasutake, Alice. Interview by author, tape recording, Seattle, Washington, 20 February 1997.

Annual Reports, City Directories, Health Care Journals, Newspapers

American Journal of Nursing
American Journal of Public Health
Annual Report of the Board of Health of the Territory of Hawaii
California and Western Medicine
California State Journal of Medicine
Hawaii Health Messenger
Hawaii Medical Journal
Hawaii Sentinel
Hilo Tribune Herald
Honolulu Advertiser

Honolulu Star-Bulletin
Husted's Directory of Honolulu and the Territory of Hawaii
The Japanese American Directory
Journal of the American Medical Association
Modern Hospital
Northwest Medicine
Polk's Directory of City and County of Honolulu
Public Health Reports
Public Health Nursing
Seattle City Directory
Washington State Department of Health (annual report)

Articles, Books, and Theses

Abel, Emily K. "Family Caregiving in the Nineteenth Century: Emily Hawley Gillespie and Sarah Gillespie, 1858–1888." *Bulletin of the History of Medicine* 68, no. 4 (1994): 573–99.

———. *Hearts of Wisdom: American Women Caring for Kin, 1850–1940.* Cambridge, Mass.: Harvard University Press, 2000.

Akira, Ishihara. "Kampō: Japan's Traditional Medicine." *Japan Quarterly* 9 (1962): 429–37.

Allen, Gwenfread. *Hawaii's War Years, 1941–1945.* Honolulu: University of Hawaii Press, 1950.

Almaguer, Tomás. *Racial Fault Lines: The Historical Origins of White Supremacy in California.* Berkeley: University of California Press, 1994.

Anthony, J. Garner. *Hawaii under Army Rule.* Stanford, Calif.: Stanford University Press, 1955.

Apple, Rima D. *Mothers and Medicine: A Social History of Infant Feeding, 1890–1950.* Madison: University of Wisconsin Press, 1987.

———, ed. *Women, Health, and Medicine in America: A Historical Handbook.* New York: Garland, 1990.

Asian Women United of California, ed. *Making Waves: An Anthology of Writings by and about Asian American Women.* Boston: Beacon Press, 1989.

Ayukawa, Midge. "Good Wives and Wise Mothers: Japanese Picture Brides in Early Twentieth-Century British Columbia." In *Rethinking Canada: The Promise of Women's History,* 3d ed., edited by Veronica Strong-Boag and Anita Clair Fellman, 238–52. Toronto: Oxford University Press, 1997.

Bailey, Beth, and David Farber. *The First Strange Place: The Alchemy of Race and Sex in World War II Hawaii.* New York: Free Press, 1992.

Barney, Sandra Lee. *Authorized to Heal: Gender, Class, and the Transformation of Medicine in Appalachia, 1880–1930.* Chapel Hill: University of North Carolina Press, 2000.

Beardsley, Edward H. *A History of Neglect: Health Care for Blacks and Mill Workers in the Twentieth-Century South.* Knoxville: University of Tennessee Press, 1987.

Beechert, Edward D. *Working in Hawaii: A Labor History.* Honolulu: University of Hawaii Press, 1985.

Borst, Charlotte G. *Catching Babies: The Professionalization of Childbirth, 1870–1920.* Cambridge, Mass.: Harvard University Press, 1995.

———. "The Training and Practice of Midwives: A Wisconsin Study." *Bulletin of the History of Medicine* 62 (1988): 606–27.

Brown, DeSoto. *Hawaii Goes to War: Life in Hawaii from Pearl Harbor to Peace.* Honolulu: Editions Limited, 1989.

Bruno, Leon H. *The Private Japanese Hospital: A Unique Social Phenomenon on Hawaii, 1907–1960.* Hilo, Hawaii: Lyman House Memorial Museum, 1985.

Buhler-Wilkerson, Karen. *No Place like Home: A History of Nursing and Home Care in the United States.* Baltimore: Johns Hopkins University Press, 2001.

Burns, Susan L. "Constructing the National Body: Public Health and the Nation in Nineteenth-Century Japan." In *Nation Work: Asian Elites and National Identities,* edited by Timothy Brook and Andre Schmid, 17–49. Ann Arbor: University of Michigan Press, 2000.

Bushnell, O. A. *The Gifts of Civilization: Germs and Genocide in Hawai'i.* Honolulu: University of Hawaii Press, 1993.

Buss, Fran Leeper. *La Partera: Story of a Midwife.* Ann Arbor: University of Michigan Press, 1980.

Bynum, W. F. *Science and the Practice of Medicine in the Nineteenth Century.* Cambridge, England: Cambridge University Press, 1994.

Cahill, Emmett. *Yesterday at Kalaupapa: A Saga of Pain and Joy.* Honolulu: Editions Limited, 1990.

Calman, Donald. *The Nature and Origins of Japanese Imperialism: A Reinterpretation of the Great Crisis of 1873.* New York: Routledge, 1992.

Campbell, Marie. *Folks Do Get Born.* New York: Rinehart, 1946.

Cassedy, James H. *Medicine in America: A Short History.* Baltimore: Johns Hopkins University Press, 1991.

Cates, Rita Takahashi. "Comparative Administration and Management of Five War Relocation Authority Camps: America's Incarceration of Persons of Japanese Descent during World War II." Ph.D. diss., University of Pittsburgh, 1980.

Chan, Sucheng. "Asian American Historiography." *Pacific Historical Review* 65, no. 3 (August 1996): 363–99.

———. *Asian Americans: An Interpretive History.* Boston: Twayne, 1991.

———. "Western American Historiography and Peoples of Color." In *Peoples of Color in the American West,* edited by Sucheng Chan, Douglas Henry Daniels, Mario T. Garcia, and Terry P. Wilson, 1–14. Lexington, Mass.: D.C. Heath, 1994.

Chaudhuri, Nupur, and Margaret Strobel. *Western Women and Imperialism: Complicity and Resistance.* Bloomington: Indiana University Press, 1992.

Cherry, Kittredge. *Womansword: What Japanese Words Say about Women.* New York: Kodansha International, 1987.

Coburn, Carol K., and Martha Smith. *Spirited Lives: How Nuns Shaped Catholic Culture and American Life, 1836–1920.* Chapel Hill: University of North Carolina Press, 1999.

Commission on the Wartime Relocation and Internment of Civilians. *Personal Justice Denied.* Washington, D.C.: Government Printing Office, 1982.

Conroy, Hilary. *The Japanese Frontier in Hawaii, 1868–1898.* Berkeley: University of California Press, 1953.

Cronon, William. "A Place for Stories: Nature, History, and Narrative." *Journal of American History* 78, no. 4 (March 1992): 1347–76.

Daniels, Roger. "American Historians and East Asian Immigrants." *Pacific Historical Review* 43 (November 1974): 449–72.

———. *Asian America: Chinese and Japanese in the United States since 1850.* Seattle: University of Washington Press, 1988.

———. *Concentration Camps USA: Japanese Americans and World War II.* New York: Holt, Rinehart and Winston, 1971.

———. *The Politics of Prejudice: The Anti-Japanese Movement in California and the Struggle for Japanese Exclusion.* Berkeley: University of California Press, 1962.

Daniels, Roger, Sandra C. Taylor, and Harry H. L. Kitano, eds. *Japanese Americans: From Relocation to Redress,* rev. ed. Seattle: University of Washington Press, 1991.

D'Antonio, Patricia. "Revisiting and Rethinking the Rewriting of Nursing History." *Bulletin of the History of Medicine* 73 (1999): 268–90.

Davis-Floyd, Robbie E., and Carolyn F. Sargent, eds. *Childbirth and Authoritative Knowledge: Cross-Cultural Perspectives.* Berkeley: University of California Press, 1997.

Declercq, Eugene, and Richard Lacroix. "The Immigrant Midwives of Lawrence: The Conflict between Law and Culture in Early Twentieth-Century Massachusetts." *Bulletin of the History of Medicine* 59 (1985): 232–46.

Doona, Mary Ellen. "Linda Richards and Nursing in Japan, 1885–1890." *Nursing History Review* 4 (1996): 99–128.

Dossey, Barbara Montgomery. *Florence Nightingale: Mystic, Visionary, Healer.* Springhouse, Penn.: Springhouse Corporation, 2000.

Dougherty, Molly C. "Southern Midwifery and Organized Health Care: Systems in Conflict." *Medical Anthropology: Cross Cultural Studies in Health and Illness* 6 (Spring 1982): 113–26.

Dower, John W. *War Without Mercy: Race and Power in the Pacific War.* New York: Pantheon Books, 1986.

Ebron, Paulla, and Anna Lowenhaupt Tsing. "In Dialogue? Reading across Minority Discourses." In *Women Writing Culture*, edited by Ruth Behar and Deborah A. Gordon, 390–411. Berkeley: University of California Press, 1995.

Embree, John F. *Acculturation among the Japanese of Kona, Hawaii*. Menasha, Wisc.: American Anthropological Association, 1941.

Ethnic Studies Oral History Project. *Remembering Kakaako: 1910–1950*. Manoa [Honolulu]: University of Hawaii–Manoa, 1978.

———. *Waialua and Haleiwa: The People Tell Their Story*. Manoa [Honolulu]: University of Hawaii–Manoa, 1977.

Ettinger, Laura. "The Birth of a New Professional: The Nurse-Midwife in the United States, 1925–1955." Ph.D. diss., University of Rochester, 1999.

Ewen, Elizabeth. *Immigrant Women in the Land of Dollars: Life and Culture on the Lower East Side, 1890–1925*. New York: Monthly Review Press, 1985.

Fett, Sharla M. *Working Cures: Healing, Health, and Power on Southern Slave Plantations*. Chapel Hill: University of North Carolina Press, 2002.

Fields, Barbara. "Ideology and Race in American History." In *Region, Race, and Reconstruction: Essays in Honor of C. Vann Woodward*, edited by J. Morgan Kousser and James M. McPherson, 143–77. New York: Oxford University Press, 1982.

Fifield, James Clark. *American and Canadian Hospitals*. Minneapolis: Midwest Publisher Company, 1933.

Fiset, Louis. "Public Health in World War II Assembly Centers for Japanese Americans." *Bulletin of the History of Medicine* 73 (1999): 565–84.

———. "A View of the Hospital and Health Care Program at the Central Utah (Topaz) Relocation Center." *Journal of the West* 38, no. 2 (1999): 34–44.

Fraser, Gertrude Jacinta. *African American Midwifery in the South: Dialogues of Birth, Race, and Memory*. Cambridge, Mass.: Harvard University Press, 1998.

Fujikawa, Yū. *Japanese Medicine*, translated by John Ruhrah. New York: Paul B. Hoeber, 1934.

Fujimura-Fanselow, Kumiko, and Atsuko Kameda, eds. *Japanese Women: New Feminist Perspectives on the Past, Present, and Future*. New York: Feminist Press at the City University of New York, 1995.

Gamble, Vanessa Northington. *Making a Place for Ourselves: The Black Hospital Movement, 1920–1945*. New York: Oxford University Press, 1995.

Garon, Sheldon. *Molding Japanese Minds: The State in Everyday Life*. Princeton, N. J.: Princeton University Press, 1997.

Garrett, Jessie A., and Ronald C. Larson, eds. *Camp and Community: Manzanar and the Owens Valley*. Fullerton, Calif.: California State University, Oral History Program, Japanese American Oral History Project, 1977.

Ginsburg, Faye D., and Rayna Rapp, eds. *Conceiving the New World Order: The Global Politics of Reproduction*. Berkeley: University of California Press, 1995.

Glenn, Evelyn Nakano. "From Servitude to Service Work: Historical Continuities

in the Racial Division of Paid Reproductive Labor." *Signs: Journal of Women in Culture and Society* 18, no. 1 (Autumn 1992): 1–43.

———. *Issei, Nisei, War Bride: Three Generations of Japanese American Women in Domestic Service*. Philadelphia: Temple University Press, 1986.

———. *Unequal Freedom: How Race and Gender Shaped American Citizenship and Labor*. Cambridge, Mass.: Harvard University Press, 2002.

Glick, Clarence E. *Sojourners and Settlers: Chinese Migrants in Hawaii*. Honolulu: Hawaii Chinese History Center and the University of Hawaii Press, 1980.

Gordon, Linda. *Pitied but Not Entitled: Single Mothers and the History of Welfare, 1890–1935*. Cambridge, Mass.: Harvard University Press, 1994.

———, ed. *Women, the State, and Welfare*. Madison: University of Wisconsin Press, 1990.

Gutierrez, Michelle. "Medicine in a Crisis Situation: The Effect of Culture on Health Care in the World War II Japanese American Detention Camps." Master's thesis, California State University, Fullerton, 1989.

Gutmanis, June. *Kahuna Laʻau Lapaʻau: The Practice of Hawaiian Herbal Medicine*. Aiea, Hawaii: Island Heritage Publishing, 1976.

Haig, Rena. *The Development of Nursing under the California State Department of Public Health*. New York: National League for Nursing, 1959.

Hane, Mikiso. *Modern Japan: A Historical Survey*. Boulder, Colo.: Westview Press, 1992.

Hansen, Arthur A. "Oral History and the Japanese American Evacuation." *Journal of America History* 82, no. 2 (September 1995): 625–39.

Harrison, Mark. "The Medicalization of War—The Militarization of Medicine." *Social History of Medicine* 9, no. 2 (August 1996): 267–76.

Haruko, Wakita, Anne Bouchy, and Ueno Chizuko, eds. *Gender and Japanese History*, vols. 1 and 2. Osaka, Japan: Osaka University Press, 1999.

Hasager, Ulla, and Jonathan Friedman, eds. *Hawaiʻi: Return to Nationhood*. Document no. 75. Copenhagen, Denmark: International Work Group for Indigenous Affairs, 1994.

Hawkins, John N. "Politics, Education, and Language Policy: The Case of Japanese Language Schools in Hawaii." *Amerasia Journal* 5, no. 1 (1978): 39–54.

Hayakawa, Noriyo. "Feminism and Nationalism in Japan, 1868–1945." *Journal of Women's History* 7, no. 4 (Winter 1995): 108–19.

Hazama, Dorothy Ochiai, and Jane Okamoto Komeiji. *Okage Sama De: The Japanese in Hawaiʻi*. Honolulu: Bess Press, 1986.

Hine, Darlene Clark. *Black Women in White: Racial Conflict and Cooperation in the Nursing Profession, 1890–1950*. Bloomington: University of Indiana Press, 1989.

Hisama, Kay K. "Florence Nightingale's Influence on the Development and Professionalization of Modern Nursing in Japan." *Nursing Outlook* 44, no. 6 (1996): 284–88.

Holmes, Linda Janet. "African American Midwives in the South." In *The American Way of Birth*, edited by Pamela S. Eakins, 273–91. Philadelphia: Temple University Press, 1986.

Horden, Peregrine, and Richard Smith, eds. *Locus of Care: Families, Communities, Institutions, and the Provision of Welfare since Antiquity*. New York: Routledge, 1998.

Horikawa, Nancy M. "The Transition from Japanese Hospital to Kuakini Hospital." *Social Process in Hawaii* 21 (1957): 54–57.

Houston, Jeanne Wakatsuki, and James D. Houston. *Farewell to Manzanar*. New York: Bantam Books, 1973.

Hunter, Janet, ed. *Japanese Women Working*. New York: Routledge, 1993.

Ichioka, Yuji. "Beyond National Boundaries: The Complexity of Japanese-American History." *Amerasia Journal* 23 no. 3 (Winter 1997–98): vii–xi.

———. *The Issei: The World of the First Generation Japanese Immigrants, 1885–1924*. New York: Free Press, 1988.

Iriye, Akira, ed. *Mutual Images: Essays in American-Japanese Relations*. Cambridge, Mass.: Harvard University Press, 1975.

Ishigo, Estelle. *Lone Heart Mountain*. Los Angeles: Anderson, Ritchie, and Simon, 1972.

Ito, Kazuo. *Issei: A History of Japanese Immigrants in North America*, translated by Shinichiro Nakamura and Jean S. Gerard. Seattle: Japanese Community Service, 1973.

Iwasaki, Pamela. "A Look at Health Care in the Japanese American Internment Camps." M.D. thesis, University of California, San Diego, 1988.

Jameson, Elizabeth. "Toward a Multicultural History of Women in the Western United States." *Signs: Journal of Women in Culture and Society* 13, no. 4 (Summer 1988): 761–91.

Japanese Association of the Pacific Northwest. *Japanese Immigration: An Exposition of Its Real Status*. Seattle: Japanese Association of the Pacific Northwest, 1907; repr., San Francisco: R and E Research Associates, 1972.

Jayawardena, Kumari. *Feminism and Nationalism in the Third World*. London: Zed Books, 1986.

Jensen, Gwenn M. "The Experience of Injustice: Health Consequences of the Japanese American Internment." Ph.D. diss., University of Colorado, 1997.

———. "System Failure: Health-Care Deficiencies in the World War II Japanese American Detention Centers," *Bulletin of the History of Medicine* 73 (Winter 1999): 602–28.

Johnson, Malia Sedgewick. "Margaret Sanger and the Birth Control Movement in Japan, 1921–1955." Ph.D. diss., University of Hawaii, 1987.

Jones, Zeina Omisola. "Knowledge Systems in Conflict: The Regulation of African American Midwifery." *Nursing History Review* 12 (2004): 167–84.

Jung, Moon-Ho. "The Influence of the 'Black Peril' on 'Yellow Peril' in Nineteenth-

Century America." In *Privileging Positions: The Sites of Asian American Studies,* edited by Gary Y. Okihiro, Marilyn Alquizola, Dorothy Fujita Rony, and K. Scott Wong, 349–63. Pullman: Washington State University Press, 1995.

Kaji, Troy Tashiro. "The Japanese-American Physicians and Japanese Hospitals of California before World War II." M.D. thesis, University of California, Davis, 1986.

Kawahara, Kimie, and Yuriko Hatanaka. "The Impact of War on an Immigrant Culture." *Social Process in Hawaii* 8 (1943): 38–40.

Keene, Donald. *Modern Japanese Diaries: The Japanese at Home and Abroad As Revealed through Their Diaries.* Henry Holt, 1995.

Kent, Noel J. *Hawaii: Islands under the Influence.* Honolulu: University of Hawaii Press, 1993; New York: Monthly Review Press, 1983.

Kerber, Linda K. "The Meanings of Citizenship." *Journal of American History* 84, no. 3 (December 1997), 833–54.

Kessel, Velma B. *Behind Barbed Wire: Heart Mountain Relocation Camp.* Privately published, 1992.

Kikumura, Akemi. *Through Harsh Winters: The Life of a Japanese Immigrant Woman.* Novato, Calif.: Chandler & Sharp, 1981.

Kimura, Yukiko. *Issei: Japanese Immigrants in Hawaii.* Honolulu: University of Hawaii Press, 1988.

Kitano, Harry H. L., and Roger Daniels. *Asian Americans: Emerging Minorities,* 2d ed. Englewood Cliffs, N.J.: Prentice Hall, 1995.

Kobrin, Frances E. "The American Midwife Controversy: A Crisis of Professionalization." *Bulletin of the History of Medicine* 40 (1966): 350–63.

Koslow, Jennifer Lisa. "Delivering the City's Children: Municipal Programs and Midwifery in Los Angeles." *Canadian Bulletin of Medical History* 19, no. 2 (2002): 1–33.

———. "Eden's Underbelly: Female Reformers and Public Health in Los Angeles, 1889–1932." Ph.D. diss., University of California, Los Angeles, 2001.

Kraut, Alan M. *Silent Travelers: Germs, Genes, and the 'Immigrant Menace'.* Baltimore: Johns Hopkins University Press, 1994.

Kurashige, Lon. "The Problem of Biculturalism: Japanese American Identity and Festival before World War II." *Journal of American History* 86, no. 4 (March 2000): 1632–54.

Ladd-Taylor, Molly. "'Grannies' and 'Spinsters': Midwife Education under the Sheppard-Towner Act." *Journal of Social History* 22 (Winter 1988): 255–75.

———. *Mother-Work: Women, Child Welfare, and the State, 1890–1930.* Urbana: University of Illinois Press, 1994.

LaFeber, Walter. *The Clash: U.S.-Japanese Relations throughout History.* New York: Norton, 1997.

Lam, Ah Chin L. "Medical Practice during the First Eighteen Months of the War." *Social Process in Hawaii* 9–10 (1945): 64–74.

Leap, Nicky, and Billie Hunter. *The Midwife's Tale: An Oral History from Handywoman to Professional Midwife.* London: Scarlet Press, 1993.

Leavitt, Judith Walzer. *Brought to Bed: Childbearing in America, 1750 to 1950.* New York: Oxford University Press, 1986.

———. "Medicine in Context: A Review Essay of the History of Medicine." *American Historical Review* 95, no. 5 (December 1990): 1471–84.

Leavitt, Judith Walzer, and Ronald L. Numbers, eds. *Sickness and Health in America: Readings in the History of Medicine and Public Health,* 3d rev. ed. Madison: University of Wisconsin Press, 1997.

Lebra, Joyce Chapman. *Women's Voices in Hawaii.* Boulder: University Press of Colorado, 1991.

Lee, Richard Kui Chi. "History of Public Health in Hawaii." *Hawaii Medical Journal* 15, no. 4 (March–April 1956): 331–37.

Lee, Valerie. *Granny Midwives and Black Women Writers: Double-Dutched Readings.* New York: Routledge, 1996.

Lerner, Gerda. *The Creation of Feminist Consciousness: From the Middle Ages to Eighteen-seventy.* New York: Oxford University Press, 1993.

Leslie, Charles, ed. *Asian Medical Systems: A Comparative Study.* Berkeley: University of California Press, 1976.

Lewis, Frances R. Hegglund. *History of Nursing in Hawaii.* Node, Wyo.: Germann-Kilmer, 1969.

Lewis, Jane. "Family Provision of Health and Welfare in the Mixed Economy of Care in the Late Nineteenth and Twentieth Centuries." *Social History of Medicine* 8, no. 1 (1995): 1–16.

Limerick, Patricia Nelson. *The Legacy of Conquest: The Unbroken Past of the American West.* New York: W. W. Norton, 1987.

Lindenmeyer, Kriste. *"A Right to Childhood": The U.S. Children's Bureau and Child Welfare, 1912–46.* Urbana: University of Illinois Press, 1997.

Litoff, Judith Barrett. *The American Midwife Debate: A Sourcebook on Its Modern Origins.* Westport, Conn.: Greenwood Press, 1986.

———. *American Midwives, 1860 to the Present.* Westport, Conn.: Greenwood Press, 1978.

Lock, Margaret M. *East Asian Medicine in Urban Japan.* Berkeley: University of California Press, 1980.

Logan, Onnie Lee. *Motherwit: An Alabama Midwife's Story.* New York: E. P. Dutton, 1989.

Loudon, Irvine. *Death in Childbirth: An International Study of Maternal Care and Maternal Mortality, 1800–1950.* Oxford, England: Clarendon Press, 1992.

———. *The Tragedy of Childbed Fever.* Oxford: Oxford University Press, 2000.

Mackey, Mike, ed. *Guilt by Association: Essays on Japanese Settlement, Internment, and Relocation in the Rocky Mountain West.* Powell, Wyo.: Western History Publications, 2001.

Marland, Hilary, and Anne Marie Rafferty, eds. *Midwives, Society and Childbirth: Debates and Controversies in the Modern Period*. New York: Routledge, 1997.

Matsumoto, Valerie J. *Farming the Home Place: A Japanese American Community in California, 1919–1982*. Ithaca, N.Y.: Cornell University Press, 1993.

———. "Japanese American Women during World War II." In *Unequal Sisters: A Multicultural Reader in U.S. Women's History*, edited by Ellen Carol Du Bois and Vicki L. Ruiz, 373–86. New York: Routledge, 1990.

McCunn, Ruthanne Lum. *Chinese American Portraits: Personal Histories, 1828–1988*. Seattle: University of Washington Press, 1988.

McEnaney, Laura. *Civil Defense Begins at Home: Militarization Meets Everyday Life in the Fifties*. Princeton, N.J.: Princeton University Press, 2000.

McKay, Susan. *The Courage Our Stories Tell: The Daily Lives and Maternal Child Health Care of Japanese American Women at Heart Mountain*. Powell, Wyo.: Western History Publications, 2002.

———. "'The Problem' of Student Nurses of Japanese Ancestry during World War II." *Nursing History Review* 10 (2002): 49–67.

Meckel, Richard A. *Save the Babies: American Public Health Reform and the Prevention of Infant Mortality, 1850–1929*. Baltimore: Johns Hopkins University Press, 1990.

Melosh, Barbara. *"The Physician's Hand": Work Culture and Conflict in American Nursing*. Philadelphia: Temple University Press, 1982.

Meyer, Leisa D. *Creating GI Jane: Sexuality and Power in the Women's Army Corps during World War II*. New York: Columbia University Press, 1996.

Miller, William J. "The World of Japan." In *The World of Asia*, 2d ed., edited by Akira Iriye, Edward J. Lazzerini, David S. Kopf, William J. Miller, and J. Norman Parmer, 153–230. Wheeling, Ill.: Harlan Davidson, 1995.

Mitchinson, Wendy. *Giving Birth in Canada, 1900–1950*. Toronto: University of Toronto Press, 2002.

Miyamoto, S. Frank. "An Immigrant Community in America." In *East across the Pacific: Historical and Sociological Studies of Japanese Immigration and Assimilation*, edited by Hilary Conroy and T. Scott Miyakawa, 217–43. Santa Barbara, Calif.: Clio Press, 1972.

———. *Social Solidarity among the Japanese in Seattle*. Seattle: University of Washington Press, 1984.

More, Ellen. *Restoring the Balance: Women Physicians and the Profession of Medicine, 1850–1995*. Cambridge, Mass.: Harvard University Press, 1999.

Moriyama, Alan Takeo. *Imingaisha: Japanese Emigration Companies and Hawaii, 1894–1908*. Honolulu: University of Hawai'i Press, 1985.

Muncy, Robyn. *Creating a Female Dominion in American Reform, 1890–1935*. New York: Oxford University Press, 1991.

Nakano, Jiro. *Kona Echo: A Biography of Dr. Harvey Saburo Hayashi*. Kona, Hawai'i: Kona Historical Society, 1990.

Nakano, Mei. *Japanese American Women: Three Generations, 1890–1990*. Berke-

ley, Calif.: Mina Press; San Francisco: National Japanese American Historical Society, 1990.

Nakayama, Gordon G. *Issei: Stories of Japanese Canadian Pioneers.* Toronto: NC Press, 1984.

Ngai, Mae N. "The Architecture of Race in American Immigration Law: A Reexamination of the Immigration Act of 1924." *Journal of American History* 86, no. 1 (June 1999): 67–92.

Niiya, Brian, ed. *Japanese American History: An A-to-Z Reference from 1868 to the Present.* New York: Facts on File, 1993.

Nishikawa, Mugiko. *Aru kindai sanba no monogatari: noto-takeshima mii no katari-yori* [A Story of a Modern *Sanba*: From the Narrative of Mii Takeshima from Noto]. Japan: Katura Publishers, 1997.

Nolte, Sharon H., and Sally Ann Hastings. "The Meiji State's Policy toward Women, 1890–1910." In *Recreating Japanese Women, 1600–1945,* edited by Gail Lee Bernstein, 151–74. Berkeley: University of California Press, 1991.

Nomura, Gail M. "Significant Lives: Asia and Asian Americans in the History of the U.S. West." *Western Historical Quarterly* 25, no. 1 (Spring 1994): 69–88.

Nursing Section, Medical Affairs Bureau, Japanese Ministry of Health and Welfare. *Report on Nursing and Midwifery in Japan.* Tokyo: Japanese Ministry of Health and Welfare, 1953.

Ōbayashi, Michiko. "Josanpu shokuno no hensen o saguru. Nihon sanba kangofu hokenfu kyokai setsuritsu zenshi" [Searching for Transitions in the Function of Midwives: The History Prior to the Establishment of the Japanese Society for Midwives, Nurses and Public Health Nurses"]. *Josanpu Zasshi* [(Japanese) Journal for Midwives] 39, no. 2 (February 1985): 84–88.

O'Brien, David J., and Stephen S. Fugita. *The Japanese American Experience.* Bloomington: Indiana University Press, 1991.

Ochiai, Hidetoshi. "Kobe de iki kamisama to shimpō sareta sanba san [A Midwife Believed to Be a Living Saint of Kobe]. *Josanpu Zasshi* ([Japanese] Journal for Midwives) 27 (March 1973): 48–52.

Odo, Franklin, ed. *The Columbia Documentary History of the Asian American Experience.* New York: Columbia University Press, 2002.

Odo, Franklin, and Kazuko Sinoto. *A Pictorial History of the Japanese in Hawai'i, 1885–1924.* Honolulu: Bishop Museum, 1985.

Ogawa, Dennis M. *Jan Ken Po: The World of Hawaii's Japanese Americans.* Honolulu: University of Hawai'i Press, 1973.

———. *Kodomo no tame ni, For the Sake of the Children: The Japanese American Experience in Hawaii.* Honolulu: University of Hawaii Press, 1978.

Ogawa, Teizo, ed. *History of Obstetrics: Proceedings of the 7th International Symposium on the Comparative History of Medicine — East and West.* Osaka, Japan: Taniguchi Foundation, 1983.

Ohnuki-Tierney, Emiko. *Illness and Culture in Contemporary Japan: An Anthropological View.* Cambridge, England: Cambridge University Press, 1984.

Okamoto, Kiyoko. "Josanpu katsudo no rekishiteki igi. Meiji jidai o chushin ni" [The Historical Significance of Midwifery: Meiji Period]. *Josanpu Zasshi* [(Japanese) Journal for Midwives] 35, no. 8 (August 1981): 21–43.

Okihiro, Gary Y. *Cane Fires: The Anti-Japanese Movement in Hawaii, 1865–1945.* Philadelphia: Temple University Press, 1991.

Okihiro, Michael M. "Japanese Doctors in Hawai'i." *Hawaiian Journal of History* 36 (2002): 105–17.

Okubo, Mine. *Citizen 13660.* Seattle: University of Washington Press, 1983.

Omi, Michael, and Howard Winant. *Racial Formation in the United States From the 1960s to the 1990s,* 2d ed. New York: Routledge, 1994.

Palmer, Albert W. *The Human Side of Hawaii: Race Problems in the Mid-Pacific.* Boston: Pilgrim Press, 1924.

Pascoe, Peggy. "Miscegenation Law, Court Cases, and Ideologies of 'Race' in Twentieth-Century America." *Journal of American History* 83, no. 1 (June 1996): 44–69.

———. *Relations of Rescue: The Search for Female Moral Authority in the American West, 1874–1939.* New York: Oxford University Press, 1990.

Reagan, Leslie J. *When Abortion Was a Crime: Women, Medicine, and Law in the United States, 1867–1973.* Berkeley: University of California Press, 1997.

Reverby, Susan M. *Ordered to Care: The Dilemma of American Nursing, 1850–1945.* Cambridge, England: Cambridge University Press, 1987.

Robinson, Greg. *By Order of the President: FDR and the Internment of Japanese Americans.* Cambridge, Mass.: Harvard University Press, 2001.

Robinson, Sharon A. "A Historical Development of Midwifery in the Black Community: 1600–1940." *Journal of Nurse-Midwifery* 29 (July/August 1984): 247–50.

Rosenberg, Charles E. *The Care of Strangers: The Rise of America's Hospital System.* Baltimore: Johns Hopkins University Press, 1987.

Rothman, David J. *Strangers at the Bedside: A History of How Law and Bioethics Transformed Medical Decision Making.* New York: Basic Books, 1991.

Rothman, Sheila M. *Living in the Shadow of Death: Tuberculosis and the Social Experience of Illness in American History.* Baltimore: Johns Hopkins University Press, 1994.

Rousseau, Julie M. "Enduring Labors: The 'New Midwife' and the Modern Culture of Childbearing in Early Twentieth Century Japan." Ph.D. diss., Columbia University, 1998.

Ryder, Reiko Shimazaki. "Nursing Reorganization in Occupied Japan, 1945–1951." *Nursing History Review* 8 (2000): 71–93.

Sarasohn, Eileen Sunada. *Issei Women: Echoes from Another Frontier.* Palo Alto, Calif.: Pacific Books, 1998.

Satō, Kayo. *Nihon Josanpushi Kenkyū: Sono Igi to Kadai* [A Study of the History of Japanese Midwives: Their Significance and Challenges]. Tokyo: Higashi Ginza Shuppansha, 1997.

Savitt, Todd L. *Medicine and Slavery: The Diseases and Health Care of Blacks in Antebellum Virginia*. Urbana: University of Illinois Press, 1978.

Schackel, Sandra. *Social Housekeepers: Women Shaping Public Policy in New Mexico, 1920–1940*. Albuquerque: University of New Mexico Press, 1992.

Scharff, Virginia. *Taking the Wheel: Women and the Coming of the Motor Age*. Albuquerque: University of New Mexico Press, 1992; New York: Free Press, 1991.

Shah, Nayan. *Contagious Divides: Epidemics and Race in San Francisco's Chinatown*. Berkeley: University of California Press, 2001.

Shima, Kazuharu. "Tanaka shin monogatari: owari naki ryo" [Journey without End: The Story of Shin Tanaka]. *Josanpu Zasshi* [(Japanese) Journal for Midwives] 37, no. 3 (March 1983): 68–76.

———. "Tanaka shin monogatari: owari naki ryo" [Journey without End: The Story of Shin Tanaka]. *Josanpu Zasshi [*(Japanese) Journal for Midwives] 37, no. 4 (April 1983): 71–73.

———. "Tanaka shin monogatari: owari naki ryo" [Journey without End: The Story of Shin Tanaka]. *Josanpu Zasshi [*(Japanese) Journal for Midwives] 37, no. 12 (December 1983): 80–87.

Shimada, Noriko. "Wartime Dissolution and Revival of the Japanese Language Schools in Hawai'i: Persistence of Ethnic Culture." *Journal of Asian American Studies* 1 no. 2 (June 1998): 121–51.

Shoemaker, M. Theophane. *History of Nurse-Midwifery in the United States*. New York: Garland, 1984; Washington, D.C.: Catholic University of America Press, 1947.

Smith, Susan L. "Medicine, Midwifery, and the State: Japanese Americans and Health Care in Hawai'i, 1885–1945." *Journal of Asian American Studies* 4 (February 2001): 57–75.

———. *Sick and Tired of Being Sick and Tired: Black Women's Health Activism in America, 1890–1950*. Philadelphia: University of Pennsylvania Press, 1995.

———. "Women Health Workers and the Color Line in the Japanese American 'Relocation Centers' of World War II." *Bulletin of the History of Medicine* 73 (Winter 1999): 585–601.

Sone, Monica. *Nisei Daughter*. Seattle: University of Washington Press, 1953.

Spickard, Paul. *Japanese Americans: The Formation and Transformations of an Ethnic Group*. New York: Twayne, 1996.

Standlee, Mary W. *The Great Pulse: Japanese Midwifery and Obstetrics through the Ages*. Rutland, Vt.: Charles E. Tuttle, 1959.

Starr, Paul. *The Social Transformation of American Medicine*. New York: Basic Books, 1982.

Steger, Brigitte Steger. "From Impurity to Hygiene: The Role of Midwives in the Modernisation of Japan." *Japan Forum* 6, no. 2 (October 1994): 175–87.

Stephan, John J. *Hawaii under the Rising Sun: Japan's Plans for Conquest after Pearl Harbor*. Honolulu: University of Hawai'i Press, 1984.

Stevens, Rosemary. *In Sickness and in Wealth: American Hospitals in the Twentieth Century.* Baltimore: Johns Hopkins University Press, 1999.

Susie, Debra Ann. *In the Way of Our Grandmothers: A Cultural View of Twentieth-Century Midwifery in Florida.* Athens: University of Georgia Press, 1988.

Takahashi, Jere. *Nisei/Sansei: Shifting Japanese American Identities and Politics.* Philadelphia: Temple University Press, 1997.

Takahashi, Masako. "'Fujin kotobukigusa' to 'toriagebaba kokoro e gusa' ni miru josanpu no sugata" [A Portrait of Midwives Seen in "Writings on Women's Longevity" and "Writings on Rules for Midwives"]. *Kango Kyōiku* [*Nursing Education*] 24, no. 8 (August 1983): 496–99.

Takaki, Ronald. *Pau Hana: Plantation Life and Labor in Hawaii, 1835–1920.* Honolulu: University of Hawaii Press, 1983.

———. *Strangers from a Different Shore: A History of Asian Americans.* Boston: Little, Brown, 1989.

———. "They Also Came: The Migration of Chinese and Japanese Women to Hawaii and the Continental United States." In *Chinese America: History and Perspectives,* 3–19. San Francisco: Chinese Historical Society of America, 1990.

Takaoka, Sumiko, and Sumie Furusaki. "Sanba no jissen katsudo to ayumi kara gakubu koto (parts 1, 2, and 4)" ["A Study of the Practices and Developmental Course of Midwives"]. *Josanpu Zasshi* [(Japanese) Journal for Midwives] 41, no. 5 (May 1987): 51–56; no. 6 (June 1987): 48–51; no. 8 (August 1987): 43–47.

Tamura, Eileen H. *Americanization, Acculturation, and Ethnic Identity: The Nisei Generation in Hawaii.* Urbana: University of Illinois Press, 1994.

Tamura, Linda. *The Hood River Issei: An Oral History of Japanese Settlers in Oregon's Hood River Valley.* Urbana: University of Illinois Press, 1993.

Tanaka, Michiko. *Through Harsh Winters: The Life of a Japanese Immigrant Woman,* as told to Akemi Kikumura. Novato, Calif.: Chandler & Sharp, 1981.

Taylor, Sandra C. *Jewel of the Desert: Japanese American Internment at Topaz.* Berkeley: University of California Press, 1993.

Terazawa, Yuki. "Gender, Knowledge, and Power: Reproductive Medicine in Japan, 1790–1930." Ph.D. diss., University of California, Los Angeles, 2001.

Thomas, Dorothy Swaine, and Richard S. Nishimoto. *The Spoilage.* Berkeley: University of California Press, 1946.

Tomes, Nancy. *The Gospel of Germs: Men, Women, and the Microbe in American Life.* Cambridge, Mass.: Harvard University Press, 1998.

———. "Merchants of Health: Medicine and Consumer Culture in the United States, 1900–1940." *Journal of American History* 88, no. 2 (September 2001): 519–47.

———. "Oral History in the History of Medicine." *Journal of American History* 78, no. 2 (September 1991): 607–17.

Tonomura, Hitomi, Anne Walthall, and Wakita Haruko, eds. *Women and Class in Japanese History.* Ann Arbor: Center for Japanese Studies, University of Michigan, 1999.

Uchida, Yoshiko. *Desert Exile: The Uprooting of a Japanese-American Family.* Seattle: University of Washington Press, 1982.

Ulrich, Laurel Thatcher. *A Midwife's Tale: The Life of Martha Ballard, Based on Her Diary, 1785–1812.* New York: Knopf, 1990.

Uono, Koyoshi. "The Factors Affecting the Geographical Aggregation and Dispersion of the Japanese Residences in the City of Los Angeles." Master's thesis, University of Southern California, 1927.

Van Sant, John E. *Pacific Pioneers: Japanese Journeys to America and Hawaii, 1850–80.* Urbana: University of Illinois Press, 2000.

Vogel, Morris J. *The Invention of the Modern Hospital, Boston, 1870–1930.* Chicago: University of Chicago Press, 1980.

von Hassell, Malve. "Issei Women between Two Worlds: 1875–1985." Ph.D. diss., New School for Social Research, 1987.

Walsh, Linda V. "Midwives As Wives and Mothers: Urban Midwives in the Early Twentieth Century." *Nursing History Review* 2 (1994): 51–65.

Weglyn, Michi. *Years of Infamy: The Untold Story of America's Concentration Camps.* New York: Morrow Quill, 1976.

Whitehead, John. "Hawai'i: The First and Last Far West?" *Western Historical Quarterly* 23 (May 1992): 153–77.

Worthen, Dennis. "Nisei Pharmacists in World War II." *Pharmacy in History* 45, no. 2 (2003): 58–65.

Yamamoto, Eriko. "The Evolution of an Ethnic Hospital in Hawaii: An Analysis of Ethnic Processes of Japanese Americans in Honolulu through the Development of the Kuakini Medical Center." Ph.D. diss., University of Hawaii, 1988.

Yanagisako, Sylvia Junko. "Transforming Orientalism: Gender, Nationality, and Class in Asian American Studies." In *Naturalizing Power: Essays in Feminist Cultural Analysis,* edited by Sylvia Yanagisako and Carol Delaney, 275–98. New York: Routledge, 1995.

———. *Transforming the Past: Tradition and Kinship among Japanese Americans.* Stanford, Calif.: Stanford University Press, 1985.

Yung, Judy. *Chinese Women of America: A Pictorial History.* Seattle: University of Washington Press, 1986.

———. *Unbound Feet: A Social History of Chinese Women in San Francisco.* Berkeley: University of California Press, 1995.

INDEX

abortion, 19, 22, 49, 55, 133, 248n131
adoption, 55, 133
African Americans, 43, 84, 92, 108, 111–12, 158, 166, 180
Akita, Mary, 89
Alien Land Act, 36; court challenge of, 36
American Indians. *See* Native Americans
Anthony, J. Garner, 145–46, 157
anti-Japanese movement, 3, 36–37, 39; and the Japanese problem, 31, 146
Aoki, Yoshi, 27–29
Appleton, Vivia B., 122, 126, 232n77
assembly centers (detention centers), 157, 162, 165, 171–72

bacteriology. *See* Germ theory of disease
Ballard, Martha, 68–70
Beppu, Grant, 85–86
Beppu, Hisuji, 82, 178
Beppu, Lincoln, 63, 83, 178, 219n83
Beppu, Sawa, 63, 67, 82–87, 98, 169, 171, 176, 178
Beppu, Taft, 83
Beppu, Teru, 83, 86–87, 99, 171, 178
birth control, 87
birthing women, 3; birth hut, 93; clothing for delivery, 131; cultural practices of, 2, 78, 93, 101, 118, 182; and folk medicine, 133; and *gaman suru* (restraint and silence in childbirth), 86–87; husband's assistance to, 59, 123, 127; and informant birth attendants, 122–23, 127; *jintsu* (childbirth pain), 66, 86–87; and midwifery in California, 58; and midwifery in Hawai'i, 118, 129, 149, 152–55; and midwifery in Japan, 22, 26–30; and midwifery in Seattle, 78, 87, 101; and modesty, 78, 118; and rest period, 27, 66, 86, 93; ritualized behavior, 121; and safety, 176, 178; and unaided delivery, 78; and white doctors, 100
birth registration, 45, 49, 86, 99–100, 122
Bisande, Guadalupe, 125, 133
Bonilla, Nuncia Morris, 125
breastfeeding, 80, 130, 172, 211nn103–4
Bubonic plague, 115–17
Buddhism, 16; and education, 35; and temples, 25, 32, 64–65, 108
Bureau of Maternal and Infant Hygiene (Hawai'i), 104–5, 122–23, 126, 129, 134–35, 139; (renamed) Bureau of Maternal and Child Health, 149–50

California: farm labor, 34–35, 78; medical association, 53; Mexican migrant workers, 58; midwife legislation, 47–48, 53; number of health-care practitioners, 53; number of Japanese immigrants in, 37; rural life, 32
Canada: and doctor's fees, 76; and hospitals, 88; and Japanese immigration, 33, 39, 72, 75, 89; and rescue homes, 97

❁

Susan L. Smith is professor of history at the University of Alberta, Canada. She is also the author of *Sick and Tired of Being Sick and Tired: Black Women's Health Activism in America, 1890–1950* (Philadelphia: University of Pennsylvania Press, 1995).

The Asian American Experience

The University of Illinois Press
is a founding member of the
Association of American University Presses.

Composed in 10/13 Sabon
with Sabon display
at the University of Illinois Press
Designed by Dennis Roberts
Manufactured by Sheridan Books, Inc.

University of Illinois Press
1325 South Oak Street
Champaign, IL 61820-6903
www.press.uillinois.edu